Animating with Flash MX:

Professional Creative Animation Techniques

Animating with Flash MX:
Professional Creative Animation Techniques

Alex Michael

Focal Press OXFORD AMSTERDAM BOSTON LONDON NEW YORK PARIS
SAN DIEGO SAN FRANCISCO SINGAPORE SYDNEY TOKYO

Focal Press
An imprint of Elsevier Science
Linacre House, Jordan Hill, Oxford OX2 8DP
200 Wheeler Road, Burlington MA 01803

First published 2003

British Library Cataloguing in Publication Data
A catalogue record for this book is available from the British Library

Library of Congress Cataloguing in Publication Data
A catalogue record for this book is available from the Library of Congress

ISBN 0 240 51905 1

For information on all Focal Press publications visit our website at:
www.focalpress.com

Printed and bound in Italy

Contents at a Glance

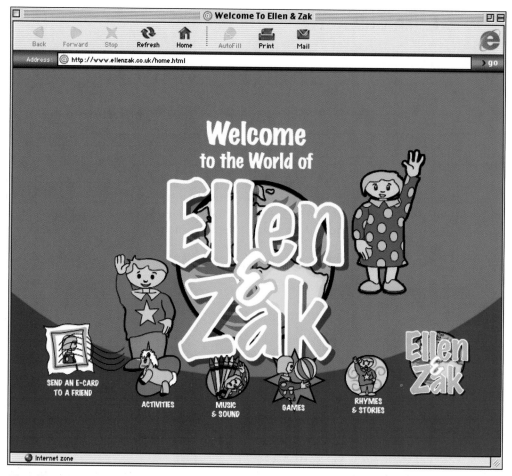

The Ellen and Zak home page

Contents in Summary

Introduction

The Introduction gives an overview of the structure of the book, what it covers and who the book is for. In particular it outlines the way that some of the basic chapters pave the way for more advanced techniques.

Chapter 1: Animation technique overview and drawing tools

An overview of the various drawing tools available for rendering characters. This includes: pen and paper techniques, use of a vector drawing tool (FreeHand 10, Illustrator), a look at a 3D environment, Flash. The purpose of this chapter is to touch on the benefits of various application environments, with a primary focus on Flash.

Chapter 2: Basic animation techniques in Flash MX

Ths chapter covers the Flash MX environment, a basic overview of Flash MX animation (keyframes, frame rates, layers, frame-by-frame animation, onion skinning), in-betweening/tweening techniques, motion guides, interactive and multimedia movies, the Flash Player, Flash file formats, seeing Flash in action.

Chapter 3: Defining character animation

This chapter looks at techniques for conveying motion (speed blurring, weight, opposing actions, anticipation, overshooting, squash and stretch), human movements (walking + fiddling), Rotoscoping.

Chapter 4: Flash and 3D animation

This chapter examines the use of Flash MX alongside 3D applications to create stunning 3D animations, modelling for rendering and animation, painting detail into a model, using symbols, building a library of standard objects, planning, readability of actions, creating a walk cycle in Poser and taking it into Flash, building 3D characters.

Chapter 5: Using sound to enhance your animation

Chapter 5 covers recording sound effects, recording music, compressing sound, integrating sound and music into your movie, creating surround sound effects.

Chapter 6: Lip syncing and facial expressions

This chapter defines lip syncing, track analysis, shows how to connect sounds to lip movements, timing mouth shapes, eye expressions, animation and tricks of the trade.

Chapter 7: Adding interactivity

Here we examine the Movie Explorer and the action panel, and an introduction to and description of the ActionScript you will need to write movies in Flash MX.

Chapter 8: ActionScript fundamentals and component user interface design

Variables, functions, if statements, while and for loops, the Array object and MovieClip hitTest are all covered here. This section prepares you for Chapter 9 by making actions and general moving of sprites understandable. At minimum it will teach you to hack and reuse code. We also cover the new Flash components featured in MX, and how to use and get the best from them.

Chapter 9: ActionScript-driven animation techniques

This includes nineteen features on Flash movies that use ActionScript-driven animation, they are: Preloader, Cursor, Sparkler Effect, Magnifying Glass, Starfield, Parallax Scrolling, Collision Detection, Movie Controller, Bug, Sparkle, Dancing Lights, Snow, Bubbles, Gravity Footballs, Wobble Buttons, Spiral, Orbit, Earthquake, Moving Eyes, Storyboard.

Chapter 10: Dynamic animation

Dynamic animation is a unique system that starts where database-driven sites have left off. This chapter talks about object oriented scripting, and how you can use it in your animations to create new levels of interactivity for the viewer. It also features a walkthrough to show you have to develop the virtual aquarium.

Chapter 11: Internet/video

You will learn about publishing and exporting your Macromedia Flash movies, optimisation, publish settings. cartoons and the Internet (preloaders, Internet restrictions), cartoons and video (preparing your movie, outputting animations from Flash MX to video).

Chapter 12: Games development

This chapter takes you through developing games using Flash. It looks at the various disciplines for animating games, and concludes with walkthroughs that will teach you how to build "ZakPac", a pacman style game in Flash, and the Flash animator's quiz.

Chapter 13: The Pocket PC

This chapter looks at issues of interface design, size, format, bandwidth for delivery and animation techniques for both mobile and portable communications. The chapter is broken down into two parts. The first part looks at the hardware and interface issues that an animator needs to come to grips with. The second part is very much the techniques of animation for small devices.

Chapter 14: Interactive TV

This chapter looks at issues of interface design, size, format, and the integration of Flash components with video-based material.

Chapter 15: Typography for the animator

This chapter first covers the history of typography, with an in-depth study of the development of different fonts, and then goes on to look at how type can be used to give your animations more impact, focusing on using the Flash Typer tool.

Case Studies
This section takes you through a number of case studies on animated projects worked on by the author for a wide variety of clients.

Showcase
A vibrant showcase of animation talent from around the Internet.

Appendix A: Animators' glossary

Appendix B: Animation software

Appendix C: Professional organisations for TV and iTV

Appendix D: Animators' web links

Appendix E: CD contents

Index

Acknowledgements

Alex Michael would like to thank:

Like the process of creating an animation film, this book has had the involvement of many people over many years. I would especially like to thank the team at Sprite Interactive with a special mention for Ben Salter and Robert Vacher. Ben has painstakingly edited the book, designed it and artworked it. Robert Vacher one way or another has been involved in the creation of the programming of all the FLAs on the CD. Without their efforts this book would never have happened.

I would also like to thank Marie Hooper and the team at Focal Press for all their support; Anthony Mascolo for all his support over the years and John Smalley for the kickstart to my career.

This book has taken many days, weeks and months to write. The people most affected by this effort have been my family. Thanks to my wife Liz for her support and my daughter Ellen (age 3) for her challenging contributions and the occasional keying in on the keyboard.

Introduction

The last thirteen years have seen a revolution in the way we interact with information on screen. It was thirteen years ago when I first played with Macromind's product Video Works. This was a very basic black and white animation tool that was unable to produce more than twelve frames per second in black or white pixels. It was another four years and a name change later, from Macromind to Macromedia in 1992, that Macromind finally brought out Director 4. This had real interactivity with the introduction of Lingo, its new scripting language. Most people in the design world questioned whether anybody would ever want to interact with a screen for all their information, or whether interaction was even desirable anyway. In those early years, however, and right through to the mid-90s, Macromedia almost single-handedly invented the multimedia revolution.

In the mid-90s, Macromedia "Shocked the Web" with the Director plug-in. For the first time on the web you had moving images that you could interact with, combined with sound. A couple of years after that, FutureSplash brought out its vector tools, which seemed so much better and faster than the Director-based products. FutureSplash's smaller plug-in and faster vector-based animation combined with interactivity soon took over the mantle of the most popular player on the web. It was purchased by Macromedia and renamed Flash.

The Flash player is now available to create animation for all kinds of devices from Internet pages on computers through to mobile devices such as PDAs and phones. So now we can watch rich animation using Flash on PDAs whilst on the move. We can watch and play Flash games in the interactive TV environment from the comfort of our sofa and we can use Flash to build clear focused interfaces for business products.

This book will teach you the process of animating, using Flash for deployment across all platforms from interactive TV through to PDAs and computers. By looking at detailed examples provided on the CD, we will take the reader through each stage of creation, build and deployment. We will look at the complexities of the interfaces and how we cater for them. Animators can now realize their vision with just an idea and talent, or just pure enthusiasm and drive.

The tradition of drawn animation is an art form that only developed in the twentieth century. Film has been the vehicle for this great technology. Traditionally, an animator needed a large team of artists to produce any moving image. The industry had to standardise itself; in this standardisation, the craft of animation was born. Animation is an art form that has no limitations but is a discipline that needs to be studied and tailored for whatever format or environment you are creating content.

What This Book Covers

This book is structured in three parts. The first section looks at some of the tools that are available for creating your content and includes applications for quick animation prototyping (Poser), lip syncing and sound, as well as other helpful applications. We also look at the process or science of animation. This takes us from in-betweening to walks, runs and exaggeration in the animated body.

The middle section looks at bringing interactivity into the animation. This starts initially with some basic principles of interactivity and continues through to some complex code. All the code is provided with clear explanation on its usage as well as how to edit it. All examples throughout the book are contained on the accompanying CD.

The final section looks at the delivery of a completed animation, for computers that are of infinite resolution, television screens and PDAs that have only 240 X 260 pixels with which to play.

There are plenty of great sources for learning Flash basics so we focus clearly in this book on those aspects of Flash that facilitate animation and sound for multi-platform playback. We start with basic principles and go through to the advanced features. This book focuses on the animation that takes advantage of the playback device and its limitations. The intention is that the animator understands the restrictions of different devices and how to compensate for those devices. If you have never animated before, persevere as the art of animation is very accessible and Flash can take your spontaneous doodle and, with creativity and care, turn it into a compelling piece of animation, as this book shows!

Throughout, the chapters are supported by complete FLA files containing all the elements you need to build your own version of the examples. Also included are games where you can redraw the characters testing out your new computer-based animation skills in games development. We recognise the importance of ActionScript and so introduce both basic concepts and complex routines that can be used in the animation process. This will save time and money. The level of ActionScript we present is geared to give confidence to the animator to amend and customise code.

Who This Book is For

If you want to learn how to create quality professional animation using Flash and deploy it across platforms varying from small screen PDAs to TV monitors, then this is the book for you. Whether you are a designer who hasn't yet used Flash, or a professional animator who wants to create digital animation for the first time, this book will take you from your first drawing and animation project in Chapter 1, through to a strong foundation for animation techniques that are just as applicable to the animation world as they are to the world of the Flash user.

This book is thorough and practical, and tutorial-led, where each chapter helps to build up an understanding through case studies and example projects reinforcing what you've learnt in that

section and how it can be applied in real projects. By having working examples to follow, difficult animation can become understandable, even easy. However, even if you are not an animator, but want to learn about enhancing your web presentation by using animation, then you can, from the material we provide.

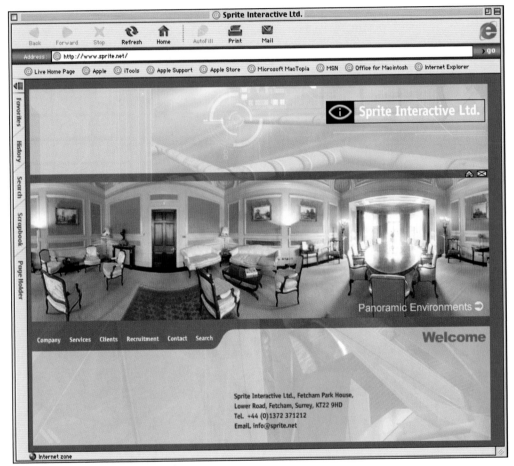

Figure I.1 *The Sprite Interactive web site*

Chapter 1

Animation Technique Overview and Drawing Tools

This chapter takes you through an overview of basic animation techniques, with practical tips on producing animation using both traditional and modern methods. The chapter also outlines and reviews the major applications that are used for drawing, creating animations and editing images

Introduction

The development of technologies for animation has heralded a new form of expression in animation and graphic design. Previously TV and cinema provided the only outlet for animators. The new era sees graphic designers animating web sites without having traditional training in animation, and it also sets a challenge for animators as the market is growing ever more sophisticated, dedicated and technical. There can be few designers who have not been exposed to a copious amount of traditional animation. Animation is part of our cultural identity. I have yet to find somebody who never fantasised about becoming an animator.

The web animator has an interesting advantage over the designer. Whilst the designer has a hundred years of animation to learn about and draw from, the animator has only five to ten years of web experience to baggage themselves with. Any animation problem you may encounter has probably been resolved a thousand times all over the world. If you encounter a problem with Flash MX you can only turn to a handful of people. Great animation is great animation wherever it's delivered. The influence of pre-digital animation is not limited to character animation, artists have always experimented with abstraction in animation and the web sees that tradition continued.

What is so very different about the digital age is that the animator needs to consider interactivity as part of the function of the animation. Interactivity now needs to be expressed in a tangible, sometimes even tactile form. While the magic can be in the animation, the desire for users to play with objects on screen and be entertained is high, something that moves is fun, but something that responds to the user is magic. Most forms of entertainment in the real world have found their niche on the web, but what is interesting is that quality animation in the traditional sense has only just become available with new tools and more bandwidth. Flash MX is going to help define the new era of animation on the web.

What is Flash?

Flash is one of the most significant applications in the web creation process. It has become a "killer app" that has been embraced by a wide spectrum of developers. Flash has a large community with developers freely sharing tips, tricks, and processes with each other, and also contributing to the development of the application itself.

Before Flash, creating animated web sites (complete with sound) involved large files, which required equally large bandwidth. Flash files are vector based and in contrast, can be very small, making bandwidth and loading times less of a concern. Furthermore, Flash has brought a level of advanced animation and interactivity previously unavailable using traditional Internet technology. Though Flash is predominantly used for the Internet it is also used outside of the web, for kiosks, for presentations and CD-ROMs, among other things.

As you work in Flash, you create a movie by drawing or importing artwork, arranging it on the Stage, and animating it with the Timeline. You make the movie interactive by using actions to make the movie respond to events in specified ways.

Figure 1.1 *The Flash MX environment*

Figure 1.2 *The Flash Player*

The Flash Player

When the movie is complete, you export it as a Flash Player movie to be viewed in the Flash Player, or as a Flash stand-alone projector to be viewed with a self-contained Flash Player included within the movie itself. In this book you will learn how to do all this.

The Flash Player functions as either a stand-alone player or as a web-browser plug-in, which is available for the two most popular web browsers, Netscape and Internet Explorer.

Movie Formats

Flash files are often referred to as movies, whether in the authoring environment or in the final playable form. You create animation and interactivity in Flash-format files, whose file extension is .fla. To create viewable movies you convert these to Flash Player format, whose extension is .swf.

Figure 1.3 *.fla and .swf file icons*

Flash is the foremost application for creating the swf format files. Swf files need the Flash Player plug-in from Macromedia to play back the swf animation. But Flash is not the only application for creating swfs. I will in the rest of this chapter highlight the different tools available for building assets for both Flash and swf playback. For years a diatribe has existed between users of FreeHand and Illustrator and I have always argued the merits of FreeHand over Illustrator, but the reality is that both applications are of master quality and it is the user that really finally defines the result. I will try to keep my prejudices to myself as I take you through the tools available to support your animation.

Macromedia published its specification for the swf format; because of this we have numerous alternatives to Flash for creating swfs. In the world of 2D we have LiveMotion, Illustrator, After Effects, Fireworks and FreeHand. In the 3D world every 3D application of note has the facility to export content in the swf format. In this chapter we will look at both Swift 3D and Poser 4.

There is no shortcut for skills and knowledge, so before you get too involved in looking at the different tools available, you need to consider and plan your animation. This is thinking about the project, identifying the right tools and deciding on the right resources for the right approach.

Figure 1.4 *Planning your movie using a storyboard*

Plan your Flash Movie

Plan out the scene using a storyboard. We have included one on the CD with support information, Storyboard.fla. I always recommend that you have the action planned out in your mind before you start to create in Flash. Also, keep in mind the character's personality, your unique drawing style and how that fits the overall picture. Time spent here will not only save you time later, but will lead to a consistency that gives the movie a fluid continuity.

Working with a number of people on an animation project can sometimes lead to a communications breakdown. To avoid this we at Sprite Interactive evolved a design methodology that plans out all the assets required for a game or film. This process not only helps you in the planning but also gives the client a document to sign off on.

Textual Description

This stage involves producing a description of the game that can be broken down into its basic elements, which could quite easily be a script. When writing the description try to include as much detail as possible about aspects of the animation such as effects and actions associated with things in the animation. The more detail you include the easier it is to break down into a smaller scene and snapshot of the actions.

Figure 1.5 *The Sprite Invaders game*

Identify Assets

Now identify the game assets by extracting all the nouns from your textual description. For example, the following description is taken from a space invaders type game:

"…you control a spaceship that is being attacked by aliens descending from above in their UFOs. You can fire missiles to destroy the aliens and they can drop bombs on you. If your craft is hit by an alien projectile it is game over."

The nouns identify the top-level assets (or objects) in the design and in Flash these directly translate to Movie Clip assets. The identified assets are:

SHIP
ALIEN
BOMB
MISSILE
PROJECTILE
CRAFT
UFO

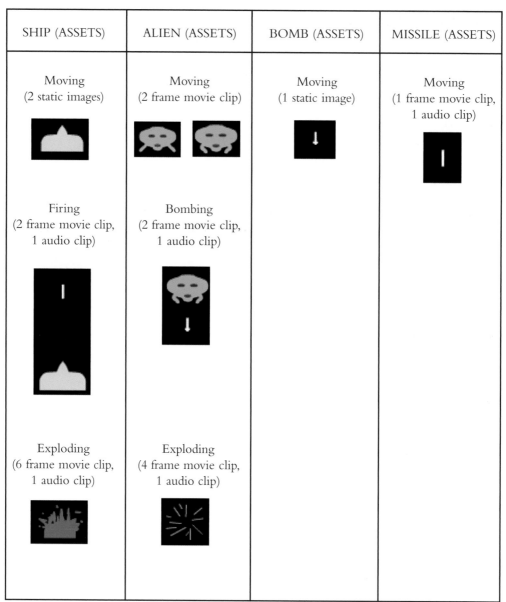

Figure 1.6 *Asset specification*

Once the nouns have been identified it is important to remove any duplicate or misleading assets, for example the PROJECTILE asset is potentially misleading and is simply an instance of either the MISSILE or BOMB assets. Similarly, UFO refers to the ALIEN asset and CRAFT is simply another way of describing the SHIP asset. This check ensures that each asset is unique and removes all redundant information.

Asset Specification

With the assets identified the next step is to plan the specification for each of these graphical assets. This involves identifying the states associated with each asset and deciding the graphical and audio requirements for each asset state. For example, the SHIP asset can be defined by the following states:

SHIP (ASSETS)
Moving (2 static images, for left and right directions)
Firing (2 frame movie, 1 audio clip)
Exploding (6 frame movie, 1 audio clip)

For each of these states the graphical and audio requirements are specified to give an indication of the amount of resources that should be assigned to developing that asset. The final asset specification may look something like:

SHIP (ASSETS)
Moving (2 static images)
Firing (2 frame movie, 1 audio clip)
Exploding (6 frame movie, 1 audio clip)

ALIEN (ASSETS)
Moving (2 frame movie)
Bombing (2 frame movie, 1 audio clip)
Exploding (4 frame movie, 1 audio clip)

BOMB (ASSETS)
Moving (1 static image)
Exploding (1 static image)

MISSILE (ASSETS)
Moving (2 frame movie, 1 audio clip)
Exploding (1 static image)

One thing to take into account is that many graphical animations can actually be achieved using simple transformations of single images, for example a car driving away may only require a single image reduced in size over time. This reduces the development time and suitable situations should be identified at this stage.

Identify User Interaction

With the graphical aspect of the game planned out, the next stage is to define the dynamic aspects of the game such as the user interaction and game functions. A textual description of the user control is first required, for example:

"The cursor keys are used to move the ship left and right. The space bar is used to fire a missile."

From this description certain elements of each event can be identified: the input, the action and the asset. These form the basis for the functions associated with each asset:

SHIP (EVENTS)
Move (called when cursor key pressed)

MISSILE (EVENTS)
Fire (called when space bar pressed)

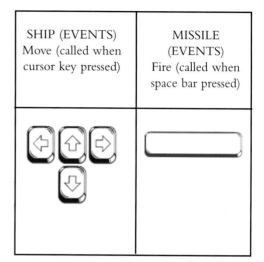

SHIP (EVENTS) Move (called when cursor key pressed)	MISSILE (EVENTS) Fire (called when space bar pressed)

Figure 1.7 *Identifying user interaction*

Identify Asset Functions

The game performs actions based on both user input and game functions. A game function could be used to control the aliens, keep score or determine the winning status. To begin identifying the possible functions that an asset can have, the verbs need to be extracted from the textual description. For example:

"The alien craft descend down the screen and drop bombs at random. When a missile is fired it is moved up the screen until it reaches the top or hits an alien. The player wins when all aliens have been destroyed."

From this description functions for the BOMB, MISSILE and PLAYER assets can be extracted. The functions are called automatically by the game engine and are not associated with any player input. The following are the non-user-based functions associated with each asset.

SHIP (FUNCTIONS)
Explode
Win

ALIEN (FUNCTIONS)
Descend
Drop bomb
Explode

BOMB (FUNCTIONS)
Move
Detonate

MISSILE (FUNCTIONS)
Move
Detonate

You are now in a position to pass the function information to a programmer to code your title.

Build Snapshots of your Movie

These are sketches that work out the staging of the characters in a scene and its key poses. Each snapshot should tell something about that part of the movie. Your scenes must fit into the visual continuity of the sequence. Your snapshots will guide you through the process of building your movie. They will act as beacons for the animation sequences.

Identify your Camera Angles

Solve your basic problems with camera angles and camera placement to give greater interest to the overall film. You should at this stage be able to update your storyboard, confirming all the camera angles and effects. You should always recheck the size relationship of all your characters.

Solve all your Camera Angles

I always try to work out each new camera angle in snapshots. It takes 12-24 drawings to create one second of animation. So don't waste time on animation if you have problems with the snapshots.

Take a Moment and Present your Ideas

I always like to take a rain check and present to my client, or somebody who is not directly involved in the project, the ideas and planning arrangements, just in case I may have forgotten something in the planning of my ideas for the scene. At this point I always double-check everything, including layouts, staging, perspective and key poses.

Timing

Now that all the key poses and staging have been planned you can concentrate on animating the acting, expressions, dialogue and timing. Timing charts are put on the key frames so the assistant can put in the additional drawings that are needed to have the character moving at the correct speed and timing the animator has in mind for the scene.

Figure 1.8 *A timing chart*

Tools of the Trade

The most reliable tool to start creating your character is a pencil and a good old piece of paper. It is the process of quick sketching over hundreds of blank white sheets of paper that finally creates those sparks of inspiration. I always build my characters out of a few main basic shapes, if the character is soft and delicate, I will make it out of soft rounded shapes, if my character is the villain then I design him so that he looks angular and jarring, with more points and angles than my soft well-rounded character. Whilst drawing your character you start to learn about it, and in most instances the character is usually full of surprises. If it's not then you have missed a fundamental part of the process and that is the art of spontaneity and surprise. Your characters should fit

Figure 1.9 *The steps to drawing a character*

together in the same environment; they should all have a fairly similar style but at the same time be unique in personality. Once sketched I then scan the images and convert them to vector line work in FreeHand 10. Both FreeHand and Illustrator applications are interchangeable, here is a short review of the both applications.

About Bitmaps and Vectors

Computers display graphics in either vector or bitmap format. Understanding the difference between the two formats can help you work more efficiently. Flash lets you create and animate compact vector graphics. It also lets you import and manipulate vector and bitmap graphics that have been created in other applications.

The data that creates vector and bitmap graphics is similar, they are both mathematical instructions, but bitmaps are more complex, and result in less manageable graphics. Vectors are compact and fully scaleable, but are less complex graphically. Bitmap instructions break the graphic into little dots and have to tell the computer where to place each dot; vector graphics describe graphics as a series of lines and arcs. If you zoom in on a bitmap you will start to see the image reduce to its dot or pixel structure. If you zoom in on a vector image you will see that the quality of the line work is maintained. You will read more about vectors in Chapter 2.

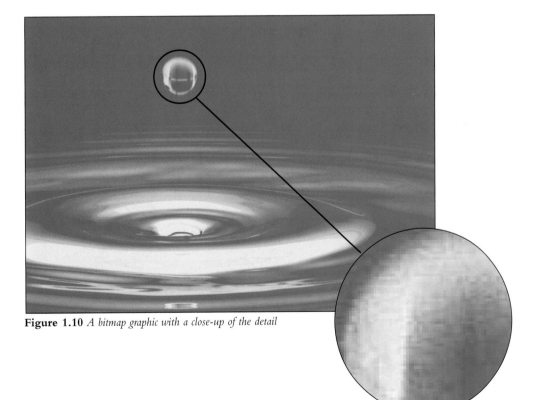

Figure 1.10 *A bitmap graphic with a close-up of the detail*

Figure 1.11 *A close-up of a vector graphic*

FreeHand

Since its introduction in 1988, FreeHand has been at the cutting edge of graphics innovations. FreeHand has support for web-based output including the ability to output Flash swf files. This application has the Flash Navigation Panel, which comes in very useful if you are trying to fine-tune an animation – you can now test animations within FreeHand before exporting them. FreeHand also benefits from a user experience that's nearly identical in all of Macromedia's design products, in particular the MX series of tools. It has updated the standard pen tool so that it looks and behaves identically in FreeHand, Fireworks, and Flash. FreeHand is a vector-based graphics tool.

Macromedia created the Flash format, so it's not surprising that it continues to expand the abilities of FreeHand's Flash support and their interconnectivity. You can now add live URLs to any element with the Flash Navigation Panel. When you export a Flash file, FreeHand saves any background graphics or illustrations only once, and then reuses them throughout the animation; this reduces the download times for the files.

Figure 1.12 *The FreeHand 10 environment*

Adobe Illustrator

Illustrator integrates better with other Adobe web-based tools like Atmosphere, LiveMotion and GoLive. Graphics symbols, slicing options, and exporting enhancements are among the most important of these tools. The use of graphics symbols is not new, and the advantages are obvious in that it keeps files smaller and easier to manage. Illustrator 10 adds several features that turn symbols into an important design tool.

Illustrator offers a web-based enhancement in the Slicing tools that let you break a web page into smaller, independent pieces. This improves the user experience, as it lets the web page load more quickly. Breaking a page up into smaller pieces is useful to a developer as well, because it lets you assign behaviours like rollover effects to specific sections of a page.

Illustrator has many of the standard Adobe user interface enhancements and it borrows from applications like Photoshop. It has some very interesting drawing tools, and instead of manually creating arcs, lines, or grids, you can use the new Arc, Line, Grid, and Polar Grid drawing tools. These controls don't replace the Pen tool, they simply provide an easy way to create the shapes they represent. It also has interesting effects tools like the Flare tool that lets you add realistic lens flares to a drawing, these flares are vector-based objects, and as such, you can fully edit them.

Figure 1.13 *The Illustrator environment*

Illustrator is a vector-based graphics tool. Both Illustrator and FreeHand are great for originating content and as both applications have a footing in the print world as well you will find that most logos will convert into the natural eps format of these applications. You will almost certainly need a paint application and the undisputed king in this area is Adobe's Photoshop.

Adobe Photoshop

Photoshop isn't just about pixels and painting. New Shape tools let you create a huge variety of sharp-edged, editable, vector-based shapes, including text. You can achieve effects using vector layers with attached Layer Effects such as glows, bevels, shadows, patterns, and gradients. Because vectors are much more memory-efficient than pixels, type effects that used to result in big files are now only 5% of the size.

Photoshop allows you to integrate vector- and pixel-based elements. Vector layer masks let you apply a clipping path to a layer rather than to the entire image, hiding the layer content that lies outside the path. You can clip layers with vector shapes, apply layer effects, and use Photoshop's

blending modes to make everything from chiselled type to 3D buttons. Photoshop is now the most typographically sophisticated of Adobe's applications and it lets you do anything with type that you can do with other vector elements, so the range of typographic treatments is enormous.

Figure 1.14 *Adobe Photoshop*

Photoshop's forte is still image editing, and version 7's layer-management enhancements make creating complex, multilayered images much easier. The 99-layer limit is gone, and you can group layers into sets and treat them as a unit. You can also lock a layer's transparent pixels, its non-transparent pixels, and its position. For web graphics, you can create slices – separate image regions that can have their own HTML code attached directly in Photoshop. And the program can create slices based on layer content, making it easy to create rollovers, animations, and other web effects. (You'll still want to use ImageReady to save slices as sets and to create rollover styles, however.) Adobe has produced some very interesting features in Photoshop's colour architecture. For example, the colour settings are combined in a single dialog box. You can set the colour behaviour to emulate Photoshop 4 or 5 if you wish, but Photoshop 6 offers "per-document colour," which leaves each image in its own colour space. This frees you from having to convert all your images to a single working colour space.

Photoshop has a support application called ImageReady. Its integration with ImageReady has some annoying interface discrepancies. ImageReady is a strong tool for anybody producing content for the web. It's undoubtedly a good alternative to Fireworks.

Macromedia Fireworks

Fireworks is basically an image editor similar to Adobe Photoshop but much more heavily geared toward web production, with a particular emphasis on vectors. I would never choose Fireworks as a replacement for Photoshop, but it does make an excellent companion, particularly for web animators. For example, you do not get the control over bitmap images that you find in Photoshop, but you do get a palette of features that makes editing and creating graphics for the web much easier than in Photoshop or ImageReady. You get a full-featured application that can create rollovers, selectively compress JPEGs, create and edit vector objects and apply effects while maintaining their editability.

The thing that has always impressed me the most about Fireworks is its ability to reduce images to the barest kilobytes while maintaining outstanding image fidelity. If Fireworks could do nothing else, I would still use it every single day for crunching images. It is a master at compression. Fireworks can handle tweening for common transformations, such as rotation and

Figure 1.15 *Macromedia Fireworks*

position. It can also be used to create rollovers and can very easily generate slices of an image that can be hyperlinked directly in Fireworks or in a web page layout program. You have a step-by-step wizard for creating interactive pop-up menus, a feature that once again brings it to the front of the interactive graphics applications.

Two additional applications that are useful for animators are Adobe After Effects and Adobe LiveMotion.

Figure 1.16 *Adobe After Effects*

Adobe After Effects 5.0

Adobe After Effects 5.0 is a post-production tool that provides compositing, 2D animation, and visual effects for broadcast-quality output in various media. The standard version provides the basic 2D and 3D compositing and effects tools that motion-graphics professionals and web designers need. It has a number of integration features with Adobe products. The Photoshop integration feature is its support for vector masks in Photoshop 7.0 files. The masks appear on the layer to which they are applied and can be manipulated independently. Much like Photoshop, layers can be preserved when Illustrator files are included in an After Effects composition. After Effects 5.0

builds on this integration with support for preserving transparency settings and transfer modes as well. Premiere 6.0 integration features are incredibly useful for anybody in video.

After Effects has always offered a variety of output options, and like many of the features, they continue to evolve as needs change. High-speed Internet connections are becoming more available, and with their increased availability comes a greater interest in movies that can be viewed on the web. Adobe has newly added support for Macromedia Flash (swf) that lets you use the full range of After Effects features on the web. The ability to export Flash files should benefit many designers as After Effects has several features, such as keyframing and motion controls, that aren't available in many other applications that export Flash.

Adobe LiveMotion

It looks like a combination of After Effects and Photoshop, with a little bit of ImageReady. It handles Photoshop filters better than Photoshop itself. This is because when you apply a filter in LiveMotion, it is rendered in a non-destructive way. In other words, your original bitmap image will always remain nested beneath whatever effects you apply to it. You can do a blur, craquelure, mosaic and texture, and you'll still always be able to get rid of those effects – in any order or entirely – and get back to your image without any loss.

Each filter that you apply to an image within your LiveMotion composition appears in the Photoshop Filters palette with a little check mark next to it. What's more, you can even double click on an effect in the Photoshop Filters palette to go in and make changes to the settings you've selected. It's safe to assume that not all Photoshop filters will work in a vector program like LiveMotion, and you can't use After Effects plug-ins.

The message here is clear: LiveMotion is not an alternative to After Effects for web animation. If you want to animate an effect in After Effects and bring it into LiveMotion as an image sequence, you're stuck with formats that don't have good support for alpha channels, so you really can't use an image sequence as an overlay. Animating objects in LiveMotion is simple, and it can be accomplished in two ways. First, by using the timeline, users can simply click on an object, select the characteristic to animate, move the timeline forward and make whatever change to the object that's required. For example, if you want an object to float around, you just click the object, select the Position characteristic, move the timeline forward and then manually drag the object to its final position, multiple keyframes can be automatically entered by dragging the object at various points in the timeline. Second, the timeline is not as feature-rich as the one in After Effects. For example, Control-clicking on the timeline does not call up a pop-up menu like it does in After Effects. In fact, there's no Control-click functionality whatsoever.

3D Applications and Flash

I have always found it very difficult to animate a character from different camera angles; in fact I learnt to use a whole new application to take some of the pressure off. I found that using a very

Figure 1.17 *Adobe LiveMotion*

basic model in Poser I could get my snapshots for my camera angles, and then it was a case of filling in the animations in between. I then extended this to using Poser to help time and sequence my more complicated animations. I have also included a review of Swift 3D because this is also a superb vector and swf format creation tool that I use predominantly for interfaces and objects in my Flash products.

Poser 4 Pro Pack

Poser, a 3D character modelling and animation package, has acquired a large user base in the animation community over the years. The interface separates Poser from many other 3D applications. It is extremely attractive and can be mastered very quickly with rollover text, making the whole process much easier. Poser uses a large customisable workspace with pop-out libraries and collapsible menus. The windows and toolbars have keyboard shortcuts and the quick-reference card included with Poser is a must.

Poser was originally developed as a way for artists to visualise figures and props for 2D digital artwork, but with subsequent releases it has been transformed into a complete 3D modelling and animation package. Poser boasts full inverse kinematics (IK) for realistic body positioning, and the

Figure 1.18 *Poser 4*

program hides the tedious work in many of its advanced features; luckily, IK is no exception. Anything can be animated in a Poser scene, including lights, cameras, props, and figures. The animation tools, which use sliders for adjustment, are easy to learn. The extraordinary models that ship with the standard version of Poser allow for animation of everything from hands and fingers to full facial controls. You can animate the eyes, brows, lids, teeth, and tongue independently, or you can combine them for advanced animations. The built-in models come with 17 preset phonemes which you can use to sync sound files to animated facial expressions.

Poser has a set of Deformers that lets you modify a prop or figure. For example, when you move a character's arm in Poser it doesn't provide for natural skin or muscle movements, but you can stretch and distort a figure's arm to simulate a muscle ripple. Like nearly everything in Poser, you can animate Deformers, creating bouncing bellies or moving cloth. Poser's output is also exceptional, and it'll let you export vector-converted Flash animations from any Poser scene. Poser is a must for any character animator.

Swift 3D

Swift 3D exports 3D stills and animations to Flash (swf). It lets you create 3D primitives and extrude 2D objects, or rotate a drawing around a central axis (lathe), which is ideal for creating symmetrical shapes such as a vase or wine glass.

Swift 3D consists of four editors. The scene editor is the heart of the program where you can view and edit all the objects in your scene. Primitives, cameras, and lights can be created and edited here in addition to importing 2D (AI, EPS) or 3D (3DS, DXF) objects. Animation is keyframe based, and there are plenty of presets for common animation tasks such as spinning logos. Swift 3D lets you use two configurable viewports for viewing your scene. You cannot freely resize them, nor can you open a third viewport. Also, you cannot make a camera isometric to compensate for perspective, so precise arrangement of objects can sometimes be hard. Having set aside these issues, the interface is very well designed, and is very intuitive. This is a great application for building 3D objects to go into your Flash scenes.

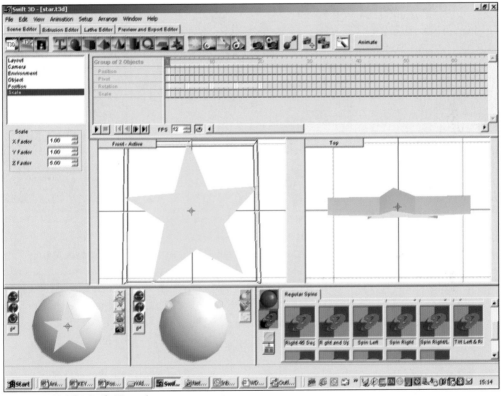

Figure 1.19 *The Swift 3D work area*

Lip Syncing Applications

The most difficult aspect of facial animation is lip syncing, or the art of matching voice to movement. There is a range of packages designed to help out in this process. These applications work either by analysing sound files or by reading the expressions of actors from video clips. We will look at applications for lip syncing in more detail in the lip syncing chapter. We have also provided a list of applications and web site for lip syncing in the appendices. For more on lip syncing see Chapter 6.

Chapter 2

Basic Animation Techniques in Flash MX

Chapter 2 takes you through basic animation using Flash MX. You will learn about the Flash environment, go through a basic overview of animation techniques and see how to publish and export your movies. By the end of this chapter you will have a solid grounding in Flash MX that will help you progress through the rest of the book.

Introduction

Animators need to go through a process of learning to master Flash MX so that the application and all its gizmos are not the overriding features of the final animation. To pick up enough skill in using an application so that your imagination creates the effects means you need to start with a solid foundation in the application. This chapter tries to do that. We assume that you have basic knowledge of the Flash environment or that you have at least run through the Flash tutorials covering the basic use of the tools. This chapter also prepares the way for the next chapter where we look at character animation and how to do it in the digital environment. You will be working with the assets that can be found in the folder "Chapter2" on the CD. In this chapter you will create a simple page in Flash MX, that could be used as a homepage for the Ellen and Zak web site.

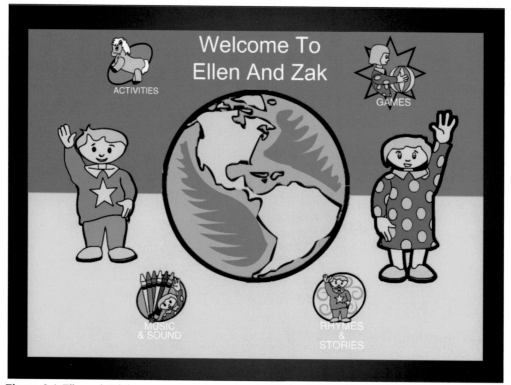

Figure 2.1 *Ellen and Zak homepage*

Working with Layers

Layers, as mentioned previously, are stacked on top of one another, and contain the items that make up your movie. They can be seen in the same way as a stack of pieces of paper. You can see the piece underneath the piece on top unless they overlap, in which case the piece on top will appear above the piece below. This is the same with your movie. If you, for example, enter some text on the top layer of a movie (as you will see later in the walkthrough) it will appear above every other element of the movie on the stage. Each individual layer also has its own internal

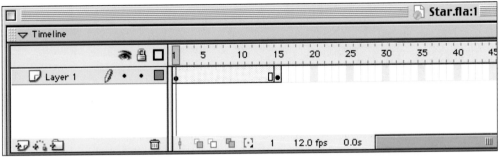

Figure 2.2 *The Flash timeline*

stacking order, and objects can be sent to the front or the back of individual layers using the Modify>Arrange>Bring Forward/To Front or Modify>Arrange>Send Backward/To Back commands.

Layers are an invaluable tool for organising movie content as ungrouped objects on two separate layers will not segment each other when they overlap. You will use layers to create the Ellen and Zak page in this chapter, but first we will run through how to use layers.

To create a rectangle in a separate layer:

1. Create a new movie by choosing File>New and create a new layer so that you now have two. You can use one of the following methods:

 - Choose Insert>Layer.
 - Click the Add Layer button from the timeline.
 - Right click on the current layer and choose Insert Layer.

2. Name the layers layer one and two by double-clicking on the current name and typing the new name. Make layer one the top layer.
3. Select layer one by clicking on it and on the stage draw a rectangle. This rectangle is now in frame one of layer one.
4. Now select layer two. Draw a rectangle in this layer. Now experiment moving both rectangles around and see how the rectangle in the top layer overlaps the rectangle in the lower layer without segmenting the rectangle.

You will use layers in nearly all of your Flash projects, so it is important to have knowledge of their basic functionality. Flash also uses guide layers that provide a point of reference to any item that you put on the stage, and they are not included in the final movie.

To create a guide layer:

1. Create a new layer and with it selected choose Modify>Layer to open the layer properties dialog box.
2. In the type selection click Guide and then click OK.
3. Choose View>Guides>Snap to Guides to make objects snap to the lines or shapes on guide layers, and then draw some objects or lines in your guide layer.
4. Now move some of the content around that you have in the other layers in your movie and see how they snap to the guide lines.

Figure 2.3 *Creating guides*

Using Rulers and Guide Lines

Rulers and guide lines are very important for precise positioning of objects on the stage. You can see this as you use rulers to place objects precisely on the stage.

1. Close your current movie and open a new one using File>New. Turn the rulers on by choosing View>Rulers.
2. Now drag a guide onto the stage by clicking on the ruler at the top of the work area and dragging down towards the centre of the stage whilst holding the mouse button. Position the first guide so that it is in line with the bottom of the stage.
3. Now position a guide so that it is 200 pixels from the bottom of the stage, and position another guide that is in line with the top of the stage.
4. Drag a guide out from the left ruler and position it so that it is in line with the right of the stage, and then another that is in line with the left of the stage.
5. Now drag out two rectangles with no strokes in the boundaries you have set with the motion guides, so that you have two solid blocks of colour on the stage. The rectangle should snap to the guides making drawing it easy.
6. Name the only layer of the movie background and then add four additional layers above the background layer called Globe, Ellen, Zak and text.

Figure 2.4 *Vector Zak*

About Bitmaps and Vectors

Computers display graphics in either vector or bitmap format. Understanding the difference between the two formats can help you work more efficiently. Flash lets you create and animate compact vector graphics. It also lets you import and manipulate vector and bitmap graphics that have been created in other applications.

The data that creates vector and bitmap graphics is similar. They are both mathematical instructions, but bitmaps are more complex, and result in fewer manageable graphics. Vectors are compact and fully scaleable, but are less complex graphically. Bitmap instructions break the graphic into little dots and have to tell the computer where to place each dot. Vector graphics describe graphics as a series of lines and arcs.

Importing Artwork into Flash

Flash is a very versatile tool, and it does not limit you in the types of artwork you can import. You can import from a wide range of sources, and if you import a vector graphic, created in FreeHand for example, it will be imported as a vector that you can then manipulate as if it were created in Flash.

If you import a bitmap into Flash it will usually increase your movie size considerably, but you can convert it into a vector by choosing Modify>Trace Bitmap and specifying your settings in the pop-up box that appears.

To import a vector image:

1. Select the Ellen layer, choose File>Import… and locate in the chapter2 folder the ellen.swf file. This is an exported Flash movie that Flash will import as a vector image.
2. Select all the components that make up the Ellen image and select Modify>Group to group them together.
3. Now position the Ellen image at x 450 y 200 using the rulers to guide you.
4. Select the Zak layer and import the zak.swf file, group the image and position it at x 100 y 200.

You have now imported two vector graphics into your movie on separate layers. It would be important you keep them on separate layers if you were animating them, as it is good practice to organise your assets on different layers to keep your movie well organised. You should also give your layers meaningful names.

Importing a bitmap graphic:

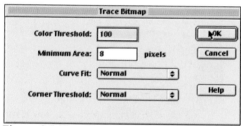

1. Select the Globe layer of the movie and choose File>Import. Click on the globe.jpg graphic in the chapter2 folder and add this to your movie.
2. Now use the Align panel to position this image on the centre of the stage. Open the Align panel (Window>

Figure 2.5 *Trace Bitmap tool*

Align) and click align to stage, and then align horizontal centre and align vertical centre.
3. You will now want to convert this image into a vector image to remove the white background from the pictures and decrease the size of the movie.
4. Select Modify>Trace Bitmap, a dialog box will appear with the following options:

 • Colour Threshold – This sets the colour difference threshold when Flash converts the file. Flash compares each adjacent pixel in the bitmap and if the difference of the RGB value is less than the colour threshold those pixels are considered to be the same colour. A lower setting therefore will result in a higher number of colours.
 • Minimum Area – The number of surrounding pixels to consider when allocating a colour to a pixel.
 • Curve Fit – Determines how smoothly curves are drawn.
 • Corner Threshold – Determines whether sharp edges are retained or smoothed.

5. Set the colour threshold to 100, the minimum area to 4, the curve fit to smooth and the corner threshold to few corners and click OK. The bitmap will be converted to a vector.
6. Now that the graphic is converted, select the white background areas of the picture and press delete to remove them.

It is worth remembering that complex bitmap images are not good candidates for conversion into vectors unless you would like to substantially reduce the number of colours, and also that Flash can compress bitmap images itself, meaning they can be used without significantly increasing the file size.

Using Text

You will now add title text to the page on the topmost layer, so that it appears above the rest of the items on the stage. You can enter text into Flash quickly and easily using the text tool, and then change its attributes using the text Panel that can be found in the main Toolbar.

Figure 2.6 *Text properties panel*

Figure 2.7 *The text correctly formatted*

To create a line of text:

1. Select the text tool from the Toolbar.
2. Click on the stage with the pointer where you want your text to start and type Welcome to Ellen and Zak.
3. When you have finished typing click elsewhere on the stage. You can then select the text box you have just created (using the select arrow) and reposition it on the stage. You can also reposition a text box with the text tool, by positioning it along the edge of the text box until it turns into an arrow and then using it in the same way as you would the selection arrow.

Formatting your text:

1. Select the text box you have created and move your mouse pointer over the small circle to the top right of the box, drag this to the left so that the text box consists of two lines. It should read "welcome to" on the top line and "Ellen and Zak" on the bottom line.
2. With the text highlighted use the Properties panel to change the font to Arial, and the size to 24 point. Make sure kerning is checked to evenly space the letters; you can increase the tracking (the space between the letters) as you wish.
3. With the text highlighted, from the main menu select Text>Align>Align Center to align the text, and then open the Align panel and centre the text vertically on the page.
4. Now position the text horizontally wherever you would like. If you hold down the shift button whilst moving the text along the horizontal axis it will stay in the same vertical position. This also applies to moving all objects around the stage.

Introduction to Animation

Traditional animation involves a series of still images, usually painted or sketched, displayed in rapid sequence. Because the receptors in our retina require recovery time, we are unable to distinguish each individual image in the sequence. In effect, as the previous image is replaced by a new image the previous image is still "burned" on our retinas. Each image is blurred into the other, creating the illusion of motion. This is called Persistence of Vision. If we didn't experience retinal lag, we'd be able to distinguish each individual frame, destroying the illusion of motion.

With film, each image is called a frame. As a result, the rate at which each frame is displayed is measured in frames per second (fps). The movies you see at a theatre display 24 frames per second. Videotapes and television display 30 frames per second at NTSC or 25 frames per second at PAL. Film and video have fixed frame rates. With Flash, you can set the frame rate. Higher frame rates result in smoother animation, but also require more processing power.

You create animation by changing the content of successive frames. You can make an object move across the stage, increase or decrease its size, rotate, change colour, fade in or out, or change shape. Changes can occur independently of, or in concert with, other changes. For example, you can make an object rotate and fade in as it moves across the stage.

There are two methods for creating an animation sequence in Flash: frame-by-frame animation and tweened animation. In frame-by-frame animation you create the image in every frame. In tweened animation, you create starting and ending frames and let Flash create the frames in between. Flash varies the object's size, rotation, colour, or other attributes evenly between the starting and ending frames to create the appearance of movement.

Tweened animation is an effective way to create movement and changes over time while minimising file size. In tweened animation, Flash stores only the values for the changes between frames. In frame-by-frame animation, Flash stores the values for each complete frame.

Frame-by-Frame Animation

Frame-by-frame animation employs unique artwork in every frame of your movie, and because of this it is great for creating detailed animations that require subtle changes. However, the main drawback is that you have to draw unique images for every frame, and this can become both time consuming and memory intensive.

Each time you want to make a change in Flash you have to add a keyframe. A keyframe is a frame that defines a significant change to a character or object. To insert a keyframe into Flash you have two options, you can insert a blank keyframe (Insert>Blank Keyframe) when you want to change the contents of the previous keyframe entirely, or you can choose Insert>Keyframe to insert a keyframe that duplicates the content of the previous keyframe, for when you want to change the content in a minor way. In the next exercise you will learn how to create simple animation.

Figure 2.8 *Timeline of a keyframe animation*

To create a simple frame-by-frame animation:

1. We will begin by creating a simple bouncing ball. Create a new Flash document and make sure the Grid is turned on (View>Grid>Show Grid).
2. Begin by drawing a ball in frame 1 of layer 1 using the Oval tool.
3. In the timeline click on frame 2 and choose Insert>Keyframe, you will see that a keyframe is created containing duplicate contents of the previous keyframe.
4. Select the ball in keyframe 2 and reposition it so that it is directly below the ball in keyframe 1, hold down the shift key while you are moving the ball to make it snap to the horizontal axis, and use the grid to reposition it exactly.
5. Create a new keyframe in frame 3 and reposition the ball so that it is directly below the ball in the previous keyframe.
6. Now create another keyframe and position the ball so that it is above the ball in the previous keyframe, and then create the last keyframe, in frame 5, and position the ball so that it is in the place it started.
7. You have now created a simple bouncing ball. To view this animation open the Controller (Window>Controller) and click the play button.

Though this animation is crude it does demonstrate the basics of creating a frame-by-frame animation. If you want to make the animation smoother all you need to do is create more keyframes and therefore create more positions for the ball animation to run through.

Figure 2.9 *The ball on the stage*

To add keyframes within an animation:

1. In the timeline select keyframe 1, choose Insert>Frame and insert two frames. Flash now creates two in-between frames that hold the content of keyframe 1. Now select frames 2 and 3, the frames you have just inserted, and choose Modify>Frames>Convert to Keyframes.
2. The frames are now converted to keyframes, and you can now reposition the ball in these frames so that they provide a smoother movement of the ball.
3. You can now add as many frames as you would like to the animation and make it much smoother and longer.

Onion Skinning

To make frame-by-frame animation easier you can use onion skinning, which displays dimmed or outline versions of the content from surrounding frames and lets you see your ball in the context of the frames around it. The buttons for turning on and off onion skinning are found at the bottom of the timeline.

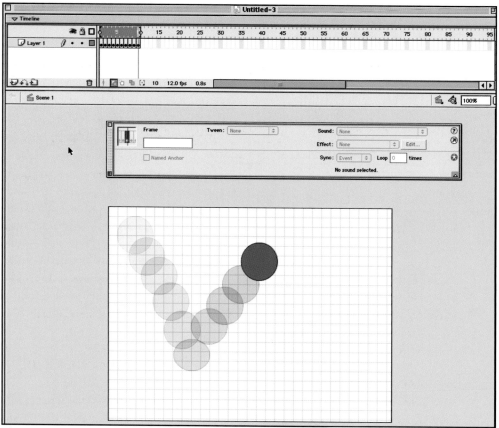

Figure 2.10 *Onion skinning*

To view onion skinning:

1. Turn on onion skinning by clicking the Onion Skin button. The content of all the frames included in the onion skin markers is displayed as dimmed objects, you can view the content as just outlines by clicking on the Onion Skin Outlines button next to the Onion Skin button.
2. To modify the number of frames you can view through onion skinning click on the Modify Onion Markers button and in the pop-up menu that appears select onion 5 to see five frames on either side of the current frame; you can select onion 2 or onion all to see either two frames or all the frames respectively.
3. You can now move frame content using the onion skins as a guide.

Animation with Motion Tweening

Motion tweening is used to animate symbols, and is typically used to convey motion. As well as moving a symbol from place to place it also allows you to scale, rotate and skew an object along a motion path and allows you to change the colour settings of an object over time. It is important to remember that you can apply motion to only one element on each layer so you have to use multiple layers when you are tweening multiple objects. The Frame properties panel allows you to control all the properties of your motion tween, and the following options can be changed:

Figure 2.11 *The tweening properties panel*

- Tweening – This specifies the type of tweening you want to use, either None, Motion or Shape.
- Scale – Turn this on if you are scaling your object.
- Rotate – This option allows you to rotate your objects as they move around an axis. All you need to do is select a type of rotation from the drop-down menu and type the number of rotations into the box. Auto rotates your object in the direction that requires the least amount of rotation, CW rotates your object clockwise and CCW rotates your object counter-clockwise.
- Orient to Path – Forces your object to orient its centre to any motion path you have specified.
- Ease – This sets the rate of your animation from start to finish to give the impression of acceleration or deceleration. If you want your animation to start slowly and then accelerate you need to push the slider down so that the animation eases in, and vice versa.
- Synchronise – This ensures that your animation loops properly in the main movie, and forces the animation to loop properly even if the sequence is not a multiple of the number of frames occupied by the symbol in the main movie's Timeline.

- Snap – Causes your animated object to jump to a motion guide as you move it around the stage.

A motion tween must consist of at least two keyframes, with the first keyframe containing the initial state of the symbol and the second keyframe containing the final state of the symbol. You then create a motion tween between these two keyframes. By creating a motion tween Flash interprets the state of the symbol in the in-between frames and will generate the positions of the symbol between the two keyframes. You will now animate the Ellen and Zak homepage to make it appear more exciting for a visitor to the site.

Figure 2.12 *Timeline for a tweened animation*

To create a simple motion tween:

1. Open the EllenZakComplete.fla file from the chapter2 folder; this is a completed version of the Ellen and Zak homepage with everything converted to symbols. You will see that there is only one frame for each layer.
2. Add a keyframe at frames 10 and 20 for the Ellen, Zak and Text layers, and add 20 frames to the rest of the layers. This makes the movie twenty frames long, creating a keyframe at frames 10 and 20 in the layers that you will be animating. You can add frames to multiple layers by simply highlighting where you would like the frame to be added on more than one layer at once.
3. Now select the first frame of the Text layer, here you will set the initial state of the text as the homepage animation begins. Move the text to above the stage, holding down shift while you move it; this is the initial state of the text.
4. Now check that the text in frame 10 is in the correct final position. To create a motion tween all you need to do is highlight the in-between frames between keyframe 1 and keyframe 10 and choose Insert>Create Motion Tween. Leave frames 10 to 20 as they are in the Text layer.
5. Now use the Controller (Window>Toolbars>Controller) to preview the animation you have created.

To create a fade-in effect:

1. Use the Colour drop-down menu in the properties panel to set the alpha transparency of both Ellen and Zak to make them fade in.

35

2. Select keyframe 1 of the Ellen layer and then select Alpha from the Colour panel drop-down menu of the properties panel and set the value to 0% to make the image transparent. Now set the transparency of Ellen at keyframe 10 to 0% and leave the transparency at keyframe 20 at 100%.

3. Now create a motion tween between keyframes 10 and 20 in the Ellen layer. You have now changed the transparency from 0% to 100% in the space between frames 10 and 20.

4. Preview this animation using the controller.

5. Now repeat this process for the Zak image.

6. Choose Control>Test Movie to see your movie in Flash Player format. The text should move down from above the top of the screen and stop in place (at keyframe 10) and then the Ellen and Zak images should fade in (at keyframe 20).

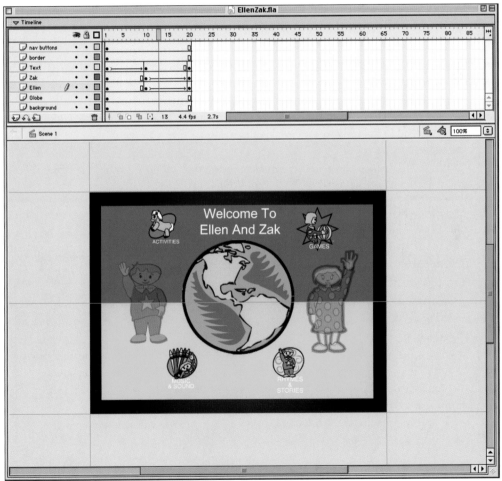

Figure 2.13 *Ellen and Zak intro with alpha tweens*

Using a Motion Guide

You can use a motion guide to force a tweened symbol to follow a specific path. This is very useful for simulating motion along a curved line. In the following exercise you will learn how to create a motion guide to make Ellen fly across the screen.

1. Open the EllenFlying.fla file from the chapter2 folder. This movie consists of a single layer with a graphic symbol of Ellen ready to be animated.
2. Now add a keyframe to frame 20 of the Ellen layer and in keyframe 20 move the Ellen graphic to where you would like her final position to be on the stage.
3. Now create a motion tween between keyframes 1 and 20 (Insert>Create Motion Tween). The animation goes in a straight line from point to point, and is a little boring; now we will make it a bit more exciting.
4. Right-click on the Ellen layer and select Add Motion Guide, a new layer called Guide: Ellen appears with a Motion Guide icon to the left of the name.
5. Now, with the Guide: Ellen layer highlighted select the pencil tool and draw a line on the stage that you would like Ellen to follow as she moves around the stage.
6. To ensure that Ellen follows the complete length of the Motion Guide select the first key frame on the Ellen layer. Now, move Ellen so that her position locks onto the start of the motion guide. Next, do the same thing on the second keyframe (frame 20) and lock Ellen onto the end of the motion path. Make sure the 'snap' box is ticked in the properties panel to make her snap to the guide.
7. With the line drawn and Ellen positioned, preview the animation using the Controller.

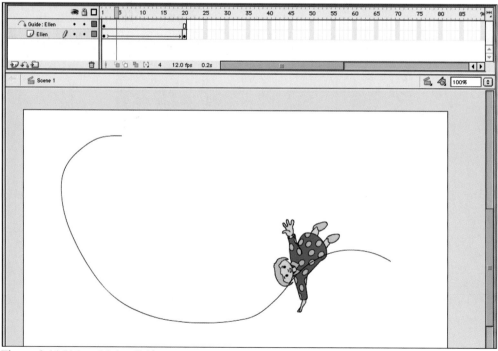

Figure 2.14 *Using a Motion Guide*

Shape Tweening

Shape tweening is used to morph shapes. Flash can only morph shapes, not grouped objects or symbols and if you want to tween a group, symbol or editable text you first have to turn it into a shape by breaking it up (Modify>Break Apart).

Movie Clips

Movie clips are symbols that have their own timeline; they are particularly good if you want a movie to play independently of the main timeline. They can contain actions, other symbols and sounds, and they are stored, like other symbols, in the library. In the next exercise you will create a movie clip, build a shape-tweened animation inside it and place it in a movie to see how it plays.

Creating a movie clip and tweening a shape:

Figure 2.15 *The Star.fla library*

1. First of all create a new movie clip, select Insert>New Symbol. In the box that appears name the symbol Star and give it a movie clip behaviour. You will now be taken into the movie clip editing mode, you will see that a movie clip looks like a Flash movie, and you can add layers and frames as you would to a scene in a movie.

2. Open as a library (File>Open as Library) the Star.fla file that is in the chapter2 folder, here you will see a circle graphic and a star graphic.

3. In your movie clip add a blank keyframe at frame 15 (Insert>Blank Keyframe). In the first keyframe of the movie clip drag an instance of the circle graphic onto the stage. As this is a graphic you will not be able to shape-tween it, so break it down into a shape (Modify>Break Apart). Now drag the star graphic to keyframe 15 and break this down into a shape.

4. Now you will tween the shapes. With the first keyframe of the movie clip highlighted set the tweening to shape in the Properties panel. Now preview your movie clip using the Controller and see how the shape tweens.

5. You have now created a basic shape tween within a movie clip. You will now place instances of this movie clip around the stage to demonstrate how movie clips run independently of the timeline.

6. If the library is not already open, open it (Window>Library) and find your star movie clip. You can preview the clip be pressing the small play button to the top right of the thumbnail of the movie.

7. Now create five layers of your movie and insert keyframes in successive layers five frames apart from each other. Now drag an instance of your movie clip into each of the keyframes positioning them wherever you like, and insert, on each layer, fourteen frames after each keyframe, this is because your movie clip is fifteen frames long and so needs that long to be able to play.

8. Now you have set up your movie clip, choose Control>Test Movie to view your work.

Figure 2.16 *Creating instances of library assets*

Publishing and Exporting your Movies

Once you have created your Flash movie it is now time to publish it. The Publish command creates all the files you need to deliver your movie on the web (including HTML files), or as a stand-alone file that can be played without having Flash Player installed, called a projector. You can also get Flash to publish a Generator Template, GIF Image, JPEG Image, PNG Image or Quicktime movie.

Optimisation

Before you publish your movie for the first time, you should check to see how your users might actually view it on the web. When building your movies you have to bear in mind the issue of quality versus quantity. Flash lets you find where your movie is slowing down or is not properly optimised by using the Bandwidth Profiler and the simulated streaming function to see how long a movie will take to load with different bandwidth settings.

Figure 2.17 *The Bandwidth Profiler*

To use the Bandwidth Profiler:

1. Choose Control>Test Movie. Your movie will now launch in the Flash Player.
2. From the Debug menu choose 56K to simulate a 56K modem speed and then choose View> Bandwidth Profiler. The graph that now appears tracks the amount of data that is being transmitted against the timeline of the movie. The bottom line represents the amount of data that will safely download quickly enough to keep up with the frame rate of the movie.
3. Now choose View>Show Streaming. This will show you how quickly the movie loads, with a green bar at the top of the Bandwidth Profiler giving you a graphical display of the amount of progress made. The green bar stops as it passes over the higher bars as it takes longer to load these parts of the movie.

When you identify frames that are too large to stream efficiently you may want to optimise your movie. You can optimise playback in a number of ways, here are a number of tips for optimisation:

- Use symbols for every repeated element in your movie.
- Use alpha channels sparingly as they take a lot of processing.
- When you embed fonts select only the characters you need.
- Use tweened animation – this uses less memory than frame-by-frame animation.
- Group elements wherever you can.

- Use library symbols for elements that appear more than once to reduce the file size of your movie.
- Use MP3 sound compression, and use sound sparingly.
- Limit the number of stroke types and the number of fonts.
- Use bitmaps sparingly.

Publish Settings

Flash offers many publishing options, as mentioned previously. Publishing your movie is easy.

Figure 2.18 *The Publish Settings panel*

Figure 2.19 *Flash Publish Settings*

To Publish your Movie

1. Open the EllenZakComplete.fla file from the chapter2 folder. You will see that this is a more updated version of the web site. Choose File>Publish Settings from the main menu.
2. In the dialog box that now appears select the Flash, HTML, GIF Image and Windows Projector checkboxes. As you select the format a tab will appear at the top of the box.
3. Now click on the Flash tab, you will see a number of options, of which the following should be modified:

 * Load Order – Determines the order in which the layers in each frame will load. This is important when files are being downloaded from slow modems as Flash shows each layer as it has been loaded. Top Down sets the frames to load from the top one first and vice versa. Set this to Bottom Up.
 * Generate Size Report – Make sure this is checked. It tells Flash to generate a text file that contains information on the size of each individual file which is very useful.
 * Protect from Import – Check this box. This allows you to protect against your swf file being imported into Flash.
 * Version – Choose Flash 5 to enable the full functionality of your movie.

4. Click the Set button next to the Audio Event setting, a dialog box appears allowing you to change the compression settings for the sounds in the movie, meaning any file that is not compressed will use these settings. Set the compression to MP3, the Bit Rate to 32 kbps and the Quality to Fast.
5. Now click on the HTML tab to set the HTML settings. Firstly set the Template to Flash only. This setting determines what kind of template will be generated, you can get more information on the template by clicking the info button.
6. From the dimensions menu choose Percent to enable your movie to scale with the size of the web browser. Then disable the display menu option, this disables the shortcut menu that opens when the user right-clicks on the screen. Lastly set the Quality to High.
7. Now click on the GIF tab to see what options are available, but leave them at their default. Click Publish when you are ready to export your movie.
8. Now look at all the movies you have just published. Open the Windows projector, which will work without Flash Player installed (the Macintosh projector works in the same way), so you can send it to a friend who has not got Player installed.

Storyboarding

The storyboard is the place to plan out your story in two dimensions. The first dimension is time. The second is interaction. The storyboard is the planning document for everybody involved in production. In it you will outline the action, visual transitions and how the voiceover interacts with the soundtrack. All aspects of the storyline and the impact it makes on the overall story will be planned out in the storyboard.

Figure 2.20 *A hand-drawn storyboard*

The Advantages of Storyboarding

Storyboarding will eventually save the team in production a significant amount of time. In fact you cannot do a full production without some kind of storyboard. It does not have to take a considerable amount of time to render a storyboard. Once the artist has established a personal style it can be as quick as doing a doodle on a piece of paper. The storyboard helps focus everybody's thoughts on the feasibility of the program. If the storyboard does not work, the program will not work. Sometime you can highlight serious omissions. I have listed a few additional points:

- The storyboard is a document, which everyone uses as a common point of reference.
- The storyboard illustrates the total content of the program and its overall size.
- Problems will be identified at this stage and corrected rather than at a later stage.
- It speeds up the content-writing process because the writer has an outline of all the content.

If storyboarding has a role to play in the design process then studying how to go about it the right way must influence the design process of an animation or film. Storyboarding is essential.

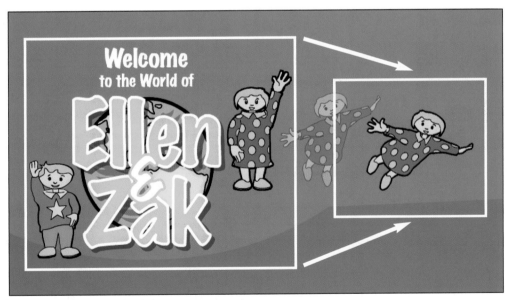

Figure 2.21 *A wide storyboard showing a pan across the stage.*

Interactive Storyboarding in Flash MX

Flash MX gives you the capability to produce interactive storyboards. An interactive storyboard is a working version of the movie produced in an easily adjusted form, without requiring any programming skills. It provides a common point of reference to illustrate the structure and look and feel of the project from the end-user experience. The storyboard will define what needs to be written, what graphic assets need to be created, and how best to apply transition and other effects. On the CD in the chapter2 folder you can find the storyboard.fla.

Figure 2.22 *Storyboard.fla*

In an interactive environment the production of the interactive storyboard should precede the production of the product specification document. This enables the prototype to be constructed. You can use this storyboard for testing the strategies and techniques of the production process and also as a tool to brief the programmers.

A screen from a storyboard is shown in Figure 2.23. Having created my assets in library format it's then easy and quick to place the character down in every frame and start building the storyline. Pathways can be tested through the material to investigate the look and feel, the consistency, and ease of use of the program.

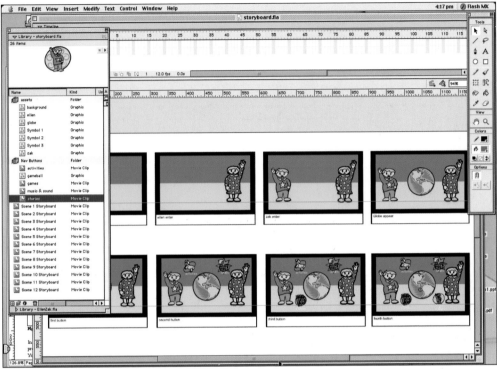

Figure 2.23 *Storyboard with assets library open*

Illustrating your Storyboard

There are many approaches to drawing, but whether you use pen and paper or draw in FreeHand or directly in Flash MX the most important thing you can do is to establish your personal style.

Figure 2.24 *Illustrations for a storyboard*

Always Visualise What you Want to Draw

Unless you have worked out in your mind what you are going to draw it's a false hope that you can just execute the drawing. I like to write a paragraph on each frame before I start drawing. I find it helps me focus the illustration.

Figure 2.25 *A focused illustration is a better illustration*

Leave the Detail until Last

Draw the big shapes first. Then work your way down to the detail. Leave 3D detail until later. When you are drawing the 3D start by just drawing the basic shapes like spheres, cylinders or cones. You're trying to establish planes for both depth and perspective. Know, refine and define the various, planes, edges and details.

Figure 2.26 *3D detail*

Proportion

Proportion is the relationship of one size to another. You need to start by working out your proportions. The proportions of the human body are the most important, get them right. The second most important proportions are between objects and the space they occupy. The basic silhouette of an object is often more important than any details. Work using contrast lighting, so, if your foreground is light, make the background dark, and vice versa.

Figure 2.27 *A well-proportioned body*

The following pages contain storyboards from recent work in both digital and pen and paper.

Example 1: Ellen and Zak TV

Frame 1 – Text fades in

Frame 2 – Globe appears with EZ text

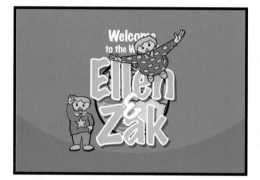

Frame 3 – Zak and Ellen appear and Ellen flies around the screen

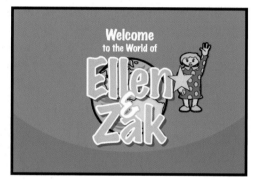

Frame 4 – Zak changes to a star and flies around the screen

Frame 5 – Navigation appears

Frame 6 – Activities section

Example 2: The Life of Einstein

Frame 1 – Picture of young Einstein

Frame 2 – The theory of relativity, an old man on a zimmerframe racing a train

Frame 3 – Einstein awarded Nobel prize

Frame 4 – First nuclear explosion

Frame 5 – Einstein addresses crowd

Frame 6 – Picture of Einstein raised by protestor

Example 3: A 30 Second TV Commercial

Frame 1 – A wide shot of a woman's face covered with a shawl

Frame 2 – Zoom in on the top of her head

Frame 3 – Lower the camera down towards the bottom of her face

Frame 4 – The shawl begins to part, revealing her face

Frame 5 – More of her face is revealed

Frame 6 – Focus on her eye

Example 4: Millennium Bug

Frame 1 – A computer reports an error on the turn of the year 2000

Frame 2 – Ant tries to find out what the problem is

Frame 3 – Ant hears something and turns his head

Frame 4 – Ant sees the millennium bug

Frame 5 – The millennium bug wrecks Ant's computer

Frame 6 – Ant's family look at their wrecked computer

Chapter 3
Defining Character Animation

This chapter covers all the major techniques for producing realistic character animations, and includes hands-on examples and a number of exclusive tips and tricks.

The art of character animation can take years to develop; this chapter tries to summarise what an animator has taken literally years of practice and learning to fine tune. Out of all the fields of computer graphics and art, animation is the most difficult. The animator must have the ability to draw or pose characters, but also have an acute sense of timing, of observation, mannerisms and movement. The following are the principles of character animation. These principles are applicable to traditional forms of character animation, computer animation and more specifically animation created in Flash MX.

The art of character animation is the art of motion that requires visualising between two extremes. These extremes are key positions that are then partly filled in by the animator or even the viewer's eyes. Character animation is different from the text animation that is seen introducing television programmes. Character animation one way or another is about adding life, and makes the subject a complex piece of machinery that does not lend itself easily to simple processes. All aspects of an object's arms, legs, head move independently, and when the character does not have arms or legs then it's even more difficult. The animator's job is to add life to non-living objects.

A live performer has personality. An animated character has appeal. Appealing animation does not mean just being comic, cute and cuddly. All characters have to have appeal or presence whether they are cute, villainous, comic or heroic. Appeal can be very difficult to build up in a computerised environment. Using your imagination and being very particular in what you accept takes the process away from the computer and brings it to the realms of the creature. Good personality development will capture and involve the audience and will bring your character to life. The art of storytelling is about appealing to the eyes as well as the mind. A well-drawn character can easily fill in the bits that an animator misses out.

In this chapter we will focus on the techniques of animation and the way the animator draws the subject using Flash. Although frame rate is an important part of movement for the moment I wish to solely focus on the technique of drawing. Later on in the book we will look at frame rate and producing for different playback devices.

Character Movement

Character movement can be incredibly complex; couple this with the stylistic approach that you choose for your character, and it can at times seem almost impossible. The animator needs to accept that the process is a learning experience, whereby the observation of everyday life, how things move and just what is going on when an old lady bends down to pick up her cat or a

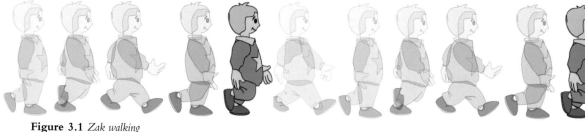

Figure 3.1 *Zak walking*

teenager kicks a can as he walks by is their study book or laboratory. It is interesting to watch people exaggerate their feelings or actions and to look at how timing can influence whether an emotion is presented correctly or with totally the wrong timing. The most represented character action is walking. We walk, we see people walking and in the character world even rabbits, dogs and cats walk. It's important to remember that there are many different types of walk and even individual characters are sometimes recognised by their particular walk. Mickey Mouse is recognised by his "double bounce walk" and the way he bounces up and down in midstride. A walk, in essence, is one foot leaving the ground, moving forward, moving to the back and stopping just before its original position. This can then loop to make a perpetual walk seem totally seamless. Another important consideration is the movement the arms and head make. Both of which need to move even if it's only slightly; the rule of thumb here is if the legs move then so do the arms and if the arms move then so does the head.

Exaggeration is a caricature of expressions, poses, attitudes and actions. Action traced from live action film can be accurate, but stiff and mechanical. In feature animation, a character must move more fluidly to look natural. The same is true of facial expressions, but the action should not be as broad as in a short cartoon style. Exaggeration in a walk or an eye movement or even a head turn will give the character more appeal.

Timing

Expertise in timing comes with experience and personal experimentation. It's impossible to determine all the conditions that your animation will play back in. The rule of thumb for me is to create everything for playback on 15 frames per second unless I am doing it for video and then I do it at 30 frames per second. The basics are:

- More drawings between poses slow and smooth the action, although you can speed the process up by increasing the frame rate of the movie.
- Fewer drawings make the action faster and crisper.

I recommend you stick to 15 frames per second. A variety of slow and fast timing within a scene adds texture and interest to the movement. Most animation is done on twos (one drawing photographed on two frames of film) or on ones (one drawing photographed on each frame of film). In the digital world with playback of 15 frames per second twos are used most of the time, and ones are used during tracks, pans and occasionally for subtle and quick dialogue animation.

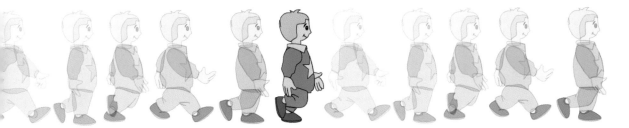

Arcs, Easing in and Easing out

All actions, except for mechanical devices, follow an arc or slightly circular path. This is especially true of the human figure and the action of animals. Arcs give animation a fluidity that allows the animator to flow from one sequence to the other. Think of natural movements in terms of a ball bouncing that just arcs itself into stillness. All arm movements, head turns and even eye movements are arcs. As action starts, there are drawings near the starting pose, one or two in the middle, and more drawings near the next pose. The fewer the drawings, the faster the action and more drawings make the action slower. Easing-ins and easing-outs soften the action, making it more lifelike. For exaggerated action, we may omit some easing-ins and easing-outs for a surprise element.

Figure 3.2 *Setting easing-in*

The Walk

The main action in a walk starts at the legs and the lower half of the body. It is basically a continuous sequence of steps.

The midway position of any walk is called the "passing position". Open the Walk.fla file and play it now, make sure that loop playback is on. A feature of the midway position is the body – it is raised higher in the passing position. The reason for this is that in the passing position the leg is straight below the body pushing the body upwards; this can also give the hips a swaying motion as the top of the legs move up to take their position at the midway point. It is important to stress that the midway should always be the middle of the animation sequence, so if for some reason you wish to do the walk in three frames then the middle frame is the high point of the walk.

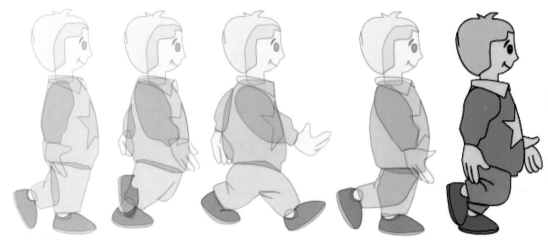

Figure 3.3 *Zak walking*

The Walk Cycles

The walk cycle is made by repeating the walk on the spot, this is also helped if the background pans through the scene; check out the parallax motion movie in Chapter 10. The walk cycle is primarily a trace back of each of the two extreme positions. All that happens in the passing position is the body is raised up while the foot slips back along the ground. You will notice that the way I have drawn Zak for these sequences it to make his centre of gravity slightly forward so there is a feeling of moving forward. The passing position applies to the whole body so as the left leg is forward, the right arm is moved forward to counterbalance it. This gives us a natural rhythm to follow that immediately suggests that the body is in balance. If you were looking for a really funky walking style then by making the hands swing out of sequence and applying a double bounce sequence you will be able to get some very interesting results.

▽ Timeline																
	🐦 🗁 ☐	1	5	10	15	20	25	30	35	40	45	50	55	60	65	70
🗐 zakwalk	⬮ • • ☐	⬡🗆•🗆•🗆•🗆•🗆•🗆														

🗗🚷☐ 🗑 ⬩ 🗁🗂🗗 [·] 1 15.0 fps 0.0s

Figure 3.4 *The walk timeline*

The Double Bounce Walk

This walk has been the hallmark of Mickey Mouse. The walk breaks down the rigidity of the animation process and ironically makes it closer to life. One lesson here is that animation should exaggerate movement. The animator needs to observe movement in everyday life and before it is applied to the character you need to "walk the walk" until you get a clear picture in your mind. This mental picture is an important part of helping you set the rhythm for the walk. This walk is created by the bouncing effect that occurs midstride, and is shown in the file DoubleBounce.fla. The stride looks like this:

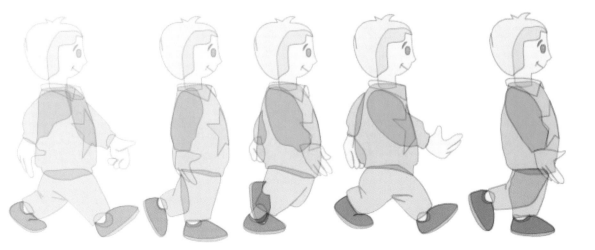

Unlike the normal walk, where the passing position is the high point, in this walk the passing positions are down with the legs fully stretched out on tiptoes on the up positions.

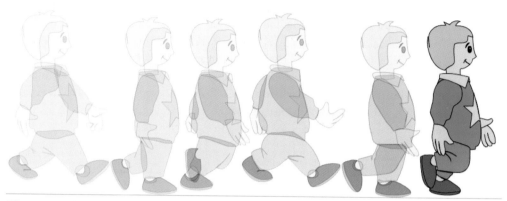

Figure 3.5 *The double bounce walk*

The Slow Lazy Walk

Open the file SlowLazy.fla. The leg movement is very similar to the normal walk, the only difference is the point of passing is lower but is still apparent. The body has a droopy posture with the head slightly forward and looking down. The head looking down takes the energy out of the body and is the anticipation of the sluggishness in the walk. I remember describing this walk to a group of students as the gallows walk, your character has been sent to the gallows for committing some heinous animation crime, this is his final walk, head down, shoulders back, arms dangling in resignation of the occurrence to follow.

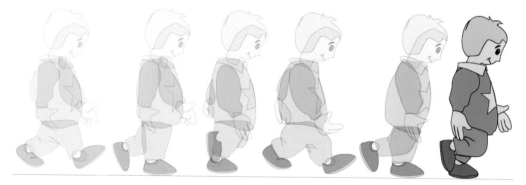

Figure 3.6 *The slow lazy walk*

The Tired/Energyless Walk

If your character should ever find itself lost in the animation desert then you should simulate the slow walk with the only real difference being the length of the body being slightly longer and lower. To achieve this effect you need to drag the legs behind the centre of gravity of the torso; tilting the torso by 30 degrees. The head should hardly move and be attached to the torso, following the torso movement. When the legs are at their furthest back position they should almost lock allowing the foot to reach out and almost drag the top of the toes on the ground. This move should be supported with a small lurch forward. The arms should dangle for most of the walk except for the short lurch when they should swing slightly. Open Tired.fla and view it.

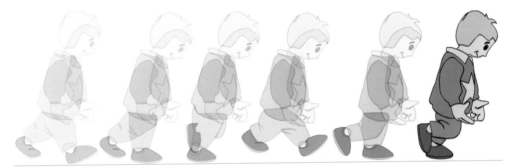

Figure 3.7 *The tired/energyless walk*

The Sneaky Walk

The basic action of the sneak falls into two movements: the short sneak and the long sneak. The short sneak is normally quite fast and on tiptoe with the top half hunched up. This is good for illustrating a character as it sneaks up behind another. The movement can be very exaggerated, and is shown in the file Sneak.fla.

The long sneak is a slower sneak. I always associate this with escaping actions as opposed to the short sneak which I always associate with moving in actions. After the character has committed an animation faux pas he slowly tries to sneak off stage. This is done with long reaches of the legs, elbows bent with most of body above the gravity point of the character. The head looks down at the legs when they are at their most elongated position, but then looks up when the body catches up with the leg. Look at the file LongSneak.fla.

Figure 3.8 *The sneaky walk timeline*

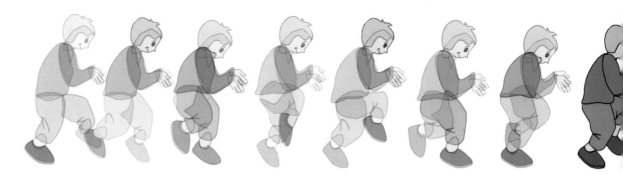

Figure 3.9 *The sneaky walk*

The Push Walk Backwards

Look at the file PushBackwards.fla. When Zak pushes an E across the stage he is doing most of the work with his legs. His shoulders and arms are hard against the letter. So we use the legs to convey the action and the face to instil the emotion. When the character is pushing a heavy weight most of the body has to be exerting itself. In most instances there is a lean back to try to make the character seem balanced. The heavier the weight the slower the movement. In this situation I always try to change the pace of the movement; at the beginning of the step the push seems slow but before full extension on the legs I double the speed of the movement. This helps convey both the weight and the energy that goes into the movement.

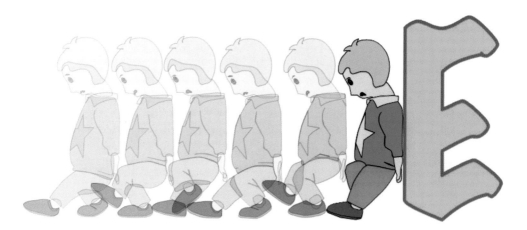

Figure 3.10 *The push walk backwards*

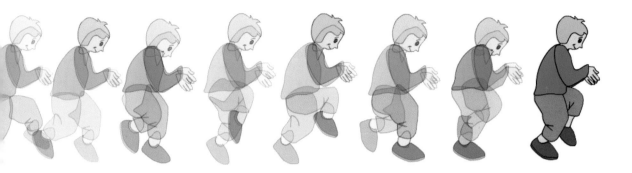

The Push Walk Forwards

I think this walk is much more straightforward. I always thought about it as: the heavier the thing you are pushing the closer you are to it. The steps in this instance are short and slow. If you are pushing a horse then assuming you can get it moving you will be at arm's length with your weight slightly forward in the direction you are going. It is shown in the file PushForwards.fla.

Figure 3.11 *Zak*

Figure 3.12 *The push walk forwards*

Running

Running is just the walk taken to its most extreme, all the limbs move at a quicker pace. Whatever your timing was for the walk, halve it for the run. You can also reduce the number of frames in your loop, making the loop seem a lot faster. When you are doing the run try lifting the body more at the passing position and enlarge the stride and the push-off at the floor to foot point. The arms are much more energetic because they drive the legs into motion. The run starts at the arms, this creates the anticipation movement that is necessary to kick life into the run. If the character is a sprinter the arms are punching in a bent position acting as a lever for the motion, the shorter the arms, the faster Zak goes. Check out Running.fla to see the example in action.

Figure 3.13 *Ellen*

Pass Pos

Figure 3.14 *Running*

We are trying to put more momentum in the run so the centre of gravity is much more forward. It is out of balance with a tipping forward so if the figure was to immediately stop it would fall over. One important definition of the run is that both feet lose contact with the ground; this is the moment of suspension, you see this in horses when they gallop or jump. For a split second the horse seems to freeze. I have, for games, drawn the run as a three frame animation but this is unfortunately too crude for character animation. You can get away with it in the limited area in a game, but not if the character is enlarged; it's not very convincing.

Personality affects the run but also what the runner has to contend with. Running up a hill is far more difficult with the Zak character needing to put all his weight forward to help himself get to the top of the hill. The contact leg is always driving forward. Running down the hill Zak will shift his body weight slightly back. He might even increase his stride, this will increase the moment of suspension; the faster the run the greater the lean backwards.

The three key positions in the run are:

1. The first contact position: This is when the energy is summoned up and the strength and direction of the character show.
2. The moment of suspension: This is the point where there is no contact with the ground but the figure is still moving forward; the lean is very apparent with the arms swinging.
3. The down contact position: This is when the body sinks into the bent contact leg.

As a rule the run should be drawn in single frames; this is known as "ones". When put into cycle these positions look like the picture below, also shown in RunCycle.fla on the CD.

Figure 3.15 *The running timeline*

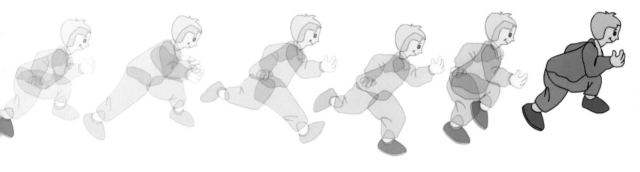

Angry Walk

This action adds to and enriches the main action and adds more dimensions to the character animation, supplementing and/or re-enforcing the main action. Example: A character is angrily walking toward another character. The walk is forceful, aggressive, and forward leaning. The leg action is just short of a stomping walk. The secondary action is a few strong gestures of the arms working with the walk. Also, there is the possibility of dialogue being delivered at the same time with tilts and turns of the head to accentuate the walk and dialogue, but not so much as to distract from the walk action. All of these actions should work together in support of one another. Think of the walk as the primary action, and arm swings, head bounce and all other actions of the body as secondary or supporting action.

Anticipation

Lifelike movement is a primary goal of animation. Early animators observed nature (including themselves) and experimented with techniques for making animated actions more closely resemble their natural counterparts. Newton's third law of motion states that "for every action there is an equal and opposite reaction". In many instances, a movement in one direction is preceded by a smaller preparatory movement in the opposite direction. By imitating and exaggerating these small movements, animated drawings are given a more naturalistic appearance. As Zak prepares to run off the screen from right to left, he initiates a left movement to shift his gravity to anticipate the move. This is done in three stages: a static pose, anticipation in the opposite direction and finally the run.

The more carefully you observe living things, the more you will notice them. In order to move a mass efficiently, a force must be directed against its centre of gravity. Aligning the mover behind the centre of gravity of the mass (for pushing) or in front of the mass (for pulling) produces part of the anticipation motion. Understanding and recognising anticipation will enhance your powers of observation. You'll begin to see the evidence of it all around you, and recognise it in the animation you watch. Here's an example of anticipation in action, Anticipate.fla on the CD:

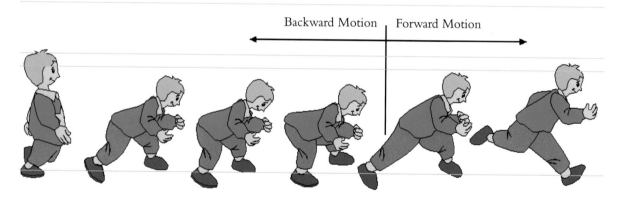

Figure 3.16 *Anticipation*

Zak is at the starting blocks of a race. He gets himself into position and then waits for the signal to go. Bang! When it goes he slips back slightly and then shoots forward. Everything that moves benefits from an anticipatory movement. If the anticipation is correctly applied you can make a character disappear offscreen in only a few positions. The audience will just fill in the rest. When moving a weight or throwing a ball remember to use the backward motion. This may be one or two swings with the ball. When Zak moves off his seat he prepares the action with a small backward lean.

Squash and Stretch

For me squash and stretch have always been a subsection of anticipation. When a ball bounces it is at the point of impact that it squashes but this anticipates the change in direction as it changes direction at the first frame the ball stretches out. This action gives the illusion of weight and volume to a character as it moves. How extreme the use of squash and stretch is depends on what is required in animation. Usually it's broader in a short style of picture and subtler in a feature. It is used in all forms of character animation from a bouncing ball to the body weight of a person walking. This is an important element to master; Flash can do a lot of the hard work in scaling distortions but you still need to have a clear picture in your mind as to what you are doing.

Stretching serves to emphasise the speed and direction of motion. Squashing highlights the effect of an abrupt change of direction or a sudden stop. Like many characteristics of animated drawing, the drawing made in the application of squash and stretch defines the animator's style. You can see the bouncing ball in the bounce.fla movie on the CD.

Squash and stretch are not limited to high-speed violent actions, they can be applied in moderation to any action. The more energetic the action, the more exaggerated the squashing and/or stretching. Often the most intense activities result in several cycles of squashing and stretching before the character returns to its initial pose.

Flexibility in Motion

An animation should be like a liquid moving along an inclined surface, totally flexible in its movement. Like a liquid not all the parts of a character move at the same time. Parts of the body, whether an arm or leg or even head, lead the action with other parts following through. Occasionally limbs will seem to break away from the action to release a ball or to swing a bat, but they will always do that as part of the follow of the whole and in line with the initial limb that leads the action. The liquid that seems to pour down our incline occasionally creates another arm that splits off and then later joins the main body.

Every action has a breaking point as it goes through a series of changes of direction in the joints; Zak throwing a ball demonstrates

Figure 3.17 *A bouncing ball*

this. As he moves through his action the movement starts with the arms and ripples out to the wrists where they seem to crack like a whip just before the moment of release. You will notice in this animation the ripple moves out not only to the wrists but at the same time down the body lifting the feet onto tiptoes – the body leans forward at the point of release. To see this in action look at Flexibility.fla.

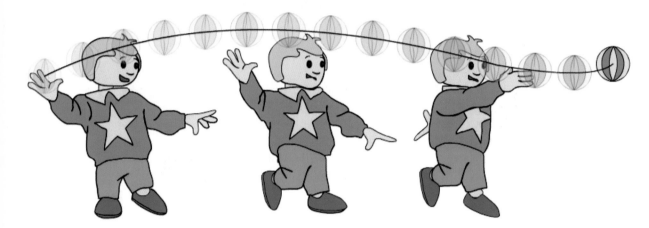

Figure 3.18 *Flexibility in motion*

Overlapping Action

When the main body of the character stops all other parts continue to catch up to the main mass of the character, such as arms, long hair, clothing, coat tails or a dress, floppy ears or a long tail. An acrobat waving a banner will change direction but the banner will follow on its path of movement until it reaches its full length, then it changes direction and follows the acrobat. Nothing stops at once.

Overlapping is a godsend to help set a scene or to set continuity. Have a look at Overlapping.fla. Clothing is a great example of overlapping action. A cape will continue to move towards Zak well after he has stopped. There might even be a little flurry or a crack at the extreme edges of the cape, as you can see in the Overlapping.fla animation. Hair, banners and scarves all move as a result of overlapping action. Timing becomes critical to the effectiveness of drag and the overlapping action.

Head Turns and Eye Movement

A pose or action should clearly communicate to the audience the attitude, mood, reaction or idea of the character as it relates to the storyline. The effective use of long, medium, or close-up shots, as well as camera angles, also helps in telling the story. We started this chapter by looking at the walk and then covering the various details associated with the walk including the arm swings. Visually most people are drawn to the eyes and mouth. There is a limited amount of time in a film, so each sequence, scene and frame of film must relate to the overall story. Anticipation and exaggeration can be a few artful strokes away from making a difference between showing the personality of a character and it being just a poor illustration. The viewer can be easily confused with too many actions at once. Use one action, clearly state it, and this will get the idea across. Staging the character in this way directs the audience's attention to the story, check out HeadMovement.fla on the CD.

The head suddenly turning with an exaggerated movement can really present a feeling of shock and surprise. The double take is a great example of this. It starts with the head swinging in an arc from left to right, the full frontal being the lowest position. The more exaggerated the movement the more shock and surprise in the viewer.

If you turn your head from side to side you will notice that your eyes blink as your head turns. If the pupil is moving from side to side of the eye this again moves in an arc position. The eyes tend to lead the direction of the head.

Figure 3.19 *Head turns and eye movement*

Animal Animation

The same rules apply for animals as apply for character animations:

- A movement is always in an arc whether it's a bird flying or a horse galloping.
- Anticipation is an important part of any movement.
- Exaggeration turns on the character of the animal and makes it more cute and likeable.

One thing I learnt a long time ago and I found very useful is: you can lose size, volume, and proportions whilst drawing animals, especially when you combine a number of animals of different sizes. The method of pose-to-pose animation is a planned-out process charted with key drawings and done at intervals throughout the scene. This matches perfectly with Flash's in-betweening process. By drawing these key frames separately it is much easier to maintain all aspects of scale and balance in the picture. Size and proportions are controlled better this way, as is the action.

Birds

Birds have four wing positions: two up and two down. The two positions of extreme are the main keyframes. The first position is the uppermost position: as the wings drag against the air of the downward thrust the wing becomes concave. This is noticed only at the full frontal position. When the wing reverses its direction upwards there is a reverse curve. At the end of each curve there is a snap to the wings. This method mimics that natural flight pattern of birds; however, in real life wings do not simply curve back the other way when they are on the way up, as they do in cartoon action, they follow the more complex structure; the wing bends in the middle and the body drops slightly resulting in a body movement in the opposite direction of the snap. Over a cycle this effect results in an up and down movement of the body. The file to look at on the CD is Bird.fla.

Birds tend to fly in different ways depending on their activity and size. A bird of prey will glide round in circles as it targets its prey. An eagle will occasionally beat its powerful wings. As a rule the larger the bird the slower the movement, the smaller the bird the faster the movement. The up and down movement of the body will also differ depending on the size of the wing; a big wing will make a more exaggerated body movement. A small wingspan will have less impact on the body movement.

Figure 3.20 *The goose flying*

Four–legged Animals

I have always approached the four-legged animal as two independent human characters. For the walk just animate the front legs – they should then map on to the back legs. The only thing to take into account is that the back legs are a stride out of sync with the front. So when the front right leg is forward, the back right leg is back. The only thing to watch out for is the potential stretch that may happen from poor distancing of the legs. All the rules of the walk in two legged animals apply here – we have created an example of a horse walking, Horse.fla on the CD.

It's possible to have a great deal of fun with the four-legged walk. The variations of this are endless. The great variation of movements, actions, double pace and bounce can make almost whatever you produce seem original. Head and tail move in the opposite direction to their nearest legs, for example when a head moves up the shoulders are moving down.

Figure 3.21 *The horse*

Figure 3.22 *A horse walking*

Rotoscoping

I have always believed that this art of tracing live action can result in a dull and mechanical animation. It is by exaggerating action that an animation takes on a life of its own. I have always found it very difficult to exaggerate a Rotoscoped movie. In the pre-computer era, a section of film would be printed out as a series of photographs. The animator would trace over the photographs and transfer the drawings to film one frame at a time. Computers have eliminated the need to photograph the drawings and speed up the process of moving from the original live action to the rotoscoped movie. For an example see Rotoscope.mov on the CD.

I have always found Apple's QuickTime video clips as the best format for Rotoscoping. All Apple Macintosh computers come with QuickTime, and if you do not have it for your PC then you can download it from www.quicktime.com. You do not need the Pro version to Rotoscope. On occasions I have shot material in DV format and reduced the frame rate to 15 fps and saved the file in component video without sound.

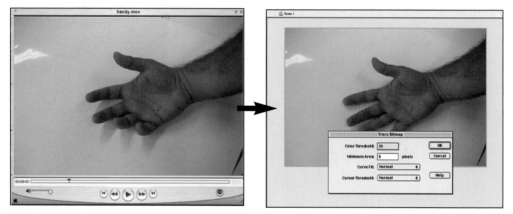

Figure 3.23 *Rotoscoping QuickTime movie to Flash*

You should set up your file to match the pixel size of your QuickTime clip. When you have set up your movie you should import the clip into Flash as a linked file. This is important because you do not want the clip embedded into the Flash movie. If you should move your fla file to another machine take note that you will probably lose the link to the movie and it will not show up in your file. If you're exporting from Flash to SWF, the imported video will not export with the animation. However, if you export it as a MOV file via file/export the video will export without sound.

Once you have imported your QuickTime movie you should lock the layer it is sitting on. You should create a new layer and add the number of frames that exist in your QuickTime movie. You can now trace the movie frame by frame. When you have finished adding the level of detail you need you can hide the layer that the QuickTime movie is on and play back your masterpiece.

Figure 3.24 *Setting up Rotoscoping in Flash*

Figure 3.25 *Rotoscoping in Flash*

Figure 3.26 *Rotoscoping in QuickTime*

Ellen Character Sheet

Zak Character Sheet

Goose Character Sheet

Horse Character Sheet

Chapter 4

Flash and 3D Animation

This chapter examines the use of Flash MX alongside 3D applications to create
stunning 3D animations.

Animation is basically one trick after another. Whatever it takes to get your vision on screen is the right way. Regardless of the software, whatever you produce will finally be judged on its appeal and quality.

I once found myself trying hard to make Zak move across the screen whilst getting larger, the view I needed was a wormeye view. For one reason or another I just could not get it right in FreeHand so I decided to go to pen and paper. I still had problems, so finally in a screaming frenzy I decided to search the web for a solution thinking that may be somebody out there had already done this walk and the material was there for me to learn from. Whilst doing the search for animated walks the links for Poser kept coming up, so I visited the site and was rather sceptical of the quality of the product for a 2D animator.

In essence what I learnt about Poser was that it was a 3D-character animation and design tool for artists and animators. You can create images, movies, and posed 3D figures from a reasonable selection of fully articulated 3D human and animal models. The Libraries of pose settings and facial expressions are also quite interesting. Poser's interface was very easy to learn, and within a short time I found that I had simulated the walk I needed and I had the individual frames in FreeHand to trace over. The character that I used was the mannequin slightly distorted to silhouette Zak.

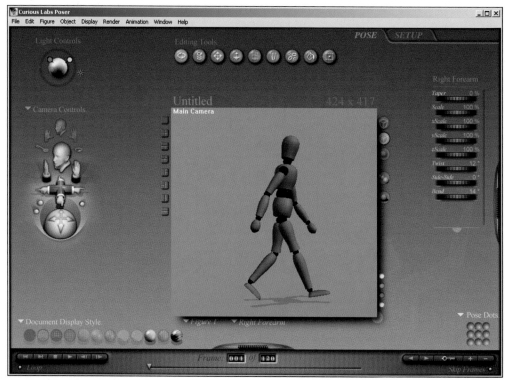

Figure 4.1 *The mannequin in Poser*

Walkthrough of Mannequin

The only real difference to this process was that in the 2D drawn animation you work on the basic poses of each scene by drawing poses of the entire character so the timing and acting can be worked out. Once the poses are finalised, then the in-between drawings are created to complete the action. With Poser animation, keyframes are values at certain frames for the articulation controls of a model, these are set up in a hierarchy. The computer calculates the in-between values based on a spline curve connecting the keyframe values.

One of the biggest differences between 2D/drawn animation and computer animation is the fact that computer animation is truly three dimensional. An animation sequence can look great from one angle but when you look at it from another, the arms may appear to be going through the body and the knees bending the wrong way. You have to get into the mindset of animating from at least two different views. The benefit of the 3D environment is you can reuse the animation of a scene or parts of the animation in lots of different ways with lots of different camera angles. If you simply look at a scene of animation from a different camera angle, it will look completely different. By just varying the timing of the motion or changing the motion of an arm or head it will cease to resemble the original.

The computer gives the animator the ability to create images that look real but are based on years of experience of rendered 3D images. We now have the ability to give characters different textures and render them with texture mapping, ray tracing and radiosity, which takes the animator down a thought process that I find quite staggering. You can make an object look just like it's made of marble or rubber and really explore the texture by using predetermined sequences. The real challenge for the animator is first to build your model (or commission your model), then you can explore the marble or rubber effects when it is in motion. Although rendering is very much a mechanical process, exploring the process is just an additional tool for the animator's tool box. Life in your character has nothing to do with the rendering and everything to do with the way the object is animated. As you build and create things in the 3D environment you also need to be aware that you still have one more process to go through before the end user can see the product. That process is the conversion of the sequences in .swf format. I have found that it can take time if you use the material directly from your perfectly built 3D model then set it to render in .swf format. What I have found is the animator loses control of the process and you are just sitting around waiting for things to render, which then always turn out different from your expectations. Poser is a great tool for the animator as not only does it teach you about movement, but it can also be a quick way of finding out what is possible in your animation and is great for storyboarding. It is the animator's imagination that gives a character its qualities.

Objects, identical in size and shape, can appear to have two vastly different weights by the animator manipulating timing alone. This sensitivity to timing and movement I found an extraordinary feature of Poser (Poser Pro Pack). The ability to explore objects and manipulate their mass and the force required to change their motion made me really appreciate the importance of Poser as an animation tool.

Modelling for Rendering and Animation

The 3D creation process can be quite complicated, with most applications offering a basic number of tools, usually made up of lathe tools for creating shapes out of a profile and extrusion of shapes. Every rendering or animation begins with a model. Characters, tables, chairs, windows and walls all pull together to form a virtual environment. There are many different approaches to building a computer model; however, there are techniques that can make the process easier, and the rendering smoother and faster. When animating characters, every movement and every action must exist for a reason, but the most important rule in modelling your character is to keep it simple. This rule is so important that you will probably discover that all of the other rules are actually just practical applications of the "keep it simple" principle. Rendering is extremely demanding on a computer, therefore, if you want to do bigger, better, and faster rendering projects you only have two choices – buy a bigger, better, faster computer, or take maximum advantage of what you've got. Translated, that means keep it simple, and you can do more.

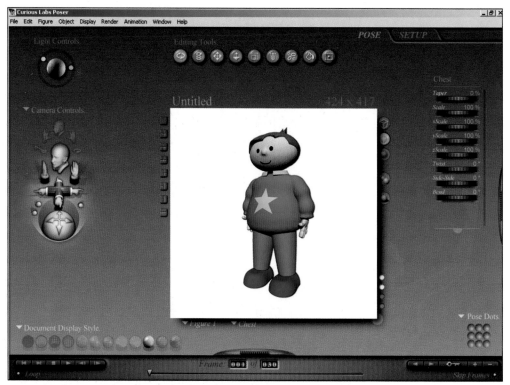

Figure 4.2 *Zak in Poser*

Paint Detail into a Model

Most 3D applications have a paint tool for doing detailed work. Details can often be painted into a model instead of being physically modelled. In fact it is sometimes almost impossible to model some detail. Many things can be painted far more easily than they can be modelled. Transparency

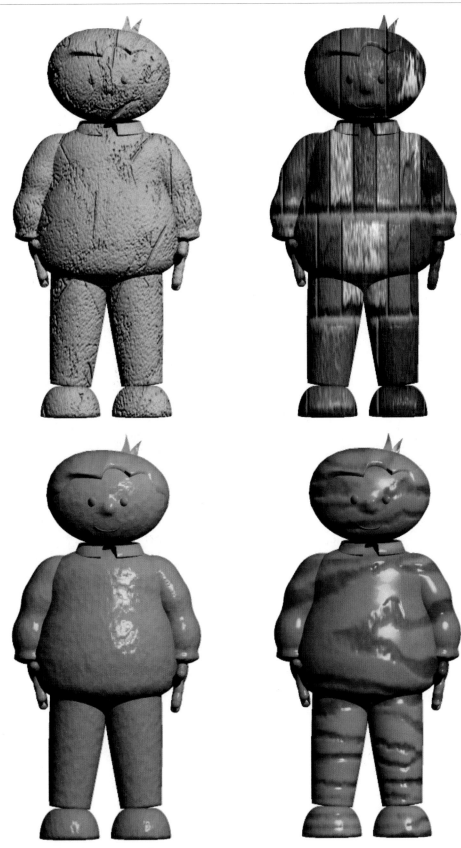

Figure 4.3 *Zak with various painted textures*

and bump mapping can add depth and dissolve sections of simple geometries allowing them to simulate things of much greater complexity. If you look at Zak's star you will see that instead of modelling that detail you can apply it as a texture map. You can of course add this level of detail within the Flash environment.

Use Symbols

Using symbols for repetitive items (doors, windows, furniture, etc.) will lower the overall size and complexity of your data file. It will also allow you to edit these items globally, and allows you to hide them to temporarily improve a rendering performance. Once you have built your basic building blocks you can then take them into your Flash environment and use them as library items.

Build a Library of Standard Objects

When building objects for rendering it's worth taking the time to do them well and importing them into Flash for testing. By building a standard library of those objects that you use again and again, you can spread the cost of building them over several projects. Organising your library into a growing database of assets will not only be a great time saver but it will be an important commercial asset.

Planning

Last but not least, you should always spend some time planning out a project up-front before building the actual model. This will help you to decide where it is appropriate to place detail, which areas might be ignored, what resources will be required, etc. Planning will also help you to maintain the project scope, and keep the job on budget.

Figure 4.4 *The hierarchy of a castle*

Readability of Actions

Proper timing is critical to making your model understandable. It is important to prepare the audience for the anticipation of an action and then action itself, and then the follow through or reaction to the action. The balance has to be the main focus on moving your model from A to B with the right look and feel, spending 15% of the time for the anticipation and 15% for the reaction. There are always exceptions to the rules, but you will find unless your object needs to move at lightning speed across the screen the above rule applies in most instances. In fact the faster the movement, the more critical it is to make sure the audience can follow what is happening. This is done through getting the opening sequence right, the moment of anticipation. You explore this moment of anticipation by setting multiple cameras onto the actions and exploring the different renderings.

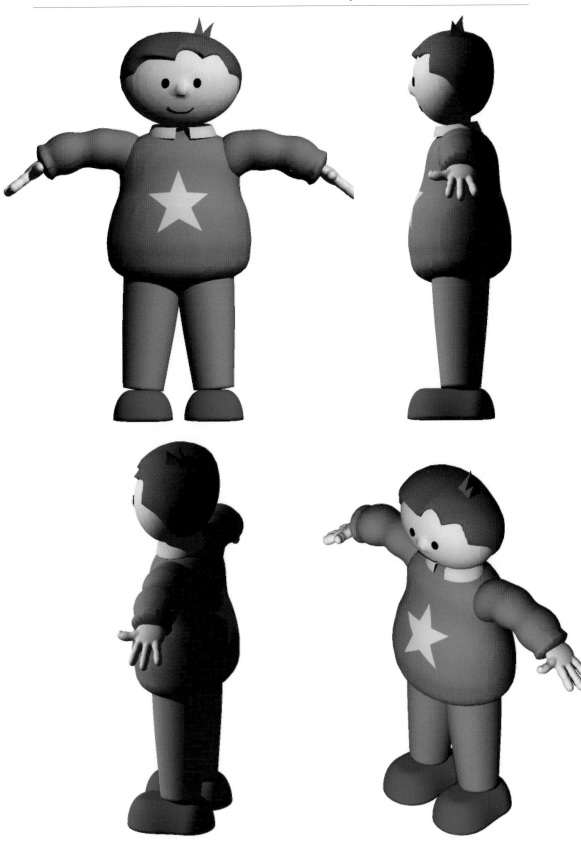

Figure 4.5 *Zak at different angles*

The audience's eye must be led to exactly where it needs to be at the right moment to see the action; they must not miss the moment of total anticipation. It is important that the audience sees only one scheme at a time; if a lot of action is happening at once, the main focus will be overlooked. The point of interest should stand out in contrast to the rest of the scene. In a still scene, the eye will be attracted to lots of chaotic movement. In a very busy scene, the eye is attracted to stillness. Actions should always overlap; this slight overlapping is the only way an animator can maintain the flow and continuity between whole schemes of actions.

Poser Walk Cycle Exported to Flash

Curious Labs, the creators of the Poser Pro Pack 4, have added the ability to export to .swf format. You can find a copy of Poser Pro Pack on the CD. This tutorial will explain the process of creating a simple walk, and illustrate the different rendering formats. The final movie plays back a number of the mannequins moving at different speeds across one movie. I have tried to simplify the process of creating a cycle with Poser Pro Pack 4 and then taking it into Flash. The different rendering options should demonstrate how to keep the resulting file size low. Poser has the potential to export large files but our objective is to render small files. My favoured approach is to use the character as a template for redrawing figures in either FreeHand 10 or in Flash MX, as I always find the characters a little too mechanical directly out of Poser. If you are thinking of

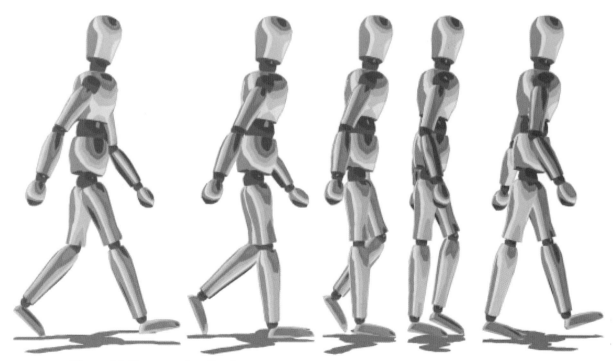

Figure 4.6 *The mannequin walk cycle*

using the characters directly, there are many rendering styles that you can set within Poser. This is not an exhaustive selection, there are many more built into Poser but you can create your own styles.

Creating the Walk Cycle

To creating a walk cycle you use the default figure that appears when launching Poser, if you'd prefer to use one of the mannequins as I did then you will need a copy of the Pro Pack. Timing of a motion can also contribute greatly to the feeling of size and scale of an object or character so whatever figure you choose to use, take into account that it may not look exactly as I have rendered it. If you think about it a large figure has much more weight, more mass, more inertia than a normal figure, therefore it moves more slowly. A quick tip: any changes of movement in a large figure should be slightly slower than a smaller figure whose movements tend to be quicker. This tip is useful if you have many figures on screen. Let's start our tutorial, which begins on the next page.

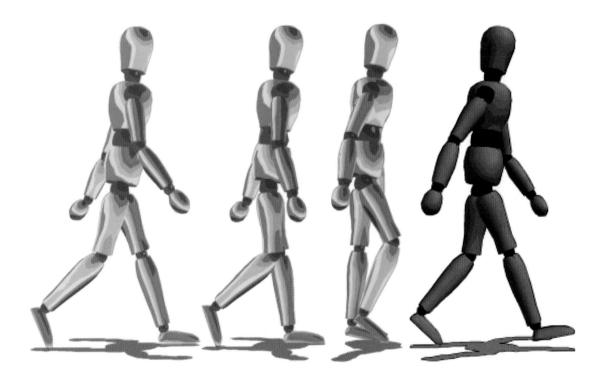

1. When you launch Poser it starts with a default figure. Open the Libraries by clicking on the handle on the middle, far right edge of the screen. Click on Poses. Inside the Poses Library, click on the black triangle to select Walk Designer. Scroll down and choose Walk.

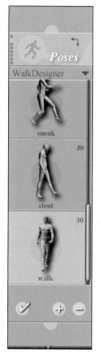

2. On the main canvas, change your camera angle from Main Camera to Left Camera.

3. Play the animation, using the controls at the bottom left of the screen. It's as simple as that. Now you're ready to save the walk cycle as a .swf. Go to Animation>Make Movie. A dialog box will appear.

4. Select Macromedia Flash from the drop-down menu labelled "Sequence Type". Select "Full" to retain its original size. With vector images size/mass is not such an important aspect of the final size of the rendered file.

5. Click the Flash Settings button. Here, set your colour number to 4. The number of colours in the exported file affects the file size. In other words, fewer colours will result in lower file size. Choosing 1 colour will create a silhouette effect. The Overlap Colours option will make the file size higher although it makes the quality slightly better. So, if file size isn't an issue, activate the Overlap Colours option. Quantisation is the process of selecting the specified number of colours that best represent your Poser figure. Check the appropriate radio button to select if you want the quantisation to occur across all frames – useful if you are animating materials or at a single frame. If you selected Specific Frame, enter the frame number where the quantisation should occur in the frame quantisation input field:

Figure 4.7
Walk poses

- Draw Outer Lines: Selecting this option draws a border around the entire silhouette.
- Draw Inner Lines: Selecting this option draws lines around each colour layer.
- Line Width: Enter the desired line width in this box.

6. Select OK on both dialog windows and your file should start to export. After naming your .swf file, save your Poser file.

The next thing we are going to do is to place the animation into a new Flash file as a movie clip. Then we are going to apply a tween to the walk cycle, making the figure move across screen whilst walking from one point to another. You can see a completed swf version of this on the CD ManWalk.swf or you can check out the fla, ManWalk.fla.

1. In a new Flash file, create a new movie clip by going to Insert>New Symbol. Inside this symbol, import the .swf file you've just created by going to File>Import. This will create 120 keyframes on your movie clip's timeline.

2. Return to the main timeline and drag the movieclip you've just created out onto the stage.

Figure 4.8 *The movie tutorial timeline*

> Motion tween the movie clip so that it moves from the left side of the screen to the right.

3. After testing your movie, adjust the tween and frame rate so you can get the right pace within the movement.

Figure 4.9 *The completed movie*

Now that you've got the basics, in every step of the production of your animation, ask yourself why is this here? Does it further the story? To create successful animation, you must understand why an object moves before you can figure out how it should move. So try it out in different camera angles to change the pace. Character animation isn't about making an object look like a

character, character animation is about making an object move as though it were alive, and making it look like all of its movements are generated by its own thought process. It is the thought that gives the illusion of life:

> *"It's not the eyes, but the glance – not the lips, but the smile..."*

By now you will have picked up the basics of the application. You now have to add experience, just play hard and it will come. The best advice I can give you is to go back to Poser and play.

Building 3D Characters

Building characters can be quite a daunting experience for the novice 3D animator. Swift 3D has to be the product of choice as it is easy to learn and is geared towards web animations and the swf format. It is no surprise that Swift 3D is very popular among Flash developers; it uses a familiar concept of timeline-based animation with keyframes and tweening, plus a few function-curve-style options for customising the characteristics of keyframes. Swift offers output for geometric solids and very good flat-colour output for organically shaped models. The tools are designed and laid out in a clear and intuitive way. If you want to move models around, do some simple animation in a package which is easy to learn and use – Swift is a good choice. You can get a demo version of it from www.erain.com.

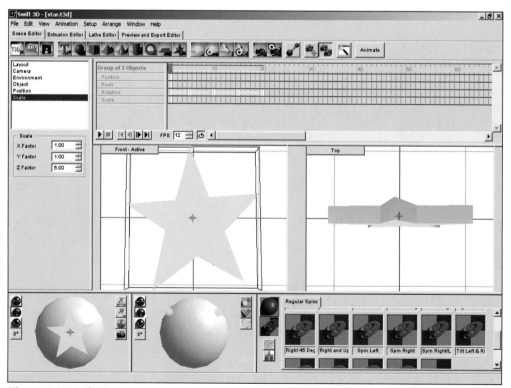

Figure 4.10 *Swift 3D*

Launch Swift 3D. The first thing I do is to split the active viewport by selecting View>Secondary Camera. If you have multiple monitors, you can undock the property tools palette and put it on another monitor to stop your view from becoming totally claustrophobic. Your viewports should be nice and big. When you mouse over any tool button in Swift 3D, you get a pretty good tooltip. Most of them say exactly what they do.

The basic nature of the viewports in Swift 3D is a little different from most 3D packages. In 3D applications, when you build an animation, you drop an actual camera into your scene, complete with all the controls that a real-world camera has. You can follow what the camera is seeing by opening a separate window for it and then toggling back to the regular viewports to move your objects around your scene in a familiar environment. In Swift 3D, the viewports are the cameras, and vice versa. There are two main areas of impact where this is concerned. First, it is easier to keep track of simple animations, because you know exactly what you are getting. The second way this affects you is that you have to be very careful when you animate cameras, this is because you only get one camera to capture your animation. If you get creative, you can animate a standard view (top, bottom, etc.) and use it as a secondary camera, but then you lose your ability to view and select in that view.

The first time you click in a viewport, you activate that viewport. The next time you click, you select the object you click on, or pan the viewport, depending on where you click. Rotation is handled with Swift 3D's transformation Crystal Trackball tool. You can constrain the rotation of objects to a number of increments, which is especially handy if you are a beginner with 3D concepts.

Swift 3D does not contain the sophistication of Poser, but unlike Poser the Swift environment does allow you to build models. The following walkthrough introduces you to the basic principles of drawing an object in Flash MX, exporting it out of Flash as an eps, importing the eps into Swift 3D to extrude and then creating a 3D animation which you then take back into Flash.

Flash 3D:

1. Start a new document in Flash. The Size and Background Colour do not matter as this is going to be exported as an eps, which will default to a transparent background unless you create a coloured object and place to cover the stage.
2. Using the Drawing Tool from Flash draw a star. Colour does not matter because all swift 3D does is take the shape of your image.
3. Once you have finished drawing your logo, select it all with the Arrow Tool. Now

Figure 4.11 *The star in Flash*

you're ready to export it so go to File> Export Image. Give it a name and save it as an EPS 3.0 (star.eps). You can use the Star.fla on the CD to export the star.

4. Create a New Document in Swift 3D. Go to File>Import and select your file star.eps. If you want to change the colour of your logo, make sure that it is selected and then choose a colour from the panel on the bottom right. This selection will only colour the Front and Back of your logo. All you have to do is simply drag the colour on top of the logo. To colour the sides you first have to extrude the shape.

5. You will notice the view of the scale menu includes a Z value; this value is the value that extrudes the shape. Give it a value of 0.5. Your logo is now a 3D logo. Click on the Animation button.

6. Select a spin effect, I selected right and up. Click on the pictures to see what kind of animation you will get. Once you have found the one you want, simply drag it on top of your logo. In my example I will be using right and up.

7. Now it's time to export your file. Go to the Preview and Export Editor and select the Generate Entire Animation. Once the frames are rendered you can export the entire animation. If you would like a different colour background, click on Environment on the top left corner. Double-click on the background colour box and select your colour. Once that's done click on Apply.

8. All you have to do now is to import the swf into your Flash movie. Remember what we did in the poser file, you should first create a symbol movie clip and then import your swf files into it.

Figure 4.12 *Extruding the shape*

Keeping your Character Alive and Believable

In 3D computer animation as soon as you go into a hold pose, the action dies immediately. Your character should never just go into a freeze-frame. The figure should always be moving, it could be the head or arms and shoulder. I have tried to demonstrate this using a dog that I created using primitives. Check the file out Dog.swf.

The eye picks up the freeze-frame immediately and it begins to look like robotic motion. To stop this from happening you should use a "moving hold". Instead of having

Figure 4.13 *The Dog.swf movie*

every part of the character stop, have some part continue to move slightly, it does not have to be in the same direction. My dog's tail wags, and when it barks its whole body lurches forward, but its legs and tail always keep going. The slightest movement will keep your character alive, and the motion should match the design of the character and the world. Look out for characteristics that suggest motion, in my model the tail was the most obvious. I have supplied the dog Swift file for you to play around with, check it out Dog3D.t3d.

3D Tools

Strata 3D is available free from www.strata.com. The package has an interesting array of 3D tools that can be upgraded at a later date to the professional version – this, combined with a complete animation toolset, makes Strata a good advanced tool for the 3D animator. When you create a new Swift 3D movie from an existing 3DS model that you created in Strata without any material (colour) information you will get the default grey colour for the entire model. If you export your entire model as one DXF and convert it automatically to a 3DS, you will not be able to ungroup the pieces of the character to apply different colours to different parts. Fixing this is easy; you can either export your model from Strata one piece at a time or use modelling software that supports every aspect of 3DS – this, however, can be an expensive solution.

Putting it all Together

Although I would not recommend you start building full blown characters just yet, I would recommend you start on the process of animating characteristics. This can be building basic 3D objects that are animated in the Flash swf format using Swift 3D. The more you do the more you will learn about your character, as you move it from 2D to 3D. Swift 3D uses the RAViX technology to trace objects in the stage and shade them appropriately, based upon light and camera angles. The file sizes are small and the output, as you have previously seen, can be quite small. In the first part of the following tutorial you will create an animation from a 3D model in Swift 3D, create a new Swift 3D document, apply standard animation to an object, export the movie to Flash swf and apply effects in Flash MX.

Figure 4.14 *Swift 3D*

1. Launch Swift 3D and create a new document by clicking on the top left button in the main toolbar. Only two icons should be clearly visible. Import or rebuild the file Gloves.t3d.

2. Make sure that the gloves are aligned to the middle of the stage. From the "Front" view you can just drag and drop the object around the stage. It does not have to be 100% accurate.

Colour animation:

1. When you import an object or build it within Swift the symbol will be a dull grey so we need to change the colour attributes. You can do this by selecting the "Material" category from the main object categories. After doing this the options will change as shown below.
2. There are three material attributes to every object. You can set each colour independently. Each attribute defines a certain region of the symbol. During a 3D rotation, you can use these attributes to create some great effects.
3. The colours of the three object attributes can be set by first highlighting one of the attributes and then dragging and dropping the colour onto the sphere icon located at the bottom of the "Material" options. The colour options are located in the bottom left of the program by default.

Figure 4.15 *The material options in Swift 3D*

Depth:

1. If you built your model; at some point you will probably need to extrude or lathe it. From the main object options you should set the depth to 5.00 as shown in the screenshot clip Figure 4.16. Click on the "Apply" after you have done so to set the attribute changes in the stage.

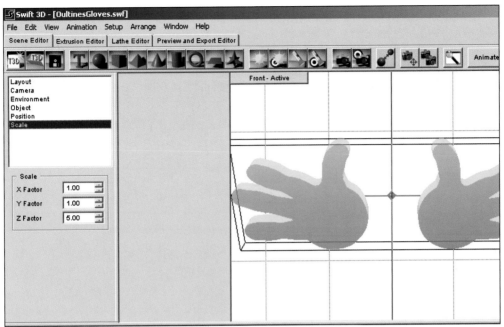

Figure 4.16 *Setting the object depth using the Z factor*

Animation:

1. After you have resized the depth of the symbol, you should add the animation. Switch the colour/animation control panel to the animation folders. These two buttons are located in the bottom middle of the main program window by default.

2. After making the switch, you should see the grid of options in the bottom right of the main program window. As with the colours section, you can also resize this one as I have done in the screenshot below.

3. In this animation we want to use the "Right 135 Degree Spin" effect that comes installed with Swift 3D. Drag and drop the predefined animation onto the symbol in the stage. You will notice that the mouse will change when the correct position for dropping the animation onto the Gloves has been reached.

4. After applying the predefined animation to the symbol, the timeline should look like the screenshot clip shown on the next page. Pay close attention to the position of the red marker in the timeline from now on.

Figure 4.17 *Animation timeline*

Resize:

1. You will notice that the symbol does not take up the entire 400 X 400 pixel movie. Using the resize tool, change the object so that it fills out the entire movie stage. Make sure that you are in keyframe 1 on the symbol timeline so that the whole timeline is affected evenly.

2. To resize the symbol, click once on the resize tool button, then click once and while still holding down the mouse, drag the object to make changes. If you need to resize the object again, you will have to reselect the resize tool.

Test and publish:

1. You can now test your movie by pressing the play button. At this point you need to avoid making any parts of your object touch any edges of the stage while it builds the rotation.

2. If you're happy with your animation, you should publish it to the Flash swf format. You can publish by selecting the "File" tab located in the top left of the main program window. Choose the "Export" option from the drop-down list.

3. Swift 3D will now render every frame in the animation. You should see pictures like the ones below being drawn one after another. A progress meter is located towards the bottom left of the main program window. Whatever colour you select at this stage you can overwrite within Flash so do not be too concerned.

Import into Flash MX:

1. You should now open Flash MX. Create a new symbol within the main movie, call the movie Gloves.fla and make it a Movie Clip. Select the OK button. From the very first frame on the only timeline, choose the "File" tab located in the top left of the main program window.

2. From the option in the drop-down menu, choose "Import..." and import the swf into your movie, the main program window should look like the screenshot above.

Figure 4.18 *Importing the movie onto the stage*

3. Don't worry about the symbol not being aligned with the centre of the stage. Since you are within a symbol that we will not rotate, it will be OK for this example. There will be many times where you will want to align the graphic within a symbol. You can do this by double embedding the imported frames into a movie.

Create and edit layers:

1. Now return to Scene1 by clicking on the "Scene1" text located in the top left of the main program window. A screenshot clip is shown below.
2. Create seven blank layers in the main timeline. This is a pretty basic example, so you can leave them with the default names. Drag and drop the "Glove" movie symbol from the library onto the stage of layer 7.
3. Layer 7 should be the one at the top. Resize the symbol so that it fits well in the stage.
4. Align the symbol so that it is located in the absolute middle of the stage. After you have set the size and location of the symbol, you should highlight the single frame that it resides in. Press

Figure 4.19 *Seven layers*

CTRL-C (Windows) to copy the symbol onto the clipboard. Highlight the first layer under the one that you just copied the symbol from and paste the symbol into the frame using the "Paste in place" feature.

5. After you have two symbols directly on top of each other, you now need to apply the Alpha effect to the lower symbol. Make sure that the lower symbol is selected/highlighted in the stage. From the menu bar in the top right of the main program window, choose the "Window" tab. You now need to display the "Effect" palette in order to apply the effect. Find the panel and select it in the tree as shown below.

6. Apply the "Alpha Fade" effect to the symbol on the lower layer. After you have done this copy the single frame containing the faded symbol (CTRL-C).

7. Paste the symbol in place on the remaining five layers below that are currently blank.

At this point the stage should look like there is only one symbol since all of the symbols are perfectly aligned. Aligning the symbols is crucial to creating the effect. You now need to stage the motion of the symbol within the main timeline. Offset each new symbol by one frame in the main timeline.

Figure 4.20 *The stage*

Add Stop action:

1. The trails will not appear when you preview the movie by pressing the enter key. Actually nothing will happen at all in the stage since we have embedded our graphics into a movie and not a graphic type of symbol. In order for the movie to work properly you need to add a single "Stop" action to the end frame to keep the main movie from looping.
2. Create a blank layer in the main timeline. Double-click on the last frame. You should see the pop-up menu that is shown below.
3. Choose the "+" symbol in the top right of the palette to add the "Stop" action to the frame. After you have done so, the frame should like like the screenshot clip shown below.
4. After doing all of this, your file is ready for export. Save and export the file as an swf file.

Why not get adventurous and try applying the movie to a path?

Figure 4.21 *The test movie mode in Flash MX*

All movement should have a purpose: to support the story and the personality of your character; its easy to forget this once you get involved with complex building of 3D characters. This is animation after all and any kind of motion is possible. You make your own rules, but the rules must be consistent for your world to be believable. The movement of your character and the world of your story should feel perfectly natural to the audience and as soon as something looks wrong or out of place, you will lose your audience. The goal is to create a personality of a character and a storyline that will hold the audience and keep them entertained for the length of your movie. After all, all that an audience wants is to be entertained.

Chapter 5
Using Sound to Enhance your Animation

This chapter outlines how you can use sound to make your animations more fun and exciting. You will learn how to record sound effects, how to record music and how to integrate these sounds into Flash MX once you have recorded them. The chapter also covers compressing sounds for optimal playback and descriptions of the different digital sound formats

Using Sounds

Adding sound to your movie adds a whole new dimension to it. Flash does not create sound files, you need to create sound with a sound program or acquire them from a sound collection. Flash imports Wave files (.wav), AIFF files, MPEG 3 files (.mp3), and SUN AU files (.au). To import a sound file, select File>Import from the main menu, then navigate to the folder where you've stored your sound file and select the file you wish to import.

There are two different types of audio that can be included in your presentations: these are streaming sounds and event sounds. Sound in Flash is primarily controlled from the Property Inspector with a sound selected.

Streaming Sounds

These are sounds that you set to play with a keyframe, and they play as long as the length of the frames that they occupy. Flash sets the movie to stream along with the sound, and if the movie cannot keep up with the sound it skips frames.

Event Sounds

Event sounds are sounds that occur when an event happens in a movie, most typically when a user presses a button. You will learn how to apply sounds to buttons later in the lesson. Event sounds are not synched to the animation, and the whole sound clip must be downloaded before the sound will play.

Importing Sounds

You import sounds in the same way that you import artwork into Flash, use the File>Import command. Flash brings the sound file into the library and to use the sound you drag it from the library onto the stage. You can also hear a sound directly from the library, in the same way as you would view a movie clip, by pressing the small play button at the top right of the thumbnail (which, for sounds, is a waveform representation of the sound).

Adding a Sound to the Timeline

Adding a sound to your movie is easy, but there are two important factors to bear in mind when you are dealing with streaming sounds: firstly you must make sure that you place the sound clip on the frame where you want the sound to begin, and secondly you must create a new layer for each sound you want to play in your movie. In the next exercise you will open a library of sounds, import one of them and then set it to play when your movie begins.

1. Firstly open the Sounds.fla file as a library (File>Open as Library).
2. Now open the EllenZak.fla file from the chapter4 folder and open the library. Go back to the Sounds.fla library and drag the Laugh.aif sound into the EllenZak.fla library.

Figure 5.1 *Importing a sound into Flash MX*

3. Now create a new layer in the EllenZak.fla movie called Intro Sound, and with this layer selected drag a copy of the Laugh.aif sound onto the stage. A graphic representation of the sound will now appear in the timeline. Now test your movie (Control>Test Movie) to hear the sound as the movie plays.

Figure 5.2 *The sound Properties panel*

The Sound Properties Panel

Once you have a sound in your movie you can add a preset sound effect to it using the sounds panel or you can customise it using Flash's editing capabilities. The sound effects in the drop-down menu are:

- None – Applies no effects to the sound file. Choose this option to remove previously applied effects.
- Left Channel/Right Channel – Plays sound in the left or right channel only.

- Fade Left to Right/Fade Right to Left – Shifts the sound from one channel to the other.
- Fade In – Gradually increases the amplitude of a sound over its duration.
- Fade Out – Gradually decreases the amplitude of a sound over its duration.
- Custom – Lets you create your own In and Out points of sound using the Edit Envelope.

The Sound Panel also lets you choose how to synchronise a sound, and you can select from the following options:

- Event – This synchronises the sound to an event, such as a button press, or when the playhead reaches a particular keyframe. An event sound plays independently of the timeline. Event sounds stop in the middle of play and start from the beginning each time they are triggered.
- Start – Start sounds are similar to event sounds, but they play to the end before restarting.
- End – This stops every occurrence of a specific sound at the frame where the stop is located. To use this function simply create a new layer, insert a keyframe where you want the sound to stop, insert the sound you wish to stop into that keyframe and set the Synch to Stop. This is the only way to make an event sound stop as they run independently of the timeline.
- Stream – This synchronises the sound to the timeline, and these sounds end when there are no more frames in the timeline, they are useful for when you are trying to synch a sound to an animation.
- Loop – Specifies the number of times you would like the sound to repeat.

Customising Sound Effects

Clicking the Edit button from the Sound Panel opens the Edit Envelope box, where you can modify and create sound effects. Edit Envelope basically lets you change the In and Out point of your sound, and lets you change the volume of each sound channel. The Edit Envelope has three windows, and a set of controls you can use to control your movie. The upper window contains the sounds in the left channel, and the lower window contains the sounds in the right channel; the central bar is the time of the sound.

The envelope line contains the volume control for each sound, each channel has its own envelope line which appears at the top of the channel displays. You move this using the small square on the line, which is called the envelope handle. You can add up to eight envelope handles to your envelope line by clicking on the line, and you can remove them by dragging it out of the window. The buttons at the bottom left of the Edit Envelope box are the stop

Figure 5.3 *The Edit Envelope panel*

and play buttons to test the sound as you edit it, and in the lower right there are buttons to allow you to Zoom in, Zoom out, and the Seconds and Frames buttons to view the sound in either seconds or frames.

Customising your sounds:

1. With the first frame of the sounds layer in the EllenZak.fla file selected open the Sound panel (Windows>Panels>Sound) and, making sure the correct sound is selected in the panel, click on the Edit button.

2. Now Zoom Out until you can see the whole sound effect and try out the different preset sound settings, which can be set from the top left of the window; you can play your sound by clicking on the play button at the bottom left of the window.

3. Now try adding envelope handles to your sound and see how they allow you to manipulate the sound effect. When you are happy with how your effect sounds click OK to close the window.

Sound Compression

Before you use sound in Flash, you should set the compression settings. Compression is always a trade-off between sound quality and file size, and Flash lets you export sound using three different formats, ADPCM, MP3 or Raw (and WAV if you are in Windows), you can also set export settings for each individual sound in Flash.

To set sound compression:

Figure 5.4 *The sound compression panel*

1. Open the Sounds.fla file and open the library. Now select one of the sounds from the library and click the Properties button to open the Properties dialog box.

2. In the dialog box that appears you can choose from the following settings:

 - ADPCM – This is best for short event sounds such as button sounds. The web publishing standard is 22 kHz (compared to 44 kHz for CD quality).
 - MP3 – This is best used for longer, streaming sounds, such as soundtracks. You see the Bit Rate and Quality and the file size reduced or increased. Choose a Bit Rate higher than 16 Kbps for better sound quality.
 - Raw – This exports sounds with no sound compression. The standard for web publishing is 22 kHz.

3. Now test the different settings by choosing a setting and then clicking the Test button.

4. When you are finished click OK to return to the main movie.

As yet Flash MX will not allow you to record sound within the program, but it does offer tools to manipulate imported sound files. With these tools you can further minimise the size of animation files by reusing files with alterations that make them seem new. Once you have found or created a sound for your animation, you get it into Flash by using the Import command on the File menu. Importing a sound places it in the library of the current project. When you play your animation, the sound will begin when the playhead reaches that keyframe. If the timing is off, just click and release the keyframe to select it, then click and drag it to another frame to change the beginning point. Sometimes, a single frame forward or backward will make a big difference, especially when you are using a low frame rate for the web.

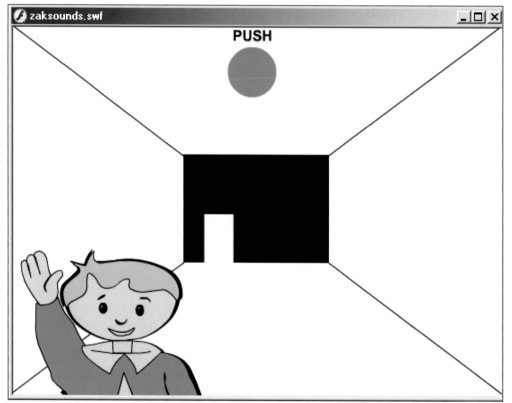

Figure 5.5 *The directional sound movie clip*

Directional Sound

ZakSounds.fla on the cover CD has one sound embedded in it, ZakOk.wav, which appears to come from the front right of the screen first, then the back centre, and then the middle left. Shifting of the sound is done within the Properties menu. It can be done even if your sounds were recorded in mono, which, for reasons of file size, usually should be the case. Select the Pan sound scene, right-click the sound's keyframe, choose Properties and then the Sound tab.

Figure 5.6 *Sound in the left channel*

Figure 5.7 *Sound in the right channel*

Flash has assumed correctly that you want stereo output, so it has put a copy of the sound file in the left channel (upper) and another in the right channel. By choosing left channel in the effects drop-down box, the volume line in the right channel has been set to zero. You can choose fade in or fade out, as well as fade right to left or vice versa. You can also choose custom, and move the sound back and forth at will. With a long dialogue, you can set each character's voice in a different speaker by alternately raising and lowering the volume line in each channel.

Figure 5.8 *A custom sound effect*

For a sound that travels from the centre to the right, the left and right channels are equal at the beginning, but the volume line goes to zero in the left channel as the sound plays.

This gives the illusion of the sound being centred, then moving to the right. A stronger illusion might be achieved by having the sound start at 50% in both channels, then rise to 100% on the right while falling to 0% on the left. In fact since the little character starts far away, a lower volume might have been chosen for the starting point of each channel. A longer sound and corresponding action would display this stereo effect better.

The beauty of manipulating the sound after recording is that it need only be downloaded once across the web. Then the Flash plug-in moves it around by changing the volume of the two stereo channels. Each time you reuse a sound, as I did in this movie, you can call up the Properties dialog box and alter the character of the sound. This same box allows you to make the sound loop over and over. This is an interesting effect with music loops or short percussive sounds. You can also use controls here to select a single portion of the sound instance to be played. This allows you to reuse different snippets of a longer sound in various places in your movie.

Sound Surround

While Flash cannot exactly create true multi-channel surround sound with just one sound clip, it comes pretty close by utilising the left and right channels to make an "enhanced" stereo effect. Open the file named ZakSounds.fla and go to the surround scene.

Once the Flash file has been opened, the steps below will show exactly how to make the sound pan from speaker to speaker. Follow these steps:

1. First, right-click on first frame in the layer marked "sound" and choose Properties.
2. Once that has been done, choose the tab marked Sound, and you should see a screen like this:

Figure 5.9 *The sound layer*

Figure 5.10 *The Edit Envelope screen*

3. Here's the tricky part – making the sound file pan from area to area. In the Sound area where all the wavy lines are, click anywhere on the area with your mouse. You should see a small box with lines coming from the beginning.
4. You can also move where the boxes are located to increase or decrease the volume for just that part. Add as many as you want up to a limit and you can scroll till you find a good place to add more marks.

Figure 5.11 *Varying the volume level*

5. The top box is for the left speaker and the bottom box is for the right speaker. Varying the volume level individually for each box will cause one speaker to be enunciated more than the other causing a simulated 3D sound effect. See the complete image below for the boxes used on the animation on the first page.

Figure 5.12 *The completed surround sound example*

Use the Zoom Out command (see the magnifying glass with the + sign in Figure 5.12) and add these lines and then preview it. The difference is amazing, and this is how many web sites have this 3D sound effect for many of their animations.

Getting Creative with Sound Effects

Using the following two component-based audio approaches, animators can mix and arrange tailored soundtracks within Flash by using it as a music sequencer. The benefit is to produce more interactive and custom-like soundtracks with greater impact and control.

Traditional production music is "flat" and pre-mixed, and doesn't give you access to the raw audio components necessary for customisation or to reduce file size. Moreover, the overabundance of loops that are available on the Internet cannot provide the breadth or flexibility to create truly compelling audio.

Figure 5.13 *Sonic Foundry's Acid software*

Figure 5.14 *An Acidised loop*

Figure 5.15 *Loop properties*

If you are a musician, you can create component-based audio in a variety of music software packages, including Sonic Foundry's Acid, which does much of the compositional work for you and is already component- or loop-based. If you're not a musician, or don't have the time to create your own original score, you can use component-based audio. These packages are usually composed by professional musicians, and have solved the tedious problems of needing to properly edit and master your component audio files so that they transition seamlessly into the frame-based timing environment of Flash and other multimedia production tools. The advantages of buying in sound clips from a professional sound library are:

- Sample accurate timing of components in multiples of length and modular phrasing.
- Specific BPM (beats-per-minute) rates which are optimised for frame-based tools.
- Tools for determining compatible frame rates, and synchronisation and arranging tools to help Flash work as a music sequencer.
- Mastered specifically for ease of mixing using layers.

Event Sounds: Mouse-overs and Transitions

Generally speaking, there are two types of event sounds:

1. Mouse-over events, which occur, you guessed it, when the user mouses over a hot spot.
2. Transitions, which occur most commonly on mouse clicks, but can also happen programmatically.

Mouse-overs usually need to be soft, arrhythmic and high-blend sounds, whereas transition sounds are usually more effective with hard sounds, and have more flexibility with regard to rhythm and blend. Of course, there are no hard and fast rules. This model assumes that you are working with a background music track and thus want mouse-overs to occur smoothly, on top of the music. Transition sounds, on the other hand, are often used to change scenes, and benefit by having a hard sound, which acts as a distraction to cover up the abruptness of a sudden stop or change in the background music. The next exercise is an example of creating buttons that have a mouse-over sound and a transition sound that fit into the background music of a movie. You can open the movie SoundMix.fla for a view of the final movie, or follow the following instructions to create your own sound effects:

1. Create a new movie clip, and set it up so it resembles the screenshot on the left. You need to build five layers, called, from top to bottom, actions, loop2, loop1, button and background.
2. Now create a new button to go into the button layer. Go into editing mode for this button and attach a soft sound to the "over" state of the button and a

Figure 5.16 *The layers setup*

110

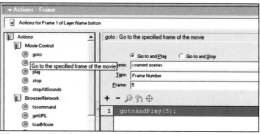

Figure 5.17 *The button with sound embedded*

hard sound to the "down" state of the button; you do this simply by dragging the sound you want to add from the library onto the stage with the particular state of the button selected. We have provided folders with a couple of examples of hard and soft sounds in the Sounds.fla file.

3. Now go back to scene 1 of your movie and import two sound clips into your library, these will be triggered as you navigate between the two areas of this movie clip. Put one in keyframe 1 of the loop1 layer, and the other in keyframe 5 of the loop2 layer and set the number of loops for each sound to a high number so it will loop continuously.

4. Now add a Stop action in the keyframe that is after each sound. This will stop the playhead in order to wait for user interaction, but the sound will have already been triggered and continue to play.

Figure 5.18 *The gotoAndPlay ActionScript*

5. Make sure there are separate instances of your button in keyframes 1 and 5 of the buttons layer, and add a gotoAndPlay action to each button, telling the button in keyframe 1 to goto frame 5 and the button in keyframe 5 to goto frame 1.

6. The last important thing to do is to tell the current playing loop to stop playing when the button is clicked so that the sounds do not overlay each other. We could use a "stop all sounds" action for our button, but that would negate the mouse hit sound we just created. Instead, place the sound you wish to stop on the timeline, and set its sync method to "stop", place the sound in the loop2 layer in the first keyframe of the same layer and set its sync to stop, and place the sound in the loop1 layer into the fifth keyframe of the same layer and set its sync to stop. Your timeline should look like the picture on the following page.

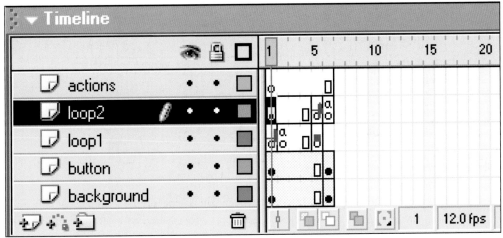

Figure 5.19 *The final layer setup*

Event sounds make for ideal usages of Flash's sound object. When creating background music soundtracks, I prefer using the timeline, because it gives me a visual interface for aligning and synchronising sounds with graphics. With event sounds, on the other hand, this is not as crucial, and ActionScript gives us much greater control. The above example can be created more easily and with greater flexibility than by using the timeline. Here's how:

1. Create your buttons the same way as in the previous example, with the mouse-over and mouse-hit sounds attached to the corresponding button states.

2. In order for sounds to be used by the sound object, they need to be "linked" and given a name. Select the first sound in the library and click the right mouse down on the sound and select linkage. Select Export for ActionScript and give it the identifier "loop1". Do the same for any other loops you will be using. Now we need to assign variables and fill them with the linked sounds we just identified.

3. Select the "actions" layer of your movie, and with keyframe 1 selected go to the actions panel. Change to expert mode by clicking on the arrow at the top right corner of the actions window and selecting expert, and type in the following code:

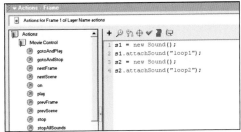

Figure 5.20 *Adding the attachSound script*

```
s1 = new Sound( );
s1.attachSound("loop1");
```

4. Do this for each sound you want to control in your movie. Now, you can tell a sound to do any of the actions provided by the sound object. In our case, we are going to tell a sound to stop on a mouse release action. Click on the button instance on frame 1, and go

to the actions window. Type in the following code (make sure you are in expert mode):

```
on (release) {
s1.stop( );
gotoAndPlay (5);
}
```

5. Do the same for the other button instance on frame 5, only subsituting correct variable name and goto frame number, like so:

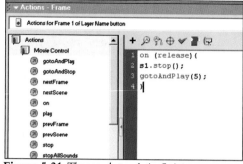

Figure 5.21 *The sound stop ActionScript*

```
on (release) {
s2.stop( );
gotoAndPlay (1);
}
```

We used the sound object in the previous example just to render the Stop actions, but you can use it to trigger your buttons mouse over and mouse hit sounds as well.

Controlled Chaos – Colliding Mouse-over Sounds

If you have many buttons with mouse-over sounds on your page, a user can cause multiple instances of event sounds to play at the same time by rolling quickly over the buttons. This can be a desired effect if the sounds blend, such as with harmonised vocals riffs. Usually, however, this creates an undesirable commotion, which can even cause clipping (digital distortion) to occur. This can be avoided by setting the mouse-over sound to the "start" method (rather than "event" method) when you are using the same sound for all buttons. The start method makes sure that not more than one instance of a sound is playing at a given time. If you are using different sounds for each button, you will need to use the stop sync method or the sound object as explained above.

Figure 5.22 *Setting the sound sync to Start*

Soundtrack Looping

One thing Flash is not so good at is seamlessly looping back to the beginning of a movie clip. If you have ever inserted an audio clip and tried to make it loop by using a goto and play action, you know what I mean. Even in forced frame mode, Flash glitches just a bit as it repeats. The best solution to this problem is fading your sound track in and out.

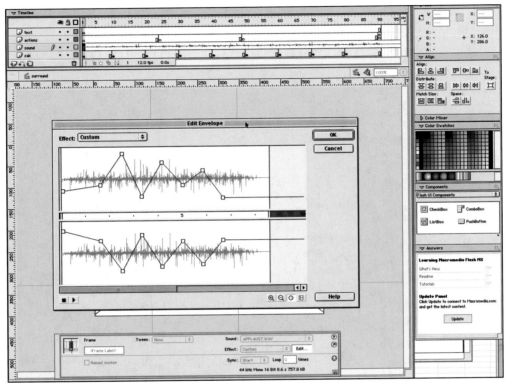

Figure 5.23 *Fading sound in and out*

Chapter 6
Lip Syncing and Facial Expressions

In this chapter you will learn how to lip sync your characters and make them produce realistic mouth movements to go with sounds. Also covered in this chapter are facial expressions such as eye movement.

What is Lip Syncing?

If you've ever animated a character and you have wanted to make it talk or sing, then you will have touched on the art of lip synching. This is the art of taking a pre-recorded dialogue, and making a character move its lips as if to speak this dialogue. This involves figuring out the timings of the speech (breakdown) as well as the actual animating of the lips/mouth. In addition making the actual setup or mouth positions needed can also be considered a part of the entire lip sync process.

Creating speech may appear to be difficult. English speech can be generalised into eight basic mouth expressions as shown below.

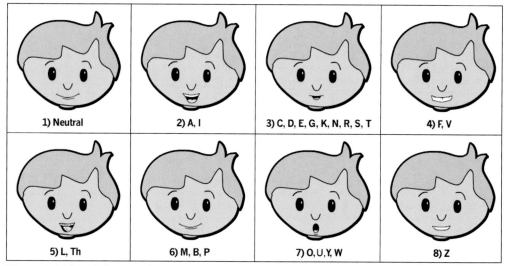

Figure 6.1 *The eight basic mouth expressions*

Starting with a neutral expression:

- The mouth is held open wide in a big smile to form the A, I expression.
- The teeth are held together with an open mouth to form the C, D, E, G, K, N, R, S, T expression.
- The lower lip is held against the upper teeth and the centre of the upper lip curves up to form the F, V expression.
- The mouth is held partly open, with the tongue placed between the teeth, to form the L, Th expression.
- The lips are held together when forming the M, B, P expression.
- The lips are in a puckered position when forming the O, U, Y, W expression.
- The mouth is in a smiling position while the teeth are held against each other to form the Z expression.

Like anything, once you start breaking it down into small components it becomes easier to understand how speech is put together. These small components are phonemes, and are the smallest utterance of sound that string together to make words. In the early studies of animation students assume that each letter has a mouth shape but it soon becomes apparent that the mouth shapes can be grouped into the eight positions above. It is good to look for overlapping shapes that might represent a number of phonemes, as this will save hours of work. For example, you may need to use the F phoneme for TH, so this should be looked at as a basis that you can work from in all situations. In certain situations when I am trying to achieve a high level of realism I tend to divide these phonemes even more, getting as specific as I can.

I find that working on long sequences of lip syncing can be a very tiring process. I have included file LipSyncModeller.fla on the CD: look and use the lip positions in Flash for other Flash animations. Try it out.

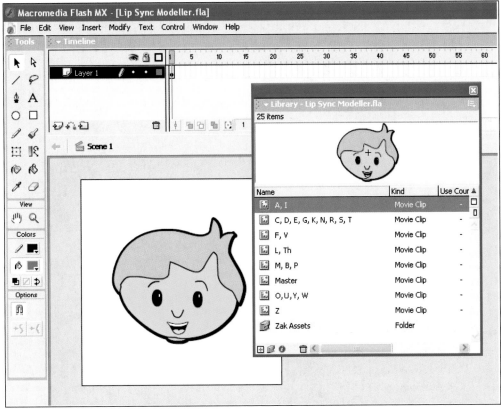

Figure 6.2 *The Lip Sync Modeller application*

M B P The lips touch together and are pressed firmly closed. They can intersect a little to show the difference between this phoneme and the neutral pose. It is worth breaking away from the symmetry by rotating the lower lip up, and the bottom lip down and in.

Sample words: Man, Bang, caP

C K G This is not opened as far as the vowel phonemes. The jaw rotates down, and the teeth are separated about the height of a tooth. A good illustration of this pose should allow for the teeth to show around 30% of the mouth area with the tongue and inside mouth representing the other 70%.

Sample words: Carry, looK

CH SH J The lips are puckered outwards and narrow the mouth a bit. The teeth are together.

Sample words: CHerry, SHout, Jump

F V The lower lip is curled/rotated up and underneath the upper teeth, so that it is pressed between the upper and lower teeth. The upper lip should be brought up a bit so the upper teeth are exposed.

Sample words: Fish, ProVe

A Place the corner of the lips above the vertical centre point of the open mouth.

Sample words: Apple, blAde, Ape

I U Open the jaw slightly more than in the A pose, but less than the O pose. The corner of the lips are placed at or below the vertical midpoint of the open mouth.

Sample words: If, Under, wOnder, pIck

O This is the most extreme open mouth position. The corners of the lips are placed at the midpoint of the vertically opened mouth, and the mouth is narrowed/puckered naturally since it needs to narrow as it opens.

Sample words: Open, OAt, Over

E This is the smallest opened mouth position, the mouth opens about the same as a C K G, but is widened out left and right.

Sample words: swEEt, EAt, feet

TH The tongue protrudes out and is pressed between the upper and lower teeth. These phonemes are the most used poses that benefit from drawing the tongue movement.

Sample words: teeTH, forTH, THat

N D T L For poses where the tongue touches the teeth, rotate the tongue up and behind the front teeth.
Sample words: Name, Dog, ouT, baL

S Z With the teeth together the lips expand up and down and widen so the teeth are visible.
Sample words: Snow, Zoo, Sneer

R You can probably get away with a regular C K G pose, but I tend to open the upper lip into kind of a sneer.
Sample words: Roll, dooR, wondER

W OO Q The mouth contracts/narrows into a small opening with the lips puckered outwards.
Sample words: WOOd, drEW, QUIet, fOOd

Sorrow

Anger

Joy

Drawing a tongue can really convince the viewer that your character is talking. Adding teeth to the drawing helps reinforce the idea that your character is really talking. Since the mouth of your character will be open it is generally a good idea to have some amount of detail in there. Teeth, gums, tongue and some inside mouth cavity. You may not think you need gums but for poses like the sneer, you'll see them, so they should be illustrated.

Having a more detailed breakdown like this can help when doing more realistic facial animation. There is one other item you need to be aware of for setup. That is emotion or expression. Unless you want your character to remain perfectly flat, you'll need to make it look happy, sad or a wide variety of other expressions. Typically there are six base emotions, shown on the right.

Fear

You need to create phonemes not only in a flat style but also in each of these expressions. So you might have the phoneme for "oh" as "oh my!" seven different ways. Think about how someone's mouth may change between saying "oh my" really loud and scared, versus a sorrowful slow expression.

Eye Expressions

It is almost inevitable that the eyes have a lot to do with expression and should not be illustrated staring blankly into space. Any variations in the eye position will be picked up by the viewer with some very dramatic consequences. No matter which language you speak the eyes have a universal way of communicating with you.

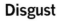

Disgust

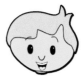

Surprise

The method you plan to use for animating will directly influence how you want to approach setup. My choice is to use different poses of phonemes and expressions. Then if I need to I sometimes tween between the start and end of each word, the tween can interpolate smoothly between each head. By illustrating the effect expressions have on the face, any phoneme or expression can be made from only a few illustrations. I have listed below a quick description of each of these illustrations and how they are used; you can also see this working in Head.swf.

Grin L and Grin R – A basic half smile. The mouth remains closed. This allows it to blend with an open vowel phoneme, such as an A to get an opened mouth smile. In some cases this blend won't be perfect and for long lasting smile shots you may want to make an open mouth smile as well. Flatten the bottom of the eyes.

Sneer L and Sneer R – This is pretty much a one muscle target, usually its good to try to get a crease line from the nose to the side of the mouth. I tend to expose a bit of the upper gums as well. These two targets can be used to expose the upper teeth more when needed during talking, as well as for anger, disgust, and other expressions.

Frown – A basic frown pose. Technically there are two separate muscles pulling the corners of the lips down. I also make the lower lip pout outwards.

Eyebrow Up L and Eyebrow Up R – For cartoon characters all you need is the simple up and down. To be realistic, the outer edge of the eyebrow tends not to move very much, while the centre area moves more.

Eyebrow Down L and Eyebrow Down R – The eyebrow moves down and in and the centre of the eyebrow area starts to wrinkle.

Squint – In this target I have the eyelids close to meet at the exact middle, and tend also to buldge up the area beneath the eye.

Blink L and Blink R – Here each eye closes individually so you can offset blinks. By having this separate from the squint, you can use the squint to get the eye shape and then go back and animate in blinks later. I tend to have the lids meet at an area 3/4 of the way down from the top.

You should try to have the left and right side as separate components, this not only gives you control of the expressions but makes the character more lifelike by breaking away from the mechanical symmetry that is so common in computer-based characters. You can make your character grin to one side, or blink one eye and so on. If you are trying to or need to save space and create some of these as one expression, you should make the illustration offset left and right a bit – such as the smile on one side slightly higher than the other. This will help make the face asymmetrical and look more natural. Once your character is set up, you are ready for the next step in lip sync, Track Analysis.

Track Analysis

Track analysis, or breakdown, is the art of listening to pre-recorded dialogue and sound, and planning the timing. Traditionally the audio would be played on a device with a counter. The animator would play it over and over and write down the estimate of when each phoneme occurred.

For cartoons this information was (and is) recorded on what is called an exposure sheet, or X-sheet for short. An X-sheet is really nothing more than a glorified table. I find opening another Flash movie and using that for my X-sheet is just as good as going down the conventional root. Quite simply, an X-sheet comprises numbers representing frames down one column, and then other areas where you can pencil in dialogue notes, camera instructions and so on.

The Flash animator should always embrace all fashioned techniques. I believe we should take the old techniques and develop them within the digital environment.

My favoured method for track analyses is to load the audio file into a Flash file so you can see the waveform and timecode. Then repeatedly play the whole or parts of the audio figuring out the timing and commenting on aspects of speech. This is exactly what you would do on an X-sheet. Track analysis can get even easier than this. There is software available that not only shows the

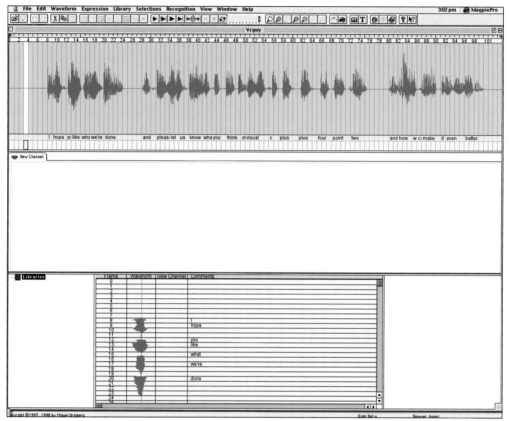

Figure 6.3 *Magpie Pro*

waveform and timecode, but actually has a digital exposure sheet and allows bitmaps of phonemes to be played in real time. So you can see and check how your breakdown is working as you create it. Another variation of this is to simply work in a 3D animation program like Poser with Ventriloquist. You can then scrub the time slider back and forth to hear the audio and then key the pose at the right place. A suitable alternative for manually breaking down audio is Magpie.

At the top of the line is automatic voice recognition. These packages automatically look at a WAV file and figure out the timing and phonemes for lip sync. All you need to do is go back and tweak to correct any errors. My personal favourite is Ventriloquist by Lips Inc. This utility can take an audio file, a text line of what is in the file, and automatically generate nicely weighted morph f-curves for phoneme-based weighted morphing. It can also create a digital X-sheet for you if you still want to enter the data by hand, or want to write your own importer. It still requires tweaking, but is pretty good for a first step, or as a final step in cases where time doesn't permit. Magpie is available at http://thirdwish.simplenet.com/magpie.html and runs on Windows 95 and NT machines. It allows you to drag and drop custom phonemes into a digital exposure sheet as well as view 2D images for each phoneme in real time for playback.

Figure 6.4 *Sound broken down into sections*

Analysing voice is simply a matter of listening to small chunks of the audio and marking the proper phoneme for the proper frames. As an example, I have used Snowwhite.fla, this is Zak telling the abridged version of the Snow White story (in my scary voice!).

1. First prepare your sound. You should break the sound clip down into separate sections as this helps to manage the animation efficiently and means that the movie can be broken down into separate scenes. A good guide is to use separate sentences, for example the story used in this example was broken down as:

 i. **story1.wav**
 "There lived a beautiful Princess named Snow White, whose beauty upset her jealous stepmother, the Queen. The Queen consulted her Magic Mirror as to who was the fairest in the land."

 ii. **story2.wav**
 "One day, the mirror said that Snow White is the fairest. The Queen plots to have Snow White killed by her Huntsman. He does not kill her."

 iii. **story3.wav**
 "She finds a cottage, and cleans it and then falls asleep. The Dwarfs return from work and find her."

 iv. **story4.wav**
 "The Queen finds out that she is still alive poisons her with an apple. She collapses."

 v. **story5.wav**
 "The Queen topples to her death. The Prince, kisses Snow White. Her eyes open. Snow White and the Prince ride off."

2. It is best to keep the original sound in the highest quality sound format possible as you can use Flash to export the audio at different compression levels for different uses, i.e. a CD-ROM would use a lower compression while a web site would need a much higher compression to save space.

3. Next create the movie. In Flash, create a new movie with three layers. Name the top layer "sound", this layer will hold the sound clip. Name the middle layer "zak", this contains the frames of the animation. Name the bottom frame "text", this contains the original lip sync text as frame comments.

4. To make the process easier, select the "sound" layer, select "Properties" from its context

Figure 6.5 *The timeline setup*

menu, and set the "Layer Height" to 300%. This will make the waveform much easier to see. Do the same for the "text" layer, and set its height to 200%. To make the frames wider select the

Figure 6.6 *Setting the height of the frames*

button in the top right of the timeline and select "Large".

5. This will be the standard layout for developing the movie. Next, open the scene panel and duplicate the scene for each section of the story, in this case it would be four times. Name each scene "Paragraph 1", "Paragraph 2" etc. Now we are ready to add the story and the sound. To add the sound clips, select File > Import, and import the five story.wav files. Once imported they will be available to use in the movie.

6. Create a keyframe on the first frame of each "sound" layer, and from the Properties panel, select the appropriate sound for the scene. Make sure also to set the "Sync" setting to "Stream", this is important since any other setting will result in sound sync problems with the exported movie. You will now see the sound waveform along the top of the timeline.

7. Create keyframes on the "text" layer for each word of the dialogue being spoken. Using

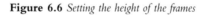

Figure 6.7 *The sound properties panel*

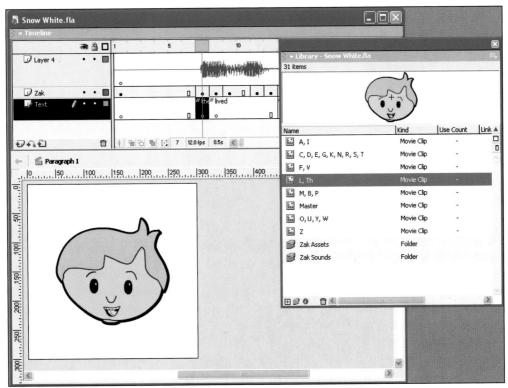

Figure 6.8 *Matching words with phonemes*

the Properties panel, set the frame label for each keyframe to be the word being spoken, add // at the start to make the word appear as a comment. Arrange the keyframes to correspond to the correct part of the audio waveform.

8. Finally, you need to create the faces and lip positions for the animation. These are based on the eight basic lip positions and are used to build the whole animation.

9. Open the file named SnowWhiteTemplate.fla, this provides you with the complete empty template as described above.

10. To begin each scene add the asset "Master" from the library to the stage, this displays Zak in a neutral pose. Create a new keyframe to correspond to the start of the next word of the dialogue. For example, the first paragraph "There lived a beautiful princess…" starts with an "L, Th"

Figure 6.9 *Creating the expressions in the library*

position for the "There", followed by another for "lived".

126

11. Continue this process for the other words in the scene. Once complete, you need to insert the lip positions for the word transitions. The new "scrubbing" feature of Flash MX allows you to preview the sound when moving the playhead along the timeline. You need to set your voice over audio file to Stream. Not only will this preserve the lip sync, but it will also allow you to "Scrub" back and forth across the timeline to hear your sound frame by frame

Figure 6.10 *Labelling frames*

The other thing to keep in mind when analysing the voice is the sound of each phoneme. Remember that a phoneme or sound of the voice doesn't need to actually match the spelling of the word. One famous example is that "ghoti" spells the word "fish". Granted, that looks like it would sound like "goat-tea" but phonetically it can just as easily sound like the aquatic animal. Here's how: Take the "gh" from the word "enough". The "o" from the word "women". Finally "ti" from the word "nation". As you can see, all of these words have sections that are spelt one way but sound another. Keep this in mind and really listen to the sound of each phrase as you do the breakdown.

Finally, it's OK to drop phonemes. For example, look at the word "Pilot". The "ihhh" sound of "lot" isn't there. It simply is dropped. One of the key tricks in getting lip sync to work right, especially fast paced speech, is to learn what to drop and what to keep. Think of the mouth as flowing and figure out what the best shape is at that point. Do this by listening and looking at what phonemes are around the current frame. In general, if you hit the M B P phoneme and the large vowels that follow, your animation will usually look correct. Everything else is really just an in-between of the extreme mouth closed, mouth open and mouth tighten poses. Think about puppets. Typically they have a mouth open, and a mouth closed pose. Yet in many cases, people accept a puppet as actually talking. If your lip sync looks off, check the timing of these poses first. Chances are correcting them will correct your animation.

When I first start to do breakdowns, I tend to put a keyframe on every frame. For example, take a look at the breakdown I have for this WAV file on the opposite page. Frame 4 has a W OO sound. However, as shown in the text version of the breakdown, I start by placing a keyframe on all frames. This does *not* mean I have a different phoneme on each individual frame. Rather, there are no in-betweens. What this does is make the animation very snappy. Each phoneme literally pops in, which makes it easier to see mistakes in the timing. If this animation looks a bit harsh or wrong, you're quite right.

Figure 6.11 *Wav file breakdown*

Essentially this version suffers from a lack of tweening, making it look too rough. Also the fact that I'm using only 14 basic phonemes – none of which really looks like a yelling type expression – makes it seem out of place. Plus the phonemes don't really smoothly correlate to each other.

Once you have finished the track analysis you should have your finished X-sheet. With that information you are ready for the final phase of actually animating your character.

Animation

We have finally arrived at the animation stage! This is where some of the real fun happens. As you saw, doing breakdowns is really pretty simple and in some ways tedious work. At this point, you can start to actually make your character have emotion and come alive.

Probably the simplest way to get from a breakdown to an actual animated character is to simply replicate the breakdown in your Flash file. All you really need is to get a keyframe of the pose on the right frame as listed on your X-sheet. The best way to animate the face is to start with the object, your X-sheet, and then manually pose each keyframe yourself. If there is one thing I'd highly recommend when doing facial animation it's buying a mirror. All you do is look at your X-sheet and copy the pose and then say the word and look at yourself in the mirror, match what you see to your character in your Flash file, go to the next keyframe and repeat this process. The benefits of this method are that you are not limited to any preset phonemes. The mouth will look very natural since you will be posing every frame as it would look. You can go extreme when needed, smaller when not. Pay attention to how letters change especially consonants when they're around vowels.

Hand animating allows you to pay close attention to snap, offsetting the left and right sides of the face to make things look more natural, and is generally a better looking result. One thing to keep an eye on in with any method though is the interpolation.

Back to our lip sync animation. At this point, you should have a pretty well-adjusted version of the character speaking. Up until now, chances are you haven't animated the upper face. Simply adding in some eyebrow and eye movement can really add a lot to the character and expression.

In fact, the eyes are what most people focus on when talking so in that sense it's even more critical than the mouth. What I tend to do is write down ideas on the X-sheet as I animate. I just make notes at different frames with things like, expand eyes, raise eyebrows, etc. Most importantly again, look at the mirror! I repeatedly act out the dialogue looking in a mirror experimenting with different versions. Then, I just match that to the animation.

This is actually quite easy, since you already have the breakdown and know when each word occurs. You might notice that when you say a certain word, or part of a word, your eyebrows go up. All you need to do is look at your X-sheet, then find what frame the word starts on and set your eyebrow keys. Actually, it's a good idea to offset the upper face and even parts of the lower face so things don't always hit keys on the same frame. When the whole face works together the results are even better.

At this point, all that is left is to animate the actual body and head motion. Once again, I use a mirror, act it out and animate. I'd recommend studying how people move when they speak. There can be some very subtle head motion – and I think there is a propensity for new animators to

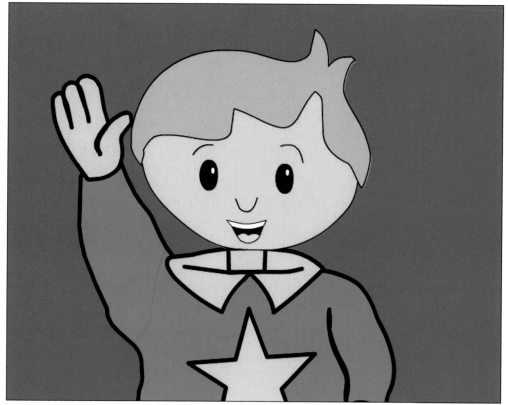

Figure 6.12 *Animated Zak with a body*

either overdo or underdo this. Think about what words you want to accent and which parts you want to play down. It also helps to get inside your character's head to figure out what it's thinking. That helps a lot especially with animating the eyes. As in all cases, study from life, and one more time, use that mirror!

Tricks of the Trade

Do not start animating before you have bought a mirror! Having got this far you should feel confident in trying out your own facial animation. Doing lip sync breakdown is a great way to work on building your timing skills. It really forces you to pay attention to every frame. There's nothing like moving a phoneme one frame back and having everything suddenly work.

Make phonemes for consonants paired with vowels. Compare how your mouth is shaped for the "L" in "Lease" vs. "Loop". In the first case it's wider, in the second much more puckered and closed. So for each consonant, you might want to make extra phonemes where it's paired with a vowel, such as "la", "li", "lo", "lu", "le" and "loo".

If you are animating someone with an accent, pay close attention to how they pronounce certain words. Actually breaking down an accented speech is a great way to force yourself to really listen to the track, instead of just dropping in what you think are correct phonemes.

Remember, one of the key points, especially for fast speech, is knowing when not to put phonemes in. If it looks like your character's mouth is opening and closing too fast, it means you need to drop frames. Think about how the mouth would blend between the phonemes, and then stick that pose in place of several others.

I will never have two different mouth positions keyed on consecutive frames. If the speech is fast, I will drop one. The general exception to this rule is the M B P and F V poses, followed by a vowel. In some cases, you may want to go from a closed mouth straight to a large open mouth. This gives more snap and may look better.

Make sure you hit the M B P phonemes and large vowels at the right point. As long as you get those extremes at the right point, your animation should look correct. In addition I usually hold the M B P and F V poses for at least two frames so that the mouth is closed at least fairly tight for two frames, then has one in-between, and finally is followed by a vowel. Note this is a general rule and sometimes has to be disregarded.

Consonants tend to take on the shapes of the vowels around them. The word "kind" and the word "look" would have different shaped 'K' phonemes. The W OO vowels tend to have a very big effect on consonants they are close to.

Chapter 7
Adding Interactivity

Flash movies can be fantastic as basic animations, but by adding user interactivity to them you can turn them into fully immersive experiences. This chapter takes you through how to use ActionScript and the various features of Flash MX that let you add interactivity to your movies and shows you how you can make your movies more immersive and exciting.

Animator or Programmer?

More and more talented people are choosing between becoming Flash animators and Flash programmers? This book has been made with the one aim: Flash animation and the animator. If you have ever studied graphics then its unlikely you will never move to the programming world. I am not saying that there are not any good programmers out there who come from a graphics background but overall the love of form, function and communication is the energy behind so much of the modern world and the fuel of all graphic designers.

This chapter and the following chapter take you through the basics of ActionScript. An understanding of ActionScript is important to the twenty-first century animator. You will probably find yourself commissioning or briefing programmers for a specific type of code and these two chapters will help you understand and get involved in the creative aspects of programming.

Adding Interactivity

Adding ActionScript to your Flash project takes it beyond the realms of a movie and into the world of interaction. Flash's ActionScript capabilities are extremely wide ranging and would take a whole book to explain fully; this chapter is designed to give you a brief overview of the subject so you can start applying ActionScript to your Flash projects.

With Flash MX, Macromedia has considerably enhanced the power of ActionScript. ActionScript can be used for a number of purposes, including automating repetitive animation, keeping track of user interaction and input, and interacting with external data sources.

ActionScript statements often consist of several words or word fragments strung together in a statement. The words are split by the use of capitalisation and not spaces. ActionScript uses the space to identify different statements. ActionScript follows the ECMA-262 Standard (the specification written by the European Computer Manufacturers Association) unless otherwise noted. In MX, some Flash 5 (and earlier) ActionScript elements have been deprecated and replaced with new ActionScript elements that correspond to the ECMA Standard.

What is a Script?

A script in Flash is a statement or a series of statements that execute specific tasks. Statements are lines of code that you attach to either a Button Instance or a key frame. When the user clicks on a button the statements attached to that button are executed. When the playhead passes over a particular keyframe with a script attached, the statements attached to the keyframe are executed. For example, the following is a statement attached to a keyframe:

```
stop ();
```

When the playhead passes over this keyframe (wherever it may be on the timeline) the statement is executed. In this case, this command instructs the playhead to stop at this point on the timeline.

Flash plays scenes and frames in sequence. The movie starts at scene 1 and plays all the frames until the end of the scene. Then it moves on to scene 2 and plays that scene. When you add interactivity you ask Flash to jump to different parts of the timeline, this could be to any frame on any scene and later I will show you how you can jump to any movie.

The Actions Panel

Familiarise yourself with the actions panel's features, because it's a panel you will use time and time again. You want as much room as possible to see your scripting especially if you start to make long comments, so open it up as wide as possible. If you are using normal mode, all the syntax can be chosen from the "+" button at the top left-hand pane. Once you have a nice size window, don't keep opening and closing it: use its windowshade feature to collapse it into its title bar by double-clicking the title bar on Windows, or clicking the top right button on a Mac.

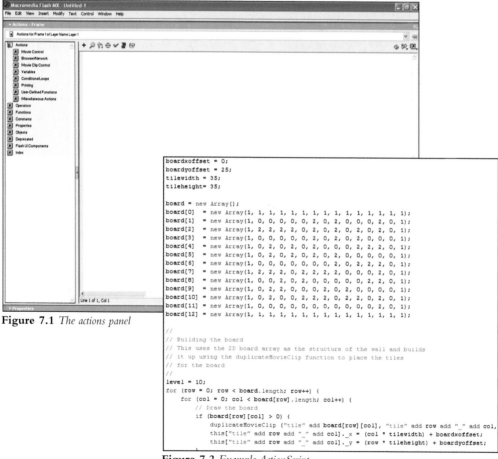

Figure 7.1 *The actions panel*

Figure 7.2 *Example ActionScript*

Movie Explorer

It used to be nearly impossible to find scripts hidden within movie clips until the advent of the Movie Explorer. Using the row of buttons along the top of the window you can activate only the script's view. You'll see in the list all the scripts you've written, and probably a few that you thought had been lost forever. Typing a keyword in the find box further narrows the list of scripts, making it even easier to find.

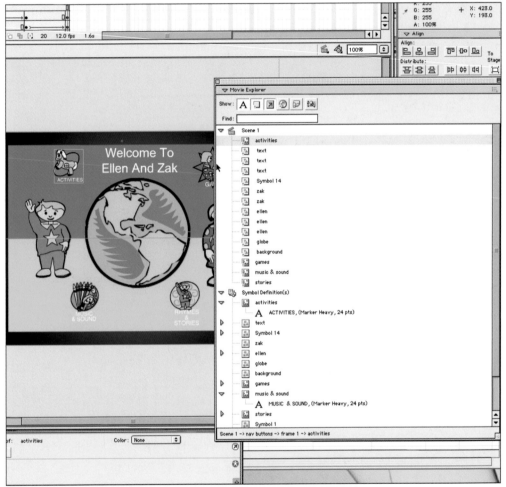

Figure 7.3 *The Movie Explorer*

ActionScript has two Types of Action

Flash names actions attached to buttons and movie clips "object actions". Buttons require feedback from the user, you would use a button in a presentation where the user holds the screen until the script is fully presented.

Figure 7.4 *The timeline*

Flash names actions attached to frames "frame actions". Unlike buttons, frame actions require no input from the user. When the playhead reaches a certain point in the movie it executes the ActionScript in that frame. Actions attached to movie clips can also respond to user input. Movie clip actions can also be triggered without user input.

Flash executes actions in the highest level frame first. When you play Flash the player looks at the top layer for actions, and not finding any it then moves to the next layer; if it finds something in the next layer then it will execute that action. If you order your layers and allocate the bottom layer for actions you will never be confused with your ActionScript, and once you create your ActionScript layer you should lock it, this will stop you accidentally adding elements to this layer but at the same time you will be able to add and edit your ActionScript.

Organised Statements

Flash MX organises statements in a hierarchical structure. These come in seven categories: Actions, Operators, Functions, properties, objects, Deprecated and Components, also available is an index which has all the scripts in alphabetical order.

Actions – In the Actions category you will find all the basic goodies that control movies and respond to users' mouse movements. You can also test certain conditions and see whether they are true or false, and work with variables and expressions.

Operators – These are the tools for working with variables and expressions. They are made up of mathematical symbols that can be used for complex maths or even just to string sentences together.

Functions – These are predefined lumps of code similar to macros on a word processing application. Like macros, when you call a particular function by its name it will automatically run a lump of code for you that can be very complex.

Properties – These are controls that can manipulate objects. If you have a car and you want to rotate it you can call the _rotate function and then specify the rotation angle.

Objects – These are collections of predefined properties. These elements are predominantly methods that carry out instructions.

Components – These are smart clips that have been replaced with new drag and drop components for User Interface items.

Deprecated – This section looks at deprecated code. This is code that is slowly being phased out.

Figure 7.5 *ActionScript hierarchy*

ActionScript Syntax

Like all languages, Flash has its own rules on syntax. When you use the ActionScript panel in normal mode it handles the use of syntax for you. Once you get more adventurous and start using the expert mode you will need to understand the grammar and punctuation of Flash MX.

The dot (.) – The dot exists as a way of splitting the object from its method. The example below uses rotation to rotate a car by 90 degrees:

```
car._rotation = 90
```

The dot links the movie clip car with the method rotation. The dot also indicates the hierarchy of the files and folders, which will be dealt with later.

Semicolon (;) – This indicates the end of a statement.

Braces ({}) – Lumps of ActionScript that have a start and end to execute.

Parentheses () – Group arguments that apply to a statement.

Jumping to a Frame or Scene

To jump to a specific frame or scene in the movie, you use the GoTo action. When the movie jumps to a frame, you can play the movie from the new frame (the default) or stop at the frame. The movie can also jump to a scene and play a specified frame or the first frame of the next or previous scene. You can see the completed example in GotoComplete.fla on the CD. To jump to a frame or scene:

1. Open the Goto.fla file from the chapter7 folder and select the button in the middle of the screen. Choose Window>Actions to display the Actions panel.
2. In the Toolbox list, click the Basic Actions category to display the basic actions, and select the Go To action. Flash inserts the Go To and Play action in the Actions list.
3. To keep playing the movie after the jump, leave the Go To and Play option (the default) selected in the Parameters pane. To stop the movie at a specified frame, deselect Go To and Play. The action changes to Go To and Stop. Leave the Go To and Play option selected.
4. In the Scene pop-up menu in the Parameters pane, specify the destination scene; in this case it is Scene 2, or you can select Next.
5. Leave the Type pop-up menu set at Frame Number and leave the number at 1.
6. Now enable simple buttons in the work area (Control>Enable Simple Buttons) and click on the button in Scene 1, you will be taken to Scene 2.

Next or Previous Frame, Frame Number, Frame Label, or Expression allow you to specify a frame. Expressions are any part of a statement that produces a value, such as 1+1. If you chose Frame Number, Frame Label, or Expression, enter the frame by number, label, or an expression that evaluates to a frame number or label. This example goes to Scene 1, frame 5:

```
gotoAndStop("Scene 1", 5);
```

The following statement indicates the frame that is five frames ahead of the frame that contains the action:

```
gotoAndStop(_currentframe + 5);
```

Figure 7.6 *The gotoAndPlay action*

Loading and Unloading Movies

To play additional movies without closing the Flash Player, or to switch movies without loading another HTML document, use the Load Movie action. The Unload Movie action removes a movie previously loaded by the Load Movie action.

To load a movie:

1. Open the Movie1.fla file from the chapter7 folder, you will see a file with a large button in the middle of it. Select the button and choose Window>Actions to display the Actions panel.
2. In the Toolbox list, click the Basic Actions category to display the basic actions, and select the Load Movie action. In the Parameters pane, for URL type Movie2.swf to specify the file movie2 (that is in the chapter7 folder) to load.
3. For use in the Flash Player or for testing in Flash, all the SWF files must be stored in the same folder and listed as file names without folder or disk drive specifications.
4. Now test the movie, Control>Test Movie, and click the button in the middle of the screen, you will be taken to Movie2.

Figure 7.7 *The Load Movie action*

If you choose Level for Location, enter a level number as follows:

* To load the new movie in addition to existing movies, enter a level number that is not occupied by another movie.
* To replace an existing movie with the loaded movie, enter a level number that is currently occupied by another movie.
* To replace the original movie and unload every level, load a new movie into level 0. The movie loaded first is loaded at the bottom level.

- The movie in level 0 sets the frame rate, background colour, and frame size for all other loaded movies. Movies may then be stacked in levels above the movie in level 0.

To unload a movie from a Flash movie window:

1. Select the frame, button instance, or movie clip instance to which you will assign the action. Choose Window>Actions to display the Actions panel.
2. In the Toolbox list, click the Basic Actions category to display the basic actions, and select the Unload Movie action. For Location, choose one of the options from the pop-up menu. For a loaded movie, select Level and enter the level of the movie that you want to unload.
3. To target a movie to unload, select Target and enter the path of the movie that you'll target to unload. To enter an expression that evaluates to a level or movie, select Expression and enter the expression. For example: unloadMovie(3); targets the movie on level 3 and unloads it.

To test a Load Movie or Unload Movie action:

- If you're testing a Load Movie action, make sure that the movie being loaded is at the specified path. If the path is an absolute URL, an active network connection is required.
- The Load Movie and Unload Movie actions do not work in editing mode.

Dot Syntax

The dot syntax is the best way of addressing. It is familiar to those who work with Object Oriented Programming or JavaScript. Each object has properties, which are listed following the main object in order of hierarchy. For example, if an MC contains another MC with a variable you wish to address, the path will be as follows:

```
Mc1.mc2.variable
```

Instead of a colon (:) before the variable as in the slash syntax, another period or "dot" is placed to maintain consistency. Methods, functions, and properties associated with an MC can be placed in the same hierarchy. For example, using the dot syntax, you can write:

```
car.wheel._rotation=75
```

"car" is an MC that contains another MC named "wheel". The rotation property in the propeller MC is set to a value of "75". In moving up a hierarchy, instead of using the "../" format, you can use "parent" for each step upward. For example,

```
_parent._parent.variable
```

This moves up through the parent of the MC to its parent and to the main timeline. Generally, it is easier to address any object on the timeline using _root to indicate the top level of any hierarchy. So instead of:

```
_parent._parent.variable
```

you can write:

```
_root.variable
```

Comments

You can use comments to add notes to scripts. They are useful for both keeping track with what you are trying to do and allowing other users to decipher your code. By choosing the comment action, the two obliques // are inserted into the script. Anything above a few lines should have a simple commented explanation on how to use it. Comments can be any length, they should not effect the final exported file size. You can put anything behind the two obliques, you do not have to follow any rules or conventions. When coloured Syntax is turned on in the Actions panel, comments are pink by default.

```
Mouse.hide();

// Use these to tweak the position of the wall
wallxoffset = 7;
wallyoffset = 7;

// Dimensions of a brick
brickwidth = brick1._width;
brickheight = brick1._height;

// Game variables
gamescore = 0;
remaininglives = 3;

// define the wall as a 2D array.
wall = new Array();
wall[0] = new Array(0, 0, 0, 0, 0, 0, 0, 0, 0, 0, 0);
wall[1] = new Array(0, 0, 1, 1, 1, 1, 1, 1, 1, 0, 0);
wall[2] = new Array(0, 0, 1, 2, 2, 2, 2, 2, 1, 0, 0);
wall[3] = new Array(0, 0, 1, 2, 3, 3, 3, 2, 1, 0, 0);
wall[4] = new Array(0, 0, 1, 2, 3, 4, 3, 2, 1, 0, 0);
wall[5] = new Array(0, 0, 1, 2, 3, 3, 3, 2, 1, 0, 0);
wall[6] = new Array(0, 0, 1, 2, 2, 2, 2, 2, 1, 0, 0);
wall[7] = new Array(0, 0, 1, 1, 1, 1, 1, 1, 1, 0, 0);

/*
    Building the wall
    This uses the 2D wall array as the structure of the wall and builds
    it up using the duplicateMovieClip function to place the bricks
    for the wall.
*/
```

Figure 7.8 *Commented code*

Objects on Different Timelines

Flash allows us to build movies in a modular way, and the main benefit of this is the reusability of all items for both animation and ActionScript. The next walkthrough demonstrates how a movie clip communicates with the main timeline and vice versa. It also demonstrates the running of two different timelines in the same movie. It is important to note that the frame rate is set by the root (main) movie; this also sets the colour of the background. The walkthrough movie contains the following layers and MCs with scripts.

- MainLine
- DataIn
- Buttons
- DataOut

The last frame of the main movie holds a set of variables. One button on the main timeline has ActionScript that sends the movie clips' value to a text field in the main timeline. This text field displays its contents to screen. When the button is activated, the value appears in the same text field in the main timeline. A button on the main timeline generates a value in a text field variable on the same timeline. Each button has a different path to do essentially the same thing. You can see a completed version of this movie in ZakMovie.fla.

Figure 7.9 *The movie timeline*

Mainline Layer

The main timeline layer – the top layer – is used for setting a variable in a single frame on the layer. It is also used as a starting point for creating another movie clip. To do this, you follow these steps:

1. Create a movie clip by selecting Insert>New Symbol from the menu bar and selecting Movie Clip for the behaviour. Name it "world". You are now in the Symbol Editor.
2. In the Symbol Editor, create a Button symbol with a width and height of 40 points. Name it "zakButton".
3. Open the Info panel. Select the Button Instance, type in "40" for "W" and "H" in the Info panel. Use the same technique for the other buttons in the movie.

Figure 7.10 *Communicating between movies on different timelines*

4. Create action scripts for the button and in the movie clip frame as follows:

 Button world (MC) – zakButton

   ```
   on (release) {
   _parent.Output = "...I am here...";
   }
   ```

5. In the main timeline, in the movie clip world, in frame 1:

 idata = "Hi Zak";

6. In the main timeline, in frame 1:

 Data = "Is this the main timeline?";

7. By looking at the top left-hand corner of the stage window you can see the list of scene 1 followed by the movie you are in. Click on "Scene 1" to return to the main timeline. You will see the button you created as a movie clip. Select Window>Panels>Instance to open the Instance panel. Enter the instance name "world1" for the MC. This is a crucial step. If more than a single instance of the same movie clip symbol is used in a movie, the

symbol and instance names should not be the same. The method I use is giving the instance the name of the symbol and then incrementing it with 1 every time I create a new version of it. Click on OK to close the window and return to the main timeline.

Buttons Layer

As the name implies, the Buttons layer is used for the buttons on the main timeline.

1. The first thing to do is to create two symbols with a height and width of 40 using the Info panel as described in Step 2 of the previous section. Name one Button symbol "home" and the other "ellen". Button − root:

 Figure 7.11 *Button ActionScript*

    ```
    on (release) {
    Output = Data;
    }
    ```

2. Using the Text tool, type this label to the right of the button: "home". Button - ellen:

    ```
    on (release) {
    Output = world1.iData;
    }
    ```

3 Using the Text tool, type this label to the right of the button: "ellen".

Output Layer

The Output layer uses a text field with a variable association:

1. Above the text field, set the Text Field modifier from the Toolbox to Off, and type in the label "Output". Your movie is ready to test.

When you test the movie, you will see different messages appearing in the main timeline's output window. The button in the movie clip announces, "…I am here…", reminding you that the variable is from the timeline of the movie clip. Second, the button labelled "root Time Line" sends the main timeline frame, which tells you that the data came from the script in the main timeline's frame, finally, the Remote button displays "Hi Zak" from a frame in the MC's timeline, not from the main timeline.

144

Buttons

A button has the ability to change its image according to what state the button is in. There are four of these states: Up, Over, Down and Hit. You see the button in its normal state, you can then interact with it by rolling the mouse cursor "over" the button. When you click a button it sends

Figure 7.12 *The button timeline*

the playhead to the "down" state for as long as the mouse button remains pressed. A button can also carry out an action when a certain state is reached. There is a four-framed timeline to define each state.

Creating a button:

1. Choose Insert>New Symbol and select "Button" as the behaviour option. Once you click OK, Flash will enter into edit symbol mode. The timeline will change to show four blank frames corresponding to the four button states. The first frame will have a blank keyframe in it. Notice how the button symbol is different to the graphic symbol.

2. Each frame in the timeline of a button symbol has a specific function:

 - Up is the state used whenever the mouse pointer is not over the button.
 - Over is used when the mouse pointer is over the button.
 - Down is the state attained when the button is clicked.
 - Hit is invisible and defines the area where the button will react to the mouse pointer.

3. It is important to note that you can't use a button within a button but you can use a movie clip for an animated button or a graphic symbol. For the purpose of this tutorial we'll create a circle. Place your circle on the stage and you'll notice that the "Up" frame now has a full keyframe in it.

4. Now click in the second frame, labelled "Over", and choose Insert>Keyframe. The circle image from the first frame will appear on the stage. This frame is essentially the rollover function so you'll want the image to be different. Modify the circle image by placing a smaller circle of a different colour in the centre. When the mouse is over the button this circle will appear. Try it.

5. Repeat this step for the "Down" and "Hit" frames. Keep your "Down" image the same as "Up" but nudge it slightly right and down the page from the "Up" position. This will give an impression that the button is pressed when clicked on.

6. To preview your button in editing mode choose Control>Enable Simple Buttons and you can see the button animate when you press it.

The "Hit" frame defines the area that will react to the mouse. It can be as big or small as you like, but it's best to ensure that the frame contains a solid shape that is large enough to surround all the images you have place in the button's frames. In terms of the circle, you want the whole circle to

interact with the mouse so a copy of the circle image in this state will suffice. The objects in the "Up" frame will be used as the "Hit" frame if you do not specify a "Hit" state.

To assign sound to the button:

1. To add your own sounds you will have to import them first into your library. Open the Sounds.fla file as a library (File>Open as Library) from the chapter7 folder and drag and drop the sounds into your library.
2. Select the "Down" frame in the button timeline, choose Modify>Frame, and select the Sound tab in the Frame Properties, now select a sound from the drop-down menu to play when you press down on your button.
3. When you've finished, choose Edit>Edit Movie or click on the Scene 1 tab above your layers, and then drag the button symbol out of the library to create an instance of it in the movie.
4. If you want to preview your button in editing mode choose Control>Enable Simple Buttons and you can hear the sound play when you press the button. Your first button!!

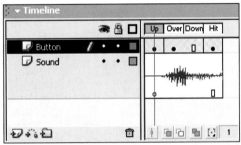

Figure 7.13 *The button timeline with sound embedded*

About Planning and Debugging your Scripts

Before you begin writing scripts, you need to formulate your goal and understand what you want to achieve. Write down these thoughts to create a plan for your scripts. This is good practice for something as simple as a button that opens a new web page, or something complex such as an entire site. Planning your scripts is as important as developing storyboards for your work. Start by writing out what you want to happen in the movie. When you know what you want, you can use the ActionScript that you need to accomplish the tasks. In time you will own large numbers of scripts that can constantly be reused for new projects.

Getting scripts to work the way you want takes time – often more than one cycle of writing, testing, and debugging. Start simple and test your work frequently. When you get one section of a script working, do a Save As to save a version of the file and start writing the next section. This approach will help you identify any problems efficiently, and ensure that your ActionScript is solid as you begin to write more complex scripts.

Chapter 8

ActionScript Fundamentals and Component User
Interface Design

This chapter of the book takes you into more complicated ActionScript functions and routines. The first half of the chapter covers variables, functions, if statements, while and for loops, the Array object and the MovieClip hitTest. The second half of the chapter looks at components and how you can use these new Flash MX features to enhance your movies.

This chapter covers the core features of ActionScript that will form the basis for any ActionScript code you write or commission.

Variables

A variable contains a piece of data. The container itself is always the same, but the contents can change. Variables can be used to store information as the movie plays and can be used for many situations such as to change the behaviour of the movie based on the user interaction.

Variables can hold any type of data: number, string, Boolean, object, or movie clip. Types of information you can store in a variable include a URL, a user's name, the result of a mathematical operation, the number of times an event occurred, or whether a button has been clicked. Each movie and movie clip instance has its own set of variables, with each variable having its own value independent of variables in other movies or movie clips.

Each variable must be assigned a name, which is not a reserved keyword (such as function, if, for, etc.) or a Boolean value (true/false).

```
mystring = "http://www.sprite.net";
mynumber = 123;
q1_question = "What is a variable?";
q1_answer = "A contains that stores information";
result = mynumber + 123;
done = false;          // A Boolean value
```

The single equals "=" operator is used to assign a value to a variable while the double equals "==" is used to compare two values to determine whether they are equal. These two operators can be easily confused so be careful.

A variable's "scope" refers to the area in which the variable is known and can be referenced. Variables in ActionScript can be either global or local. A global variable is shared among all timelines, i.e. a global variable in one movie can be accessed by another movie using the dot syntax.

```
var myvar = _root.movieA.movieAA.anothervariable;
```

A local variable is only available within its own block of code (between the curly braces). A local variable is defined using the "var" keyword. Examples of both global and local variables are:

```
myglobal = "Hello, I'm a global variable" ;
testlocal();
function testlocal() {
   // mylocal is not available outside the testlocal function
```

```
        var mylocal = "Hello, I'm a local variable";
        trace(mylocal);
        trace(myglobal);
    }
        trace(mylocal);        // this will not print "Hello, I'm a ..."
                               // as mylocal is not defined outside the
                               // testlocal function.
        trace(myglobal);       // this will print, since myglobal
                               // is defined globally.
```

Figure 8.1 *Code to define a variable*

Functions

You can define functions to execute a series of statements on passed values. Your functions can also return values. Once a function is defined, it can be called from any timeline, including the timeline of a loaded movie. Like variables each function is defined with a name, and can also define a set of variables that it expects to receive. For example, the following function moves a movie clip "ball", on the root movie, to a defined co-ordinate, the finished file is BallComplete.fla on the CD. This should be defined in a frame action on the root movie.

```
    function moveball(x, y) {
        _root.ball._x = x;        // set the x co-ordinate of the ball
        _root.ball._y = y;        // set the y co-ordinate of the ball
    }
```

This function is called by a button on the root movie, using the following code:

```
on (release) {
    // move the ball to x=100,y=200
    moveball(100,200);
}
```

Figure 8.2 *Inserting a frame action*

Try this code out on ball.fla. Functions can also return values which can be useful for testing values, for example modify moveball to return a string value when it has finished, e.g.

```
function moveball(x, y) {
    _root.ball._x = x;
    _root.ball._y = y;
    return "moved ball";   // return the string "moved ball"
}
```

Now modify the button code to print the returned value:

```
on (release) {
    // move the ball to x=100, y=200, putting the return value in
    // 'result', and displaying it in the output window.
    result = moveball(100,200);
    trace(result);
}
```

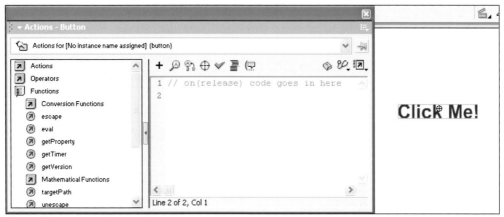

Figure 8.3 *Inserting a button action*

You should now see "moved ball" printed in the output window when you click the button. Functions are a useful way of breaking up large amounts of code as well as defining code that can be reused.

Figure 8.4 *Adding code to the library asset*

Functions can also be defined in MovieClip assets in the library. For example, open the ball asset and add the following function to the first frame action of the movie:

```
function changealpha(newalpha) {
    // set the alpha channel to the new value
    this._alpha = newalpha;
}
```

And modify the button code to read:

```
on (release) {
    result = moveball(100,200);
    trace(result);
    _root.ball.changealpha(50); // make the ball semi-transparent
}
```

The 'if' Statement

If statements are used to check whether a certain condition is true or false. If the condition is true, ActionScript executes the statement block that follows. If the condition doesn't exist, ActionScript skips to the next statement outside the block of code. For example, the following code checks to see if the variable "test" is true:

```
test = false;
if (test == true) {
    trace("Yep, test is true");
}
```

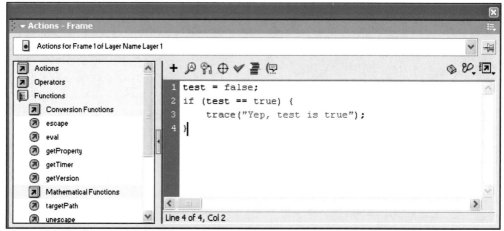

Figure 8.5 *The if statement ActionScript*

An if statement can also be used to check more than one condition and provide a block of code that is executed if all the conditions are false. This is done using the if…else… statement. For example, open If.fla (complete file IfComplete.fla) and add the following code to the first frame action:

```
test = "fifteen";
if (test == "one") {
    stop();
} else if (test == "fifteen") {
    gotoAndStop(15);
} else if (test == "thirty") {
    gotoAndStop(30);
} else {
    gotoAndStop(45);
}
```

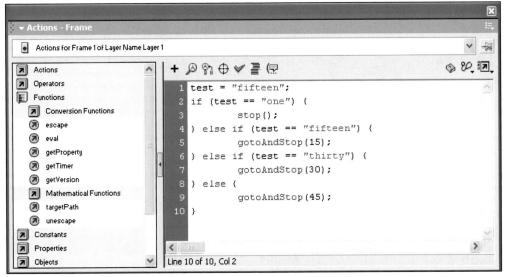

Figure 8.6 *Example ActionScript*

This code compares the value of test to determine which frame to move the movie to. If test is not "one", "fifteen" or "thirty" then it will jump to frame 45 in the final else block. The condition is generally constructed using the following comparison operators:

```
A < B    - A is less than B
A > B    - A is greater than B
A <= B   - A is less than, or equal to B
A >= B   - A is greater than, or equal to B
A == B   - A is equal to B
A != B   - A is not equal to B
```

The 'while' Statement

No language would be complete without some form of iteration (repeated execution of a block of program code). Flash offers several of these methods, the simplest of which is the "while" loop. This simply executes a block of code repeatedly while a specific expression is true. For example, check out While.fla:

```
while (done == false) {
    // ... some game functions ...
    if (endofgame == true) {
        done = true;  // this tells the while loop to stop
    }
}
// 'while' loop jumps to here when it has finished.
```

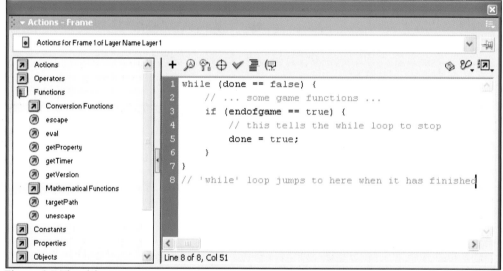

Figure 8.7 *The while statement*

The expression is evaluated before the code is run; if it is true the code is executed and when finished the expression is re-evaluated. This continues until the expression is false, whereby it jumps to the end of the block. You can also check the while condition at the end of the loop by using a do…while loop. This means that the loop is always executed at least once before the expression is evaluated, for example:

```
do {
    ... some game functions ...
    if (endofgame == true) {
    done = true;
    }
} while (done == false);
```

However, generally you will find that a for loop proves to be more useful.

The 'for' Statement

A 'for' loop can be used to repeat a block of code for a specific number of times. It requires three expressions, one to start the loop, another to test whether it should continue and a third to increment the loop, for example (see BlockComplete.fla on the CD):

```
for(count = 0; count <= 10; count++) {
    trace(count);
}
```

In this case, the starting condition (count=0) is evaluated first, before the loop is started, to set the count variable to 0. Next, the continue condition is evaluated (count <= 10) and the loop is repeated if it is true, in this case, if count is less than or equal to 10. The body of the expression is then executed, which prints the number to the output window. Finally, the loop increment expression is evaluated (count++) which adds one to the count variable. The continue condition is then re-evaluated and the cycle then repeats until the count reaches 11. To demonstrate this open Block.fla and add the code on the following page to the first frame action.

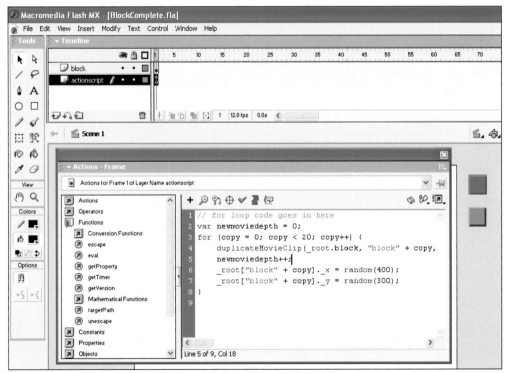

Figure 8.8 *Using a for loop*

```
var newmoviedepth = 0;
for (copy = 0; copy < 20; copy++) {
    duplicateMovieClip(_root.block, "block" + copy, newmoviedepth);
    newmoviedepth++;
    _root["block" add copy]._x = random(400);
    _root["block" add copy]._y = random(300);
}
```

This code performs a for loop that repeats 20 times. In the for block the first line duplicates an instance of a movie clip that exists on the stage, called block. The duplicateMovieClip function is used to create a copy of an existing movie clip with a new name and at a specific depth on the stage.

In this case, the block movie is duplicated and given the name "block0", "block1", "block2", etc. The depth is simply incremented for each copy since each movie must be at a unique depth.

The next two lines make use of the random() function to place the newly created movie copy at a random position on the stage. The random(num) function simply generates and returns a random integer between 0 and the specified number, num. An alternative is to use the Math.random() function which generates a random decimal number between 0 and 1.

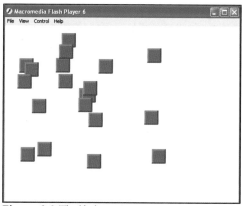

Figure 8.9 *The block movie*

The for loop repeats this process to create 20 copies of the block movie. Experiment by changing the values in the for loop and random functions, and if you're feeling adventurous try modifying the code to duplicate 'blockblue' as well.

The 'Array' Object

Arrays objects are used to store an indexed set of objects or variables. For example, an array could contain a high score table, list of player names or the status of the game. Each element in the array has an index that is used to retrieve that element. The element can be a reference to any Flash object, typically these will be one of the standard data types (String, Number, Boolean) although they can also be a reference to any other Flash object, even another Array object. By storing Array objects in an array it allows you to build multidimensional arrays, but more on this later.

To create an array:

```
myArray = new Array();
myArray[0] = "first element";
myArray[1] = "second element";
myArray[2] = "third element";
```

To retrieve elements from an array:

```
first = myArray[0];
third = myArray[2];
arrayLength = myArray.length;
```

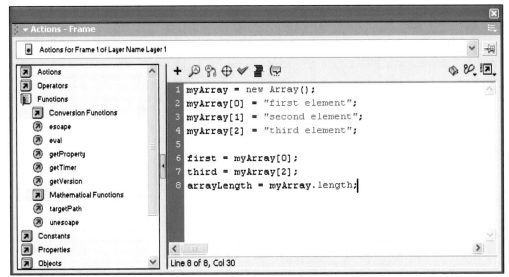

Figure 8.10 *Creating an array*

As well as the standard way of setting and retrieving elements of the array using their index, the Array object also provides other useful methods for manipulating them. The current size of the array is always stored in the length property of the Array object, this is useful for determining the end of the array. For example:

myArray.length = 5

"first"	"second"	"third"	"fourth"	"fifth"
myArray[0]	myArray[1]	myArray[2]	myArray[3]	myArray[4]

The for loop is ideal for iterating through an array, this example demonstrates how to print each value of an array to the output window:

```
myArray = new Array();
myArray[0] = "first element";
myArray[1] = "second element";
myArray[2] = "third element";

for(count = 0; count < myArray.length; count++) {
    trace("Item " + count + " is " + myArray[count]);
}
```

The Array object provides the pop/push and shift/unshift methods to add and remove elements from the array. The pop method "pops" an element from the end of the array and returns it, while the shift method "shifts" and element from the start of the array and returns it. Their opposites are used to add elements to the array. The push method is used to "push" one or more elements onto the end of the array while unshift is used to add one or more to the start. These can save time and provide a nice alternative to indexes. For example, the following code moves the elements from one array to another and reverses the order of the values:

```
arr1 = new Array(0,1,2,3,4,5,6);
arr2 = new Array();
trace (arr1);
while (arr1.length > 0) {
    // pop() removes and returns the last element
    arr2.push(arr1.pop());
}
trace(arr2);
```

Arrays can also be useful for defining instances of movie clips, for example open Array.fla and add the following code to the Generate! button object action (the complete file is ArrayComplete.fla):

```
on(release) {
    depth = 0;
    things = new Array();
    things[0] = "star";
    things[1] = "ellen";
    things[2] = "ellen";
    things[3] = "zak";
    things[4] = "star";
    things[5] = "star";
    things[6] = "ball";
    things[7] = "ball";
```

```
things[8] = "ball";
things[9] = "zak";
things[10] = "zak";
things[11] = "zak";
for(thing=0; thing<things.length; thing++) {
    duplicateMovieClip(_root[things[thing]],
    "thingy" + thing, depth);
    _root["thingy" add thing]._x = random(400);
    _root["thingy" add thing]._y = random(300);
    depth++;
}
}
```

Figure 8.11 *Adding code to the Generate! button*

This code defines a new array called "things", each element of the array contains the name of a movie on the stage. The for loop cycles through each element of the things array and creates a copy of the particular movie referenced at that element in the array, i.e. on the fourth loop, the

"zak" movie will be duplicated since it is the fourth element in the things array. Once duplicated, the new copy is randomly placed on the stage.

The 'hitTest' Function

The MovieClip object in ActionScript provides the hitTest function to test for collisions with other movie clips. For example:

```
movie1.hitTest(_root.movie2);
```

The hitTest function, in its simplest form, accepts a movie as its single argument. The function will return true if movie1 and movie2 collide, i.e. the bounding boxes of both movies intersect. The function also provides a way to check if a particular point is located within the movie, for example:

```
movie1.hitTest(100,200,true);
```

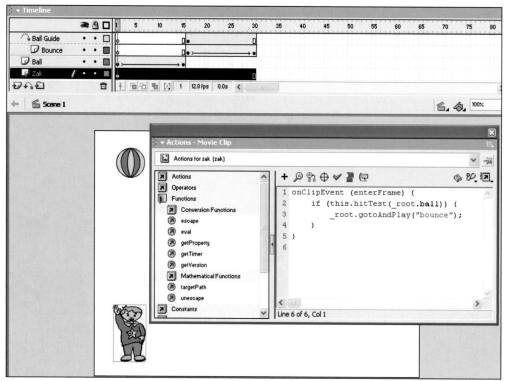

Figure 8.12 *Adding collision detection*

In this case, the function will return true if the point 100,200 lies within the shape specified by movie1. If the third argument is true then only the shape defined in the movie is used to detect collisions; if set to false then the bounding box of the movie is used. Look at HitTest.fla, and add the following code to the "zak" movie object action (check out HitTestComplete.fla for the finished version):

```
onClipEvent (enterFrame) {
    if (this.hitTest(_root.ball)) {
        _root.gotoAndPlay("bounce");
    }
}
```

This code tests whether the ball movie has collided with the zak movie on every frame. If there is a collision then the movie is moved to the frame named "bounce".

Working with Components

Components are Macromedia Flash MX movie clips with defined parameters that are set by the author of the application. The parameters correspond to variables attached to the movie clip, which influence the behaviour and appearance of the movie clip. Components provide pre-built user interfaces and scripting for adding interactivity to Flash movies. With components, you can add interactivity to a Flash movie without needing to create the ActionScript that controls the interactivity. To use a component in a movie, you simply add an instance of the component symbol to the movie and select values for the component parameters.

You can use components to create simple interactivity that affects only the current movie, such as buttons that navigate between frames. You can also use components to send data to an application server and receive data from a server.

Change Handlers

All components have a Change Handler function that is called when the user selects a menu item, a radio button, or a checkbox. Specifying a function for the Change Handler parameter is optional. Using this function depends on the requirements and layout of your form or user interface, and the purpose of the component.

You can write Change Handler functions in a variety of ways. It is good practice to create a single handler function that specifies the actions for the components in your document, and then use the name of this handler function as the Change Handler parameter for the components. This makes sure that conflicting actions are not assigned, and makes it easier to update and change the code. More on Change Handlers later.

The Components Panel

All components are stored in the Components panel. To display the Components panel choose Window > Components.

Figure 8.13 *The Components panel*

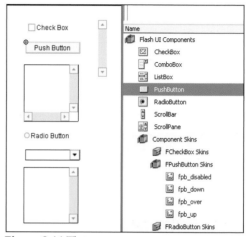

Figure 8.14 *The components on screen*

When you add one or more components to a Flash document, a Flash UI Components folder is added to the Library panel. This folder contains:

- The component movie clip,
- A Component Skins folder, with a Global Skins folder containing its graphic elements,
- A Core Assets folder with assets for Data Provider API and the class hierarchy.

The Library folder structures components as you create or import them. You can add more instances of a component by dragging the component icon from the library to the stage.

Skins folders contain the graphic symbols, used to display a component type in a Flash document. All components use the skins in the Global Skins folder. In addition,

Figure 8.15 *Components in the library*

components have Skins folders specific to the component type. Components that use scroll bars share the skins in the FScrollBar Skins folder, and the ListBox component uses the skins in the ComboBox Skins folder. You can edit the skins in the folders to change the appearance of components but you cannot edit the components themselves by double-clicking the instance.

Property Inspector and Parameters Panel

Once you have added an instance of a component to a Flash document, you use the Property Inspector to set and view information for the instance. You create an instance of a component by dragging it from the Components panel onto the stage, then you name the instance in the Property Inspector and specify the parameters for the instance.

Live Preview

The Live Preview feature lets you view components on the stage as they will appear in the published movie. Live Preview lets you see the approximate size and appearance the component will have in the published movie. Live Preview does not reflect changes you make to component property settings or to component skins. Components in Live Preview are not functional. To test, you can use the Control > Test Movie command. You can turn Live Preview on or off, choose Control > Enable Live Preview. A check mark indicates that it is enabled.

Adding Components to Flash Documents

You can add components to Flash documents using the Components panel, or using the MovieClip.attachMovie ActionScript method. We will focus on using the Components panel for adding components. When you add a component to a document using the Components panel, the items for the component are added to the Library panel, inside a Flash Components UI folder as previously described in Figure 8.14.

To add a component to a Flash document using the Components panel:

1. Select Window > Components.
2. Drag a component from the Components panel to the stage.
3. Select the component on the stage.
4. Choose Window > Properties.
5. In the Property Inspector, enter an instance name for the component instance.
6. Click the Parameters tab and specify parameters for the instance.
7. Change the size and scale of the component as desired.
8. Change the colour and text formatting of a component as desired, by editing multiple properties in the global style format assigned to all Flash UI components.

Customise the appearance of the component if desired, by editing the skins in the Component Skins folder for a component type.

To delete a component's instances from a Flash document, you delete the component from the library by deleting the component type icon and the associated Component Skins folder. To delete it from the stage you just select the component and hit delete. If a component instance is not large enough to display its label, the label text is truncated. If a component instance is larger than the text, the hit area extends beyond the label.

The CheckBox Component

The CheckBox component lets you add check boxes to Flash movies with simple drag and drop functionality. You can set the following parameters for each checkbox

Figure 8.16 *The CheckBox component*

instance in your Flash document using the Parameters tab on the Property Inspector or the Component Parameters panel:

- Change Handler is a text string specifying the name of a function to call when the value of the check box changes.
- Initial Value specifies whether the check box is initially selected (true) or unselected (false).
- Label is the name that appears next to the check box.
- Label Placement specifies whether the label appears to the left or to the right of the check box. By default the label is displayed to the right of the check box.

▼ Properties			
Component	Label	Check Box	
\<Instance Name\>	Initial Value	false	
	Label Placement	right	
W: 100.0 X: 130.3	Change Handler		
H: 13.0 Y: 235.8			

Figure 8.17 *The CheckBox Properties panel*

You can set the width, but not the height, of a CheckBox component using the Free Transform tool. The area that will respond to the mouse click is the combined size of the check box and check box label. The CheckBox component uses the skins in the FCheckBox Skins folder and the FLabel skin in the Global Skins folder in the Component Skins folder in the library. Customising the CheckBox component skins affects all check box instances in the Flash document.

The ComboBox Component

The ComboBox component lets you add scrollable single-selection drop-down lists to Flash movies by creating both static and editable combo boxes. A static combo box is a scrollable drop-down list that lets the user

Figure 8.18 *The ComboBox component*

select items in the list. An editable combo box is a scrollable drop-down list with an input text field (similar to a search field) in which a user can enter text to scroll to the matching menu item in the scroll list.

The ComboBox component uses values with the index 0 as the first item displayed. When adding, removing, or replacing list items using the FComboBox methods, you may need to specify the

index of the list item. The ComboBox component has the following built-in mouse and keyboard controls:

- Up Arrow key moves the selection up one line in the scroll list.
- Down Arrow key moves the selection down one line in the scroll list.
- PageUp moves the selection up one page. The size of the page is determined by the Row Count parameter.
- PageDown moves the selection down one page.
- Home selects the item at the top of the list.
- End selects the item at the bottom of the list.

You can set the following parameters for each combo box instance in your Flash document using the Parameters tab on the Property Inspector or the Component Parameters panel:

- Change Handler is a text string specifying a function to call when a user selects an item or enters text in the input field.
- Data is an array of text strings specifying the values associated with the items (labels) in the combo box.
- Editable tests whether the combo box is editable or static.
- Labels is an array of text strings specifying the items displayed in the combo box.
- Row Count is the number of items displayed in the combo box before the scroll bar is displayed.

Figure 8.19 *The combo box Properties panel*

You can set the width but not the height of ComboBox components using the Free Transform tool. If the text of a list item is longer than the width of the combo box, the text is truncated to fit inside the box. The height of a ComboBox component is determined by the size of the font displaying the list items and the Row Count parameter, which specifies the number of items visible in the drop-down list at one time.

The ComboBox component shares the skins in the FScrollBar Skins and Global Skins folders (in the Component Skins folder in the library), with all other components that use scroll bars and bounding boxes.

The ListBox Component

The ListBox component lets you add scrollable single- and multiple-selection list boxes to Flash movies. You add the items displayed in the ListBox using the Values dialog box that appears when you click in the

Figure 8.20 *The List Box component*

labels or data parameter fields. The ListBox component uses a zero-based index, where the item with index 0 is the first item displayed. The ListBox component has the following standard built-in mouse and keyboard controls:

- The Up Arrow key moves the selection up one position.
- The Down Arrow key moves the selection down one position.
- PageUp moves the selection up one page. The size of the page is determined by the height of the list box instance.
- PageDown moves the selection down one page.
- Home selects the item at the top of the list.
- End selects the item at the bottom of the list.

You set the following parameters for each list box instance in your Flash document using the Parameters tab on the Property Inspector or the Component Parameters panel:

- Change Handler is the name of the function that you want to call when the user selects an item in the list box.
- Data is an array of text strings specifying the values associated with the items (labels) in the list box.
- Labels is an array of text strings specifying the items in the list box.
- Select Multiple specifies whether the user is allowed to select more than one item in the list box (true) or not (false). The default setting is false.

Figure 8.21 *The list box Properties panel*

You can change the width and height of list box instances using the Free Transform tool. The width of the list box instance is determined by the width of the bounding box. If the text of the list items is too long to fit inside the bounding box, the text is truncated. The height of the list box instance is automatically adjusted to display the lines of text without increasing the size of the box. The ListBox component shares the skins in the FScrollBar Skins and Global Skins folders in the Component Skins folder.

The PushButton Component

The PushButton component lets you add simple push buttons to your Flash movie. The PushButton component accepts all standard mouse and keyboard interactions, and has an onClick parameter that allows you to specify a

Figure 8.22 *The PushButton component*

handler to execute actions. You set the following parameters for each push button instance in your Flash document using the Parameters tab on the Property Inspector or the Component Parameters panel:

- Click Handler is a text string specifying the function to call when a user presses and releases the push button.
- Label(s) is the text that appears on the push button.

Figure 8.23 *The push button Properties panel*

You can size the height and width of push button instances using the Free Transform tool. If the push button is not large enough to display the label, the label text is truncated. The PushButton component uses the skins in the FPushButton Skins folder and the FLabel skin in the Global Skins folder in the Component Skins folder in the library.

The RadioButton Component

The RadioButton component lets you add groups of radio buttons to your Flash document. The groupName parameter logically groups radio button instances

Figure 8.24 *The RadioButton component*

together and prevents more than one radio button in the same group from being selected at the same time. You can set the following parameters for each radio button instance in your Flash document using the Parameters tab on the Property Inspector or the Component Parameters panel.

- Change Handler is the name of the function that you want to execute when the user selects one of the radio buttons in a group.
- Data is the data associated with the radio button label.
- Group Name specifies the radio button as one of a group of radio buttons.
- Initial State specifies whether the radio button is initially selected (true), or clear (false).

- Label is the name of the radio button.
- Label Placement specifies whether the label appears to the left or the right of the radio button.

▼ Properties			
Component	Label	Radio Button	
<Instance Name>	Initial State	false	
	Group Name	radioGroup	
W: 100.0 X: 128.8	Data		
	Label Placement	right	
H: 13.0 Y: 243.3	Change Handler		

Figure 8.25 *The radio button Properties panel*

You can set the width, but not the height, of RadioButton components during authoring using the Free Transform tool. The hit area of the radio button instance is the size of the radio button and radio button label area. If the radio button instance is not large enough to display the label, the label text is truncated. The RadioButton component uses the skins in the FRadioButton Skins folder and the FLabel skin in the Global Skins folder in the Component Skins folder.

The ScrollBar Component

The ScrollBar component provides drag-and-drop functionality for adding vertical and horizontal scroll bars to dynamic and input text fields. Adding scroll bars to dynamic and input text fields allows the text field to overflow without requiring that it be displayed in one go.

The ScrollBar component is used by the ComboBox, ListBox, and ScrollPane components. Adding these components to a Flash document automatically adds the

Figure 8.26 *The ScrollBar component*

ScrollBar component to the library. If an instance of the ScrollBar component is already in the library, you can add instances of the ScrollBar component to the document by dragging them from the library. However, you should not add another copy of the ScrollBar component to the document by dragging it from the Components panel.

When you drag a scroll bar onto a dynamic or input text field on the stage, the scroll bar automatically snaps to the nearest side at the vertical or horizontal position where you place it. The scroll bar and the text field must be in the same timeline. Note: the ScrollBar component cannot be used with static text fields.

Once the scroll bar is snapped to the text field, Flash enters the instance name of the text field for the targetTextField parameter for the scroll bar instance in the Property Inspector. Although the scroll bar automatically snaps to the text field, it is not grouped with the text field. Therefore, if

you move or delete the text field, you must also move or delete the scroll bar. To create a scrollable text field:

1. Use the Text tool to create a text field on the stage.
2. Choose Window > Properties to open the Property Inspector.
3. Choose Dynamic Text or Input Text from the Text type menu in the Property Inspector.
4. Enter a name in the Instance Name field.
5. Choose Window > Components to open the Components panel. If you have already used a ScrollBar or a component that uses scroll bars in your Flash document and have modified the scroll bar properties or skins in any way, drag the ScrollBar from the library, not the Components panel.
6. Drag a ScrollBar component onto the text field bounding box close to where you want to place a scroll bar.
7. Repeat step 6 to add additional ScrollBar components to the text field.
8. If you resize the text field, drag the ScrollBar off the text field and then onto it again to resize the scroll bar.

You can set the following parameters for each scroll bar instance in your Flash document using the Parameters tab on the Property Inspector or the Component Parameters panel:

- Horizontal specifies whether the scroll bar is horizontal (true) or vertical (false).
- TargetTextField is a string specifying the instance name of the text field for the scroll bar.

Figure 8.27 *The scroll bar Properties panel*

This parameter is automatically filled in with the instance name of the text field when the scroll bar snaps to the text field on the stage. Changing or deleting this parameter disassociates the scroll bar from the text field on the stage.

Scroll bars added to text fields are automatically sized to fit the text field. If you resize the text field, the way to resize a scroll bar instance is to drag it off the text field and then back on again. You should not use the FScrollBar.setSize method to size scroll bars attached to text fields.

The ScrollBar component shares the skins in the FScrollBar Skins folder in the Component Skins folder in the library with all other components that use scroll bars.

The ScrollPane Component

The ScrollPane component lets you add window panes with vertical and horizontal scroll bars to display movie clips (or JPEG files that are converted to movie clips) in Flash documents. The ScrollPane component is useful for displaying large areas of content without taking up a lot of stage space. The

Figure 8.28 *The ScrollPane component*

ScrollPane component only displays movie clips. To add scroll bars to text fields, you use the ScrollBar component.

You can set the following parameters for each scroll pane instance in your Flash document using the Parameters tab on the Property Inspector or the Component Parameters panel:

- Drag Content specifies whether a user can drag the content in the scroll pane to change the view (true), or use the scroll bars to change the view (false).
- Horizontal Scroll tests whether a horizontal scroll bar is displayed (true), not displayed (false), or displayed only when necessary (auto).
- Scroll Content is a text string specifying the symbol linkage ID of the movie clip to be displayed in the scroll pane.
- Vertical Scroll tests whether a vertical scroll bar is displayed (true), not displayed (false), or displayed only when necessary (auto).

▾ Properties			
Component	Scroll Content		
<Instance Name>	Horizontal Scroll	auto	
	Vertical Scroll	auto	
W: 212.4 X: 113.3	Drag Content	false	
H: 100.0 Y: 167.3			

Figure 8.29 *The scroll pane Properties panel*

You can change the width and height of scroll pane instances during authoring using the Free Transform tool. The ScrollPane component shares the skins in the FScrollBar Skins folder (in the Component Skins folder in the library) with all other components that use scroll bars.

Components Tutorial Overview

Macromedia Flash UI components can be quickly and easily developed from the selection in the library. It is also possible to customise the library components to create a new look and feel. This tutorial is designed to introduce components to beginner and intermediate Flash users and show how they can be used to easily create a simple navigation system that moves the user between frames. This tutorial will teach you how to add components to a Flash document and then configure them.

View the Movie Navigation Demo

You can navigate through components in a form by doing the following:

1. Choose File > Open and navigate to the CD directory. Open Chapter 8/ Components.swf. This is the completed movie.
2. Test each of the five sections by navigating through using the buttons and boxes in the movie.

Now open Components.fla in the same directory. This is the Flash document that generated the movie.

Figure 8.30 *The Components.fla file*

Figure 8.31 *The layers setup*

Add Components

In the first step we added the components to the stage and placed them on the form. You will do the same for a radio button, a check box, a list box, a combo box, and a scroll button. You will also add a push button to every section to initiate the request to move on. To add components to a document, you can either drag elements from the Components panel to the stage, or double-click them in the Components panel to place them in the centre of the stage. After you add a component to a document, it appears in the document's Library panel. It is a good idea to create a new layer for the components:

1. Open and navigate to the chapter8 CD directory. Open Components.fla. The completed file is ComponentsComplete.fla.
2. Choose File > Save As and save the file with a new name, such as Components2.fla.
3. Create a new layer and name it Components. You will place the components on this layer.
4. Click frame 15 in the Components layer of the timeline. Choose Insert > Blank keyframe to add a blank keyframe. Do this again for frames 30, 45, 60.
5. Make sure the following panels are open:

Figure 8.32 *The Library*

Figure 8.33 *The Components panel*

Figure 8.34 *The Property Inspector*

Add a Combo Box

Use the ComboBox component to create a simple drop-down menu of items that can be selected by users:

1. Select frame 1 in the Components layer.
2. Drag the ComboBox component from the Components panel to the stage. Place it in the centre of the screen. The component appears in the Flash UI Components folder in the Library panel.

Figure 8.35 *The combo box on stage*

Add a Radio Button

Now use the RadioButton component to create a box with a value of either true or false:

1. Select frame 15 in the Components layer.
2. Drag the RadioButton component from the Components panel to the stage. Place it in the centre of the screen and add another three RadioButtons below the first one.
3. The component appears in the Flash UI Components folder in the Library panel.

Figure 8.36 *The radio buttons on stage*

Add a Check Box

Use the CheckBox component to create a box with a value of either true or false:

1. Select frame 30 in the Components layer.
2. Drag the CheckBox component from the Components panel to the stage. Place it in the centre of the screen and add another three CheckBoxes below the first one.
3. The component appears in the Flash UI Components folder in the Library panel.

Figure 8.37 *The check boxes on stage*

Add a List Box

Use the ListBox component to create a box with Labels and Data:

Labels	Data
ComboBox	ComboBoxFrm
RadioButton	RadioButtonFrm
CheckBox	CheckBoxFrm
ScrollPane	ScrollPaneFrm

Figure 8.38 *The list box on stage*

1. Select frame 45 in the Components layer.
2. Drag the ListBox component from the Components panel to the stage. Place it in the

centre of the screen and add the information in the properties window for the labels and the data associated with those labels.

3. The component appears in the Flash UI Components folder in the Library panel.

Add a Scroll Pane

You can use the ScrollPane component to create a window for scrolling around a movie clip:

1. Select frame 60 in the Components layer.
2. Drag the ScrollPane component from the Components panel to the stage. Add the information in the properties window for the contents of the pane, ScrollPane Contents, which is a movie that sits in the library. You will need to link this movie using the linkage properties in the library. Select "export for ActionScript" and "export for first frame".

Figure 8.39 *The scroll pane on stage*

Add Push Buttons

Use the PushButton component to create push button on frames 15, 30, 45, 60. The buttons will be used to submit the information on the "form" in each section:

1. Drag the PushButton component from the Components panel to the stage. Place it at the bottom of the screen.
2. The component appears in the Flash UI Components folder in the Library panel.
3. After you have dragged a component from the Components panel to the stage, you select additional instances of it from the Library panel.

Configure the Components

The next step is to configure the components so that all the clicks become meaningful actions. You set the parameters for a component using the Parameters tab of the Property Inspector or the Components Parameters panel. Advanced users can use API methods and properties for each component to set the parameters, size, appearance, and other properties of the component.

Configure the Combo Box

Select the ComboBox component on the stage. Its parameters are displayed in the Property Inspector.

1. Type RadioButtonFrm in the Instance Name text box. Make sure the Editable parameter is set to False. This prevents users from typing in their own text.
2. The Labels parameter displays a list of values users can select. Click the Labels field, then click the magnifying glass to open the Values pop-up window. Click the Plus (+) button to enter a new value.
3. Click in the default value field, then type RadioButton for the first value.
4. Click the Plus (+) button to enter the next value. Click in the default value field, then type CheckBox for the next value, ListBox for the next, and ScrollPane for the next.

Figure 8.40 *The combo box values*

5. There is no need to enter a Change Handler parameter name as the handler is attached to the button. When you are finished, the Property Inspector should look like the image on the following page.

The ActionScript Dictionary in the Flash MX Help files has more information on using API methods to change properties, see the listing for FComboBox (component).

Figure 8.41 *The completed combo box Property Inspector*

Configure the Radio Buttons

Select frame 1 on the Components layer, then select the RadioButton component on the stage. Its parameters are displayed in the Property Inspector.

1. Type ComboBox in the Label text box. Do the same for CheckBox, ListBox, ScrollPane.
2. Type ComboBoxFrm in the Value text box. Do the same for CheckBoxfrm, ListBoxfrm, ScrollPanefrm.
3. In the Initial Value parameter pop-up menu, select True for all the buttons. This specifies whether the initial state of the RadioButton component is selected (True) or unselected (False).
4. The Label Placement should be set to right alignment. The label will be displayed to the right of the check box. Do not put in anything for the Change Handler parameter. When you finish, the Property Inspector should look like this:

Figure 8.42 *The completed radio button Property Inspector*

The ActionScript Dictionary in the Flash MX Help files has more information on using API methods to change properties, see the listing for FComboBox (component).

Configure the Check Box

In this example the first selected item will be used to guide the user to the next section. Select frame 1 on the Components layer, then select the CheckBox component on the stage. Its parameters are displayed in the Property Inspector.

1. Type CheckBoxFrm in the Instance Name text box.
2. Type CheckBox in the Instance Name text box and in the Label text box. In the Initial Value parameter pop-up menu, select True.
3. Leave the default value set to right alignment. The label will be displayed to the right of the check box. Do not alter the Change Handler parameter. When you finish, the Property Inspector should look like the picture on the following page.

Figure 8.43 *The completed check box Property Inspector*

The ActionScript Dictionary in the Flash MX Help files has more information on using API methods to change properties, see the listing for FCheckBox (component).

Configure the List Box

The ListBox component lets you add scrollable single and multiple-selection list boxes to Flash movies. Select the ListBox component on the stage. Its parameters are displayed in the Property Inspector.

1. Type ListBox in the Instance Name text box and type ComboBox in the Label text box. Do the same for CheckBox, ListBox, ScrollPane.
2. Type ComboBoxFrm in the Value text box. Do the same for CheckBoxfrm, ListBoxfrm, ScrollPanefrm. The Select Multiple should be set to false.
3. Select frame 45 on the Components layer, then select the ListBox component on the stage. Its parameters are displayed in the Property Inspector.
4. Select True for all the buttons. The Label Placement should be set to right alignment. Do not put in anything for the Change Handler parameter. When you finish, the Property Inspector should look like the picture below:

Figure 8.44 *The completed list box Property Inspector*

The ActionScript Dictionary in the Flash MX Help files has more information on using API methods to change properties, see the listing for FListBox (component).

Configure the Scroll Pane

Use the ScrollPane component to create a window for scrolling around a movie clip.

1. Select the ScrollPane component on the stage. Its parameters are displayed in the Property Inspector.
2. Type ScrollPane Contents in the Scroll Contents text box. In the Drag Content box set false to change the view using the scroll bars and set horizontal and vertical scrolling to auto.

3. Do not put in anything for the Change Handler parameter. When you finish, the Property Inspector should look like this:

Figure 8.45 *The completed scroll pane Property Inspector*

The ActionScript Dictionary in the Flash MX Help files has more information on using API methods to change properties, see the listing for FScrollPane (component).

Configure the Push Buttons

Select the PushButton component in frame 1, its parameters are displayed in the Property Inspector.

1. Type Go! in the Property Inspector Label text box. This text is displayed in the body of the button.
2. Type jumpToFrame1 for the Click Handler name. You will write the Handler later. When you are finished, the Property Inspector should look like this:

Figure 8.46 *The push button Property Inspector*

3. Select the PushButton component in frame 15. Do the same as above for the label and type jumpToFrame2 for the Click Handler name.
4. Select the PushButton component in frame 30. Do the same as above for the label and type jumpToFrame3 for the Click Handler name.
5. Select the PushButton component in frame 45. Do the same as above for the label and type jumpToFrame4 for the Click Handler name.
6. Select the PushButton component in frame 60. Do the same as above for the label and type jumpToFrame5 for the Click Handler name.

The ActionScript Dictionary in the Flash MX Help files has more information on using API methods to change properties, see the listing for FPushButton (component).

ActionScript for the Movie

ActionScript for components is placed in keyframes. The Click Handler parameter specifies what happens when the PushButton component is activated. The values are set to jumpToFrame*, which means that when the user clicks on a push button, it is activated. You will begin by creating a function for jumpToFrame1.

1. Create a new layer and name it ActionScript. This will be used for ActionScript that should run throughout the movie. If the Actions panel is not open, choose Window > Actions.
2. Switch to expert mode by pressing Control+Shift+E (Windows) or Command+Shift+E (Macintosh), or by clicking the control in the upper right corner (a triangle with a check mark above it) and selecting Expert Mode from the pop-up menu.
3. Enter the Submit button handler in frame 1. Enter the following code in the ActionScript layer:

```
stop(); // This stops the movie from playing on
// This function is called as the 'Click Handler' function of
// the 'Go!' PushButton.
function jumpToFrame1() {
    // Use the getValue() function of the ComboBox to get
    // the value of the currently selected item.
    var next_frame = _root.FrameSelector.getValue();
    gotoAndPlay(next_frame);
}
```

4. Enter the Submit button handler in frame 15. Enter the following code in the ActionScript layer:

```
stop(); // This stops the movie from playing on
// This function is called as the 'Click Handler' function of
// the 'Go!' PushButton.
function jumpToFrame2() {
    // Use the getValue() function to get the value of the
    // currently selected radio button.
    var next_frame = _root.RadioGroup.getValue();
    gotoAndPlay(next_frame);
}
```

5. Enter the Submit button handler in frame 30. Enter the following code in the ActionScript layer:

```
stop(); // This stops the movie from playing on
```

```
// This function is called as the 'Click Handler' function of
// the 'Go!' PushButton.
function jumpToFrame3() {
    // Using the getValue() function of each CheckBox, this
    // function checks each checkbox in turn and jumps to its
    // associated frame.
    if (_root.ComboBoxChk.getValue()) {
        gotoAndPlay("ComboBoxFrm");
    } else if (_root.RadioButtonChk.getValue()) {
        gotoAndPlay("RadioButtonFrm");
    } else if (_root.ListBoxChk.getValue()) {
        gotoAndPlay("ListBoxFrm");
    } else if (_root.ScrollPaneChk.getValue()) {
        gotoAndPlay("ScrollPaneFrm");
    }
}
```

6. Enter the Submit button handler in frame 45. Enter the following code in the ActionScript layer:

```
stop(); // This stops the movie from playing on
// This function is called as the 'Click Handler' function of
// the 'Go!' PushButton.
function jumpToFrame4() {
    // Use the getValue of the ListBox to get the
    // value of the currently selected list item.
    var next_frame = _root.ListBox.getValue();
    gotoAndPlay(next_frame);
}
```

7. Enter the Submit button handler in frame 60. Enter the following code in the ActionScript layer:

```
stop(); // This stops the movie from playing on
// This function is called as the 'Click Handler' function of
// the 'Go!' PushButton.
function jumpToFrame5() {
    // This uses the same method as on Frame 1 to
    // use a combo box to navigate the movie.
    var next_frame = _root.FrameSelector2.getValue();
    gotoAndPlay(next_frame);
}
```

Now test your movie...

Chapter 9
ActionScript-driven Animation Techniques

This chapter deals with ActionScript-driven animation, and the techniques that go into building code-driven effects. The chapter consists of twenty examples, all of which can be plugged into your movies to create animation effects but at the same time taking a minimum of file size. Use this chapter to learn how to add a whole new range of effects and interaction to your movies.

ActionScript-driven animation techniques

Computer-based animation has developed along two lines, frame-based animation, and the script- or code-driven animation. This chapter covers code-driven animation generated using ActionScript, and will teach you the fundamental techniques for editing and generating this code.

The Flash timeline allows you to create very sophisticated animations without having to deal with the code that lies behind them. However, sometimes there are benefits to getting in there and using code to generate your animations. ActionScript-driven animation is fundamental to Flash games, and can generate some amazing text effects and dynamic animations that the user can control! The animator can also benefit from ActionScript, using code to automate repetitive tasks. For this chapter the team at Sprite Interactive have created useful movies that can be easily pulled into your project.

The development of code-driven animation, particularly in Flash, has opened up whole new realms of possibility for designers and programmers alike, and we have recently seen a move away from the conventional tweening techniques towards code-based techniques. Code-based techniques can produce a wide range of results, ranging from the artistic to the mechanical; the results are always computer generated but with a little imagination can be stunning. Traditional frame-by-frame animation can also be combined with code-driven animation to make your animations run more smoothly and create unique effects, and you can also easily model physical behaviours, such as gravity. Using code-driven animation animators are now not limited to traditional animation techniques, and can create complicated effects with just a basic knowledge of the methods used. Code-driven animation can be as small as 3% when compared to a similar frame-driven animation. This is great for delivery over a telephone line or playback on a PDA.

Before Flash, code-driven animations had to be written in a lower-level languages such as C and Java, which needed a lot more programming expertise, were less robust (particularly Java) and took a lot longer to write. With the development of ActionScript, a high-level language, a lot of the hard work is already done for you, for example you do not have to tell it how to move an asset, you just have to tell it where to put it. ActionScript also has a robust structure to code around (the Flash Interface) which makes it much easier to get to grips with.

Code-driven animation consists of a number of static elements that use a function to move over a mathematically generated path. The beauty of code-driven animation lies in its flexibility, and the parameters of the animation can easily be changed to manipulate your animation without having to redraw it. Code-driven animation is also very memory-friendly, and only needs the space needed to store the lines of code. You can also reuse lines of code in other code-driven animations, making them very efficient. The fact that you can reapply your code also means that you can easily use a favourite technique over and over without having to redraw all the frames. Our examples are a source of extra functionality for your animations, and give sophisticated results with minimum fuss and effort.

In this chapter we have compiled twenty ActionScript-driven animations, and have provided commentary on the code, so that you can plug them into your Flash projects and customise them to play in any way you like. We have also included a storyboarding movie that will help you organise the way you plan your animations.

You can experiment with the examples in the rest of the chapter. Remember you can edit these in any way you like to fit them into your movies. Have fun!

The ActionScript-driven Animation Movies:

Preloader – learn how to add a preloader to your movies, invaluable if you are creating large animations.

Cursor – we show you how to change the appearance of the cursor in your animations.

Sparkler Effect – create fireworks that follow your mouse pointer around the screen.

Magnifying Glass – a great magnifying glass example to magnify the background of your movies.

Starfield – a classic space starfield effect that you can plug into your movies.

Parallax Scrolling – we demonstrate how to create parallax effects.

Collision Detection – learn how to build collision detection into your movies and animations.

Movie Controller – add a dynamic controller to your movies.

Bug - create bugs that crawl around the screen.

Sparkle – the classic Disney wand sparkle, attached to your cursor.

Dancing Lights – a nice animated effect to generate fading lights all around your screen.

Snow – a plug in and play snow effect.

Bubbles – plug this effect into your animation to create bubbles rising to the top of the screen.

Gravity Footballs – real gravity created by ActionScript.

Wobble Buttons – make your buttons wobbly.

Spiral – a piece of ActionScript code that makes objects spiral around a set point.

Orbit – a simple way to create complex orbit effects.

Earthquake – make the screen shake like an earthquake.

Moving Eyes – eyes that follow your mouse pointer around the screen.

Storyboard – a useful tool for laying out storyboards for your movies.

Preloader

A preloader is a separate scene at the start of your movie (usually a looped animation) that uses a simple piece of ActionScript to check if the rest of the movie is loaded; once it has detected that the movie is loaded it begins playing the rest of it. Most Flash movies contain actions, sounds and images, which means a large file size. A preloader is essential if you are creating large Flash animations, and is very easy to create.

You can check whether your movie needs a preloader by selecting the View>Show Streaming command when you test your movie from within Flash, and then turning on the Bandwidth Profiler, by selecting View>Bandwidth Profiler. If there are bars, which denote content in each individual frame, over the red line, which denotes the streaming threshold, then the movie will not stream properly and will need a preloader so that it does not skip or hold up when it is playing.

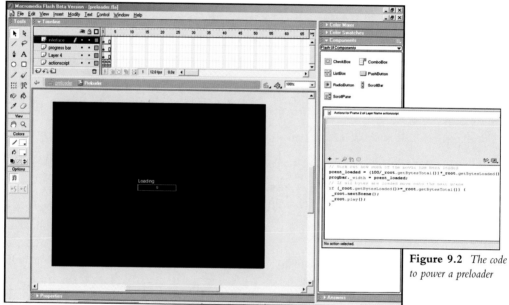

Figure 9.2 *The code to power a preloader*

Figure 9.1 *An example preloader*

To make a basic preloader all you need to do is create a twenty frame animation loop (this can be longer or shorter), and at the beginning of this loop insert a script to check whether the last frame in the last scene of the movie is loaded, if it has then it begins playing the next scene. At the end of this loop you insert ActionScript to loop the playhead back to the start of the preloader. This has the effect of looping the animation while the rest of the movie is streaming behind it, when the last frame in the movie has streamed through the preloader goes on to play the next scene.

The example we have written contains a progress bar. This checks how much of the movie has loaded, by using the getBytesTotal command, and then shows that much progress on the bar. All you need to do to plug this into your movie is to create a new scene at the start of your movie and drop the Preloader movie clip in. Check out the Preloader.fla file on the CD.

Cursor – Standard Change of Cursor

Changing the appearance of the cursor is a great way to make your movies and animations more visually appealing. It is also very simple. All you need to do is drop the "Change Cursor" movie clip into your movie, and the cursor will change. Updating the graphic is also easy, all you need to do is change the graphic in the "Change Cursor" movie clip.

The ActionScript in this example, Cursor.fla on the CD, first of all hides the mouse, and then locks the "cur" movie clip onto the mouse, it then uses the startDrag command to drag that movie clip around the screen. The code looks like this:

```
Mouse.hide();
cur._x = _xmouse;
cur._y = _ymouse;
startDrag (cur, true);
```

Figure 9.3 *Embedding a movie clip into the cursor*

Sparkle

This animation creates a sparkler effect around the mouse pointer that follows it around and slowly dissipates towards the bottom of the screen. The sparkles generated are a random size and fall away from the pointer at a random speed, which are both fully customisable. To change the sparkle graphic open the "Sparkle Graphic" movie clip, and make any graphical changes you want. The sparkles appear at a set rate, which is not updateable, and they fall at a set speed. To integrate the sparkler with your movie all you need to do is drag the "Sparkler" movie clip from the library onto the stage and it will automatically work. The variables that dictate what the Sparkler looks like are as follows, and can be found in the first keyframe of the "Sparkler.fla" movie clip on the CD:

```
FireworksShow = 0;
gravity = .98;
xspeed = 3;
yspeed = 6;
zspeed = 10;
dustsize = 3;
dustinstances = 3;
rotation = 360;
startDrag ("MouseDrag", true);
stop();
```

Figure 9.4 *The sparkler movie clip*

190

Magnifying Glass

A magnifying glass is a fun tool that you can feature in your animations. For example, it could be used for a game where the user has to find certain hidden objects around a picture using the magnifier. In the example we have provided you can magnify the Ellen and Zak web site homepage.

Figure 9.5 *Magnified and unmagnified images*

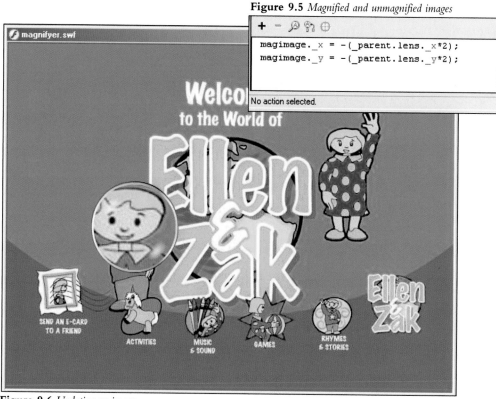

Figure 9.6 *Updating an image*

The magnifier works by taking the picture you are magnifying, putting it through the lens, which acts as a mask over the first image, blowing the image up to twice its size, and creating a magnified effect. It is quite a simple process, but is hard to get the picture positioning exact, so you can't move the picture around. To update the picture being magnified all you need to do is go into the library, select the image, which in this case is image.jpg, and bring up its Properties dialog box, then select the Import button and choose the image you would like to magnify – the size of the image should be 640 X 480. Check out Magnify.fla on the CD.

The ActionScript featured in the movie is very simple, and consists of a small piece of script to tell the movie to make the cursor invisible and to make the lens draggable, and actions in the lens movie clip to set two variables that tell it to magnify the picture by two times:

```
magimage._x = -(_parent.lens._x * 2);
magimage._y = -(_parent.lens._y * 2);
```

Starfield

A starfield is a nice effect that can add a great sense of depth to your movies if you are building space animations. Check out Starfield.fla on the CD, the "Star Field" movie clip can be dropped straight onto your movies, and only requires a small amount of tweaking to work in any size of movie. The star graphic is a tweened animation that is called "Moving Star", which can be found in the "Star Field Assets" folder in the library. You can change the graphical assets in this animation to make the stars in the starfield appear however you would like.

To see the ActionScript that drives the movie open the "Star Field" movie clip in editing mode and then select keyframe 1 of the actions layer. Here you need to set the width and height of the movie you will be dropping the starfield into, and the rest of the calculations are done for you. The ActionScript looks like this:

```
// Set the width and height of your
movie here
moviewidth = 550;
movieheight = 400;

//--------
n=0;

// calculate global centre point
centrePoint = new Object();
centrePoint.x = Math.round(moviewidth/2);
centrePoint.y = Math.round(movieheight/2);
globalToLocal(centrePoint);
```

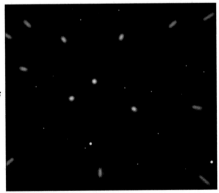

Figure 9.7 *The Starfield code*

```
if (n == 50) {
  n = 0;
  removeMovieClip("star" add n);
}

duplicateMovieClip("star","star" add n, n);
this["star" add n]._x = centrePoint.x;
this["star" add n]._y = centrePoint.y;
this["star" add n]._rotation=random(360);
n++;

star._visible = false;
```

Figure 9.8 *The Starfield*

Parallax Scrolling

Parallax scrolling is the effect one sees when looking at a scrolling series of "layers" scrolling at different speeds. Each layer represents a distance from the viewer (the foreground, the background, far in the distance, etc.). As the entire view "scrolls" or moves in a 2-dimensional direction (no depth movement), the layers scroll at a different speed. The farther away from the viewer a layer is supposed to be, the slower it will scroll. This creates the illusion of depth. Parallax scrolling is used extensively in computer games, you can see the example in Parallax.fla on the CD.

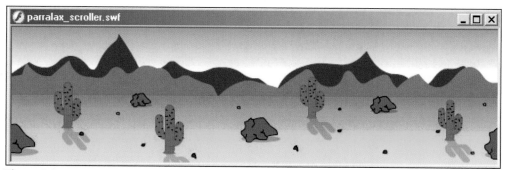

Figure 9.9 *The background to our parallax scrolling example*

The beauty of parallax is that you can place a movie clip of a character moving in the foreground, and then change how fast it moves simply by speeding up or slowing down the speed of the scrolling. The example in this chapter uses a desert scene that can easily be modified, all you need to do is change the graphics in each movie clip that makes up the scene. There are four movie clips, Background, Far, Middle and Near, and you do not have to change the code to change the background, just the graphics. You will notice that the three levels of the scene all move at different speeds, this variable is set in the first frame of the Parallax Background movie clip. The movie clips are tiled across the screen, and the second frame of the movie clip sets each level of the scene to start its movement again if it has moved half way across the main scene. The script to drive the scrolling is to the right.

```
// If the far background has moved
half way, start it again
if (bg._x < -(bg._width/2)) {
   bg._x = -far_speed;
   } else {
   bg._x -= far_speed;
   }

// If the near background has moved
half way, start it again
if (bg1._x < -(bg._width/2)) {
   bg1._x = -mid_speed;
   } else {
   bg1._x -= mid_speed;
   }

// If the foreground has moved half
way, start it again
if (bg2._x < -(bg2._width/2)) {
   bg2._x = -near_speed;
   } else {
   bg2._x -= near_speed;
   }
```

Collision Detection

Collision detection is particularly useful if you are building games or animation where you want the movie to be able to detect collisions between objects. There are several ways to detect collisions, the most common uses the hitTest() method to detect whether one movie overlaps another and therefore collides. More advanced trigonometry can also be used to accurately detect collisions between particular parts of an object. The demonstration here is not a plug-in-and-play type example, it demonstrates the principle of collision detection, so that you can learn how to integrate it into your movies. It is called Collision.fla on the CD.

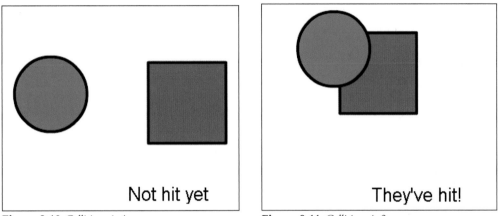

Figure 9.10 *Collision pic 1* **Figure 9.11** *Collision pic 2*

Our example uses the hitTest() method to check whether two movie clips, a square and a circle, have collided. The ActionScript to drive the example is stored on the "object 1" movie clip (the circle) and it simply uses the hitTest() method to check whether "object 1" has collided with "object 2", if it has then it tells the "status_text" text box to display the "They've hit" text. The ActionScript embedded in the circle movie clip looks like this:

```
onClipEvent (enterFrame) {
    if (hitTest(_root.object2)) {
        _root.status_text = "They've hit!";
    }
}
```

This example is very simple, but clearly demonstrates the basics of collision detection, and you can customise and use this technique throughout your movies and animations.

Movie Controller

The movie controller is a simple movie clip that can be added to any movie, and allows you to dynamically control the movie while it is playing. A movie controller is particularly useful if you would like the user to be able to control an animation while it is playing. It could be used, for example, if you have written a presentation in Flash that you would like the recipient to be able to control. You can use the movie controller in any movie simply by dragging it from the library and positioning it on the stage. The movie controller uses all the scenes and frames in the movie to calculate the position of the playhead, and if you want to use it in a movie with multiple scenes you will have to place it in every scene of the movie. Check out MovieController.fla on the CD.

The movie controller works firstly by calculating the number of frames there are in the movie, and applying these to the length of the dragbar to the left of the controller. The controller then sets up the actions for each of the buttons on it, backwards, rewind, fast forward and pause, and then tells the dragbar how to work out which frame to go to when it is dragged (the current frame of the movie multiplied by the pixels_per_frame variable). To tell each button to work each one has a value of 1 or 0 applied to one of the four modes of play (backwards, rewind, fast forward and pause), which turns that mode on or off.

You can easily change the graphical appearance of the movie controller by updating the graphics that make up the buttons. The ActionScript to drive the play and fast forward buttons is shown below:

```
on(release) {
        rewindmode = 0;
        fastforwardmode = 0;
        backwardsmode = 0;
        pausemode = 0;
}
on (release) {
        rewindmode = 0;
        fastforwardmode = 1;
        backwardsmode = 0;
        pausemode = 0;
}
```

Figure 9.12 *Movie controller in a movie*

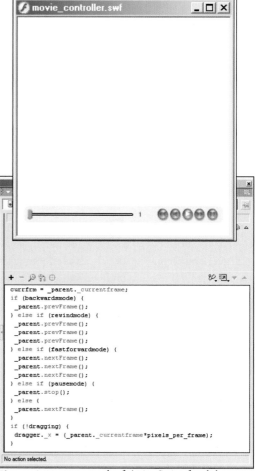

Figure 9.13 *Screen grab of ActionScript for slider*

Animated Bug

This fun code-driven animation allows you to put bugs into your movies that move around the screen in a random manner, it is called Bug.fla on the CD. The bug graphic is a simple two-frame animation of the bug moving, and the ActionScript in the "crazy bug" movie clip makes the bug move around screen in a random way. It is easy to update the bug graphic, just open the "bug" movie clip in editing mode and edit.

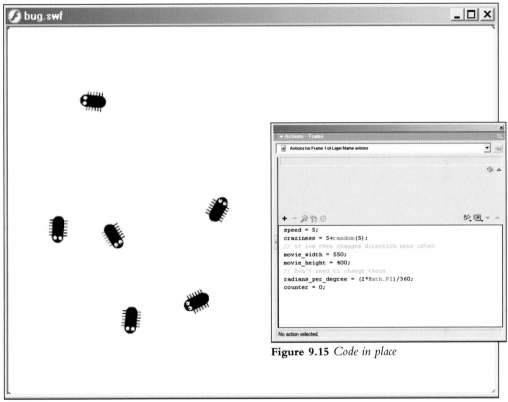

Figure 9.15 *Code in place*

Figure 9.14 *Movie showing crazy bugs*

The ActionScript that powers the bug can be found in the "crazy bug" movie clip, in the "actions" layer. The first keyframe controls the random movement of the bug, and you can set the speed, which controls how fast the bug moves, the craziness, which controls how crazy the bug's movement is (how often it changes direction) and the movie width and height, which controls the bounding box for the bug's movement. The ActionScript looks like this:

```
speed = 5;
craziness = 5 + random(5); // if low then changes direction more often

movie_width = 550;
movie_height= 400;

// Don't need to change these
radians_per_degree = (2 * Math.PI) / 360;

counter = 0;
```

Sparkler Effect

This little piece of code-driven animation creates fireworks that follow the mouse pointer around the screen; check out Sparkle.fla on the CD. All you need to do to integrate the effect into your movie is to drag the Fireworks movie clip onto the stage and it will automatically work. The fireworks are created in a movie clip called "animated firework" that can be found in the Firework Assets folder in the library. The "animated firework" clip can be modified so that the mouse pointer "sparkles" in any way you like, all you need to do is open the Fireworks movie clip in editing mode and change the graphic asset that it tweened in the small sanimation loop.

The ActionScript in the movie duplicates the Firework movie clip and sets it to play at a random angle, therefore creating the "sparkling" type effect. This ActionScript can be edited, but it is so simple and so effective that it is not really necessary. It is as follows:

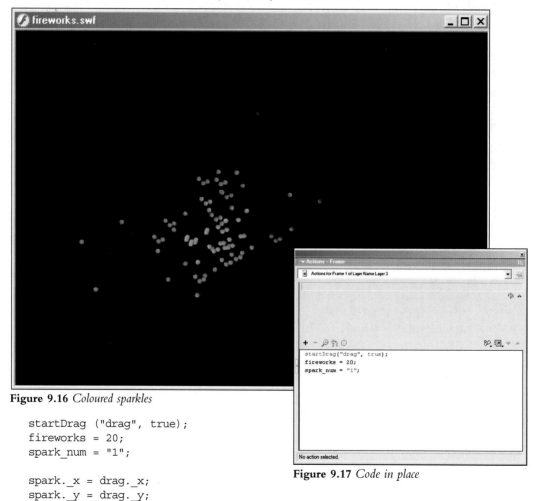

Figure 9.16 *Coloured sparkles*

Figure 9.17 *Code in place*

```
startDrag ("drag", true);
fireworks = 20;
spark_num = "1";

spark._x = drag._x;
spark._y = drag._y;
duplicateMovieClip ("spark", "spark" add spark_num, spark_num++);

if (spark_num<fireworks) { gotoAndPlay (2); }
```

Dancing Lights

This is a great piece of code-driven animation that generates a preset number of lights that dance and fade into the distance; this could be used as an introduction for an animation, or to add a visually appealing effect to your animation. Look at DancingLights.fla. To use the dancing lights as an effect all you need to do is drag as many instances of the "Dancing Lights" movie clip onto the stage as you want, they will then play when the playhead passes over the movie clip.

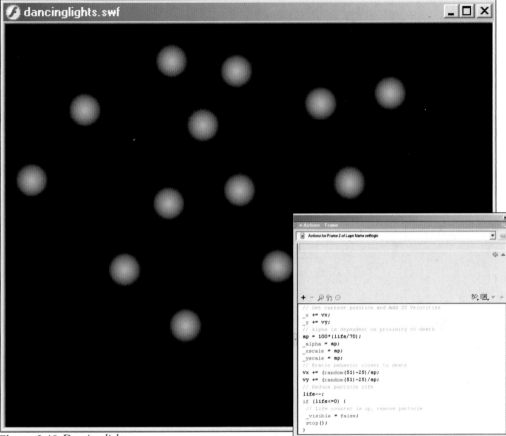

Figure 9.18 *Dancing lights* **Figure 9.19** *Code in place*

The graphics of the dancing lights can easily be changed by opening the movie clip in editing mode and substituting the "dust" graphic for your own. The ActionScript that drives the lights can also be edited. You will find this script in the actions layer of the "Dancing Lights" movie clip, the first keyframe sets the direction of the light, the x and y values, and also sets the lifespan of the lights, the higher number you enter here, the longer it takes to "die". The rest of the script in the other two keyframes of the actions layer generates random behaviours for the lights, so there is no need to edit these as the results are random anyway. The actions you can edit look like this:

```
vx = (random(3)-1)/5;   // Give the light a random direction
vy = (random(3)-1)/5;   // Give the light a random direction

life = 70; / /Set number of loops particle will live for
```

Snow

This handy snow effect can be plugged into any movie simply by dragging the Snow Generator movie clip onto the stage. The snow falls down the screen randomly, and follows a sine wave to give a wavy snowing effect. Check out Snow.fla on the CD.

The ActionScript that controls how the snow falls can be updated depending on the movie size and how much snow you want to fall. The actions for the Snow Generator can be found in the first keyframe of the actions layer of the Snow Generator movie clip. You can alter the amount of snow by entering a value for the amount_of_snow variable and the snow_speed variable controls how fast the snow falls, handy if you want to whip up a snowstorm! The movie dimensions in the ActionScript should be set to the height and width of the movie you are putting the effect into and you can change the sine values to affect how the snow falls.

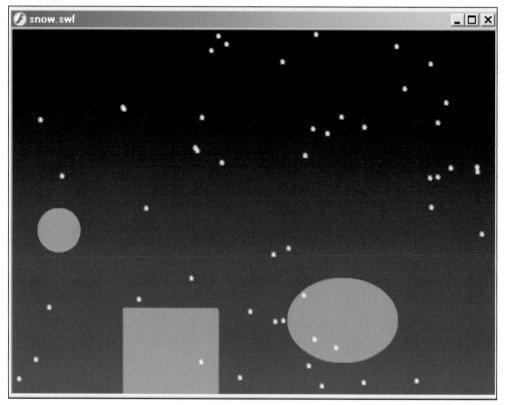

Figure 9.20 *Snowstorm*

The ActionScript that you can edit looks like this:

```
amount_of_snow = 50; // This sets the amount of snow
snow_speed = 2; // This sets the speed that the snow falls
movie_width = 550; // Movie dimensions
movie_height = 400;
sinTable = new Array(movie_height);    // Precalc SIN values, speeds things
up a little for (i = -movie_height; i < movie_height; i++) { sinTable[i] =
Math.sin(i/8); }
```

Bubbles

The bubble effect is very similar to the previous snow effect, but creates bubbles that rise up the screen and increase in size and fade out as they approach the top of the stage. Like the snow effect you can drag and drop the Bubble Generator from the library onto the stage to integrate the effect into your movie. Look at Bubbles.fla on the CD.

The ActionScript that drives the bubble effect works in the same way as the snow effect, and you can change the variables in the same way, the ActionScript to control the bubbles can be found in the first keyframe of the actions layer of the Bubble Generator movie clip. The number_of_bubbles variable sets the number of bubbles that appear on the screen at once, the bubble_speed controls how fast the bubbles move up the screen, and you need to set the dimensions of the movie you are inserting the bubbles into to make the effect work properly. You can also change the sine values to affect how the bubbles travel up the screen. The ActionScript that you can edit looks like this:

```
number_of_bubbles = 50; // This sets the number of bubbles
bubble_speed = -2; // This sets the speed that the bubbles rise

movie_width = 550; // Movie dimensions
movie_height = 400; // Movie dimensions

// Precalc SIN values, speeds things up a little
sinTable = new Array(movie_height);
for (i = -movie_height; i < movie_height; i++) {
sinTable[i] = Math.sin(i/16);
```

Figure 9.21 *Bubble effect*

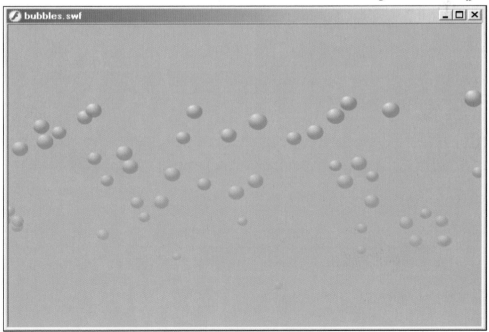

Gravity Footballs

Creating a gravity effect using ActionScript is a great way to animate objects without using complicated motion guides or paths. Have a look at Gravity.fla on the CD. You can add this football to your movie simply by dragging the "Football" movie clip from the library onto the stage and you can easily change the graphical appearance of the football object by changing the graphic asset in the "Ball" movie clip that is situated in the "Football Assets" folder.

The ActionScript that powers the animation is found in the first three keyframes of the actions layer of the "Football" movie clip. If you open the actions for the first keyframe of the actions layer you will see all the editable areas. You can set the vertical velocity of the ball, to control how fast it falls towards the ground, the horizontal velocity of the ball, which runs from left to right, so if you want the ball to travel right you have to enter a minus figure (as you can see from the default entry). The next area sets the radius of the ball, and then the strength of the gravity; try entering different settings into here to see how gravity affects the ball. The bounciness of the ball is controlled in the next part of the script, ranging from 0.1 to 1.0, and the last area of editable script is to set the movie dimensions, which make sure the Football fits in with the movie you are dropping it into. The script looks like this:

```
// Vertical velocity
yv = 0;

// Horizontal velocity
xv = -2;

// Radius of ball
radius = ball._height / 2;

// Gravity
gravity = 10;

// How bouncy the ball is 0 - 1
(really bouncy)
bounciness = 0.8;

// Movie dimensions
moviewidth = 550;
movieheight = 400;
```

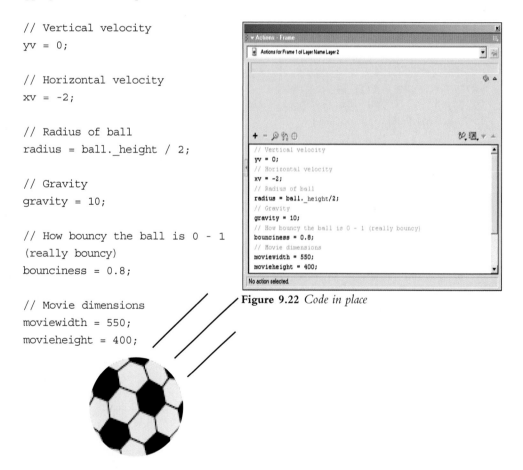

Figure 9.22 *Code in place*

Wobble Button

The wobble button is a function that creates wobbly buttons. Buttons are essential if you are building interactive movies, where the user can either navigate around or make decisions on screen. The wobble button is a fun tool that would be perfect for creating fun buttons on a web site or on a kids' game. You will see the effect of the wobble button when you run your mouse pointer over it. Have a look at WobbleButton.fla from the CD.

You can also easily change the graphics that make up the button by just going into the actual button and changing the graphical assets. The script that runs the wobble buttons is fairly simple, it sets a number when you roll over the button that it increases its size to, and then sets another number as you move the mouse pointer away from the button to decrease the size of the button. The numbers to set the size of the button as the mouse rolls over it can be found in the "Wobbler" movie clip in the actions for the button, and you can experiment with changing them here. The actions on the "Wobbler" button are also where you put the interactivity for the button, and you can see the comments in the script explaining how to add interactivity to the on(release) handler. The most important thing to remember is that you have to reference the _root of the movie if you are adding interactivity, as the Wobbler button is a button within a movie clip within another movie clip and therefore is not on the top level of the main movie. The script is shown below:

```
on (rollOver) {
buttonTarget = 200;
}
on (releaseOutside, rollOut) {
buttonTarget = 100;
}
on (press) {
buttonTarget = 400;
}

// To add an action to the
button add the
// appropriate code to the
on(release)
// handler below.
on (release) {
    buttonTarget = 200;

// Example actions
// getURL(....)
// _root.gotoAndPlay(...)
}
```

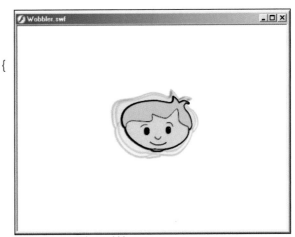

Figure 9.23 *The wobble*

Spiral

The spiral example is a nice piece of ActionScript code that you can use to create a spiral effect (such as water draining down a plughole) without having to line up awkward tweens. It is Spiral.fla on the CD. The spiral movement is actually generated by ActionScript; all you need to do is attach the movie clip that you want to spiral in the code.

To change the settings for the spiral you need to click on the spiral movie clip (represented by a small spiral graphic) on the top level of the movie and open the ActionScript panel. You can then change four different settings: you can set the angle of the spiral, the speed of the object spiralling (the higher the faster), the radius of the spiral, which sets how far out the spiral actually starts, and how tight the circular motion is (from one to ten), which sets how many times it will spiral before stopping. In this section you also set which movie clip is attached to the spiral, the default movie clip is "test", but this can easily be changed simply by taking the movie you want to attach into the library and referencing it from this point. The ActionScript that you can edit is shown below:

```
// The direction of movement
direction = "ccw";
// either cw or ccw
// The radius of the sprial
radius = 100;

// The speed that the movie
moves
speed = 6;

// This sets how tight the
spiral is.
// 1 - very loose, 10 - very
tight
tightness = 3;

// This sets the initial angle
the movie clip
starts at:
// 180 - top
// 90  - right
// 270 - left
// 0,360 - bottom
angle = 180;

// The movie clip to animate
movieclip = _parent.test;
```

Figure 9.24 *Spiral code*

Orbit

The orbit example is a simple way to create complex orbit effects. The example file, Orbit.fla from the CD, contains the "sun" with the "earth" orbiting around it, and the "moon" orbiting around the earth. To set up an orbit first of all drag the "Orbit Generator" onto the stage and open its actions panel. You will see a number of areas that can be changed to affect how the orbit function works, the movie clip that is referenced in the "movclip" field is the movie clip that is being orbited around, and the "movclip2" field is the movie clip that is orbiting. You can then set a number of variables in the same actions panel: you can set the angle of the orbit, which is the angle that the orbiting object starts at, the speed of the orbit (the higher the faster) and the radius of the orbit, which sets how far out the orbit begins. As you can see in the example movie you can set objects to orbit around others that are moving across the screen, which can lead to some stunning effects, and you can put as many orbits on the screen as you like. The areas of the ActionScript that you can edit are outlined below:

Figure 9.25 *Objects for orbit*

```
// direction = "ccw";
// The direction of movement
(either cw or ccw)

// radius = 100;
// The radius of the orbit

// speed = 6;
// The speed of the orbit

// angle = 180
// This sets the initial angle
the movie clip starts at:
// 180 - top
// 90  - right
// 270 - left
// 0,360 - bottom

// movclip = "earth"
// The name of the movie clip to
orbit around

// movclip2 = "moon";
// The name of the movie clip to
animate (must be quoted as a
string)
```

Earthquake

This is a handy piece of ActionScript that makes your movies "quake" when it is placed on the stage with them, great if you want to simulate an earthquake effect. Have a look at Earthquake.fla on the CD. To use all you need to do is place the "quake?" movie clip into your animation and then it will work automatically. The ActionScript that you can edit can be found on the "Earthquake Generator" movie clip, which looks like a zig-zag. On this clip you have to tell the generator which movie clip to "quake"; this has to be the instance name of the clip, which you set in the properties panel, and you also have to specify the richter_scale of the earthquake, the higher this setting is the faster the object will vibrate.

Moving Eyes

A fun pair of moving eyes that follow your mouse pointer around the screen. See MovingEyes.fla from the CD. These eyes are part of a whole face, which can be edited in any way you like simply by editing the "face" graphic. The eyes are a movie clip called "creepy eyes" that can be dropped into your movie to make them work. The ActionScript that drives the example is quite complicated, and can be found on the actions layer of the "creepy eyes" movie clip. It uses trigonometry to track the cursor and point the pupil of the eye towards the pointer, whilst at the same time keeping it inside the boundary of the eye.

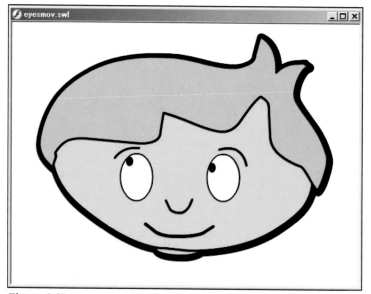

Figure 9.26 *Eyes move by following the cursor*

Storyboard

This is not a code-driven animation as such, but is a very useful tool for laying out your storyboards, it is also very simple. To build a storyboard you set up each individual scene as a slide of your storyboard. Each movie clip for each scene is stored in the library. We already have up to twelve scenes worth of storyboards pre-prepared for you in the library, but you can easily create your own, just follow the naming convention that is already in place. All you then need to do is drag and drop the relevant movie clip onto the relevant scene of the movie, e.g. Scene 1 Storyboard should be dropped onto scene 1 of your movie. The last scene of the movie is an overview of all the slides in your storyboard, and you can arrange this however you like, but we have provided a sample layout for you in Storyboard.fla on the CD.

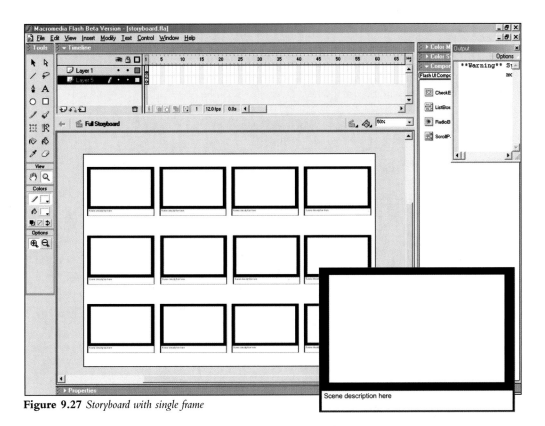

Figure 9.27 *Storyboard with single frame*

Chapter 10
Dynamic Animation

Dynamic animation is a unique system that starts where database-driven sites have left off. This chapter talks about object oriented scripting, and how you can use it in your animations to create new levels of interactivity for the viewer.

Narrative that Responds to User Interaction

Computer animation is the main source of animation for multimedia applications. Typically, an excerpt of animation is synchronised with some event, which may be machine initiated or user initiated. Other media, such as sound or digital video, may also be played back to the user. Elaborate documents, such as interactive CD-ROMs, can be constructed using such mechanisms. In general though, these applications simply present pre-recorded media to the user. This chapter will explore techniques that allow the expression of a narrative that is capable of responding to user interaction, by generating media dynamically in response to that interaction.

Originally web pages were, for the most part, static files – that is, once you loaded them, they stayed the same. This is inherent in hypertext markup language (HTML), the basic programming language of web pages. HTML basically consists of simple tags that tell a web browser where to display web page elements. As the Internet continued to evolve web designers found this static quality fairly limiting, as for the animator the only opportunity of expression was through the crude system of gif animation. Designers wanted to add dynamic content to their web sites, content that could change once the user had already downloaded a particular web page.

Figure 10.1 *A static HTML page*

Dynamic HTML, or DHTML, is the term for the software technology that makes this possible. DHTML content is actually produced by using a number of complex scripting languages, such as JavaScript, to access the document object model on an Internet browser. Basically, the document object model (DOM) controls everything about how a browser displays a web page.

DHTML was not created with animation in mind, but it does let you alter HTML elements with the result of adding movement to a web page. A DHTML script can simply tell the browser to keep changing the placement of a particular image on the page, so it travels around the screen. If you do this with several different images, you can move a series of graphic elements around each other to make interesting movies.

DHTML is fairly limited in its animation applications, because all it can really do is move still images around on the screen. What is interesting with DHTML is the ability of the dynamic page to be updated from a database that personalises the viewable content.

Flash MX lays the groundwork for dynamic animation because ultimately it has a stage, a library and a scripting language that can be updated dynamically. The ability for the user to author their own navigation is probably the most exciting aspect of dynamic animation. For the designer animator the traditional script approach to storytelling has to be reinvented. One needs to change this approach and move from a script dominated story to a cast of characters that have behaviours around them, with the structure for the narrative being produced through the interaction of the environment and each character's personality. In our

Figure 10.2 *Ellen and Zak*

exploration of these methods we have created a library of behaviours for both Ellen and Zak.

It is possible to oversimplify the problem by only creating two potential roots for the experience, but then, once a decision has been made by the user to bring Zak on stage, the interaction becomes very limited. One way of overcoming this problem is by ensuring that exploring the stage set or environment becomes a rewarding experience; combine this with moving characters and randomness within the movement and the virtual experience comes alive.

The first step towards creating an interesting story for a set of characters is to understand the constraints of both your resource and the Flash environment. One set of constraints comes from the character's environment. The size of the house that Zak lives in, for example, would create complex and interesting situations based on the size of the characters and their movement inside

the house. Once you have resolved the stage, or environmental problems, of your character you need to make your characters interact with each other, encourage exploration, and maintain interest in the characters. Your characters should act and interact in such a way that they generate continuous change.

At times the complexity of plot lines can make users remove characters from the stage. To overcome this the designer needs to develop characters that are attracted by some situation, yet repulsed by either crowds or other characters; this repulsion then beomes the character walking on and off stage. By avoiding a large number of character requirements or simultaneous interactions you remove the possibility for the user to be totally overcome with plot situations. From a design perspective this allows the designer to focus the interest of the visitor.

Identifying the behaviour features of your characters can be done through a process of identifying the drives or goals of each character and then visualising this behaviour into a series of movies. Once you have sketched the personalities of each of your characters the next step is prioritising goals, behaviours and determining their necessary conditions. For example, Ellen occasionally flies. This has a fairly high priority in her character make-up, but the motivation should be reduced to stop this act becoming infinite, so we extend this feature by making her fly round the stage only once. The growth of the Flash library means that we had to create subsections of the library to allow for the difference between environment architecture and behaviour.

Figure 10.3 *Ellen flying*

In designing an interactive experience the goal is to provide both interesting media for expressing the content to be authored and tools that facilitate the re-authoring. The richness of this kind of user experience is still based around a handful of situations with limited opportunity for true authorship by the user.

An environment for testing the process of user authoring is the Tomagachi pet. The user is allowed direct control over the pet and its well-being but at the same time a level of randomness is introduced with the processor clock influencing the state of the pet. We have also introduced a

database feed that influences the pet's behaviour. The aquarium project on the CD, fishtank.fla, demonstrates the key principles of this.

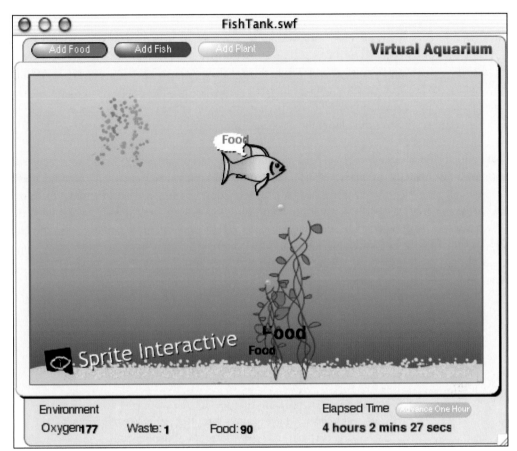

Figure 10.4 *The virtual aquarium*

This was an interesting project, and also illustrates many of the advanced features of Flash MX. We created an aquarium as a home to several kinds of living things. These include fish and plants. The challenge is to stock the aquarium with numbers of fish and plants so that everything lives as long as possible.

The aquarium starts out full of clean and fresh water. The basic unit of time for the aquarium is the "hour". Twenty-four of these hours make one "day". The user needs to maintain a balance in the aquarium, proper maintenance of the environment, and proper care and feeding of the living things. Over time, the fish will become more and more hungry. In order to make the fish less hungry the user needs to feed them. Each unit of fish food makes one fish one unit less hungry, if a fish becomes too hungry, it will suffer and die. The fish consumes a random amount of food, and as a by-product of feeding your fish it produces "waste". Each unit of fish food eaten

will produce one unit of waste. If there is too much waste in the water the plants stop producing oxygen and the fish starve of oxygen. If you feed your fish too much food, the food will just sit there, decay, and will make all of your fish suffer. Plants are also an essential part of your aquarium. Fish waste is fertiliser for the plants; too little waste, and your plants will become "hungry" and will eventually die. There are a few things that you can do to help maintain the health of your aquarium; add a fish/add plants/feed your fish.

Each hour you may do any number of these things. Of course, you can't remove something that isn't there; you can add fifty fish and a hundred plants, or you may choose to do nothing at all. You can "advance one hour" every time you press the "advance one hour" button. When the hour advances, your fish will produce waste, and your plants will consume the waste. If something dies it will be removed from the aquarium. Your goal is to run your aquarium for the longest amount of time. The simulation ends when the last fish dies.

Some rules you need to be aware of:

- Each feeding will feed about ten fish.
- Feeding a fish that is not hungry makes that fish sick.
- Sick fish will not become less hungry with a feeding.
- The fish hunger scale is from 0 to 100. A fish at hunger 100 is not hungry. A fish at 0 is starving.
- Feeding the fish affects all fish equally, you can't feed a specific fish.
- Each fish will become 100 units hungrier at every hour.
- Each plant will consume one unit of waste making it one unit less hungry.

Note: if you run out of "waste", the plants that haven't eaten can't. All fish and plants that are at hunger level 0 will rapidly suffer, die and will be removed from the environment.

Understanding Interactive Authoring

There are two extremes for understanding interactive authoring: one based on an environment, this easily fits in with the cast, behavioural model. The other offers a multiplicity of scripts that the user unfolds:

1. Creating an environment or space. The interface of a building or a board is basically interactive; you move in it or around it. Activity is an integral part of its existence. The point of view is mobile and directional, not stable.

2. The viewer unfolds the story, but the author remains always in control; certain narrative is revealed only after other narrative. The reading is directed. To a large extent the activity of the user resembles exploration. The user's exploration is a creative act of rewriting a story already told by the author. The navigation, as open as it seems, occurs in a single and prescribed route; it is a statement the user realises rather than expresses.

The process of defining yourself as an author within this range or scale, choosing between creating open ground for the user's activity as in the aquarium or prescribing a more or less linear unfolding of the narrative, is the defining decision that is almost irreversible.

Personalised and Database-driven Web Sites

The ability to automate and personalise the creation of advanced Flash content offers huge potential. This potential is realised when an application server is set up to feed the personalised information to the user's web page. This process in the past has been described as dynamic. In reality the dynamism of this process is totally predictable, but the animator needs to understand the processes behind just such a system. Invariably, if a designer animator is found in a position where a client requests a slightly different content for different type of user, then they need the assistance of a SQL database designer and a jsp/asp programmer. You might be able to get away with using UltraDev for simple interfacing with the SQL database.

Macromedia until recently supported a product called Generator, this was like a mail-merge for Flash. This extra functionality is provided in the form of template authoring extensions to the underlying Flash program. A Flash movie is created in the usual way but with placeholders used for text and graphical elements. These placeholders are linked to variables in an external data source, and it is these variables that are used to generate the final SWF image. The set-up of the template involves considerably more work and planning, but updating the data source and generating a new Flash movie then become quick and simple. The most obvious use of a Generator template is in the production of a movie that needs to be regularly updated to show the latest headlines or share prices. The text placeholder is created simply by inserting the text as a variable name within curly braces, while the link to the data source is established with the Set Environment command in the new Template tab in the Frame properties dialog. The data source can be a comma-delimited text file, database or Java class and can be specified as a URL. The final movie could be tested using the Test Movie command to create a preview SWF file.

Using Shared Libraries

Generator has been superseded by a number of different Macromedia products. But for simple customisation it is possible to use Flash MX. Flash MX can deal with graphics as well as text and these are controlled with a linkage to a shared library. This is commonly used to insert existing symbols or movies, but can also be used to link to JPG bitmap and text files.

Shared libraries allow multiple movies to share media such as movie clips, graphics, buttons and sounds. For example, a shared library might contain several different buttons and sounds that are used in several different Flash movies. The user can dictate the process of identifying the character or element to be personalised by the clicking of a combination of buttons. Once the movie containing the shared buttons and sounds has been downloaded, these buttons and sounds are accessible to any other movie that references that external media. Since each movie doesn't contain the actual media and simply references external media,

Figure 10.5 *Creating a shared library*

download times can be reduced. For an overview of shared libraries, see Flash Basics > Using Shared Libraries.

Building Database Applications

The database-driven site takes things even further as it processes templates on the fly to create live web content. This is achieved by linking the HTML page and the Flash content on that page directly to the Generator SWF template file. When the page is opened by a client browser, the web server starts to process the embedded template commands and substitute variables to generate the necessary SWF or alternative files as required. As variables can be linked to any JDBC/ODBC-compliant database it's possible to enable the live update of information such as ticket sales and share prices. By linking to cookies you can even create completely personalised, one-off content and presentation that is unique to the current visitor – and all this happens automatically.

The process is clearly a resource intensive process, but for online, on-the-fly creation of personalised content it's still a small price to pay. How databases hold their information and how application servers interface that data with the user's web page are clearly beyond the scope of this book and ultimately this process is not truly dynamic. The database-driven web site does give you the opportunity to present customised data, it does allow you to recognise a user through a cookie or a login procedure but this process is not truly dynamic. The aquarium example was truly dynamic because it was written with objects that had behaviours and although the software technology used was Flash MX it was true object oriented programming.

About Object Oriented Scripting

In object oriented scripting, information is organised into classes. A class is an organisational description or label. So a vehicle is a class, which contains a number of cars, but also motorbike objects. The additional and very important feature of a class is that a hierarchy exists within a class and this hierarchy inherits qualities from its higher-level object. You can create multiple instances of a class, called objects, to use in your scripts. You can create your own classes and use the built-in ActionScript classes; the built-in classes are located in the Objects folder of the Actions panel. When you create a class, you define all the properties (characteristics) and methods (behaviours) of each object it creates, just as real-world objects are defined. For example, a vehicle could be said to have properties such as type, passenger number and colour, and methods such as speed and sound. In this example, vehicle would be a class, and each individual vehicle would be an object, or an instance of that class.

You can see objects as containers of data, or they can be graphically represented on the stage as movie clips, buttons, or text fields. All movie clips are instances of the built-in class MovieClip, and all buttons are instances of the built-in class Button. Each movie clip instance contains all the following properties.

```
MovieClip
_height,
_rotation,
_totalframes
methods
gotoAndPlay,
loadMovie,
startDrag
```

Figure 10.6 *The fish movie clip*

To define a class, you create a special function called a constructor function. For example, if you want information about a fish in your movie, you could create a constructor function, Fish, with the properties time and distance and the method getSpeed, which tells you how fast the fish is travelling:

```
function Fish(t, d) {
    this.time = t;
    this.distance = d;
    this.getSpeed = function() {return this.time / this.distance;};
}
```

In the Fish example, you create a function that needs two pieces of information, or parameters, to do its job: t and d. When you call the function to create new instances of the object, you pass it the parameters. The following code creates instances of the object Fish called salmon and shark:

An Object Oriented Model for the Aquarium

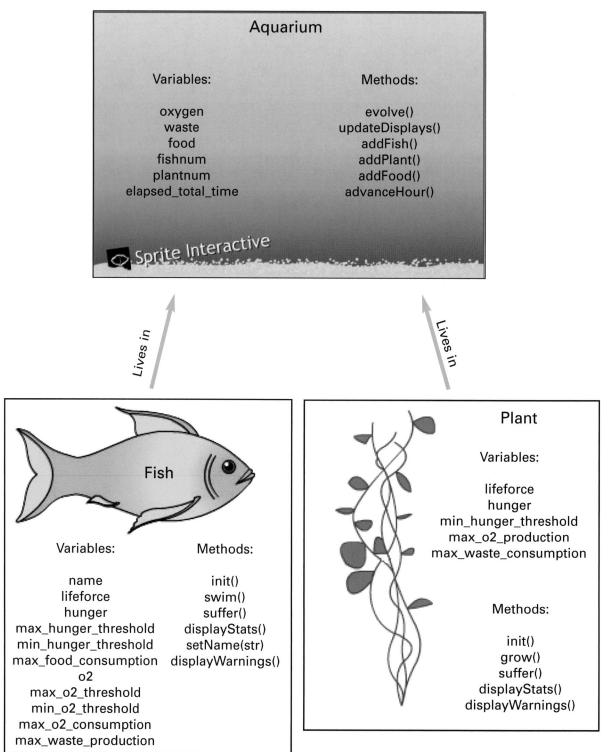

```
shark = new Fish(30, 5);
salmon = new Fish(40, 5);
```

In object oriented scripting, classes can receive properties and methods from each other according to a specific order; this process is called inheritance. You can use inheritance to extend or redefine the properties and methods of a class. A class that inherits from another class is called a subclass. This process of inheritance occurs when an object of the class car inherits all the car properties and methods but it also inherits all the properties of vehicle. A class that passes properties and methods to another class is called a superclass. A class can be both a subclass and a superclass.

The MovieClip Object

Flash MX has a number of built-in classes called objects. The object is a class instance that allows you to access certain types of information. The example that Macromedia present in their tutorial is the Date object. A Date object has methods that allow you to read information from the system clock, this can be in the form of getFullYear, getMonth. The Sound object has methods that allow you to control a sound in a movie; the methods are setVolume and setPan. The MovieClip object has methods that allow you to control movie clip instances using the play, stop, and getURL methods. You can also get and set their properties using _alpha, _framesloaded, _visible.

The Movie clip object is probably the most important object in Flash, because it is a mini-Flash movie. This allows any instances of a movie clip to act as autonomous objects that can communicate by feeding variables to each other.

Every movie clip instance has a unique instance name so that in situations where you have many copies of the movie on stage you can target individual clips with ActionScript. To assign an action that tells one particular instance to play, you need to use its name. In the following example, the movie clip's name is fish1:

```
fish1.play();
```

Instance names also allow you to duplicate, remove, and drag movie clips while a movie plays. The properties in a Movie clip can have values that can be set and retrieved dynamically with ActionScript. Changing and/or setting these properties can alter the appearance and identity of a movie clip and is the key to creating interactivity. For example, the following script uses the setProperty action to set the transparency (alpha setting) of the fish1 instance to 5:

```
setProperty("fish1", _alpha, 5);
```

Two Different Kinds of Objects

The Math object is a top-level object. When you call it you call it without creating a new instance of the object. You need to use the name of the built-in object followed by the method or property. Other built-in objects, like the Date object, require you to create a new instance of the object to use its methods and properties. You use the new operator with a constructor function to create an object. (A constructor function is a function that creates a new instance of an object.) The ActionScript built-in objects are prewritten constructor functions. When you create a new instance of a built-in object, all the properties and methods of that object are copied into the instance.

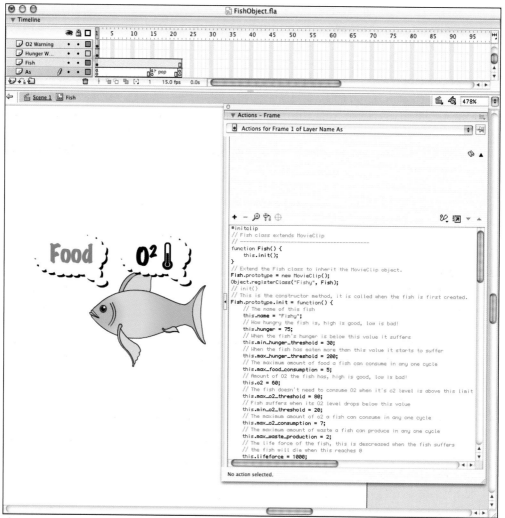

Figure 10.7 *The fish movie clip with ActionScript*

This is similar to dragging a movie clip from the library to the stage. For example, the following statement creates a new Date object called currentDate and then calls the getMinutes method:

```
currentDate = new Date();
currentMinute = currentDate.getMinutes();
```

Each object that requires a constructor function has a corresponding new element in its folder in the Actions panel.

The FishObject.fla, from the chapter10 folder on the CD, demonstrates the fish object. With these methods we created init(), Swim(), displayStats(), Suffer(), SetName(), displayWarnings().

Object Oriented Programming (OOP) is said to be difficult to learn. The way Flash MX presents OOP is actually easy to learn, and once you understand it, you can make your code more flexible and reusable. In Flash, code is organised into objects, each object contains its own methods and properties. Methods define what an object does, and properties are the characteristics of the object. Many programming languages mimic other programming languages' approach on OOP. In our case, ActionScript mimics Javascript's OOP structure. OOP isn't necessary for everything you do in Flash. It's ideal when you are creating complex Flash applications, such as a guest book or a game. It is one of the only ways of creating true dynamic content without building hundreds of predetermined movies that have different scenarios.

Even though OOP may seem confusing at first, once you understand how it works, the beauty of using objects will convert you to this system of scripting.

Fishtank Tutorial

This tutorial will take you through the steps to building the Fishtank. A lot of the code you have to use is in text files, in the Fishtank folder the CD, due to the amount of code in the fla.

1. First step is to create the tank. Open FishTank.fla, create a new layer called "Tank" and drag the Tank MovieClip from the library onto the stage. This provides the graphic for the aquarium.

Figure 10.8 *The layer set-up*

2. To display the oxygen, waste and food levels in the fishtank create three dynamic text fields next to the appropriate label on the Gauges layer. Also create a fourth text field to display the elapsed time.

3. In the properties panel, set the "Var" value to o2_output for the oxygen gauge, waste_output for the waste gauge, food_output for the food gauge and elapsed_time for the elapsed time gauge.

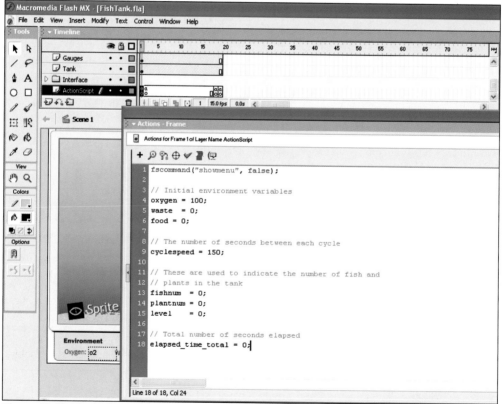

Figure 10.9 *Creating the dynamic text fields*

4. Create a layer called "ActionScript" and on the frame action add the code from code1.txt. This code sets the initial environment variables and other starting settings for the tank.

```
fscommand("showmenu", false);

// Initial environment variables
oxygen = 100;
waste = 0;
food = 0;

// The number of seconds between each cycle
cyclespeed = 150;

// These are used to indicate the number of fish and
// plants in the tank
fishnum = 0;
plantnum = 0;
level = 0;

// Total number of seconds elapsed
elapsed_time_total = 0;
```

Figure 10.10 *The timeline and the actions window*

5. The next step is to create the Fish and Plant MovieClips that will provide the life in our tank. Open the library panel and open the Fish movie clip.

6. The tasks the Fish has to perform are to swim around consuming food and oxygen and

producing waste. The waste is then consumed by the plants in the tank and the plants in turn produce oxygen for the fish. However, overfeeding harms the fish and having too much waste in the water consumes oxygen. This cycle is the basis for the simulation.

7. Create keyframes on the "ActionScript" layer at frames 1, 15 and 22, and give frame 15 the frame label "pop". Frames 15 to 22 are only played when a fish has died and needs to be removed. Frame 1 is used to create the new fish object.

Figure 10.11 *The keyframe set-up*

8. As well as the actual fish animation, we also need add the feeling bubbles to display the feelings of the fish. These are used to display when the fish is hungry, overfed or lacking O_2. Create three new layers, "Food Warning", "O2 Warning" and "Hunger Warning".

9. As the Fish is a tweened animation, and the bubbles need to follow the path of the fish, they need to be created as tweened animations too. Open FishAnim and the animations in the feelings folder in the library to see how it works.

10. Open the Fish movie clip, on the first frame add HungerFeelingAnim to the "Hunger Warning" layer, OutOfO2FeelingAnim to the "O2 Warning" layer and FullFeelingAnim to the "Food Warning" layer. Postion each bubble above the fish.

11. Give the movie clips you just placed the instance names, "O2Warning" for the "O2 Warning" layer, "FoodWarning" for the "Food Warning" layer and "HungerWarning" for the "Hunger Warning" layer.

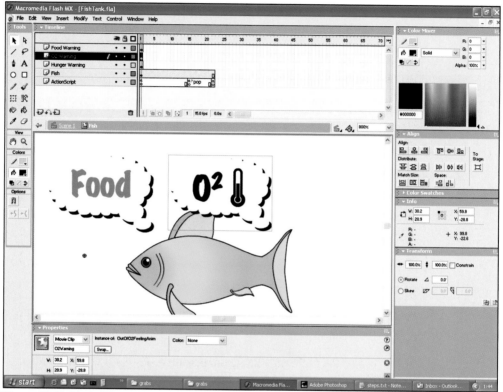

Figure 10.12 *The bubble properties*

12. The elements that can be added to the tank will be created as ActionScript objects. This process involves defining a new object that extends and inherits from the standard MovieClip object so that it can be linked to a MovieClip animation.

13. The new object will define a constructor function that will set initial variables for the object when a new instance of the object is created on the stage. The new object will also define functions for simulating it in the fish tank, and displaying the status of the object.

14. Add the code from code2.txt to the first frame action of the Fish movie. This code uses an #initclip block to define the Fish object. The Fish object extends the MovieClip object by using the code: Fish.prototype = new MovieClip();

15. To associate the MovieClip in the library with the new object, the object needs to be linked using the registerClass() function. This function accepts two arguments, the first is the linkage name of the MovieClip in the library and the Object we want to register with the MovieClip, in this case Fish.

16. The init() method is used to define variables for how the fish lives such as food and O_2 consumption rates. Refer to code comments for details of each variable.

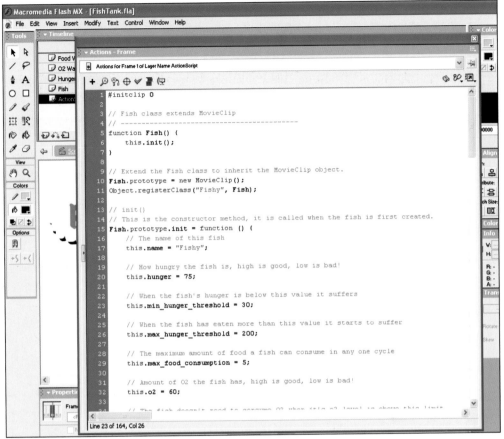

Figure 10.13 *The code from code2.txt*

17. The swim() method performs the living functions for the fish such as consuming oxygen and food and producing waste. It also makes the fish suffer when it is low on resources and causes it to die when it's suffered enough.

18. The other functions defined in the #initclip block are used to display warnings and the fish's status. Frame 15 is played when a fish dies and is used to remove the fish movie clip. Place the code from code3.txt on frame 15 and code4.txt on frame 22.

19. Next, open the Plant movie clip. This has an image of a plant and animated bubbles. Add a new layer called "Hunger Warning" and place the HungryFeeling movieclip on the first frame so that it exists for 80 frames.

Figure 10.14 *The Hunger Warning layer*

20. Give the HungryFeeling movie clip the instance name "FoodWarning". This is used to indicate when the plant needs feeding. On the "ActionScript" layer create keyframes on frames 1, 80, 81 and 88. Give frame 81 the frame label "pop".

21. The Plant movie works in a very similar way to the Fish movie with the same type of constructor and living functions. Insert the code from code5.txt to the first frame action, code6.txt to frame 80 and code7.txt to frame 88.

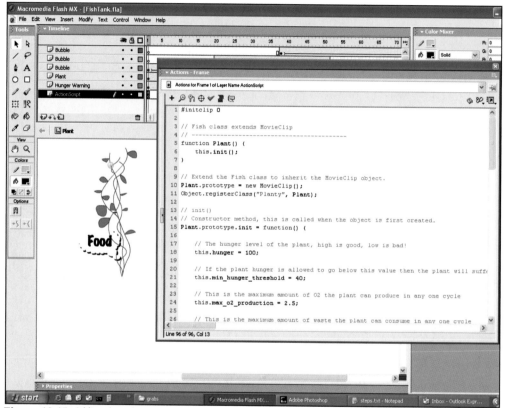

Figure 10.15 *Adding the code*

22. The main living method for the plant is the grow() function. This serves the same purpose as the swim() method for the fish. Refer to the comments in code5.txt for details on the other Plant variables and functions.

23. When the plant dies, the movie clip jumps to the "pop" frame and the plant is removed. With the Fish and Plant objects complete, we now need a mechanism to add them to the tank and simulate the aquarium.

24. Go back to the main movie, create a new layer called "Buttons" and place an instance of "Add Fish Button", "Add Plant Button" and "Add Food Button" to the layer. Position the buttons at the top of the interface.

25. Add the code from code8.txt to the "Add Fish" button. This code uses the attachMovie to create a new instance of the Fish object in the tank. The variables and methods of the new fish can then be accessed directly using the dot notation, e.g. `FISH1.swim()`.

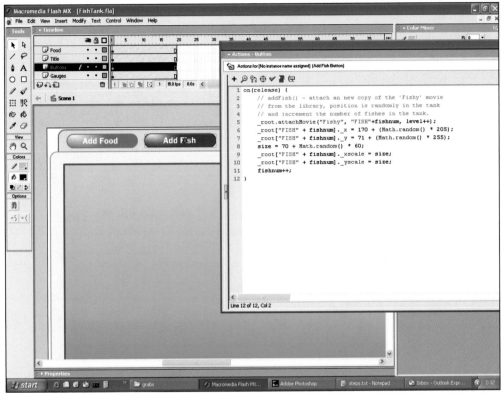

Figure 10.16 *Adding the code to the AddFish button*

26. Add the code from code9.txt to the "Add Plant" button. This code works in the same way as adding fish, whereby the attachMovie function is used to create a new instance of the plant.

27. Now we've a method to add fishes and plants to the tank, we need to simulate the environment. The simulation is based on cycles. After a set cycle time the swim/grow function of the objects in the tank is activated and the environment in the tank updated. The cycle time is set by the cyclespeed variable on the first frame. The default is 150 seconds, meaning that the environment is simulated 24 times an hour. Decreasing this value will speed up the simulation.

28. The process works by looping the movie every 15 frames and activating the simulation every time the cycle time elapses. Frame 2 of the movie is used to activate the simulation. Frame 18 is used to check if it is time to activate the simulation; if it is Frame 2 is played otherwise the movie is looped from frame 3. The movie runs at 15 fps so a single loop takes 1 s. It is processed like this to add flexibility to the timing so the simulation can be advanced or sped up.

29. Add the code from code10.txt to the frame action of frame 2. This is used to activate the simulation and update the environment displays. The simulation works by running the grow() or swim() function of the fishes and plants in the tank.

30. Add the code from code11.txt to the frame action of frame 18. This is used to keep track of the elapsed time and determine whether the simulation needs to be activated. Finally add the line gotoAndPlay(2); to the frame action of frame 19, this is used to activate the simulation when the cycle time has elapsed.

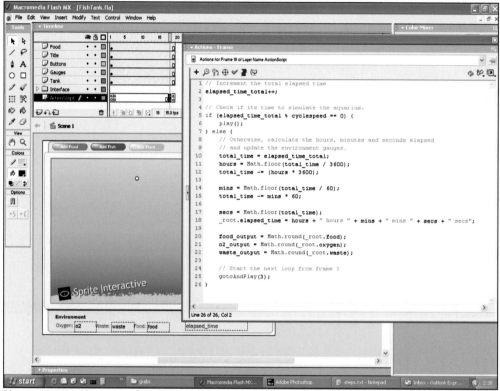

Figure 10.17 *Adding code to frame 19*

31. By playing the movie at this point you will notice that the fish quickly consume all the food and die, so we next need to add a way of feeding the fish. Create a new layer on the main movie called "Food" and place the "Food Scrap" movie clip on the stage. Give the movie clip the instance name "foodscrap".

32. Add the code from code12.txt to the action on the "Add Food" button. Clicking this button adds food to the tank and displays the feeding animation to let you know it has happened.

33. Place an instance of the "Advance One Hour" movie clip onto the stage next to the Elapsed Time label. This button will be used to advance the simulation one hour every time it is pressed.

34. As the simulation is based on cycles, it can be advanced by simply running a number of cycles in one go. So, to advance one hour, where there are 24 cycles an hour, we just need to activate the simulation 24 times and add an hour to the elapsed time. If the cyclespeed was set for 50 cycles an hour, we would need to activate it 50 times and add an hour.

Figure 10.18 *Adding the "Advance One Hour" button code*

35. Finally, add the code from code13.txt to the "Advance One Hour" button.
36. Why not try experimenting with different parameter values for the Fish and Plants, or you could even create new species, maybe carnivorous fish or different types of plants.

Chapter 11

Internet/Video

This chapter discusses development for television and video, and will teach you how to optimise your Flash movies for publishing on video.

This chapter focuses on how to get your title onto the web, video and film. DVD, video and TV are very specialised areas. This chapter starts by demystifying this world and then moves on to explaining the basic principles of exporting your movie to other formats.

The Video Format

Probably the single greatest human invention is television. Although we may have some concerns about the content of what we see on TV, the technology of TV has completely and irrevocably changed the human race.

As web animators move away from the very young industry of animation on the Internet to the more established medium of television and video they have been astounded by its total lack of standardisation and despite advances in communication and technology that bring the World together, video standards keep us apart. It's hard to believe that a person from the UK travelling in the US and shooting video cannot view their recordings on a US TV or VCR. Even DVDs suffer from this problem. DVD standards also include a factor called region coding, which adds a whole layer of complication. Radio transmission enjoys standards that are in use everywhere in the world, yet television does not. The world is divided into three standards that are basically incompatible: NTSC, PAL, and SECAM.

So why are there these three standards or systems? Television was "invented" at different times in various parts of the world (US, UK, and France) and politics played a large part regarding which system would be employed as the national standard. The rise of globalisation and the standardisation of the digital economy was an almost impossible leap to predict, and no consideration was given to global TV broadcast systems. The thought that information could be exchanged electronically, and as easily as having a conversation with someone over the phone, was almost unbelievable.

NTSC (720 X 480 and 29.97 fps)

NTSC stands for National Television Standards Committee and was approved by the FCC (Federal Communications Commission) as the standard for television broadcasting in the US It is the US standard that was adopted in the early 1930s and debuted at the World's Fair in New York in 1939 as the first consumer video format. NTSC is based on a 525-line, 60 fields/30 frames-per-second at 60 Hz system for transmission and display of video images. It is an interlaced system in which each frame is scanned in two fields of 262 lines, which are then combined to display a frame of video with 525 scan lines. This system works fine, but one drawback is that colour TV broadcasting and display were not part of the equation when the system was approved. The

implementation of colour into the NTSC format has been a weakness of the system, leading it to be nicknamed "Never Twice The Same Colour". You may have noticed that colour quality and consistency varies quite a bit between Broadcaster. Nevertheless with all its failings NTSC is the official analogue video standard in the US, Canada, Mexico, some parts of Central and South America, Japan, Taiwan, and Korea.

Figure 11.1 *NTSC dimensions and restrictions*

PAL (768 x 576 and 25fps)

PAL is the dominant format in the world for analogue television broadcasting and video display and is based on a 625-line, 50 fields/25 frames per second, 50 Hz system. Like NTSC, the signal is interlaced into two fields, composed of 312 lines each. Several distinguishing features are:

- A better overall picture than NTSC because of the increased amount of scan line.
- Since colour was part of the standard from the beginning, colour consistency between stations and TVs is much better.
- The biggest problem with PAL is the fewer frames (25) displayed per second, this creates a flicker in the image, very much like the flicker seen on projected film.

Since PAL and it variations have such world domination, it has been nicknamed "Peace At Last" by those in the video professions. Countries on the PAL system include the UK, Germany, Spain, Portugal, Italy, China, India, most of Africa and the Middle East.

Figure 11.2 *PAL and SECAM dimensions and restrictions*

SECAM (768 x 576 and 25 fps)

Developed in France, SECAM is superior to NTSC, but not necessarily superior to PAL (in fact many countries that have adopted SECAM are either converting to PAL or have dual-system broadcasting in both PAL and SECAM). SECAM is the "outlaw" of analogue video standards.

Like PAL, it is a 625-line, 50 fields/25 frame-per-second interlaced system, but the colour component is implemented differently than either PAL or NTSC. In fact, SECAM stands for (in English) Sequential Colour With Memory. In the video profession, it has been dubbed "Something Contrary To American Methods", due to its different colour management system. Countries on the SECAM system include France, Russia, Eastern Europe, and some parts of the Middle East.

Figure 11.3 *Total safe playback for all three systems*

The main reason that each system is incompatible is that they are based on different frame rates and bandwidth, which prevents such things as video tapes and DVDs recorded in one system from being played in the other systems. However, there are solutions to these conflicting technologies already in place in the consumer market. In Europe, for instance, many TVs and VCRs sold are multi-system capable, and in the US this problem is addressed by retailers that specialise in international electronics products. You can also get video tape converted from one system to another and you can even purchase camcorders (Hi8 and Digital8) in the US market that, even though they record in the NTSC system, can play your tape back on either an NTSC or PAL TV.

The Human Eye

The human eye retains an image for a fraction of a second after it views it, this is called persistence of vision and is essential to all visual display technologies. Still frames are presented at a fast enough rate so that persistence of vision integrates these still frames into motion. Originally, motion pictures set the frame rate at 16 frames per second, this was found to be unacceptable and the frame rate was increased to 24 frames per second. In Europe, this was changed to 25 frames per second, as the European power line frequency is 50 Hz.

When NTSC television standards were introduced, the frame rate was set at 30 Hz (half the 60 Hz line frequency). Then, the rate was moved to 29.97 Hz to maintain 4.5 MHz between the visual and audio carriers. Movies filmed at 24 frames per second are simply converted to 29.97 frames per second on television broadcasting.

The brighter the still image presented to the viewer, the shorter the persistence of vision, so bright pictures require more frequent repetition. If the space between pictures is longer than the period of persistence of vision, then the image flickers, therefore, to arrange for two "flashes" per frame, interlacing is used. The basic idea here is that a single frame is scanned twice, the first scan includes only the odd lines and the next scan includes only the even lines. With this method, the number of "flashes" per frame is two, and the field rate is double the frame rate, thus, NTSC systems have a field rate of 59.94 Hz and PAL/SECAM systems a field rate of 50 Hz.

Interlacing creates a problem due to the fact that you really do not have a frame rate of 50/60 Hz. For example, vertically adjacent picture elements do not appear at the same time; if the scene is moving then this creates a series of serrations on the edge of moving objects. Other aberrations include such things as misalignment (where the horizontal edges of one scan do not match with the next), and interline flicker where slight mismatches between subsequent lines cause a shimmering effect. If the still frame images are presented at too low a rate, rapid motion becomes jerky and odd looking. This is especially a problem in action movies where high-speed chase scenes are common.

Figure 11.4 *Persistence of vision*

Digital Versatile Disc (DVD) Video Technology

There are four main areas that digital video can be divided into:

- Physical CD distribution
- Collection of original footage (similar to Hi8/VHS/S-VHS camcorders)
- Over-the-air broadcast television
- Cable/satellite broadcast television

DVD-Video is the physical, disc-based distribution channel. All of the DVD variations are based on the same CD. However, compatibility issues exist. DV is the most common collection of original digital footage. DTV is used fairly often to describe the overall digital over-the-air broadcast method. With specific formats noted as:

- HDTV – High Definition TV, a 16 X 9 ratio image at greater than a 1000 lines of horizontal resolution. There are two resolutions defined by the United States Federal Communications Commission (FCC). Both can be presented in progressive (typical of computer monitors) or interlaced (typical of NTSC televisions).
- SDTV – Standard Definition TV, a 4 X 3 ratio image at approximately 720 lines of horizontal resolution. Also available in interlaced and progressive. Takes only a small part of the HDTV bandwidth allowing as much as four separate programmes to be sent down the same HDTV channel.
- DSS is the generic term for the small dish satellite systems used to deliver multitudes of channels to the home. Cable TV operators deliver a similar digital signal via cable to their subscribers.

The one thing to remember about all of these different digital video formats is that hardly any of them are directly compatible with any other format. To get from one format to another will require some form of transcoding.

DVD-Video Compared

DVD-Video uses an MPEG-2-based compression technique for the video image. MPEG-2 is also used with DSS, digital cable, HDTV and SDTV.

DVD-Video employs a variable bit-rate compression scheme. Variable bit-rate compression allows the compressionist (the person making the decisions about how much compression to use) to apply a higher compression ratio to a low detail, low action scene; while allowing a high detail, high action scene to be compressed at a lower ratio. This is because the higher detail/action scene would show artifacts more as the compression ratio is increased. A lower detail/action scene doesn't change as often and thus can be compressed at a higher ratio without artifacts appearing. A disadvantage of variable bit-rate compression is that it is not a real-time operation.

Another element of the MPEG-2 stream used with DVD-Video is the additional information

encoded in the video stream. Navigation information, language information, subtitle information, parental control information, Dolby Digital audio are all contained in the DVD-Video MPEG-2 video stream.

DSS and digital cable use a constant bit-rate compression. Since these distribution channels are dealing with real-time events, there is no time for variable bit-rate compression, therefore, the image is always compressed the same amount whether it is a low detail/action scene or a high detail/action scene. DSS and digital cable do not provide navigation, subtitle, parental control and alternate language abilities found in DVD-Video, these delivery channels would not be able to interpret these data elements.

The MPEG-2 stream coming from over-the-air broadcast channels contains a different structure than either of the other MPEG-2-based data streams. Resolution is one of the first things that differs from the other two. DV tapes do not use an actual MPEG-2 compression. While the basic theory used for compression is the same for DV and MPEG-2, the DV compression is not MPEG-2.

Figure 11.5 *Badly compressed material*

DVD-Video Quality

DVD-Video uses MPEG-2 compression. Any time an image is compressed there is the opportunity for image degradation. A good compressionist can create such a good image that most viewers will not be able to see any compression artifacts in the movie.

A computer screen is capable of providing a much higher quality image than an NTSC/PAL/SECAM television screen. There are text titles, which may be perfectly acceptable on a television but will look very poor on a computer screen; this difference will most likely be traced back to a less than ideal job of compressing the original material.

General Video Information

There is DVD-ROM, MPEG-2 and DVD-Video:

- DVD-ROM is the big picture.
- DVD-Video is one way to use DVD-ROM.
- DVD-Video is one way to use MPEG-2.
- DVD-Video is a specific use of MPEG-2 video on DVD-ROM in a specific manner.

A DVD-Video disc contains a stream (a track) of MPEG-2 (Main Profile@Main Level, also

Figure 11.6 *Scan tests using Synthetic Aperture's "Test Pattern Maker" software*

known as MP@ML) video compressed and encoded in either a Constant Bit Rate (CBR) or in a Variable Bit Rate (VBR). The DVD-Video specification also allows the lower resolution MPEG-1 CBR and VBR video.

An interesting aspect of DVD-Video is the ability to have the 24 frames per second (fps) film encoded at 24 frames a second. With other forms of home video, the 24 fps film standard has to be converted to the NTSC spec of 29.97 fps via a process called 3:2 pulldown. (NTSC consists of 30 frames with two fields each.) What 3:2 pulldown does is double one field creating three fields for one of 24 film frames – and does this often enough to turn the 24 film frames into 30 video frames (actually 29.97 video frames). In order to display these 24 frames on an average television, the DVD-Video playback device does an "on-the-fly" 3:2 pulldown.

So, why have 24 frames encoded and do on–the–fly conversion? With current computer displays and with future digital TVs it will be possible to display the actual 24 fps in which the film was shot. As a result, a more correct feel will be imparted to the playback of movies shot on film and transferred to video.

Video Image Information

The number of pixels in a DVD-Video frame is typically 720 x 480 of NTSC source material. The traditional method of measuring NTSC devices has been "lines of horizontal resolution". Using this method:

- VHS source material is rated at approximately 230 lines for standard 4:3 screens (approximately 172 for 16:9 screens).
- Laserdisc is approximately 425 for 4:3 (approximately 318 for 16:9).
- DVD-Video is approximately 540 for 4:3 (approximately 405 for 16:9).

In practical terms, DVD-Video will most likely be rated at approximately 500 lines of horizontal resolution.

A 720 X 480 pixel count should not be confused with a "lines of horizontal resolution" measurement. The numbers may be different. Here's why: "lines of horizontal resolution" (LoHR) comes from the ability of a device to resolve an industry-standard reference image. Part of the image has groups of lines printed at various distances from one another. LoHR is determined at the point where these printed lines are resolvable into individual lines. So while it is possible to have 720 horizontal pixels, if you cannot visually distinguish each line, you don't have 720 LoHR.

MPEG uses temporal compression. Temporal compression uses a key frame to record everything in the frame, this complete frame is an I-frame. During temporal compression, subsequent frames consist of only the differences from the I-frame, so a still image can be an I-frame. The still frame can be displayed for a specified amount of time; or it can be displayed indefinitely – generally with a "continue" button on the screen. Still frames can play sound. Menus are generally still frames.

Subpictures are not still frames, they are much more restrictive and do not have the colour range or detail of MPEG-2 video. Subpictures are used as overlays on the MPEG-2 video stream for subtitles, closed-captioning, karaoke, menus, and very simple animation. A portion of the DVD-Video interactive command set allows a title developer to perform effects such as scroll, move, colour, highlight and fade subpictures. There are 32 subpicture streams available within the DVD-Video spec and they can contain four colours from a palette of 16 colours and four contrast values out of 16 levels from transparent to opaque.

Audio Options

A DVD-Video disc can have up to eight audio tracks (tracks are sometimes referenced as streams).

Figure 11.7 *The Flash Sound Properties*

Each of these tracks can be one of three formats:

- Linear PCM – from 1 to 8 channels.
- Dolby Digital (also known as AC-3) – from 1 to 5.1 channels.
- MPEG-2 audio – from 1 to 5.1 or 7.1 channels.

Note: tracks (or streams) are composed of channels.

Additionally, the Digital Theatre Sound (DTS) format is an optional format. DTS is another 5.1 channel format developed to improve the audio experience in movie theatres. There is reserved

within the DVD standard an audio stream format for DTS. DTS format DVD-Video discs first appeared in the late spring of 1998.

Linear PCM

Linear PCM is generally the default audio track. It is sampled at a rate of 48 kHz or 96 kHz; audio CDs are sampled at 44.1 kHz. A sample size of 16, 20 or 24 bits is allowed, audio CDs use a sample size of 16 bits.

According to the DVD-Video specification it may contain up to eight channels, and there is a maximum bit rate of 6.144 Mbps. Linear PCM is uncompressed audio which means the choice for the number of channels may limit the sample rate or sample size used. Typically up to five channels should be able to use the highest data rates and sizes.

While DVD-Video playback devices are required to support any of the above variations, the device could subsample from 96 kHz down to 48 kHz while not using the full 20 or 24 bits. Still the lowest output from the PCM track would be 48 kHz @ 16 bits – better than audio CDs using 44.1 kHz @ 16 bits.

Dolby Digital

The Dolby Digital format is compressed data using the AC-3 technique. The source material is normally taken from PCM recordings at 48 kHz at up to 24 bits. Typically you will find Dolby Digital to be a 5.1 channel format. The "5" breaks down to left, centre, right, surround left and surround right. The ".1" channel is the low frequency effects (LFE) channel – the channel that would be directed to a subwoofer. However, there are a number of valid channel formats in DVD-Video Dolby Digital:

- single mono
- dual mono channels
- standard stereo
- left/centre/right
- stereo w/single surround
- left/centre/right/single surround
- stereo w/dual surrounds
- left/centre/right/dual surrounds

With each of the previous settings the ".1" (LFE) channel is optional. Again, the most common channel format you will find for Dolby Digital is the 5.1 arrangement. You will also find that most regional 1 DVD-Video discs contain a Dolby Digital track. Although as of late spring 1998 a number of DTS DVD-Video discs started to appear.

MPEG-2 Audio

The definition of MPEG-2 audio allows it to be a multi-channel format, although some playback devices provide only basic stereo left/right delivery. Somewhat like Dolby Digital there are a number of channel configurations available with MPEG-2 audio, including:

- single mono
- stereo
- stereo w/single surround
- stereo w/dual surround
- left/centre/right
- left/centre/right/single surround
- left/centre/right/dual surround
- left/left-centre/centre/right-centre/right/dual surrounds

As with Dolby Digital, the LFE channel is optional on all of the above channel configurations. When the LFE is added to the last one in the above list, it is often notated as "7.1".

Both MPEG-2 and MPEG-1 formats are supported, although MPEG-1 Level III (also known as MP3) is not supported.

DTS (Digital Theatre Sound)

DTS is an optional DVD-Video multi-channel audio format (typically 5.1). The DTS format can provide a data rate nearly four times as much as Dolby Digital – meaning less possibility for audio artifacts from compression. It also means that other options in the overall data stream may have to be dropped (like fewer language tracks or no alternate angle tracks, and so forth). DTS has several possible channel configurations, including:

- single mono
- stereo
- left/centre/right
- stereo w/single surround
- stereo w/dual surrounds
- left/centre/right/dual surrounds

All have the option to include the LFE channel. The devices which support DTS are normally marked with an official "DTS Digital Out" logo.

SDDS (Sony Dynamic Digital Sound)

Another option for multi-channel audio is SDDS in 5.1 or 7.1 configurations. However, Sony has not announced any plans to provide support for SDDS in the DVD-Video arena.

Interactive Video

DVD-Video allows a limited amount of interaction with the disc contents. This interaction is far less than CD-ROM on computers, but it is more than people would expect from a video tape or laser disc.

The primary method of interaction is through the use of menus. Most DVD-Video discs provide a menu for selecting a variety of elements from the disc, such as playing the movie, playing the background video, hidden surprises, and even simple games. Some discs provide alternate story lines that can be selected via the menu system.

The menus consist of a backdrop image with up to 36 buttons which are selected by using a remote control with left-right-up-down arrows (or a mouse/trackpad on a Macintosh with DVD-Video). Once a button is selected, a select button on the remote control will activate the selected activity.

Supporting the menus is a very basic command instruction set (not available to the person playing the movie, but available to the disc developer). There are 24 system registers that contain information such as language code, audio and subpicture settings, parental level, and so forth. There are also 16 general-purpose registers for command instructions. Using the commands provides a method to branch to other commands. Commands are used to control the player's settings, move to different sections of the disc and control such elements as the selection of audio streams, video streams, camera angles, subpicture, and so forth.

The content of a DVD-Video disc is organized by "title" (movie) and "sections of titles" (chapters). The chapters can be organised through the use of a program chain or "PGC". For example, a PGC can be created to play back only the chapters that would cause an "R" rated movie to become a "G" rated movie if the parental control level was set in such a way, or the PGC could create an alternate storyline. PGCs can be used to construct other sequences of chapters as well.

Following a PGC is seamless; there are no breaks in the flow of the movie – like there is when two sided laser discs are flipped. Different PGCs are different paths through the same material.

Subtitles

Subtitles are not generated by the computer, they are placed on the disc by the DVD pressing operation. The subtitles are therefore a part of the MPEG2 data stream that can either be "turned on" or "turned off". If they are "turned on" they are composited over the top of the video image. If "off" they are ignored by the process and simply are not displayed. On most DVD-Video discs there will be more than one language available for subtitles. Each of these different language subtitles are a part of the MPEG-2 data stream. If a specific language is selected to be displayed, that part of the data stream is composited over the video image. The font is selected and recorded in a subpicture stream prior to the pressing of the DVD-Video disc.

Flash to Video

The process of outputting movies to video has been available for as long as you have been able to export QuickTime movies, and has been the case since the advent of Future Splash Animator. QuickTime video is incredibly versatile: we have used it for everything from broadcast-quality video for television to web streaming. Flash MX strengthens this link between the two applications to make them work together. We have produced interactive buttons for movies running on a layer in QuickTime.

Flash can save images directly as a QuickTime movie, either as a movie with a video (bitmapped) track or as movie with a Flash track. The Flash movie retains its native format, and Flash vectors are not converted into bitmaps or QuickTime vectors. Bitmapped graphics embedded in a Flash.swf remain bitmaps after import into QuickTime.

To convert the Flash movie to bitmaps, export the movie in a QuickTime video format and the Flash vector images will be converted into cel animations. These movies are typically much larger than they would be if they retained the Flash graphics in their compact vector format.

Figure 11.8 *Flash in QuickTime*

One reason for creating a Flash movie in a QuickTime movie is to include graphics in formats that are not directly supported by QuickTime. For example, the Flash application can directly import vector graphics from Adobe Illustrator or Macromedia FreeHand. An easy way to incorporate these graphics into QuickTime is to import them into Flash and then import the Flash .swf as a QuickTime track.

Producing interactive movies using the Apple QuickTime player opens a whole new dimension in interactive kiosk work. The process of using an application like Director or Flash to produce kiosk software can be compelling but its biggest downfall is in its inability to deal with video in real time. To overcome this problem you can use content in QuickTime with an interactive Flash layer. The buttons on this layer seem to move at almost lightning speed to different areas within the movie unlike the clunky Director or Flash movie. We have had this working with an intro animation, navigation linking to bookmarks in a movie, a semi-transparent control interface, and titles layered over a movie.

MiniDV

QuickTime creates lots of different playback opportunities. The particular one I will focus on is to use QuickTime as a carriage device to record your animation to tape. All professional systems can record QuickTime to tape, and BetaSP and DigiBeta are the most popular video formats that TV broadcasters use.

MiniDV can parallel the quality of the high-end systems. You can take a MiniDV recorded Flash animation and dupe it to BetaSP through the S-Video output onto an editing deck. The quality is of a professional standard. The sound on MiniDV is 16 bit, 48 kHz stereo (this is slightly above CD quality) so any output from Flash should be without any compression to give it the maximum fidelity.

Preparing Flash Movies for Video

First you need to establish the playback device's frame rate. NTSC is 30 fps (frames per second) and PAL/SECAM is 25 fps. If you are animating for NTSC your frame rate would be exactly 29.97 fps which over a short sequence is of no consequence, but over five to ten minutes will cause your animation to lose sync with your audio. You can overcome this problem by splitting your animation into small chunks and then stitching them back together in an application like Adobe Premier.

Most of the time you will animate for 30 fps, and you can even animate at 15 fps. If you create your animation at the rate of 15 fps the video will show one animation frame for every two video frames with the total effect of you character walking slightly slower.

Colour

Computer monitors show millions of colours, but the TV screen does not have the same colour range, in particular certain colours like bright reds, yellows and light blues suffer from bleeding. The standard colour palette in Flash is really not the best colour palette for video production. If you have created an animation sequence already you can force the video colour palette using Adobe Premiere or After Effects. Both applications have filters for enforcing colour on video clips. The problem with forcing a colour palette onto a video clip is that you will almost certainly get colours that do not translate well, and if this is the dominant colour of your character then almost certainly it becomes a problem. It is better to understand the limitations of the colour palette and select a colour that will work in all playback environments.

Computer Screen to Video Anomalies

Frame dimension for video can vary from format to format but a standard for images on computer (based on square pixels) is 640 X 480 which should be used for all computer-based images for video. Computer monitors use a square-pixel format which will scale in proportion into the format required. Anything you draw that needs to be circular will appear squashed and

distorted on TV. If you take your image and scale it to fit 720 X 480 pixels you will notice on the computer screen that the image is distorted but when converted to TV the images look fine.

Another anomaly you need to watch out for is the problem that occurs because of interlacing. A TV screen is interlaced, which means that the cathode ray scans every other horizontal line of phosphors at every cycle of a complete image on screen. On a computer this only happens once, and the problem occurs because a TV screen drops out 1/60 of a second. So if any of the horizontal line work in your art is one pixel thick expect the artwork to flicker. This is a very distracting condition and is best avoided at all costs. Because of Flash's vector capabilities it is easy to get caught out by this problem, the solution is to avoid all small details, including thin line work.

Circle drawn at 640 X 480 on a computer screen

Circle on a computer screen in video format after scaling to 720 X 480

Circle viewed on TV

Circle drawn at 720 X 480 on a computer screen

Circle on a computer screen in video format at 720 X 480

Circle viewed on TV

An application that I have found useful for maintaining colour and scale integrity is Echo Fire (http://www.synthetic-ap.com). It displays the composition on your NTSC or PAL video monitor, letting you see how your artwork really looks. After all, if you're not seeing what your project really looks like, you're not seeing differences in colour, the interlace and colour coding artifacts, and the image overscan. Working with non-square pixels on a square-pixel computer monitor means your image is always stretched or squashed, and being able to see your project previewed on a real NTSC or PAL video monitor lets you work accurately and more quickly.

Figure 11.9 *The SyntheticAperture web site*

Working to film resolution is quite interesting; ultimately you will need to convert your file out of the vector format to a high-resolution .bmp. This conversion process is disastrous if the original Flash file contained any bmp file and the bmp picture will become jaggy and unattractive unless you use high-resolution originals. Depending on the film recorder you are printing to you may need to go up to 4k pixels across for Super Panavision 70 film.

Film is an analogue medium, so it doesn't have "pixels" as such, but the film scanners that you will ultimately have to pass through have pixels and a specific resolution. Once you have established the resolution for your film you can export a numbered sequence by "Exporting Movie" and

using the pict or bmp format. This will export individual frames on the chosen resolution. You will almost certainly need a high capacity tape drive, as each frame may be as much as 2 megabytes.

Outputting Video from Flash

In this tutorial we will output a QuickTime video file. You cannot do this on the PC but you can do an equivalent conversion of AVI files with the exception of the codec choice. Open up the file named ZakVideo.fla.

1. Choose File>Export Movie. In the save as type list, select QuickTime Video.
2. The QuickTime Video format converts the Flash movie into a sequence of bitmaps embedded in the file's video track. The Flash content is exported as a bitmap image without any interactivity. This format is useful for editing Flash movies in a video-editing application and is not to be mixed up with the QuickTime Publish option. This creates movies in the QuickTime 4 format, copying the Flash movie onto a separate QuickTime track. The Flash movie plays in the QuickTime movie exactly as it does in the Flash Player, retaining all of its interactive features. If the Flash movie also contains a QuickTime movie, Flash copies it to its own track in the new QuickTime file.

3. In the dialog box, enter 720 X 480, uncheck Maintain Aspect Ratio. This stretches the 640 X 480 pixel image.

4. Set the format to 24-bit colour and check the smooth check box. This applies anti-aliasing to the exported QuickTime movie. Anti-aliasing produces a higher-quality bitmap image, but it may cause a halo of grey pixels to appear around images when placed over a coloured background. Deselect the option if a halo appears.

Figure 11.10 *Quicktime export settings*

5. Set the Compressor to DV-NTSC or DV-PAL and move the Quality slider all the way to the right for a full uncompressed file.
6. Select sound to the highest possible using 44 kHz, 16-bit Stereo. Click OK. This conversion of vector-to a pixel-based video can create enormous files in DV format.

Windows users will need to convert the AVI file to DV using Media Cleaner or a similar conversion application. If you export from Flash using the animation codec at its highest setting and in the Format pop-up window select 32-bit colour the result will be a movie with an alpha channel you can composite over other elements in a video-editing application such as Adobe Premier.

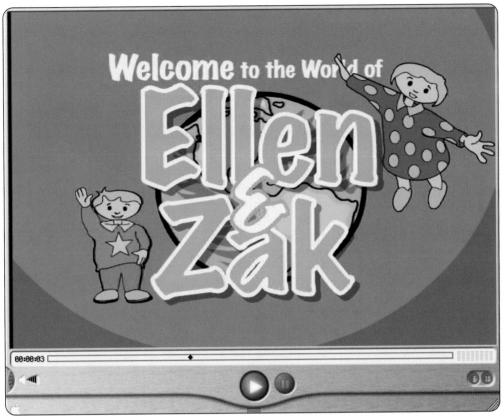

Figure 11.11 *The movie in QuickTime*

Publishing Macromedia Flash MX Movies to the Web

Once you have created your Flash movie it is now time to publish it. The publish command creates all the files you need to deliver your movie to the web (including HTML files), or a stand-alone file that can be played without having Flash Player installed, called a projector. You can export an entire movie as a Flash movie, as a series of bitmap images, as a single frame or image file, and as moving and still images in various formats, including GIF, JPEG, PNG, BMP, PICT, QuickTime, or AVI.

Optimisation

Before you publish your movie for the first time, you should check to see how your users might actually view it on the web. Flash automatically performs some optimisation on movies: for example, it detects duplicate shapes on export and places them in the file only once, and it converts nested groups into single groups. When building your movies you have to bear in mind the issue of quality versus quantity, and Flash lets you find where your movie is slowing down or is not properly optimised by using the Bandwidth Profiler, and using the simulated streaming function to see how long a movie will take to load with different bandwidth settings.

To use the Bandwidth Profiler:

1. Open the ZakSounds.fla file from the chapter11 folder on the CD and choose Control>Test Movie. The file will now launch in the Flash Player.

2. From the Debug menu choose 56K to simulate a 56K modem speed and then choose View>Bandwidth Profiler. The graph that now appears tracks the amount of data that is being transmitted against the timeline of the movie. The bottom line represents the amount of data that will safely download quickly enough to keep up with the frame rate of the movie.

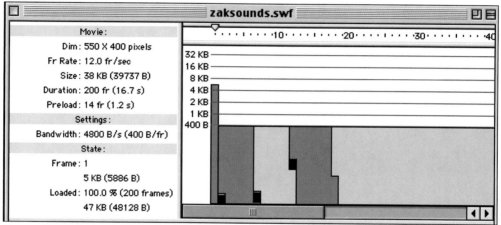

Figure 11.12 *The Bandwidth Profiler*

3. Now choose View>Show Streaming. This will show you how quickly the movie loads, with a green bar at the top of the Bandwidth Profiler giving you a graphical display of the amount of progress made. The green bar stops as it passes over the higher bars as it takes longer to load these parts of the movie.

When you identify frames that are too large to stream efficiently you may want to optimise your movie. You can optimise playback in a number of ways:

- Use symbols for every repeated element in your movie.
- Use alpha channels sparingly as they take a lot of processing.
- When you embed fonts select only the characters you need.
- Use tweened animation – this uses less memory than frame-by-frame animation.
- Group elements wherever you can.
- Use movie clips instead of graphics for animated sequences.
- Use MP3 sound compression, and use sound sparingly.
- Limit the number of stroke types and the number of fonts.
- Use bitmaps sparingly.

The Export Setting

The Export commands do not store export settings separately with each file, as does the Publish command. The Export Movie command lets you export a Flash movie to a still-image format and create a numbered image file for every frame in the movie. You can also use Export Movie to export the sound in a movie to a WAV file (Windows only). To export the contents of the current frame or the currently selected image to one of the still-image formats or to a single frame Flash movie, use Export Image.

Publish Settings

Flash offers many publishing options, as mentioned previously.

To publish your movie:

1. Open the EllenZak.fla file from the chapter11 folder. Choose File>Publish Settings from the main menu.
2. In the dialog box that now appears select the Flash, HTML, GIF Image and Windows Projector check boxes. As you select the format a tab will appear at the top of the box.
3. Now click on the Flash tab, you will see a number of options, of which the following should be modified:

 * Load Order – Determine the order in which the layers in each frame will load. This is important when files are being downloaded from slow modems as Flash shows each layer as it has been loaded. Top Down sets the frames to load from the top one first and vice versa. Set this to Bottom Up.
 * Generate Size Report – Make sure this is checked. It tells Flash to generate a text file that contains information on the size of each individual file which is very useful.
 * Protect from Import – Check this box. This allows you to protect against your SWF file being imported into Flash.
 * Version – Choose Flash 5 to enable the full functionality of your movie.

4. Click the Set button next to the Audio Event setting, a dialog box appears allowing you to change the compression settings for the sounds in the movie, meaning any file that is not compressed will use these settings. Set the compression to MP3, the Bit Rate to 32 kbps and the Quality to Fast.
5. Now click on the HTML tab to set the HTML settings. Firstly set the Template to Flash only. This setting determines what kind of template will be generated; you can get more information on the template by clicking the info button.
6. From the dimensions menu choose Percent to enable your movie to scale with the size of the web browser. Then disable the display menu option, this disables the shortcut menu that opens when the user right-clicks on the screen. Lastly set the Quality to High.
7. Now click on the GIF tab to see what options are available, but leave them at their default. Click Publish when you are ready to export your movie.

Chapter 12
Games Development

In this chapter we take you through developing games using Flash. It looks at the various disciplines for animating games, and concludes with a walkthrough that will teach you how to build "ZakPac", a PacMan style game in Flash.

Computer Games

Computer games have grown from being developed by individuals to being major commercial projects produced by teams of people working, in some cases, on projects that can take years to come to fruition. The definition of what is a game is almost a waste of time, but I would say that whatever you produce that allows user interaction is a game. The games industry is a rapidly growing industry, employing large numbers of people. As the complexity of games has increased, so has the delivery medium and development roles have become more defined. The games industry now has clearly marked areas of specialist knowledge and skills. The purpose of this chapter is to give the animator an understanding of the complexity of this industry and at the same time allow the animator the skill to both design games and contribute to the look and feel, and animation of, games programming and games graphics/design.

The animator reading this book should be aware that developing knowledge and skills in the areas of games design, games production, image manipulation for games, modelling and animation for games is an area of study that is totally out of the scope of one book. What I will try to do in this chapter is start the animator down the root of experimentation. I have also provided a run through of a game Sprite Interactive developed. The purpose of this game is to allow the animator the opportunity to test out Flash skills within a game setting.

The Game Loop

A game can be decomposed into five processes that continually run into a loop. It is a basic formula that almost every game has to have. The game loop is a series of procedures for getting input from and displaying output to the user and updating the game. The five basic processes are:

1. **The Introduction** – The start screen has an animation sequence that shows off some aspect of the game's story or background and a start button to play the game or to change various parameters that affect the game in some way. The parameters include sound volume, graphic options, difficulty and starting level.
2. **Player Input** – These actions will take the player's input from whatever device is being used, and store it in a way that the game can process in order to make changes to the game internals.
3. **Updating Game** – These routines are the real guts of the game. Everything from moving the player's character using their input, to the actions of the enemies and deciding whether the player has won or lost the game is determined here.
4. **Displaying the Screen** – You can do this in two ways: either draw everything to the screen at one time and present this as a refresh, or, what is more commonly done, set everything up to be drawn and then draw the screen afterward, this could be because your character has moved onto a different level. You need to find the smallest of changes to refresh you screen, as redrawing the screen can take longer than most processes in a game. Determining what is necessary to be drawn can take a relatively long time with all the checks your game could have, so it is best to find ways of testing the processor insensitivity of graphics before you commit to large sequences.

5. **Ending the Game** – Once the game is over there is normally an ending sequence. An ending sequence can invite the player to play again or even to type out their details to load onto a high scoreboard that sits on the web.

Understanding what elements go into creating a game loop can definitely make starting your first game easier. Sprite methodology (as described in Chapter 1) for identifying the assets and scripts is key to making this process reusable for future projects. Before you start programming anything, sit down and plan it out – the end result will be much better.

Start Very Small and Work your Way Up

Until you understand that all the skills in game development are learned by experience, you will probably be doomed never to finish your projects. The learning is incremental. Unless you start small and build up you will make many attempts before you manage to finish a full-scale epic, and the problems will be disproportionate to its size.

So How do I Start?

Learn by copying from the masters. Tetris is the perfect game to begin your first steps into the world of games development. Tetris contains all the elements found in every game, and can be done with just about the least amount of work. Also, you don't have to be an artist to make a good-looking Tetris game in Flash, in fact it does it for you.

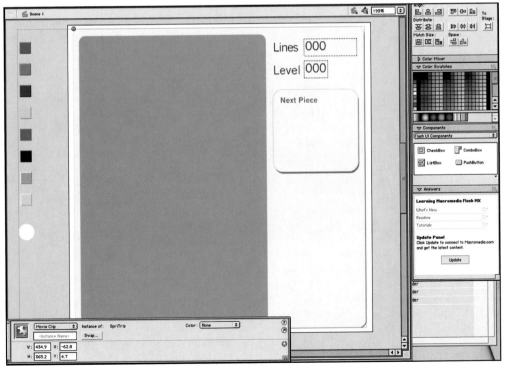

Figure 12.1 *The Flash Tetris game*

The movie Spriteris.fla can be found in the chapter12 folder of the CD. Tetris has all the individual components that all games have in common. It has a game loop, which reads in input, processes the input, updates the elements of the game, and checks for results, and whether you have won or lost.

A game should have all of these things, so learning the process and actually implementing it is extremely important. Once you have done it for the first time you will have overcome the most significant hurdle in your games career. Having done this all the way, at least once, you will have a proper grasp of each of the elements. When you have larger projects, there will be more unknowns that you can't judge for in complexity and time. If you don't even fully understand the entire process because you have failed to do it, you will likely be helpless to create schedules or estimate times properly and will most likely not succeed.

Tetris is a trademark of the Tetris Company which is owned by Alexey Pajitnov, the creator of Tetris. It is his exclusive right to use the name Tetris, so do not upset the man by calling your game Tetris.

What's Next?

After you have finished your version of Tetris, you are ready for your next challenge: Breakout.

The breakout I have included was built by Sprite Interactive and is on the CD as Breakout.fla. Breakout adds much more advanced collision detection than was necessary in Tetris. You will also need to add some simple deflection physics of the ball rebounding off different portions of the paddle and the blocks. But the explanation of all this is not part of the scope of this book. The code is well commented, so enjoy.

Figure 12.2 *The Breakout game*

The level layout also becomes an issue in Breakout, and in order to have more than one level you will need to come up with a way to create levels. This deals with another component found in all larger games, which is saving and loading resources, switching and creating levels.

After you finish your Breakout masterpiece you should move on to making ZakPac. ZakPac is an evolutionary step because it adds the element of artificial intelligence (AI). In the original Pac-Man the four different ghosts had different goals in trying to defeat you as a team. The aggressor would try to follow the shortest path to you, making you directly avoid him. The interceptor would try to go to a junction that was closest to where you would have to move to avoid the aggressor. A second interceptor would try to stay more towards the middle and try to cut you off from using the tunnel through the sides. The last ghost would wander aimlessly about. ZakPac also increases the complexity of levels, and adds a good deal more flexibility for using sounds. Sound is one of the most important features of making a game immersive and can certainly be the crucial feature to the success of your game. Finally, once the user has completed the game – they have actually achieved something by beating the ghosts – you need to add a fireworks effect on the screen for the end of the game. Do not just put "You Have Won!" on the screen when a player has spent endless hours trying to beat your game, give them an ovation.

Figure 12.3 *ZakPac*

When is a game finished?

Finishing a game does not mean just getting to a point where the game is playable. A finished game will have an opening screen, a closing screen, menu options and information on how to play and start the game, introduction screens to playing, success screens and a scoreboard.

There is always a temptation to believe that once the bare bones of a game are complete then the game is finished. But this is not so and there is a process that you need to go through, which is made up of two stages. The first stage is the debugging of the game, this is done by getting people who have not been part of the project to test your game. The next stage is the finishing touches. The difference between when you thought the game was complete and when it is complete can be (depending on the size of the game) weeks if not months. As your game becomes more complex you will get exponentially more involved in the finishing process. Accomplishment does wonders for self-esteem!

What you are looking for at the end of the game development cycle is a user's ability to pick your game up and have no problems moving through it because everything is well presented. With your first game you will learn all about the details that go into really finishing a game, so do not miss out on the details of wrapping things up, which will leave a blank spot in your mind when you try to plan larger projects in the future.

I suggest you gradually build up your understanding of games development, and I have outlined the order of games for you to learn about the process. This is not the only way, but it works, and it is so much easier to learn to walk before you start running.

As an animator, if you are really interested in making games, then you need to separate your desire to create the next cutting edge game, and focus on how your art is implemented within a gaming environment. Like animation, the best way to do this is through gaining experience.

The design and creation of a simple game is hard, especially if you want to do it well. Once you have finished a game, then you're onto the first steps of creating games that utilise your skill as both an animator and a games designer. Just remember one thing, if you can't play it, then it's not a game.

The following ZakPac.fla game can be found on the CD with all the tutorials in the chapter12 folder. I would love to see how you customise this game so please send me an email (alex@sprite.net) with a link to what you have done.

ZakPac

Figure 12.4 *The ZakPac game*

Introduction

The aim of this tutorial is to bring together the skills we have covered in this chapter to build a complex game. The game is based on the popular PacMan design where the player navigates their character through a maze collecting points on their way while avoiding the ghosts roaming around the maze. The aim of the game is to collect all the points.

Building the Game – The Board

To begin building the game we first need a create a world for our little things to run around in. The board design uses the grid construction approach found in many games. This works by using an array to define the layout of a set of simple tiles on a grid. This provides great flexibility in the

design of the board and also has the advantage that it is much simpler to edit and create new boards to different levels.

The game will be developed as a normal Flash library asset so we first need to create this, we'll call it 'ZakPac'. Before we start building the board we must first decide how big our board needs to be, this also affects the size of the tiles we create. For this game a grid of 15 X 13 tiles is used and a tile size of 35 X 35 pixels, this means that the size of the board will actually be 525 X 455 pixels. A number of tiles are required for the walls and borders of the

Figure 12.5 *Creating the ZakPac movie*

board, these are simply created as separate Flash library assets. The main graphic for each tile must be 35 X 35 pixels in size and its centre must be located at 0,0.

Figure 12.6 *Creating a wall board tile*

Figure 12.7 *Creating a border tile*

Figure 12.8 *Adding the tiles*

Now that we have the tile assets we can build the actual board. The board is generated using the duplicateMovieClip ActionScript function to create an instance of a particular tile for each position on the grid. To begin we must first add each tile to the ZakPac asset, these will be duplicated for each tile on the board. Name each tile "tile1", "tile2" and so on. Now we need to insert the ActionScript to create the board, this needs to be placed in the frame action of the first frame.

```
boardxoffset = 0;
boardyoffset = 25;
tilewidth = 35;
tileheight= 35;

board = new Array();
board[0]  = new Array(1, 1, 1, 1, 1, 1, 1, 1, 1, 1, 1, 1, 1, 1, 1);
board[1]  = new Array(1, 0, 0, 0, 0, 0, 2, 0, 2, 0, 0, 0, 2, 0, 1);
board[2]  = new Array(1, 2, 2, 2, 2, 0, 2, 0, 2, 0, 2, 0, 2, 0, 1);
board[3]  = new Array(1, 0, 0, 0, 0, 0, 2, 0, 2, 0, 2, 0, 0, 0, 1);
board[4]  = new Array(1, 0, 2, 0, 2, 0, 2, 0, 0, 0, 2, 2, 2, 0, 1);
board[5]  = new Array(1, 0, 2, 0, 2, 0, 2, 0, 2, 0, 0, 0, 0, 0, 1);
board[6]  = new Array(1, 0, 0, 0, 0, 0, 0, 0, 2, 0, 2, 2, 2, 0, 1);
board[7]  = new Array(1, 2, 2, 2, 0, 2, 2, 2, 2, 0, 0, 0, 2, 0, 1);
board[8]  = new Array(1, 0, 0, 2, 0, 2, 0, 0, 0, 0, 0, 2, 2, 0, 1);
board[9]  = new Array(1, 0, 2, 2, 0, 0, 0, 2, 0, 2, 0, 0, 0, 0, 1);
board[10] = new Array(1, 0, 2, 0, 0, 2, 2, 2, 0, 2, 0, 2, 0, 0, 1);
board[11] = new Array(1, 0, 0, 0, 0, 0, 0, 0, 0, 0, 0, 0, 2, 0, 1);
board[12] = new Array(1, 1, 1, 1, 1, 1, 1, 1, 1, 1, 1, 1, 1, 1, 1);

// Building the board
// This uses the 2D board array as the structure of the wall and
// builds  it up using the duplicateMovieClip function to place the //
iles on the board.
level = 10;
for (row = 0; row < board.length; row++) {
   for (col = 0; col < board[row].length; col++) {
      // Draw the board
      if (board[row][col] > 0) {
         duplicateMovieClip ("tile" add
               board[row][col], "tile" add row add
               "_" add col, level++);
         this["tile" add row add "_" add col]._x =
               (col * tilewidth) + boardxoffset;
         this["tile" add row add "_" add col]._y =
               (row * tileheight) + boardyoffset;
      }
   }
}
```

The variables boardxoffset and boardyoffset are used to define the co-ordinates for the top left-hand corner of the board, relative to the top left corner of the ZakPac movie. These are used to position the tiles on the movie.

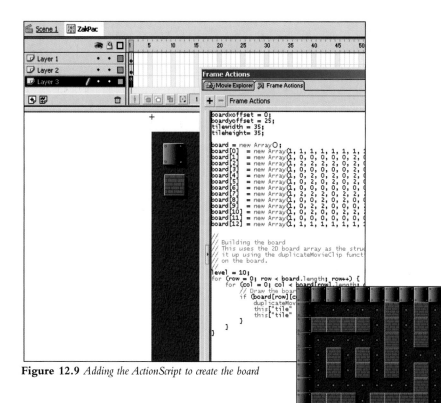

Figure 12.9 *Adding the ActionScript to create the board*

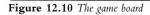

Figure 12.10 *The game board*

Next the board array is defined. This uses a 2-dimensional array, which is essentially a normal array but where each element is itself an array. An element in a 2-dimensional array can also be accessed in a similar way, for example board[1][2] accesses the second row and third column, just like a grid, remembering that the grid starts at board[0][0]. Using this method the layout of tiles for the board is defined, 0 represents no tile, 1 is a boundary wall and 2 is an internal wall. These numbers correlate with the tiles we will duplicate for each position on the grid.

The next stage is to use our newly defined board to generate the board. This is done by using two "for" loops, the first to cycle through each row of the grid, and the inner one to cycle through each column of that row. At each grid position we will get the tile number from the board array and duplicate the associated tile onto the stage. This is done using the duplicateMovieClip() function, every duplicated tile is given a name corresponding to its position on the grid, for example, the tile on the fourth row and second column will be named "tile3_1". Once duplicated, the tile needs to be placed in its correct position on the board. This is done for both x and y positions by calculating its position on the grid multiplied by the height or width of the tile plus the offset of the board. An image was imported to act as the background for the board.

By placing the ZakPac movie on the stage we can see the generated board. The next step is to add some things for our character to collect. The way this is done is similar to the way we create the board. In the same frame action we need to add an identically sized array to define the things that will appear on the board. First we need a graphical asset to represent our things. Create this as a movie asset and place it on the ZakPac movie, just like the tiles. Name the thing assets "thing1", "thing2" etc. The following code is used to duplicate the newly created thing assets onto the board.

```
things = new Array();
things[0]  = new Array(0, 0, 0, 0, 0, 0, 0, 0, 0, 0, 0, 0, 0, 0, 0);
things[1]  = new Array(0, 0, 1, 1, 1, 1, 0, 1, 0, 1, 1, 1, 0, 1, 0);
things[2]  = new Array(0, 0, 0, 0, 0, 1, 0, 1, 0, 1, 0, 1, 0, 1, 0);
things[3]  = new Array(0, 1, 1, 1, 1, 1, 0, 1, 0, 1, 0, 1, 1, 1, 0);
things[4]  = new Array(0, 1, 0, 1, 0, 1, 0, 1, 1, 1, 0, 0, 0, 1, 0);
things[5]  = new Array(0, 1, 0, 1, 0, 1, 0, 1, 0, 1, 1, 1, 1, 1, 0);
things[6]  = new Array(0, 1, 1, 1, 1, 1, 1, 1, 0, 1, 0, 0, 0, 1, 0);
things[7]  = new Array(0, 0, 0, 0, 1, 0, 0, 0, 0, 1, 1, 1, 0, 1, 0);
things[8]  = new Array(0, 1, 1, 0, 1, 0, 1, 1, 1, 1, 1, 0, 0, 1, 0);
things[9]  = new Array(0, 1, 0, 0, 1, 1, 1, 0, 1, 0, 1, 1, 1, 1, 0);
things[10] = new Array(0, 1, 0, 1, 1, 0, 0, 0, 1, 0, 0, 1, 0, 1, 0);
things[11] = new Array(0, 1, 1, 1, 1, 1, 1, 1, 1, 1, 1, 1, 0, 1, 0);
things[12] = new Array(0, 0, 0, 0, 0, 0, 0, 0, 0, 0, 0, 0, 0, 0, 0);

// The total number of things that the player can collect
targetscore = 90;
// Adding things to the board
// This uses the 2D things array as the structure of the things that
// appear on the board, building it up using the duplicateMovieClip
// function to place the things on the board.
for (row = 0; row < things.length; row++) {
    for (col = 0; col < things[row].length; col++) {
        // Draw the things
        if (things[row][col] > 0) {
            duplicateMovieClip ("thing" add
                    things[row][col], "thing" add row add
                    "_" add col, level++);
            this["thing" add row add "_" add col]._x =
                    (col * tilewidth) + boardxoffset;
            this["thing" add row add "_" add col]._y =
                    (row * tileheight) + boardyoffset;
        }
    }
}
```

The two "for" loops do exactly the same thing as they do for building the wall, except that it duplicates the things rather than the tiles.

Building the Game – Adding Ghosts

Now that we have a board, we can add some ghosts to roam around it. We first need an asset to represent the ghost, simply create this as a movie clip in the library. The characters in the game must be the same width as a tile, although their height is not restricted so they can be taller than the walls. The duplicateMovieClip function is used to duplicate a specific number of ghosts onto the board. So first we place the ghost asset onto the ZakPac movie and name it "ghost". Then we need to add the code for the first frame action to duplicate the ghosts.

```
ghostStartCol = 13;     // Starting Column position of a ghost
ghostStartRow = 1;      // Starting Row position of a ghost
ghostSpeed = 4;         // How fast the ghost moves, lower is faster
numGhosts   = 4;        // How many ghosts

// Arrays to store the grid positions of the ghosts
ghostColPositions = new Array();
ghostRowPositions = new Array();

for (num = 0; num < numGhosts; num++) {
   duplicateMovieClip("ghost","ghost" add num,level++);
   ghostColPositions[num] = ghostStartCol;
   ghostRowPositions[num] = ghostStartRow;
   this["ghost"add num]._x=(ghostColPositions[num] * tilewidth)
                    + boardxoffset;
   this["ghost"add num]._y= ghostRowPositions[num] * tileheight)
                    + boardyoffset;
}
```

This code starts by setting variables that control where on the board the ghosts start, how fast they will move and how many of them there will be. The two arrays are used to keep track of where all the ghosts are located on the board. The "for" loop is used to duplicate the "ghost" movie for the number of ghosts we specified. Each duplicated ghost is positioned on the second row, fourteenth column, named "ghost1", "ghost2" etc. and their starting grid position stored in

Figure 12.11 *The ghost asset*

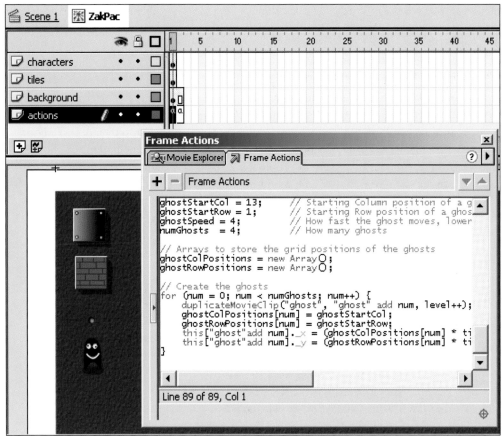

Figure 12.12 *Adding code to create the ghosts*

the two ghost position arrays, ghostColPositions and ghostRowPositions. The x and y co-ordinates are then set using their starting grid positions.

Once this is done it gives us a board with our ghosts placed on it. The next step is to make them move. This is done by inserting an ActionScript function into the ghost asset that will be called every frame to cause the ghost to move. First we must make the movie loop between two frames. This is done by creating two more frames in the ZakPac movie; frame 2 will be used to call each ghost's move() function while frame 3 will simply loop back to frame 2. Next we need to add the move() function to the ghost asset. To do this open the ghost asset from the library and open the frame action for the first frame. The code on the following pages is required to move the ghost around the maze.

```
ghostMoving = 0;
ghostPreviousDirection = "x";
ghostYstep  = _parent.tileheight / _parent.ghostSpeed;
ghostXstep  = _parent.tilewidth  / _parent.ghostSpeed;

function move(num) {

   // Get the position of the ghost
   r = _parent.ghostRowPositions[num];
   c = _parent.ghostColPositions[num];

   // If the ghost isn't moving then we can change it's
   // direction
   if (ghostMoving == 0) {
      // This array is used to store the possible directions
      //from the ghosts current location.
      directions = new Array();

      // Lets first see which directions we can move in
      // making sure that the ghost doesn't reverse
      if (_parent.board[r][c+1] == 0 &&
         ghostPreviousDirection != "l")
         directions.push("r")
      if (_parent.board[r][c-1] == 0 &&
         ghostPreviousDirection != "r")
         directions.push("l");
      if (_parent.board[r+1][c] == 0 &&
         ghostPreviousDirection != "u")
         directions.push("d");
      if (_parent.board[r-1][c] == 0 &&
         ghostPreviousDirection != "d")
         directions.push("u");

      // If there are all no possible directions we must
      // have hit a dead end therefore reverse, otherwise
      // pick a direction at random
      if (directions.length == 0) {
         if (ghostPreviousDirection == "r")
               moveDirection = "l";
         else if (ghostPreviousDirection == "l")
               moveDirection = "r";
         else if (ghostPreviousDirection == "d")
               moveDirection = "u";
```

```
            else if (ghostPreviousDirection == "u")
                moveDirection = "d";
        } else {
            moveDirection=directions[random(directions.length)];
        }

        // Now that we've got a direction to move it, set the
        // amount to move the ghost by in the x and y
        // directions
        if (moveDirection == "d") {
            ghostXmove = 0;
            ghostYmove = ghostYstep;
            _parent.ghostRowPositions[num]++;
        } else if (moveDirection == "u") {
            ghostXmove = 0;
            ghostYmove = -ghostYstep;
            _parent.ghostRowPositions[num]--;
        } else if (moveDirection == "r") {
            ghostXmove = ghostXstep;
            ghostYmove = 0;
            _parent.ghostColPositions[num]++;
        } else if (moveDirection == "l") {
            ghostXmove = -ghostXstep
            ghostYmove = 0;
            _parent.ghostColPositions[num]--;
        }

        // Store it's current direction to make sure that it
        // doesn't reverse
        ghostPreviousDirection = moveDirection;
        ghostMoving = _parent.ghostSpeed;
    }

    // If the ghost is moving then move it.
    if (ghostMoving > 0) {
        // Move the ghost
        ghostMoving--;
        _x += ghostXmove;
        _y += ghostYmove;
    }
}
```

Don't worry, it's quite a chunk of code, but it's really quite simple. Everytime the move() method is called, it looks to see if the ghost is moving or not. If not the possible directions that the ghost can move in are put into an array, a random direction is then picked and the ghost is set moving. The "ghostSpeed" variable is used to control how many frames it takes the ghost to move from one grid square to another.

The first four variables are used to control the ghost's movement. "ghostMoving" is used by move() to indicate whether the ghost is moving, "ghostPreviousDirection" keeps track of the current direction of the ghost so that it cannot reverse, and "ghostXstep" and "ghostYstep" are used to control the amount of movement that the ghost moves in every frame. The move() function starts by retrieving the current grid position of the ghost from the parent movie. It then looks to see if the ghost is already moving. If the ghost is not moving we create an array to store possible directions that the ghost can move in and look at the parent board array to determine which directions the ghost can move next. For each free direction, its corresponding letter (l, r, u, d) is pushed onto the array, unless it is the reverse of the ghost's previous direction.

The next step is to pick a direction to move in. If the array doesn't contain any values then the ghost must be at a dead end so it has to reverse, otherwise a random direction is selected from the array. With the moving direction picked we can actually move the ghost. This is done by setting the "ghostXmove" and "ghostYmove" variables to the x and y increment values that will need to be applied to move the ghost in the chosen direction. For example, if the ghost is moving right and ghostSpeed is 4 frames, ghostXmove will be 8.75 (tilewidth/4) pixels and ghostYmove will be 0, so that over 4 frames the ghost will have moved 35 pixels right and 0 pixels down.

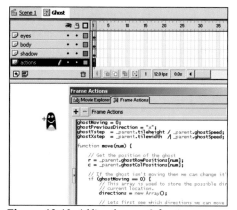

Figure 12.13 *Adding the move() function*

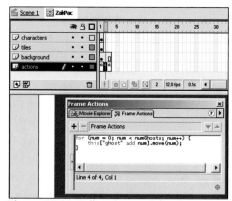

Figure 12.14 *Calling the move() function*

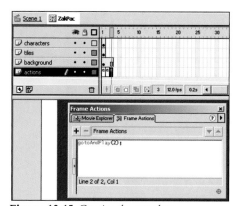

Figure 12.15 *Creating the game loop*

With the movement increments set, the "ghostColPositions" and "ghostRowPositions" array of the parent movie are updated with the ghosts' new grid position, the "ghostPreviousDirection" set and the "ghostMoving" indicator set to the ghost speed. Finally, if the ghost is moving, i.e. "ghostMoving" is not 0, then we need to move the ghost by its "ghostXmove" and "ghostYmove" increments and decrease the number of frames left to move by decrementing "ghostMoving", so that when it reaches 0 the ghost is in its destination grid square.

Phew, still with me. The last thing left to do is call the move() method for each ghost on the board. For this we need to go back to the ZakPac movie and add the following code to the second frame action:

```
for (num = 0; num < numGhosts; num++) {
    this["ghost" add num].move(num);
}
```

and make the third frame loop back to the second frame by adding gotoAndPlay(2) to the third frame action. Take a look at demo4.fla to see this in action.

Building the Game – Adding Zak

What we have so far is a board with some ghosts roaming around it; the next obvious step is to add Zak. The Zak character will move in a similar way to the ghosts except that he is controlled by the player, not randomly. First we need some graphics for Zak facing in different directions for when he is moving left, right, up and down. These are created as separate movie clips, each with a number of frames showing Zak walking. Each frame of the movie has a frame action that stops the movie clip, since we want to be able to control his walking, the last frame action simply loops to the first frame. Four of these movies are required for each direction he can move. Once created

place these on the stage and name them "zakleft", "zakright", "zakdown" and "zakup". When creating these assets, make sure that they exist for the entire length of the movie since they need to be available to be duplicated throughout the game, not just the first frame, which is the case for the tiles, things and ghosts.

Now that we have our character we need to actually create an instance of him in the maze. He is initially created on the first frame of the movie, in the frame action after the ghosts have been created. The following code sets up and creates Zak in the maze.

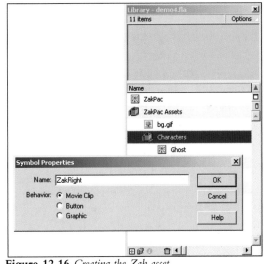

Figure 12.16 *Creating the Zak asset*

```
zakCol    = 1;        // Column position of Zak
zakRow    = 1;        // Row position of Zak
zakScore  = 0;        // Zak's score
zakLives  = 3;        // Zak's lives
zakSpeed  = 4;        // How fast Zak walks
zakWalking = 0;

// Create zak
duplicateMovieClip("zakright", "zak", level++);
zak._x = zakCol * tilewidth + boardxoffset;
zak._y = zakRow * tileheight + boardyoffset;
```

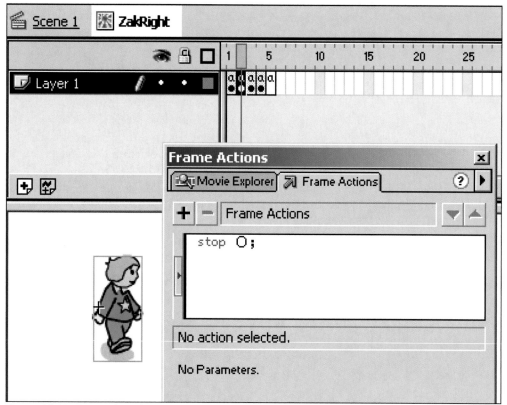

Figure 12.17 *Creating the Zak asset*

The first six variables are used to set Zak's initial starting position on the grid, the number of lives he has, his score, how fast he walks and his walking state. In this case he is started in the top left-hand corner of the grid and is set to move at the same speed as the ghosts. The

duplicateMovieClip function is then used to duplicate the "zakright" movie to the movie "zak" which will always be our main character. The newly created movie is positioned on the board using the "zakCol" and "zakRow" grid positions.

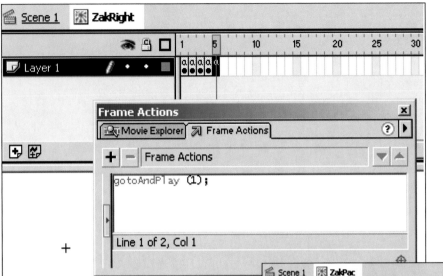

Figure 12.18 *Making the Zak movie loop*

To control Zak we need to add some code to the second frame, since this is repeated throughout the game. The code to control him needs to detect whether a key has been pressed, determine whether Zak can move in the requested direction by checking the board array, and if it is a valid move then remove the current "zak" movie and replace it with Zak facing in the appropriate direction. For example, if the left key was pressed, the block to the left of Zak's current position is checked, if it is empty then the current "zak" movie is removed and "zakleft" duplicated in its place. To actually move Zak a similar method to the one used for the ghosts is applied whereby the X and Y increment is calculated and applied to the movie's position over a number of frames. To control Zak the code on the next page is added to the second frame action.

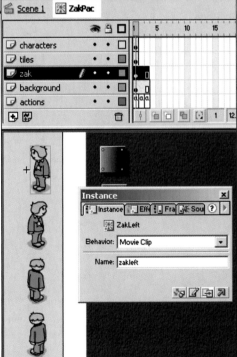

Figure 12.19 *Adding Zaks to the game*

270

```
// If Zak is stationary move Zak depending on
// which key was pressed
if (zakWalking == 0) {

    // Move Zak Right
    if (Key.isDown(Key.RIGHT)) {
        // First check that he can move in that direction
        if (board[zakRow][zakCol+1] == 0) {

            // Duplicate the appropriate movie to
            // change the way he's facing
            zak.removeMovieClip();
            duplicateMovieClip("zakright", "zak", level);
            zak._x = zakCol * tilewidth + boardxoffset;
            zak._y = zakRow * tileheight + boardyoffset;

            // Update his grid position and set the
            // X and Y movement increment to make him walk
            zakCol++;
            zakWalking = zakSpeed;
            zakXstep=tilewidth/zakSpeed;
            zakYstep=0;
        }
    } else if (Key.isDown(Key.LEFT)) {
        // Move Zak Left
        if (board[zakRow][zakCol-1] == 0) {
            zak.removeMovieClip();
            duplicateMovieClip("zakleft", "zak", level);
            zak._x = zakCol * tilewidth + boardxoffset;
            zak._y = zakRow * tileheight + boardyoffset;

            zakCol--;
            zakWalking = zakSpeed;
            zakXstep=-(tilewidth/zakSpeed);
            zakYstep=0;
        }
    } else if (Key.isDown(Key.DOWN)) {
        // Move Zak Down
        if (board[zakRow+1][zakCol] == 0) {
            zak.removeMovieClip();
            duplicateMovieClip("zakdown", "zak", level);
            zak._x = zakCol * tilewidth + boardxoffset;
            zak._y = zakRow * tileheight + boardyoffset;
```

```
                zakRow++;
                zakWalking = zakSpeed;
                zakXstep=0
                zakYstep=tileheight/zakSpeed;
            }
        } else if (Key.isDown(Key.UP)) {
            // Move Zak Up
            if (board[zakRow-1][zakCol] == 0) {
                zak.removeMovieClip();
                duplicateMovieClip("zakup", "zak", level);
                zak._x = zakCol * tilewidth + boardxoffset;
                zak._y = zakRow * tileheight + boardyoffset;

                zakRow--;
                zakWalking = zakSpeed;
                zakXstep=0;
                zakYstep=-(tileheight/zakSpeed);
            }
        }
    }

    // If Zak is moving
    if (zakWalking > 0) {
        // Move him by his specified X and Y increment
        zak._x += zakXstep;
        zak._y += zakYstep;

        // Move the Zak movie to the next frame to make
        // him look like he's walking
        zak.nextframe();
        zakWalking--;
    }
```

First, if Zak is stationary then the user can move him. He is controlled by using the four cursor keys. The last keystroke is checked using the inbuilt Key object, for example Key.isDown(Key.RIGHT) will return true if the right cursor key has been pressed. For more information on the Key object refer to the ActionScript dictionary. Next, if a key has been pressed, the board array is checked to see whether Zak can actually move in the direction the player wants. If the destination grid square is empty then we can start to move him. This is done by first removing the current "zak" movie clip from the stage and duplicating the appropriate Zak in its place, i.e. the "zak" movie which is facing the direction we want to go. Once the new movie is in place, the grid position of Zak is updated, the zakRow and ZakCol variables. His X and Y

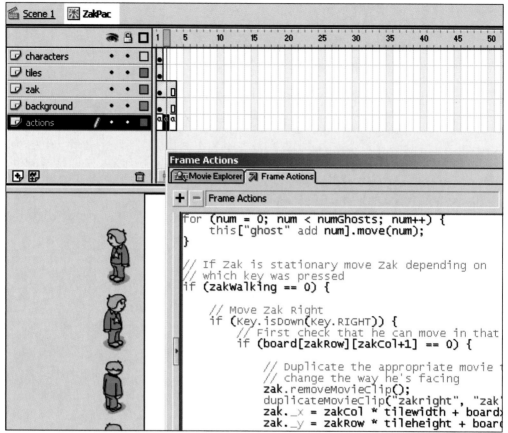

Figure 12.20 *Adding code to control Zak*

increment is calculated so that over the next few frames he will walk to the destination square instead of simply jumping there, these are zakXstep and zakYstep. This same procedure is repeated for all four directions he can move in.

The final check is to see if Zak is not stationary, in this case his X and Y positions are updated, using the zakXstep and zakYstep variables, and to make Zak actually walk, the "zak" movie is instructed to move onto the next frame.

Building the Game – The Finishing Touches

By running demo6.fla you will see that we have both Zak and the ghosts happily moving around the maze; however, nothing happens so we need to add the finishing touches to actually make it a game.

First we need Zak to pick up the gold balls. This is done by adding a small piece of code on the second frame action:

```
// Now see if he's standing on anything
// Call the activate() function of the thing he's standing on
if (things[zakRow][zakCol] != 0) {
    ["thing" add zakRow add "_" add zakCol].activate();
    ["thing" add zakRow add "_" add zakCol].removeMovieClip();
    things[zakRow][zakCol] = 0;
}
```

This code checks the things array to see whether Zak is standing on anything. If he is then the activate() function of the thing he is standing on is called and the thing itself removed from the board and the things array. The activate() function is placed in the first frame of the thing movie clip, for example the following code is placed on the first frame of the "thing1" movie clip:

```
function activate() {
    _parent.zakScore++;
    _parent.score = _parent.zakScore;

    // If the player has collected all the things
    // then jump to the frame named 'win' on
    // the root movie.
    if (_parent.zakScore >= _parent.targetScore) {
        _parent.gotoAndPlay("win");
    }
}
```

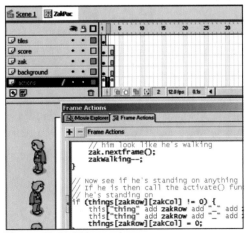

Figure 12.21 *Pick up code*

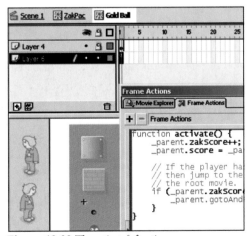

Figure 12.22 *The activate() function*

This activate() function increments the player's score (zakScore) and sets the value of the text field named "score" to their current score, to show the player their score. The function is also used to determine whether the player has won or not by comparing their score to the target score for the

game. If they have collected all the things then the game is moved to its winning state. In order for the score display to work a new dynamic text field needs to be created on the ZakPac movie and given the variable "score". The winning state is a frame in the ZakPac movie named "win".

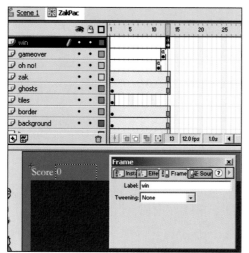

Figure 12.23 *The winning state frame*

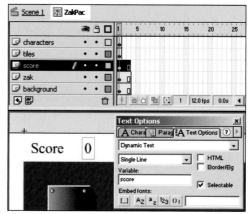

Figure 12.24 *Adding the scorefield*

Finally, we need to make the ghosts catch Zak. For this we add the following code to the ghost's move() function:

```
// Check if it's got zak
if (_parent.ghostRowPositions[num] == _parent.zakRow &&
    _parent.ghostColPositions[num] == _parent.zakCol) {
    // Got him!!
    _parent.gotoAndPlay("gothim");
}
```

This code simply looks to see if the ghost occupies the same grid square as Zak, and if it does then the movie is told to goto the frame labelled "gothim". Once this frame is called it removes one of Zak's lives and restarts the game. His lives are displayed as hearts which are simply created as movie clips. Three hearts are placed on the the ZakPac movie and named "life1", "life2" etc. The following code then needs to be placed in the frame action of the "gothim" frame.

```
zakCol=1;
zakRow=1;

this["life" add zakLives]._visible = false;
zakLives--;
```

275

```
if (zakLives == -1 ) {
    zak.removeMovieClip();
    life1._visible=true;
    life2._visible=true;
    life3._visible=true;
    nextframe();
}

// Reset zak
zak.removeMovieClip();
duplicateMovieClip("zakright",
    "zak", level++);
zak._x = (zakCol * tilewidth)
    + boardxoffset;
zak._y = (zakRow * tileheight)
    + boardyoffset;
zakWalking = 0;

// Reset the ghosts
for (num = 0; num < numGhosts; num++) {
    ghostColPositions[num] = ghostStartCol;
    ghostRowPositions[num] = ghostStartRow;
    this["ghost" add num].ghostMoving = false;
    this["ghost" add num]._x = (ghostColPositions[num] * tilewidth)+
                        boardxoffset;
    this["ghost" add num]._y = (ghostRowPositions[num] * tileheight)+
                        boardyoffset;
}
```

Figure 12.25 *Code to check if Zak is caught*

Essentially all this code does is reset the positions of the ghosts and Zak on the board and remove one of Zak's lives. It removes the life by simply decreasing "zakLives" by one and hiding the corresponding "life" movie on the stage. If "zakLives" reaches 0 then the movie moves to the next frame which displays game over and allows the player to restart the game by simply restarting the ZakPac movie.

Figure 12.26 *Adding the life indicator*

Animator's Quiz Game

The quiz game has been written to show you how to use some of the new features of Flash MX. The questions in the quiz are all animation and Flash-related, so you need to brush up on your animation knowledge before playing, and you can find the finished quiz, Quiz.fla, in the Appendix A folder on the CD. In the tutorial you will learn how to use all the new Flash User Interface components, such as radio buttons, drop-down menus and push buttons, and you will learn some of the new ActionScript functions, most notably the new dynamic loading of sound into the movie. The finished movie can be found on the CD, in the chapter12 folder, as Quiz.fla.

Stage 1 – Movie Setup

1. First, prepare your movie, create seven layers named, from top to bottom, Question Display, UI Components, ActionScript, labels, Background and Backlayer then import the background graphic onto the background layer, background.swf from the folder on the CD, and the image background.jpg from the CD onto the Backlayer layer.

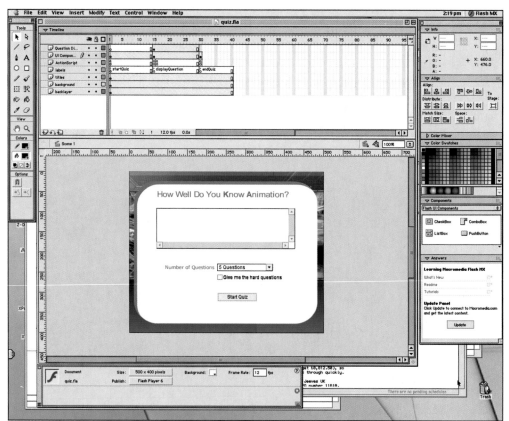

Figure 12.27 *Setting up the movie*

2. Next we need to place our user interface components on the stage. Select the UI Components layer, open the "Components" panel and drag a new "ComboBox" component onto the stage. This will be used to select the number of questions to answer.

3. Select the new ComboBox and open the properties panel. From here enter two values in the "Labels" field and corresponding values in the "Data" field. Give the ComboBox the instance name "numQuestions".

Figure 12.28 *ComboBox properties*

4. Next drag a new "CheckBox" component onto the stage and give it the label "Give me the hard questions". When this is selected by the player an alternate set of questions is used. Give the check box the instance name "hardQuestions".

5. Drag a "PushButton" component onto the stage and give it the label "Start Quiz". Since you want the button to actually do something you need to add a Click Handler, this is an ActionScript function that is called when the push button is clicked. To assign a handler set the "Click Handler" field to "startQuiz". Now add the script from code1.txt to the first frame action of the Actions layer. This code defines the startQuiz function that is used to load the questions for the quiz and start the game.

Figure 12.29 *Setting the Click Handler field*

6. The function uses the getValue() function to get the number of questions selected from the ComboBox. It loads the appropriate set of questions by calling the getValue() method on the CheckBox; it will return true if checked.

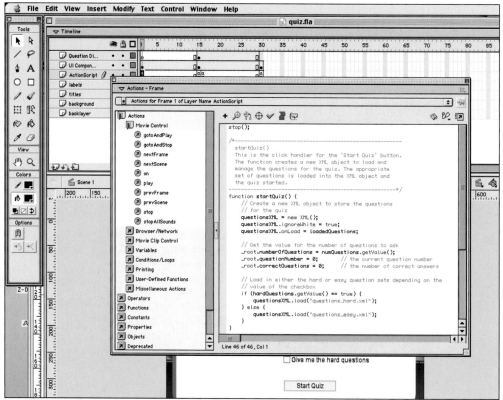

Figure 12.30 *The getValue() function*

Stage 2 – Adding the Questions

7. The questions are loaded from an XML file. The file contains a number of elements. Each element defines a question, its possible options and its answer. Refer to comments in code1.txt for more details on the XML functions that are used for the quiz, and question_easy.xml for an example of the XML format.

8. Once the questions have been loaded, you need to start the quiz. On the "labels" layer create keyframes on frames 1, 15 and 30. Give the first frame the label "startQuiz", frame 15 "displayQuestion" and frame 30 "endQuiz". These will be used to control the quiz.

9. The "displayQuestion" frame is used to display the current question, the text for a question, its possible answers and a button to move onto the next question. You first need

create two dynamic text fields, one to display the question number and another to display the question. Create these on the Question Display layer and give them the variable names "questionIndicator" and "questionText". Make sure to make the "questionText" field multi-line so that it displays the questions correctly.

Figure 12.31 *Adding the text fields*

10. Drag three "RadioButton" components onto the UI Components layer underneath the questionText field. Select the first RadioButton and set its Data field to 1, set the second to 2 and the third to 3. The Data field is the value returned for the selected radio button when the getValue() function is called on the radio button group.

11. Name the RadioButtons "option1", "option2" and "option3". Drag a new PushButton onto the stage and give it the label "Next Question", and the instance name "nextQuestionPattern". With the RadioButtons and PushButton in place the layout for the question display is complete.

12. Add the code from code2.txt to the frame action on frame 15 on the Actions layer. This piece of code disables the next question button. It

Figure 12.32 *Adding radio buttons*

280

does this by calling the setEnabled() function of the PushButton component. It then updates the questionIndicator display with the current question number.

13. To display the question, the code retrieves the current question from the array of XML question objects that you loaded at the start of the quiz. The values for a question can then be retrieved by accessing the attributes object of the question. Using this method the question text is displayed in the question text field and the radio button labels are updated to display the question's possible answers (the values of .attributes.option1, etc.). To set a RadioButton label, the setLabel() function is used on each of the three radio buttons.

Figure 12.33 *Setting up the radio buttons*

14. To re-enable the button once they've selected an answer you need to add a Change Handler to each radio button. In the Change Handler field of each radio button add the value "enableNextQuestion", this will be the name of the function to call when they select an answer.

15. Add the code from code3.txt to the frame action on frame 15. This code defines the enableNextQuestion() function which uses the setEnabled() function to re-enable the "Next Question" button. You need to add a Click Handler to the "Next Question" push

button. To do this change the value for the Click Handler field of the button to "nextQuestion". Add the code from code4.txt to the frame action on frame 15. This code defines the nextQuestion() function.

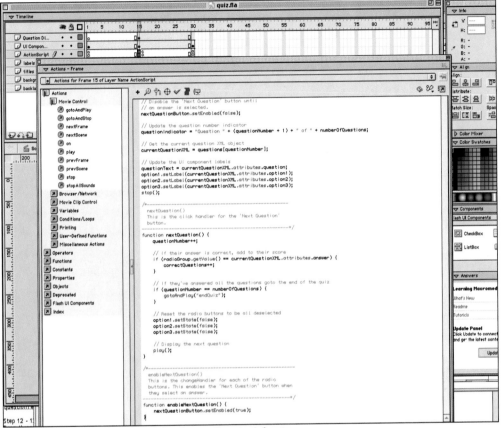

Figure 12.34 *Adding the code to define the nextQuestion() function*

16. This function first increments the current question number. It then checks if the answer selected is correct by comparing the values of getValue() result from the radio button group with the defined correct answer for the question. If identical then the player's score is increased. The function then checks if the player has answered all the questions, if they have it jumps to "endQuiz", otherwise the radio buttons are all deselected and the "displayQuestion" frame repeated to display the next question.

Stage 3 – Finishing Off

17. Now you let the player know how well they've done. This is done on the "endQuiz" frame. On this frame create a multi-line text field with the variable name "welldone", this will display the end of quiz message. Drag a push button from the components panel onto the stage, give it the label "Play Again" and the Click Handler "restartQuiz".

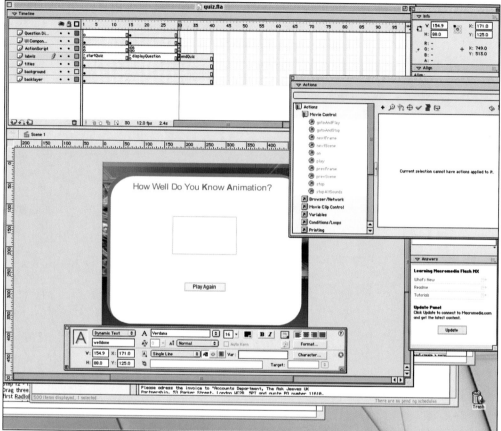

Figure 12.35 *Adding the "welldone" text field*

18. Paste the code from code5.txt into the frame action of frame 30. This code generates a message depending on the player's score and displays it in the "welldone" text field. It also defines the restartQuiz() function that is used to restart the quiz. If the player gets a good score a sound clip will be played. To import the sound select File > Import and select cheer.mp3. Next, open the library and select the Linkage option for the imported sound effect. Check "Export for ActionScript" and give it the identifier "cheer".

Figure 12.36 *The timeline with the imported sound*

19. To play the sound a new sound object is created and the "cheer" sound is attached using the attachSound function. The sound is played using the start() function and the new onSoundComplete handler is used to automatically restart the quiz when the sound clip finishes. To attach the onSoundComplete handler the code defines the function stopCheer() and uses the line cheer.onSoundComplete = stopCheer to attach the function. The stopCheer() function performs the same function as "restartQuiz".

Figure 12.37 *Adding the stopCheer function*

20. Now drag a ScrollPane component onto the stage. Next, open the library and create a new movie clip called "Instructions" to hold the contents of the scroll pane. Write the instructions into this movie using the text tool and, using the Linkage option, check "Export for ActionScript" and give it the identifier "Instructions". To attach the Instructions movie clip to the scroll pane, select the ScrollPane component you created and open the properties panel and enter the value "Instructions" for the "Scroll Data" field.

Games Case Studies – Goose Game

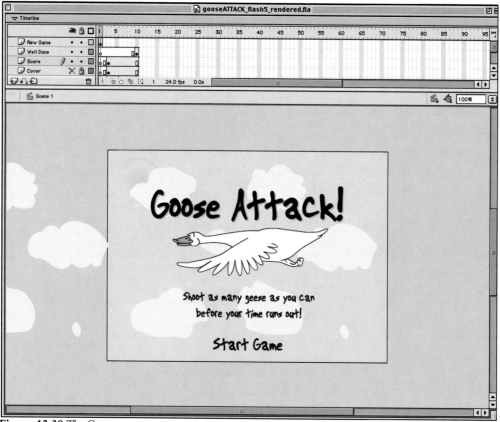

Figure 12.38 *The Goose game*

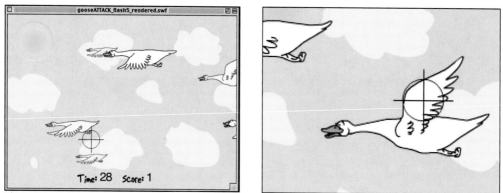

Figure 12.39 *Playing the Goose game* **Figure 12.40** *The Goose game on the PDA*

The goose is a character from Ellen and Zak, and the game was created to be totally multi-platform, running on both computers and PDAs. The files GooseComp.fla and GoosePDA.fla are on the CD.

Games Case Studies – Spriteris

Figure 12.41 *The Spriteris game in Flash*

Figure 12.42 *How high can you go?*

Figure 12.43 *Spriteris*

Spriteris is Sprite's own version of the classic Tetris game, where you have to see how many blocks you can stack on top of each other. The game was developed in Flash MX, and you can find the file, Spriteris.fla, on the CD.

Games Case Studies – Sprite Invaders

Figure 12.44 *Sprite Invaders*

Figure 12.45 *Only one more to go!*

Figure 12.46 *The aliens*

Sprite Invaders is Sprite's version of the classis Space Invaders game, developed in Flash 5. The game is featured on our web site, www.sprite.net, and can be found on the CD as spriteinvaders.swf.

Games Case Studies – Breakout

Figure 12.47 *Breakout*

Figure 12.48 *The ball stuck to the paddle*

Figure 12.49 *Breakout in Flash*

Breakout is a version of the classic Breakout game, designed in Flash. The aim of the game is to hit the ball at a brick wall and break through it. This game was one of the first classic games, and is on the CD as Breakout.fla.

Games Case Studies – Voltigame

Figure 12.50 *Voltigame*

Figure 12.51 *The winning screen*

Figure 12.52 *Voltigame in Flash*

The Voltigame was developed for a company called Voltimum, an electrical contractors installation portal. It can be found at www.voltigame.co.uk, and is a version of the 'pipeline' game where the player has to find a route from one end of the maze to another.

Games Case Studies – Wrangler Jeep

Figure 12.53 *The different Jeep models*

Figure 12.54 *The technology centre* **Figure 12.55** *Accessing the true stories section*

Originally developed for a Wrangler Jeep CD, the user drives a Wrangler Jeep around a landscape; along the way they encouter lots of different aspects of Wrangler lifestyle.

Games Case Studies – Solaglas

Figure 12.56 *The intro page*

Figure 12.57 *Smashing all the glass*

Figure 12.58 *A glass related question*

This CD-ROM was created with a character that takes the user through the product range at Solaglas. It stops along the way to advise and present educational games.

Games Case Studies – Ellen and Zak Memory Game

Figure 12.59 *Completing the game*

Figure 12.60 *The game has vivid colours and sounds*

Figure 12.61 *The opening game screen*

The Ellen and Zak memory game is an educational game from the Ellen and Zak site based on the pairs game.

Chapter 13
The Pocket PC

This chapter is an overview of developing content for the Pocket PC. You will be taken through essential issues such as interface design, movie size and format and optimum movie size for playback on the Pocket PC. This chapter discusses in depth the importance of mobile communications as we look into the future, and how they will change the multimedia industry.

Manufacturers of mobile phones and personal digital assistants (PDAs) are making moves into each other's markets by launching integrated products. The user interface of these systems varies greatly. Some believe that it is the mobile phone vendors who will win in the long run, because they are masters of some very demanding technology and established channels into their market.

Most people carry a mobile phone but not so many carry a PDA. This indicates that users will expect convergent devices to be the same size and weight as conventional mobile phones. But, to take advantage of the PDA functionality, consumers will want a larger screen and the level of usability they now experience with PDA user interfaces.

The embedded software and the user interface present the biggest challenges for any kind of development in the PDA market. No matter how small and efficient a device, consumers will not accept it if it is dull or difficult to use.

An essential part of the user experience is the operating system (OS) of the device. Unless the manufacturer develops a custom OS for its integrated product there are three main options: Palm OS, Windows CE (Pocket PC) and Symbian. The choice of OS can have a significant impact on power consumption, which is a vital issue for wireless devices. For example, while Palm OS can run on a 33 MHz processor, Windows CE requires processing in the region of 206 MHz so has a much shorter battery life.

This is a growing market in its early years. The type of animation or design house that makes a success of convergence will be the one that dominates the market. Ultimately, whatever you create the user will decide the success of your product.

Macromedia Flash on the Pocket PC?

Macromedia Flash enables animators to develop content once and deploy it on different playback devices from computers, interactive TV and the Pocket PC environment. Flash content is viewable across multiple browsers, platforms, and Internet appliances, and it allows designers to author TV-quality animations and games.

Flash files are compact and easily deployed over wireless networks, because the transfer rates usually run between 9.6 kbps and 19.2 kbps. Mobile devices – unlike desktop machines – also have limited storage capabilities, making the small footprint of Flash ideal. With Flash, animators and developers can build portable, multi-platform, custom user interfaces for the device as well as for the desktop. Animators can easily deploy existing content to Macs, PCs, and Linux in Internet Explorer and Netscape without recreating the content.

User Interface

There are some new challenges to deal with when developing Flash content for the Pocket PC. If the Pocket PC project is actually a portable version of a project originally developed for

delivery on the desktop, make sure to use the same assets, but optimise these for the PDA. Do not simply scale down an interface from the desktop and expect the device users to have a seamless experience.

The Goose game is an example of this multi-delivery approach. Originally drawn by me in FreeHand the flying goose became a demonstration in animation and how birds fly. I then asked one of my programmers to develop it into a game running on a PDA. The brief for the game was to use one asset to create a flock of geese. The geese, although one asset, would vary by size and with the use of tints we are able to give them the illusion of distance. The two screens below are grabbed from GooseComp.fla for playback on computers and GoosePDA.fla for playback on PDAs, both of which are on the CD. An interesting interface difference between the two is the cross-hair on the computer version which is draggable and moved round by input from the mouse. On the PDA version the user uses the stylus for shooting the geese and so the cross-hair does not exist on this version.

Figure 13.1 *Goose on the PC*

Figure 13.2 *Goose on the Pocket PC*

User Input

The Pocket PC supports various methods of input. The main methods include the stylus (operated like a pen or pencil), a screen-based keyboard, used to enter text into any form and to control movies, hardware keys that can be remapped to perform specific functions, and external keyboards. Function keys are not supported, devices usually offer some type of small keyboard with arrows and most ASCII characters, but no function keys. Certain keys are not supported, and it's a good idea not to use them but to provide alternatives for desktop and PDA applications. For example, small touchable icons that can be used with the stylus or a finger are often a good substitute. When using the Pocket PC keyboard, Flash content is covered by the on-screen keyboard. You can also create a special icon that brings up a small touchable keyboard or keypad if the on-screen keyboard is not desired.

The stylus is the main method of interaction between the user and the device. The animator should always try to create navigational controls and buttons that encourage dragging and clicking. The ZakModular.fla from the CD demonstrates the simplest use of the stylus, by allowing the user to drag and drop the star on Zak's shirt. We have also built functionality around the arrow keys on the unit. Try this out.

Buttons

Buttons should be treated differently for the Pocket PCs. The main difference is that Pocket PCs do not use mice for input and as a result they have no cursor. When the user is interacting with a Pocket PC movie, a pen tap generally translates as a mouse click. A rollover state is not needed, and should be avoided as pen taps can "stick", meaning the rollover state will be displayed after the click. Make sure to make the hit states on the buttons large enough for a hasty pen tap or the occasional finger if the application is a "quick reference" piece.

Right-click Menu

Holding down the pen does not bring up a contextual menu (right-click menu). If the hold-down menu was enabled, it would interfere with file dragging operations because PDAs are stylus-driven. This has been disabled to allow drag and drop functionality to be implemented more easily into the Pocket PC environment. In projects that require a zoom feature, which had previously been in the right-click menu, you can use on-screen controls to allow the user to zoom.

Screen Economy

Not all devices have the same screen size. While most development environments don't have an easy method for dealing with this issue, Flash vector technology can easily be set to scale to fit the display size of the device. A Pocket PC application should be expandable and not require specific screen parameters to function. If an application relies solely on the characteristics of the display area, then the user interface has not been clearly separated from the application.

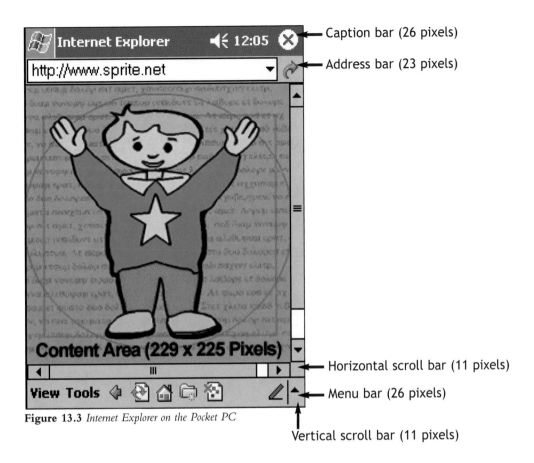

Caption bar (26 pixels)

Address bar (23 pixels)

Content Area (229 x 225 Pixels)

Horizontal scroll bar (11 pixels)

Menu bar (26 pixels)

Vertical scroll bar (11 pixels)

Figure 13.3 *Internet Explorer on the Pocket PC*

Both vertical and horizontal scroll bars are available, but you should try to fit all your content onto one page. The resolution you need to work to is 240 X 320 pixels. However, there are two areas that cannot be used for content:

1. The caption bar at the top of the screen.

2. The menu bar at the bottom of the screen.

Both bars take 26 pixels off the vertical resolution. Therefore, your page content must not exceed 240 X 268 pixels. Once the page exceeds 268 vertical pixels, the vertical scroll bar will appear and further reduce the screen width to 229 pixels. The user can also decide to switch off the address bar, allowing for an additional 23 pixels but there is no way for you to determine the state of the address bar so do not count on it. When utilising the full 240 pixels, the horizontal scroll bar will also appear, because Internet Explorer for Pocket PC needs to provide a way to reveal the remaining 11 pixels with the vertical scroll bar. It is possible to gain 11 additional vertical pixels if designing content in a way that does not require a horizontal scroll bar.

Figure 13.4 *HTML export settings*

Movie Size

Choose the "Pixels" option to set the values of the width and height in the HTML Publish Settings. To avoid undesirable results, do not choose "Percent". Internet Explorer for Pocket PC ignores the "%" when defining width and height in the HTML embed tag, for example defining "width=100% height=100%" is the same as "width=100 height=100". In most cases, this result is not desirable. Internet Explorer for Pocket PC will not display SWF files when the embed tag defines width and height that ignore the SWF file's original aspect ratio. For example, an SWF that is 200 X 200 pixels won't display because the embed tag defines width=50 and height=175.

Fonts and Text

In general, most sans fonts display better than serif fonts. Serif fonts tend to lose their details on screens. The Flash Player 4 for Pocket PC includes four built-in fonts:

- Tahoma (default font for variable width fonts)
- Courier (default fixed width font)
- Bookdings
- Frutiger Linotype

Colours, Vectors and Images

Pocket PCs vary in how well they display content and how many colours are available. Depending on the model, the colour depth of a Pocket PC display can be anywhere from 4096 to 65535 colours, or from four to 16 levels of grayscale. Choose highly contrasting colours when possible because the displays often have low contrast. Use graphics that have a high contrast ratio between colours and that have sharp edges in the details of the picture.

Setting Bitmap Properties

Apply anti-aliasing to a bitmap to smooth the edges in the image. This method helps the display of images on the smaller screens, and at other times the poorer screen quality of mobile devices can improve images of lesser quality. Select a bitmap in the Library window and in the Bitmap Properties dialog box, select Allow Smoothing to smooth the edges of the bitmap with anti-aliasing.

Figure 13.5 *Bitmap Properties*

Developers can also adjust the compression settings global in the Publish Settings area (File > Publish Settings). To control bitmap compression in the Publish Settings, Flash Tab, adjust the JPEG Quality slider or enter a value. As with the compression settings previously described, lower image quality produces smaller files; higher image quality produces larger files. Try different settings to determine the best trade-off between size and quality; 100 provides the highest quality and least compression.

Stacking Content

Scrolling large amounts of text and graphics, particularly with Flash, will slow down any device because of slower processor speeds. When displaying multiple pages of text or graphics on a Pocket PC, it is often better to avoid scrolling completely by adopting a "Stacking" model – displaying the one piece of information needed at one particular time, with navigation for the user to flip between pages, or "cards" in the stack. This system allows the developer to create more space for more content. Adding a new chunk of information pushes it on top of the current project phase. When finished with the current phase, go back to the previous "card". For a scheme like this, create a panel that knows how to push itself onto the card stack and pop itself back off. The ease and flexibility of using Macromedia Flash comes into play at this point. Using simple frame actions to go forward and backward in the timeline is a quick way to create a "stacked experience".

Sound

The less sound the better. Sound requires large amounts of processing power to uncompress the sound data and it also consumes precious power resources. The Flash Player 4 for Pocket PC is an ideal way to deploy "music pictures", mobile entertainment and animations, while linking into content and purchasing information on web sites. MP3 technology is not currently supported in the Macromedia Flash Player 4 for Pocket PC. Use

Figure 13.6 *Sound settings*

APDCM 11 kHz 4-bit audio for the Macromedia Flash Player 4 for Pocket PC when only voice or low-quality sound is needed. For music and clear speech, use RAW 11 kHz or 22 kHz audio, depending on quality and file size. Do not use the same audio successively. For instance, do not use the same sound on multiple buttons that can be clicked one after the other. If troubleshooting sound issues or if the next sound does not play automatically, put at least three empty keyframes after the end of each audio track. This approach debugs some sound issues. In addition, the Flash Player 4 for Pocket PC will not support the high-quality filtering (medium level of filtering will be used in place of the high mode). Most Pocket PCs support external speakers and headphones. Test to any sound output with headphones and/or speakers as many users also use the Pocket PC as an MP3 player and usually use these peripherals.

Things to Avoid:

1. Large amounts of animation and tweening.
2. Intensive visual effects. These include large masks, extensive motion, alpha blending, and complex vectors such as extensive gradients.
3. Full screen wipes, full screen fades, and full screen animations.
4. Updating large numbers of pixels at a time can be slow and chunky.

Pocket PC Tutorial

1. Before you start on this tutorial you should make sure your Pocket PC is set up to play Flash. It is necessary for you to have Activesync installed on your device, so that you can copy Flash and HTML files across to it, and you need to make sure that you have the Flash player installed, which can be downloaded from the Internet if you do not already have it on your machine.
2. This tutorial takes you through the basic steps towards creating a small animation on the Pocket PC. You can see the finished Star.fla on the CD.
3. Create a new blank movie in Flash and open up the movie properties by selecting Modify>Document. Set the movie height and width to 240W X 260H and set the frame rate to 12.

Figure 13.7 *A new blank movie*

4. The animation is going to consist of a button that you hit to trigger a simple animation, so first of all you need to create the button. To do this, first of all import the stargraphic.swf graphic into your movie by choosing File>Import and selecting the graphic from the tutorial folder.

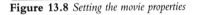

Figure 13.8 *Setting the movie properties*

5. Now, with the star graphic selected, choose Insert>Convert to Symbol and in the dialog box that appears select "button" and give it a name, such as "starbut".

6. Now you need to give the button a label and make sure it behaves properly on the PDA. Enter the editing mode for the button by double-clicking on it while it is on the stage, and insert a frame in the "hit" state of the button. Now add a new layer to the button, called text, and on this layer write text saying "press me" and position it over the button.

Figure 13.9 *Creating a button symbol*

7. Two important things to remember when creating this button are that, firstly, the x and y positions of the text have to be set to a whole integer value, not a decimal value, as the Pocket PC will display it as fuzzy if it is a decimal; you can do this using the info panel. You also have to remember not to put a keyframe in the "over" state of the button, as the

Pocket PC does not use a mouse for input, so there is no "over" state, and it could lead to unexpected results.

8. Now we need to set up the ActionScript to control the movie. Create a new layer, and call it "actions". In this layer insert a blank keyframe at frame 2 and another at frame 30. In keyframe 1 insert a "stop" action, and label the frame "start". At keyframe 2 label the frame "move", and at keyframe 30 enter the following ActionScript:

```
stop ();
gotoAndStop ("start");
```

This tells the playhead to stop and then go back to keyframe 1, which is labelled "start".

Figure 13.10 *Adding script to the timeline*

Figure 13.11 *Adding script to the button*

9. Now you need to add actions to the button. Add the following ActionScript:

```
on (press) {
gotoAndPlay ("move");
}
```

You need to make sure that your on (event) setting is set to "press" and not "release" as the Pocket PC has a stylus so only the "press" input is recognised.

10. Now you need to create an animation effect. Create a new layer called "animation" and insert keyframes at frame 2 and frame 30. You now need to create an animation for after the button has been pressed. I have created a very simple motion tween, with a motion guide, which reduces the size of the star, and then moves the star around the screen and spins it at the same time; you can read more about creating animations in Chapter 3, so draw a simple animation and preview your movie to see how it looks.

11. Now you need to publish the movie. Select File>Publish Settings and make sure the Flash and HTML check boxes are selected. Go into the Flash settings, and change the Version to "Flash 4". In the HTML settings make sure the Template is set to "Pocket PC", the Dimensions is set to "pixels" (entering the correct dimensions for your movie – 240 X 260), that there are no Playback Options checked and that the Quality is set to medium. Now hit Publish and then OK.

12. Now you will have three files on your computer ready to take across to your Pocket PC. First of all, however, you need to prepare the HTML file.

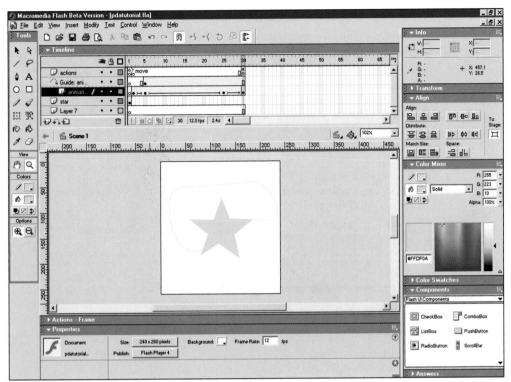

Figure 13.12 *The finished movie*

13. Open the file in an HTML editing program, I have used Dreamweaver 4, and set the margin widths to "0", this will mean the movie will be up against the Pocket IE borders and will also contain no scroll bars. You also need to make sure that you have an <OBJECT> ID value set to something. It can be anything, but you need to have the ID variable with a value present in your code, if you don't then the file will not display properly on your device. The ID in this example has already been automatically set to "pdatutorial".

14. Now save your file, and copy the files to your Pocket PC using Activesync. To launch the Flash file you need to tap on the HTML file that you previously created and the animation will launch in Pocket Internet Explorer.

Gaming and Interactivity

Flash on the Pocket PC platform is well suited for the creation of small games. As Pocket PCs become more widespread people will increasingly use them for entertainment, particluarly games. It is best to develop non-processor intensive single-player games (any of the solitaire-style games), or games that can be played against the computer (make the Macromedia Flash game include rules logic). Therefore games such as card games or turn-based games are good choices for Pocket PC.

Flash cannot currently save anything to the Pocket PC device so it's difficult to save scores or game states. Since most users won't be directly connected to the web through these devices, but instead will be syncing to send or receive information, it's extremely difficult to create games that require saved information or communication with others.

Figure 13.13 *A Pocket PC game in landscape format*

Figure 13.14 *The code to make Zak move*

Internet Explorer for Pocket PC

A Macromedia Flash movie must be embedded inside an HTML page; there is no stand-alone player functionality at this time. The same rules apply to PDA devices as desktop computers. Using supported HTML tags is key, otherwise the content cannot be rendered. Using supported and industry standard HTML tags will enable the application to transfer more elegantly onto a handheld device. Make sure to support the character sets of the particular device. For instance, the application is immune if displaying Flash or images, but textual content needs to follow the device guidelines. Most handheld devices use the full set of Latin1 characters. International characters are not yet available as internal fonts on some devices. Some devices require "old tricks" with HTML. Adding space with a GIF file often corrects issues with spacing.

When using HTML tables, do not create overly large or complex nested tables. Tables can quickly consume screen space, requiring both vertical and horizontal scrolling, and unnecessarily affect performance during rendering. When publishing, the presence of the <Object> tag is mandatory; otherwise the SWF movie won't play. The <Object> tag is an Internet Explorer way to instantiate ActiveX control (in this case Macromedia Flash). On the desktop version of Internet Explorer, it can recognise either the <Object> tag or the Netscape <Embed> tag. However, the Internet Explorer for Pocket PC only supports the <Object> tag. If the HTML only uses the <Embed> tag, Internet Explorer for Pocket PC won't be able to recognise it and will not be able to load

Macromedia Flash. The content creator should support both APIs as a good habit to ensure compatibility on various browsers. Furthermore, the <Object> tag must have an ID attribute. The value could be arbitrary though the file name of the SWF movie is highly recommended. Otherwise, the SWF movie won't play. ID tells Internet Explorer to instantiate a Macromedia Flash player ActiveX Control. Its presence is mandatory. Enclosed between <Object> and </Object>, there must be a tag <Param name="movie" value="moviename.swf"> where "moviename.swf" should be the actual file name of the SWF movie. Otherwise, the SWF movie won't play. The examples provided in the kit, as well as the included Publish Template, will help developers automate this process.

Choose the Pixels option to set the values of the width and height in the HTML Publish Settings. To avoid undesirable results do not choose Percent. Internet Explorer for Pocket PC ignores the "%" when defining width and height in the HTML embed tag. For example, defining "width=100% height=100%" is the same as "width=100 height=100". In most cases, this result is not desirable. Internet Explorer for Pocket PC will not display SWF files when the embed tag defines width and height that ignore the SWF file's original aspect ratio. For example, an SWF that is 200 X 200 pixels won't display because the embedded tag defines width=50 and height=175.

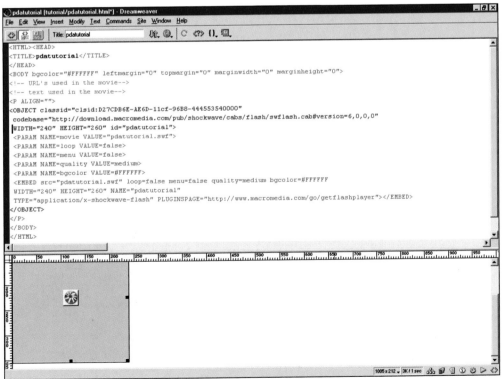

Figure 13.15 *Example HTML code*

Supported HTML Tags

Internet Explorer for Pocket PC is HTML 3.2 compliant, with some minor exceptions. Therefore HTML tags that are defined by this standard can be displayed in Internet Explorer for Pocket PC.

File Size and Memory

The application file size is more important now than the web itself. While the actual transfer of the file from the storage card of device media may be instant, PDAs are lacking in RAM compared to desktop PCs. It is better to construct your movie from lots of smaller files rather than one large one to reduce loading times. Also, users may want to beam or transfer the application, so the smaller the file the better for faster transfer. Some users may be connecting wirelessly with average connection speed of less than 9.6 Kbps.

Connected vs Unconnected

In most cases the content will be transferred to a device by either "synching" with a desktop machine or transferring the files over some type of connection. A connected application gives the developer a speedier connection, and news, weather, and portal-like content are good examples of this content. For an unconnected application (wireless transferring or live querying) the content needs to be as small as possible. Loading in text files that drive Flash content via Load Variables is a good example of when Macromedia Flash files cannot be transferred at all. A currency calculator is also a good example; you could make the device look for an external text file containing the values of today's exchange rate when it opens.

Publishing Checklist for the Pocket PC

When copying content to the Pocket PC, make sure you do the following:

1. Publish the SWF as a Macromedia Flash 4 file (File > Publish Settings).
2. Publish with the Included Pocket PC MTML Template; be certain to properly embed and ID the movie into an HTML page; see pages 305–6 for more information.
3. Transfer the file via the "Pocket PC My Documents" folder or via browsing to "My Computer/Mobile Device". If enabling Pocket PC content to be viewed via a wireless connection on the Pocket PC, see pages 305–6 for more information.

Emulate

An emulator is a good place to start testing, and all device kits usually have a device emulator as part of the development environment. But it's never as accurate as the real device. Testing on an emulator at 70%–80% of the development cycle and then again at the final 20%–30% of the cycle is a good balance between ease of testing and also provides a safety margin if the emulator isn't quite accurate. You can downloaded the Pocket PC emulator here: http://www.microsoft.com/mobile/downloads/emvt30.asp

Figure 13.16 *A Pocket PC emulator*

This emulator doesn't currently play Macromedia Flash movies, but it can view images, so you can use it to test the size of your movies. You will need to pay careful attention to the caveats associated with each emulator you use. While the emulators can save hundreds of hours in testing, they can also cause false expectations of application performance. A series of HTML files and images created to help "emulate" the PDA experience is also included in the kit.

You will need to test the application frequently on the actual device. This advice may sound obvious, but this step is often overlooked, and is especially important when developing Flash content for Pocket PC. No matter how much device detection or proactive steps a developer takes, the final delivery remains the most important step in the development cycle. Developers make the most impact and give the strongest message by delivering a well-designed user experience. If the application is slow, sluggish, or unviewable, the application becomes diluted. Some devices require lengthy synching, and this is where emulation comes in. Emulation is helpful for a bulk of the testing, but don't assume that it's the ultimate test.

Chapter 14
Interactive TV

This chapter takes a look at developing for interactive television, in particular the Liberate platform. It covers issues such as interface design, animation size and fomat and how to integrate your Flash MX movies into television and video content. Interactive television, like the Pocket PC, is one of the major new technological developments, and this chapter covers how you can best take advantage of this medium.

What is Interactive Television (iTV)?

iTV is a combination of traditional TV watching with the interactivity of the Internet on a personal computer. Interactive TV covers a variety of technologies – cable and satellite set-top boxes, game consoles, electronic programme guides, personal video recorders, "walled garden" formats where content is enclosed within a controlled environment, video-on-demand, enhanced TV programmes as well as the capability to browse the Internet on a television.

iTV gives animators and web professionals new opportunities to work in television, offering viewers more reasons to interact with their favourite programmes. iTV is connected through a set-top box, which typically sits on top of a television. The user can interact with the programmes through a wireless keyboard or a remote control.

As the digital television era gains ground with consumers and more digital television programming is aired, then the interactive nature of iTV will increase as digital television systems are capable of more efficient use of bandwidth. Also combine that with increased broadband resources, personal video recorders, video-on-demand options, electronic programme guides, etc. and iTV will be commonplace. Research shows that people want additional facts on their favourite programmes, as well as video streams, alternative commentaries, and web support as part of the programme they are viewing.

Things you can do with iTV include:

- Interactive animated cartoons
- Answer trivia questions during a TV show
- News, weather and sports
- Home banking and shopping
- Interactive entertainment guides
- Electronic programme guides/interactive programme guides
- Polls/Surveys
- Interactive games and sports
- Interactive advertising
- Videoconferencing
- Distance learning
- Interactive betting
- Photo display services
- Interactive multi-camera-angle events (switch camera angles)
- Interactive magazines
- Interactive music selection
- Messaging and email
- Instant shopping – movie tickets, CDs and books, pizza from a commercial

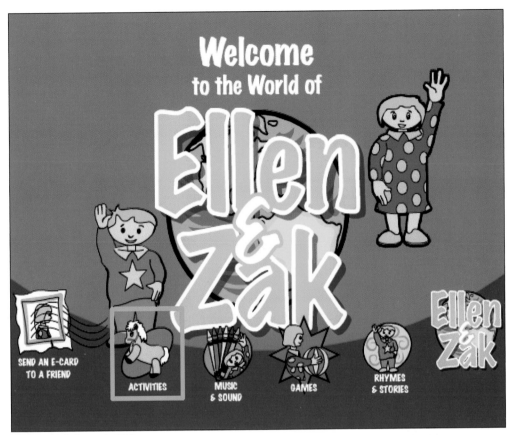

Figure 14.1 *Interactive TV content*

iTV Delivery Platforms

The most popular iTV types are TV-on-PC, sync to broadcast, and the set-top box connected to a TV. As iTV evolves we will begin to see a focus on multi-platform development with an emphasis on newer technologies that focus on reusability and dynamic content transformation. Television is evolving, and the content developer's market is growing, moving out of the conventional TV and post-production studios to web design and animation studios.

However, the most powerful piece of functionality this technology provides is the ability to combine TV with the web. Using the programming feed as a basis for the content and using the web interface to interface related interactive functionality. This convergence will give rise to an new set of applications. TV adverts coupled with web-based e-commerce technology will allow for instant purchase with a click of the remote control. Detailed information about a movie or its actors can easily be provided, and interactive quiz shows, interactive guest chats, educational programmes with attached web sites, and unimaginable viewer interactive scenarios will start to take shape.

TV-on-PC

As display screen sizes increase and computers become more powerful, the possibilities of watching TV on your PC, Mac, or even laptop have become more numerous. Whether it's the latest updates from television news, video playback, or routing a game system through a PC rather than a television, the options for TV on PCs have expanded and costs have come down. This solution requires the TV-tuner computer hardware that takes in a PCI or AGP slot and is used to receive and view the TV broadcast signal on your computer. The process of synchronised-to-broadcast (SyncTV) is defined as watching a programme on TV and simultaneously using a computer to interact in some way with the program's web site, or the programme advertiser's web content. TV-on-PC already has a strong user base but is unfortunately geared to one-to-one viewing and is therefore unlikely to have a major impact in the home. Growth areas for this technology will be within e-learning.

Set-top Box

The set-top box is an electronic device that sits on top of your TV set to allow interactive content and video to work together through a middleware platform. Middleware is the layer of software between the operating system and the set-top box. Set-top boxes are becoming as stable as the average desktop PC with video-on-demand (VOD), MP3 jukebox, smart home and network functions, local and Internet gaming and broadband Internet access. When developing for a set-top box you will need to decide between developing an iTV application or web content for surfing on TV.

The iTV vision is a broadband high-speed connection to the home, whether it takes the physical form of a telephone wire, a cable television line or a satellite link, displayed on TV via a digital set-top box or a computer, content can come through the following sources:

- ADSL (copper wire): telephone broadband, used for computers. BT is heavily investing in it. Videonet plan to offer videos on demand (VOD) using broadband technology. Very fast, but difficult to deploy. No media partnerships.
- Cable Modem (fiber/coax): cable broadband, geared for interactive TV. Cable and Wireless, NTL, and Telewest all plan to use it. Not as fast as ADSL but quicker to deploy using existing wiring ("last mile").
- Satellite: currently works like an advanced Teletext with modem backup. Data is streamed to everyone ("carousel") and you wait your turn until it comes up. Slow reaction but easiest to deploy. Non-web compliant.
- The base functionality is HTML 3.2-standard web pages, tables, forms.
- Extra multimedia functionality to play sounds, synchronise events, play animations.

The first thing this new technology allows is Internet connectivity with greater access at a higher bandwidth. For the first time most of the population will be able to experience e-mail and the Internet within their home. The expanded viewing audience will drive content, resulting in much more personalised content combining real-time events, chat and audience participation.

```
HTML: Send An E-Card

<HTML>
<HEAD>
<TITLE>Send An E-Card</TITLE>
</HEAD>
<BODY BACKGROUND="ecardbg.gif" text="#663300" BGCOLOR="#FFCC00" LEFTMARGIN="0" TOPMARGIN="0" MARGINWIDTH="0" MARGINHEIGHT='
<TABLE CELLSPACING="0" CELLPADDING="0" BORDER="0">
<TR>
<TD>

<form action="http://www.ellenzak.co.uk/cgi-bin/card.cgi" method=post>
<input type=hidden name='job' value='see'>
<input type=hidden name='midi' value='none'>
<input type=hidden name='subject' value='title'>
<input type=hidden name='backcolor' value='ffffff'>
<input type=hidden name='wordcolor' value='000000'>
<center><br><img src="ecardtop.gif"><br><br></center>

<table border="0" cellspacing="3" cellpadding="3">
<tr>
<td></td>
<td colspan="2"><img src="1.gif"></td>
</tr>
<tr>
<td><img src="invis.gif" width="45" height="10"></td>
 <td valign="top">
  <img src="invis.gif" width="25" height="10">
<font face="Arial, Helvetica, sans-serif" size="2"><b>Your name</b></font>
 </td>
 <td>
<input type="text" name="fromname" size="30">
 </td>
</tr>
<tr>
<td> </td>
 <td valign="top">
  <img src="invis.gif" width="25" height="10">
<font face="Arial, Helvetica, sans-serif" size="2"><b>Your e-mail address</b></font>
 </td>
 <td>
<input type="text" name="fromemail" size="30"><br>
<font size="1" face="Arial, Helvetica, sans-serif">(ask a parent if you do not know your email address)</font></td>
</tr>
```

Figure 14.2 *Interactive content based on HTML 3.2*

Standards for iTV Content

Designing and developing interactive television is very similar to web design. The design process starts with the content and moves onto the specific platform using preset protocols from a governing standards body. Some platforms contain proprietary software that causes cross-platform content display complications, as is seen between PC and Macintosh® systems or Internet browsers: Netscape® and Internet Explorer. Using a common set of standards to create iTV content ensures that not only will your material run on today's platforms but will also last into the near future.

Interactive Television Standards

The convergence of Internet technologies with television is the key driving force of iTV. The more successful standards that are currently used are of shots of Internet protocols, such as HTML, JavaScript™, and Macromedia® Flash. The OpenCable consortium has recently released the Open Cable Application Platform (OCAP), which has an engine based on an HTML browser with extensions for interactive TV. The Advanced Television Enhancement Forum (ATVEF) has produced a standard set of HTML extensions that have been adopted by OpenCable, as well as some of the key software providers such as Microsoft® and Liberate®.

The World Wide Web Consortium (W3C) has not endorsed the use of Macromedia® Flash™ technologies, although the majority of the iTV platforms support Macromedia Flash to some degree. Vector-based technologies had to become a part of the standard and its more than likely it will be Macromedia Flash that will be the favoured application environment.

iTV Standards Comparison Chart

Technology	ATVEF 1.1	AOL TV (Liberate)	Liberate TV Navigator Standard 1.2.x	Microsoft TV Enhanced	MSN TV (Web TV)	Moxi Media Centre	Nokia Media Terminal (OST)	Open TV Mosaic	Worldgate
Markup Language	HTML 4.0	HTML 3.2	HTML 3.2	HTML 4.0	HTML 4.0	N/A	HTML 4.0	HTML 4.0	HTML 3.2
Scripting Language	JavaScript 1.1	JavaScript 1.1	JavaScript 1.1	JavaScript 1.2 Microsoft TV JavaScript	JavaScript 1.2	N/A	ECMA-262 Revision 3	JavaScript 1.4	JavaScript 1.1
Cookie Support	Not Defined	Y	Y	Y	Y	N/A	Y	Y	N/A
Frames Support	Not Defined	Y, non-traditional	Y, non-traditional	Y, non-traditional	Y, non-traditional	N/A	Y	Y	N
Dynamic Tables	N	Y	Y	N	N	N/A	N	N	N
CSS	Level 1	N	N	Mix of level 1 Level 2	Mix of Level 1 Level 2	N/A	Level 1	Mix of Level 1 Level 2	N
Macromedia Flash	3.0	3.0	4.0	4.0	4.0	5.0	5.0	5.0	N
PNG	Y	Y	Y	Y	Y	N/A	Y	Y	N
JPEG	Y	Y	Y	Y	Y	N/A	Y	Y	Y
GIF	Optional	Y	Y	Y	Y	N/A	Y	Y	Y
Audio Support	AU, WAV (Optional)	WAV, AIFF, AIF, AU, RMF, MIDI, MID, RAM	WAV, AIFF, AU	MIDI, MOD, RMF, AIFF, WAV, AU, MPEG-1 (layers 1,2,3), MP3 (MPEG-2 layer 3)	Windows Media Audio 7, Microsoft Audio 4.9 (up to 22kHz), ACLEP by SiproLabs, MPEG Audio layer 1, MPEG Audio Layer 3	N/A	MP3, WAV	N/A	N
Video Support	Not Defined	N	N	ASF, ASX, MS Audio, MPEG-4, ACLEP, MP3	Windows Media Video 1, Windows Video 7, ISO-MPEG 4.3, ISO-MPEG-4.2	N/A	Real Player (Version N/A)	N/A	N

iTV Middleware

The middleware layer is what gives the content its portability. The layer of software sits between the operating system of the set-top box, hardware and the applications. This makes the content very portable, since it writes to a middleware that can be ported to multiple boxes and operating systems. Examples of middleware include OpenTV®, PowerTV®, WebTV®/Microsoft TV, MediaHighway and Liberate®.

The Authoring Equipment Environment

The minimum you will need is a basic personal computer, an HTML editor like Macromedia's Dreamweaver, a graphics editor like Photoshop, and middleware tools or emulators. This set-up is good for non-programmers especially multimedia artists who design web content but are not responsible for coding or programming.

Hardware:

- Television set with connected set-top box
- Two personal computers with 166 megahertz (MHz) CPU or faster
- 128 megabytes of RAM or more
- CD-ROM
- 20 GB hard disk drive
- Internet connection through a 56 Kbps modem or Ethernet connection to a local area network (LAN)

Optional hardware:

- ITV trigger data encoder: Mixed Signals Technologies or Norpak Corporation
- Platform specific hardware: Microsoft TV, Liberate®, OpenTV®, etc.
- Video recorder
- Modulator
- Two editing decks
- Color printer

Software recommendations:

- Operating systems: Windows® 98, 2000, NT® 4.0, XP or Macintosh®
- HTML editor: Macromedia® Dreamweaver® or HomeSite™
- Graphics editor: Macromedia Fireworks® or Adobe Photoshop®
- Animation editor: Macromedia® Flash™
- Database software: Microsoft® Access or Oracle SQL®
- Internet service provider or web server: MS Internet Information Server or iPlanet
- Netmanage® software: CuteFTP or FTP Voyager

Optional software:

- ASP, JSP, ColdFusion® editor: Macromedia® UltraDev™ or JRun™ Studio
- Server software: ColdFusion and JRun
- Advanced vector graphics editor: Macromedia FreeHand®
- Firewall software
- iTV trigger creator software: Mixed Signals Technologies, TwoWayTV
- Middleware development software: SpinTV Studio Suite Kit, Liberate® TV Emulator™, Microsoft TV Simulator, MSNTV (WebTV) Viewer, Open TV Software
- Platform specific software: Microsoft TV, Liberate, OpenTV®, etc.

Television Broadcast Signal

The purpose of iTV is to ultimately improve the television experience by adding a whole new dimension. This adds pressure on the designer/animator to make the programme seamless between the traditional full-screen television and the interactive experience. The enhancements must be evenly integrated to provide a transition between what has traditionally been two different technologies.

A couple of methods can be adopted when working with the TV signal. The first is to overlay layer elements over the full-screen TV signal. This works when presenting additional information without resizing the television broadcast. Another method is to embed the TV window within an HTML page surrounded by the enhancements. I'll explain this method further later on in this chapter.

Figure 14.3 *Layer elements over a full screen*

Figure 14.4 *A TV window embedded in HTML*

Cross-platform Design Rules

The Internet is moving further away from the desktop PC to TV, mini-laptops, PDAs and telephones. To be a content developer in this ever-changing environment you require true cross-platform design capability. Convergence and the multi-platform environment become a principle factor in web design; it should be understood that convergence can only be established when fundamental divergences between the player appliances are taken into account.

HTML and iTV

The Advanced Television Enhancement Forum (ATVEF, now SMPTE) defines HTML 4.0 as the current standard for building interactive TV content. A majority of these platforms support a subset comparable to HTML 3.2. Interactive programmes use very few HTML pages and are designed to deliver information choices to the viewer as simply as possible. It is like building a mini version of a web site. An important principle in television design is the KISS. (Keep It Simple Stupid) principle. The most popular editor among designers and developers for producing this HTML content is Macromedia® Dreamweaver®. Other WYSIWYG iTV editors include Chyron's Lyric iTV; Lyric iTV easily allows television professionals and iTV producers to maintain a consistent look and feel between television and iTV graphics.

Macromedia Flash Player

Macromedia Flash™ Player is currently supported on the majority of set-top boxes with some limitations. Leading platforms such as Liberate® and Microsoft TV now support Macromedia Flash 4.0 on their respective platforms. With other platforms you will usually find Macromedia Flash 4.0 version or higher, but these platforms are rapidly pushing to advance the player version amidst the growing demand for iTV content developers.

Figure 14.5 *Interactive content in Flash Player*

The processor speed and the data rate are where you will need to start when considering using Macromedia Flash in a set-top box environment. Macromedia Flash enables web sites to animate with striking visual effects that often require a small amount of data, but unless you can understand the performance issues of your chosen platform those dozen kilobytes (KB) can be cripplingly slow. A typical set-top box viewer receives data at a rate of about 2–3 Kbps so Flash is probably best used sparingly, and in conjunction with HTML. You can use Macromedia Flash content in place of static images, or Graphical User Interface components like a button or a form field, or text headers and titles.

Figure 14.6 *Liberate supports the Flash Player*

Avoid any type of scrolling through large amounts of text and graphics, which can be very processor-intensive and can create ugly ghosting effects. Instead, use "Layer Stacking" as covered in Chapter 13. A "Layer Stacking" system is based on the stack of cards analogy that shows the user a piece of information that's required at a particular time. The user can navigate content by flipping between pages, like cards in a deck. Using simple Flash frame actions to move forward and back in the timeline is a quick way to create a "stacked" experience.

Vector Graphics and Screen Sizes

The majority of iTV platforms will adjust your content to fit within a specified safe area. If your content exceeds this area, even by a pixel or two, the result can be a breaking up of the screen. With a vector-based application like Flash it's less of an issue as the Flash movie will resize itself.

Probably the most significant advantages of Flash is that movies will still be playable if any resolution changes are made to the middleware environment. Flash will simply adjust and resize accordingly to fit correctly within the limitations of the safe area. This ties in with the philosophy of reusabilty and at the same time helps the content creator distribute their content across a wider audience of both platforms and environments.

Fonts and Text

TV screens and living room sizes vary, there is no standard font size for use on TV screens. As a rule, however, you should use fonts that can be read from a distance of at least 10 feet while viewing a 25-inch TV screen. Increase the size of the fonts being displayed. Font sizes of 18 points

or higher may be required in order to give acceptable results. Games generally use smaller fonts because people sit closer to the TV while using them. When considering colour for text, remember that light-coloured text on a dark background or similar high contrasts are much more readable on TV. The contrast between dark background and light text is easier on the eyes and the text tends to swim less on the screen. Font choice is also an important design consideration to ensure your application will be readable.

One of the more popular typefaces is the Geneva font. You should also avoid typefaces with very thin lines, as these will tend to break up on video. Sans serif fonts display better than serif fonts for these types of screens. Serif fonts tend to lose their details on screens that aren't as sharp as computer monitors.

If you are scaling your Flash movie up 200%, you can start with 8-point type. If you are reducing it to 50%, you should use 32-point type or greater. Blurry fonts on television are really a limitation of the TV set and the analogue video signal. Colour scheme and contrast level play a large part in the appearance of text on a television. Even at optimum quantity text is hard to read if there is too much of it, so keep it simple, present large amounts of text using the stacking system.

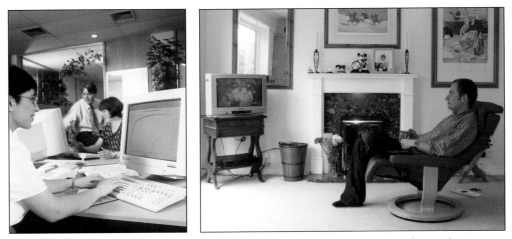

Figure 14.7 and 14.8 *A distance from screen comparison between using a computer and watching a television*

TV Line Weight

One line of video is made up of two sets of scan lines, therefore, a horizontal line 1 point thick or less will flicker on video. It is made visible for one set of scan lines and then disappears on the next. So the rule is that all horizontal lines must be at least 2 points thick or greater to show up correctly. Any vertical lines close to the edge of the screen will tend to vibrate.

Graphics on PAL/NTSC/SECAM Screens

Graphics should follow the same guidelines set for video graphics – these include safe colours and formatting. Movies should scale to fit within the TV screen limitations.

- Develop graphics at 72/92 dpi, the same as for a computer screen.
- Fine details tend to "burn out" due to the relative blurriness of the TV screen.
- Fine detail, patterns and textures tend to flicker, especially if contrast is high.
- Avoid spliced images as they can cause major HTML formatting isues.

Navigating TV

Create navigation controls that are easy to use and intuitive as most users will have experience using a computer or surfing the web. Those that do not will need a tried and tested system, so copy ideas from web navigation. You can test things by looking at the web through a TV linked to your computer, this is a great way of exploring navigation. iTV navigation is similar to tabbing through a web page on the PC. Viewers navigate between links, forms and functions using a remote control or an infrared keyboard. With navigation being so limited without a pointing device (mouse) you have to work hard at identifiyng items of navigation embedded in your content. Your links should follow a left to right, top to bottom tab pattern with your selected items standing out visually, as most users will be some distance from screen. I would consider using opposite colours for all navigation devices, it works and its a simple solution. If you are using image maps use client-side image maps rather than server-side. Like all things within any restrictive environment keep it simple – KISS – Keep It Simple, Stupid.

Figure 14.9 *A good navigation system*

HTML page links are converted to highlights made of a yellow box, which move on the screen one at a time, using the navigation control keys to sequence among the links; this functionality is seen in Flash movies when using the tab key. For example, when the viewer clicks a directional arrow on their remote control or keyboard, a selection box appears around the navigation elements and moves to the next closest selection in the direction of the arrow button.

Unlike computer screens the navigation point needs to be viewed from a distance. When combining both HTML and Macromedia Flash navigational elements on one page, you must take into consideration the smooth transitioning of focus from one element to another. When the user moves the navigation link there is an automatic selection hierarchy based on how your elements are placed on the screen from one another. For example, in Figure 14.10 below, the yellow highlight box will place its focus automatically on the top left button, "Net-Op"; when the page loads the point of attention by default is the top left navigation element on the page.

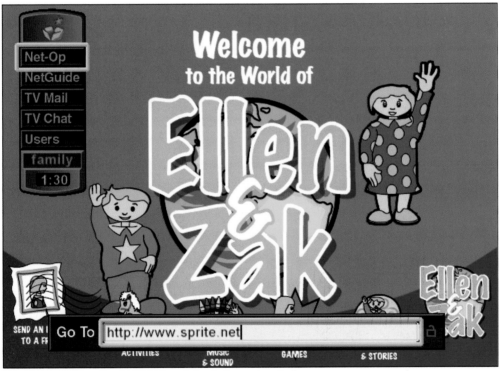

Figure 14.10 *The yellow highlight box placing its focus automatically*

Scrolling TV

Some services do not support scrollable pages, so your content may become inaccessible to the TV viewer. Imagine your content as a slide show when building web sites or iTV applications for television. You may have navigation elements for moving forwards and backwards or scrolling text elements, but not the entire page itself.

What are Triggers and Why Do I Need Them?

Triggers are the event synchronisation elements of an Enhanced TV show. They are events occurring in real time and can be triggered automatically or with user confirmation. Triggers are most commonly used to invite the viewer "to go interactive" or to introduce new interactive elements during a show.

Trigger links can activate many different kinds of events, they can contain a URL that specifies the location of the web content. They are executed through JavaScript™ functions. The scripts can perform dynamic actions taking in a text feed visible at a certain time, or returning a viewer to full-screen viewing mode. The trigger process involves three parts: creating triggers, sequencing triggers, and encoding triggers. Triggers are easy to create and deliver by using proprietary tools such as Mixed Signals "TV Link Creator" and related hardware.

Macromedia Flash Animation

Due to processor limitations avoid using large amounts of animation and motion tweening, and take advantage of repeating assets and the vector capability of Flash within a set-top box environment. Figure 14.11 illustrates this using buttons. The buttons can be repeated with the only difference being the text on the buttons.

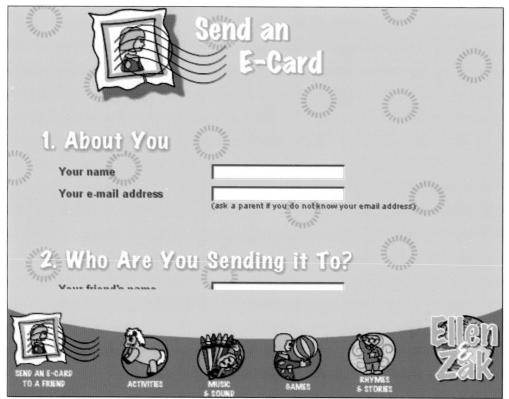

Figure 14.11 *Flash buttons*

Figure 14.12 *The Spritris game in Flash*

A small Flash animation downloads quickly and starts working almost immediately. Larger animations and sound take longer to download, and this can be painfully slow for a user who is used to the immediacy of TV. By incorporating subtle but interesting ambient animations and keeping the file size small, you can help hold your viewers' attention through the use of an interesting preloader – they might even be games. We created a Tetris style game, Spritris.fla in the chapter14 folder, it only takes a few seconds to download, but holds the viewer for bigger Flash movies as they download. Avoid intensive visual effects such as large masks, extensive motion, alpha blending, complex vectors and extensive gradients, but most importantly avoid static screens.

Processer speeds can vary widely in terms of "scaling" and "arranging" the text by the iTV system. When "scaling" of the text is performed by the iTV system the text is rendered in a font equivalent to 18-point Helvetica. Optimum font sizes for broadcast TV are between 16 and 20 points (HTML size 3–4). Use sans serif font and crisp anti-alias to avoid jagged edges. Also be aware of "arranging" performed by iTV systems. When "arranging" occurs, the iTV system adjusts the wrapping of text elements to fit in the specified safe area by squeezing the text together. This is why fixed line breaks can make text hard to read.

Supported Flash Features

Most iTV navigators provide full support for the following standard Flash features:

- Multi-Layer Support. Objects can be layered on top of each other.
- Font Outlines. Fonts embedded in the Flash file will display properly. Although supported avoid Device fonts as they can look ugly on a TV screen.
- Sound. Embedded sound in the native Flash ADPCM format. Supported input formats include: ADPCM, RAW, 16/8 bit, stereo/mono, 11 kHz–44 kHz. The MP3 format is not supported.
- Bitmap Artwork. Supports embedded objects in JPEG, GIF, BMP, and PNG formats.
- Vector Artwork. Supports imported vector artwork from programs such as Adobe Illustrator, Macromedia FreeHand, and Corel Draw.
- Keyboard Input. Flash movies can trap keystrokes for input.
- Editable Text Fields. Functions similar to an HTML text field, but must use a specified font outline.
- JavaScript Movie Control. Supports the full range of JavaScript movie controls, including: Play, Stop, GotoFrame, Pan, Zoom, LoadMovie, and others.
- JavaScript from Flash. Lets you pass JavaScript commands from the movie to TV Navigator, or use the GetURL function to load HTML assets into named destinations.

Background Transparent to Video

Use the following procedure to make the background of a Flash movie transparent to video:

1. Create the Flash movie with a unique background movie colour. Best results can be obtained by using a colour that is not used by any of the animation objects.

Figure 14.13 *Exporting your movie from Flash*

```
Flash movie (Untitled-1*)
Title: Flash movie

<html>
<head>
<title>Flash movie</title>
<meta http-equiv="Content-Type" content="text/html; charset=iso-8859-1">
</head>

<body text="#000000" bgcolor="transparent" background="tv.">
<object classid="clsid:D27CDB6E-AE6D-11cf-96B8-444553540000"
codebase="http://download.macromedia.com/pub/shockwave/cabs/flash/swflash.cab#version=5,0,0,0"
width="240" height="262">
  <param name=movie value="file:///Macintosh%20HD/Jobs/Sprite/express.swf">
  <param name=quality value=high>
  <embed src="file:///Macintosh%20HD/Jobs/Sprite/express.swf" quality=high
  pluginspage="http://www.macromedia.com/shockwave/download/index.cgi?P1_Prod_Version=ShockwaveFlash"
  type="application/x-shockwave-flash" width="240" height="262" BGCOLOUR="transparent">
  </embed>
</object>
</body>
</html>
```

Figure 14.14 *HTML code in Dreamweaver*

2. Export the movie to .swf format using the standard settings.

3. In the HTML page that will hold the movie, make the background colour of the page "transparent" and specify the background image as "tv:" video. For example:<body bgcolor="transparent" background="tv:">.

4. Then, in the <embed> tag of the Flash object, specify BGCOLOR="transparent".

Since Flash anti-aliases most of the time, you may notice some jaggedness around the edges of objects with transparent backgrounds. There is no way to anti-alias to the live video background; each pixel is either on or off. Making BGCOLOR="transparent" will let the solid colour of the current page or table cell, or the TV signal blend into the animation. The Flash movie may also allow other backgrounds, such as GIF images, to blend into the animation, but this behaviour must be verified on the target set-top box.

Unsupported Features

Below is an outline of the main unsupported features in the TV Navigator implementation of Flash. Most of them are due to intense process activity rather than the state of the software environments.

* Device Fonts. Flash allows you to specify the following "device fonts" in a movie: _sans, _serif, and _typewriter. On a standard browser, text specified with one of these fonts displays using the fonts built into the operating system. Support for this feature is incomplete in TV Navigator. If device fonts are used, they must be fetched from the transcoder. Rotating and shearing effects are not supported, but bold and italic variations are. The range of sizes and styles available is at the discretion of the service provider.

Typically, _sans and _serif will display in the Swiss face, and _typewriter will display in the Monospace face. The range of available sizes will generally be between 12 and 30 points.

- MP3 Audio. TV Navigator does not support software-based MPEG decompression. When using sounds in a movie, specify the ADPCM format when exporting the movie.

- Mouse-type Behaviours. Users interact with the TV using the remote control, so behaviours like dragging will not work as intended.

- Moving Buttons. In TV Navigator, the initial focus of the page is determined when the first frame of the movie is available. Once a button is highlighted, the button's bounding box has to remain in approximately the same location on the screen or the highlight will disappear.

- Pre-loading content when presenting users a series of HTML pages sequentially. Specifying a link to the next page in the series allows that page to be loaded into memory as users are still reading the current page. This gives users a feeling of even faster network performance. To perform pre-loading, place the following code in the head of your HTML document, replacing the URL with yours: <link rel="name"href="http://www.sprite.net">.

What is TV Emulator?

The emulator simulates the operation of a cable set-top box running the operating system platform on the PC. The Liberate TV Navigator Standard emulator (see Figure 14.15) has been modified to run on Microsoft Windows-based computers. It allows you to test content from your workstation before making it available to set-top box users. Emulators also provide a number of utilities that will help you monitor and debug your content.

TV Emulator imitates the data-over-cable connection to the set-top box by using TCP/IP over Ethernet as the two-way network interface. When used with a compatible TV tuner card, TV Emulator will display live video in its window just as it would appear on a television connected to a set-top box. At some point you will still need to view your content exactly as your end users will see it.

Using TV Emulator

You can test your final code in a number of ways:

- The Liberate TV Emulator™ program
- A digital set-top box
- An analogue set-top box (AOLTV SM system)
- A video card with TV output

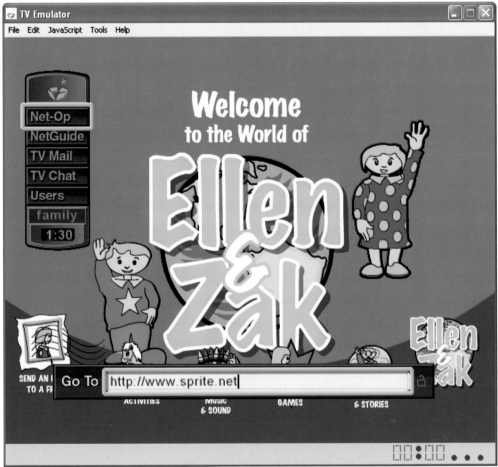

Figure 14.15 *Liberate TV Navigator Standard Emulator*

Conclusion

Almost every programme or movie on television has an associated web site. Viewers can either surf the associated sites on television while watching the programme, this is called single-screen iTV, or they can watch television and surf the Net on different screens at the same time, this is known as dual-screen iTV. Either way, television is undergoing an evolution. This is not just interactive television; this is a convergence of technologies that will change the way we interact with the world.

Chapter 15

Typography for the Animator

This chapter takes a look at using typography effectively in your animations. It first covers the history of typography, and then goes on to look at how type can be used to give your animations more impact.

Although this book is about animation it seems unlikely that the animator or designer of these techno times will not encounter a situation where type is needed in the project. The Internet has changed the nature of type. What at one time was solid and made of lead and had its rules is now reduced to dots on a screen completely in the designer's control. I start the first part of this chapter by looking at some of the background to type, its history and some of its rules.

Many early printers were not just printers, but typographers as well. The first independent typefoundery was owned by the French type master Claude Garamond. Although not the inventor of movable type, Garamond was the first to make type available to printers at an affordable price. Garamond based his type on the roman font. Before Garamond's independent practice, men such as Jenson, Griffo, and Caxton played specific roles in the development of type. Jenson perfected the

Figure 15.1 *Zak with an old fashioned font*

roman type, Caxton conceived a bastard gothic font, and Griffo developed italic. Several of the fonts we see on our computers have evolved from the work of typefounders of the fifteenth and early sixteenth centuries.

The period of stagnation for type design was in the sixteenth and seventeenth centuries. Many

ABCD EFGH

Figure 15.2 *The fifteenth century witnessed probably the most drastic revolution in typeface design*

AaBbCcDdEeFfGgHhIiJjKkLlMmNnOoPpQqRrSsTtUuVvWwXxYyZz

AaBbCcDdEeFfGgHhIiJjKkLlMmNnOoPpQqRrSsT

AaBbCcDdEeFfGgHhIiJjKkLlMmNnOoPp

AaBbCcDdEeFfGgHhIiJjKkLlMmN

Figure 15.3 *Garamond, based on the roman font of Griffo*

presses overlooked the rules of type design and mixed many sizes and styles of type into single pages, fliers, and playbills. These 100–150 years witnessed very little in the progression of typography. Some histories of type start from ancient Egyptians and their hieroglyphs, but we are going to examine the type of fonts that you're likely to encounter in your everyday work. If we do not take into account some really exotic faces, the modern history of type begins in the fifteenth century, when the first examples of the fonts now called Old Style appeared.

During centuries prior to that time, the prevalent style of letterforms was the blackletter, or "Old English". Complex, whimsical blackletter shapes were difficult to write and read; what's worse, they were clashing with the ideology of then Renaissance movement and its admiration of classic Roman and Greek art. New, humanist writings required creating a new type of font – more secular, more legible, and more elegant.

 The first time craftsmen looked into the past in order to create better typefaces for the present they encountered a few problems. The ancient Romans only had uppercase, capital letters. While adopting their designs for capitals, Renaissance typographers had to spend more time working on lowercase lettershapes. As a basis, they took scripts that were common in the early Middle Ages, but changed them significantly to match the Roman uppercase letters and to better adopt to Gutenberg's printing technology that had just appeared.

One of these new fonts was Antiqua, i.e. "Ancient" (later, the term Antiqua was used for all typefaces that appeared after the blackletter era, and the original Antiqua fonts came to be named "Old Style" or "Humanist Antiqua"). Antiqua fonts provide the most up to date and fashionable look for the modern eye. Their light, spruce, stylish outline conveys the humanist spirit, and these fonts are now very popular for all sorts of design jobs.

The Old Style typefaces are made up of fairly constant width of all strokes and serifs. They are described as having low contrast, complex non-linear shapes of strokes, and so-called "cove" serifs that form curves where they join the main strokes (the ends of serifs are also sometimes rounded). The thick parts of strokes do not necessarily go vertically; where the thickest parts of the outline are at bottom left and top right. This feature, called diagonal stress, is an attempt to imitate the handwriting of the scribes, who held their pens at some less-than-90° angle to the direction of the line.

AaBbCcDdEeFfGgHhIiJjKkLlMmNnOoPpQqRrSsTtUuVvWwXxYyZz

AaBbCcDdEeFfGgHhIiJjKkLlMmNnOoPpQqRrSsT

AaBbCcDdEeFfGgHhIiJjKkLlMmNnOoPp

AaBbCcDdEeFfGgHhIiJjKkLlMmN

Figure 15.4 *Times New Roman is the most widely used of all Transitional fonts*

Authors of modern Old Style revivals had to artificially match independent designs, often created by different typographers and in different centuries, to compose a complete font family with roman and italic faces. Early italic faces had a more handwritten look and a small slant, while later, sixteenth century italics have a more pronounced slant and peculiarly narrowed letterforms. In roman faces, the late Old Style design fonts like Garamond lose their diagonal stress, the contrast of strokes is increased, and strokes become more linear. By the end of seventeenth century, a new type of font design was emerging. This new type design, belonging to the eighteenth century, is now called Transitional because of its intermediate position between the Old Style and Modern styles. It was during this period that the font faces such as the Times Roman and Baskerville emerged; their features include higher level of contrast (vertical strokes are noticeably thicker than the horizontal ones), mostly vertical stress, and a more linear, austere design. Serifs in these fonts are not too long, sometimes pointed, and connected to main strokes through outspoken coves (so the serifs seem to have a triangular shape). The shapes and proportions of letters, the prominence of strokes and serifs, the contrast level – all these features are nearly transparent to the eye, adding minimum, if any, distinctive or "personal" features to a font. The Transitional design could be described as a generic serif font.

The Modern Font

The new font design created at the very end of the eighteenth century and dominating throughout the nineteenth century was, quite naturally, called Modern or New Antiqua. This style has further developed some of the Transitional trends, but abandoned some others.

AaBbCcDdEeFfGgHhIiJjKkLlMmNnOoPpQqRrSsTtUuVvWwXxYyZz

AaBbCcDdEeFfGgHhIiJjKkLlMmNnOoPpQqRrSsT

AaBbCcDdEeFfGgHhIiJjKkLlMmNnOoPp

AaBbCcDdEeFfGgHhIiJjKkLlMmN

Figure 15.5 *Use Modern typefaces such as Gill Sans to create an old fashioned look (pun inevitable)*

Modern fonts have drastically increased contrast, leading almost to the edge of legibility and technical feasibility. Giambattista Bodoni had to improve the printing machinery he had available in order to reproduce the new fonts. The long, hairline serifs and horizontal strokes are the first things we notice about this font style.

Due to the high contrast and the lack of almost any coves and rounded corners, the Modern fonts can be very dry, rigid, elaborate, unnatural. Although Modern has an easily recognisable style of its own, the fonts were described as a revolutionary improvement and called "modern".

Modern has in fact served as a base for several design variations created throughout the nineteenth century. The most notable Modern offsprings are slab serif fonts where serifs were as wide as main strokes or even wider. Later, Clarendon fonts reintroduced cove serifs and lowered contrast while preserving the overall style of Modern letterforms. Both classic Modern faces and their derivatives pretty much dominated the typography scene in the nineteenth and well into the twentieth centuries.

It was not some new fashion that replaced Modern faces in mass book production. Instead, the century drawing to a close was marked by a wave of revivals, fonts created from ancient prototypes of the Old Style, Transitional, and early Modern ages. Now the spectrum of digitised serif typefaces is wider than ever; dominated by revivals, it also contains a numerous original faces, for both body text and display setting, combining modern trends with the best features of all previous ages of typography. The first half of twentieth century is the end of the Modern era, the moment when revived typefaces were flooding the typography mainstream. But it was also the time when a completely different font design was booming, called sans serif (French for without serifs). It wasn't totally original at that time, since the first sans serif faces had appeared at the beginning of the nineteenth century; but the trend claimed importance in the 1920s and 1930s.

It is amazing that the simple idea of dropping serifs at the ends of strokes didn't occur to the great many typographers who experimented with their shapes and sizes so much. This is due to the inertia of scribes' tradition who, with their quills, simply could not produce a reasonably clean cut of a stroke. Old typographers also knew the fact that was later confirmed by experiments: serifs help the eye to stick to the line and thus facilitate reading.

AaBbCcDdEeFfGgHhIiJjKkLlMmNnOoPpQqRrSsTtUuVvWwXxYyZz

AaBbCcDdEeFfGgHhIiJjKkLlMmNnOoPpQqRrSsT

AaBbCcDdEeFfGgHhIiJjKkLlMmNnOoPp

AaBbCcDdEeFfGgHhIiJjKkLlMmN

Figure 15.6 *Futura In The Past, or A Triumph of Geometry: developed by Paul Renner in 1928*

When the first examples of sans serif fonts finally appeared, they seemed so controversial that the first name given to them was "grotesque", and they were very rarely used except in advertising. And so it remained until the newest trends in art and industrial design, most notably the German Bauhaus movement of 1920s, required adequate means of typographic expression. These movements stressed utilitarian aspects in design, claiming functionality and denying any attempts to artificially adorn the face.

The Futura font, created in Germany in 1928, displayed the core of the Bauhaus ideology: strictly geometric outline, without any embellishments and just barely conforming to the historical shapes of letters. Now we're much more accustomed to the look of Futura and its many derivatives, but the inborn radicalism of the font still shows through and has become the source of many techno fonts.

The Radical Sans Serif

As all radical movements, the "new sans serif" typography of the 1920s was taken by designers to mean the imminent death of all serif fonts. This didn't happen. Futura itself didn't manage to become so neutral and familiar in the mass perception as to become a standard sans serif font. The standard sans serif position was taken by Helvetica, a font that became ubiquitous almost to the point of being misused However, it cannot be denied that Futura played an important role in sans serif becoming a mainstream type style, and a contrasting pair for the time-proven serif fonts.

Sans serif proliferation was also due to the higher demand for display typefaces in all media, the demand which is much more severe than at any time in the past. The most natural use of a sans serif font is still for display purposes (ads, titles, logos, labels of all sorts), although it can be successfully used for body text as well.

The Humanist Sans Serif

One of the first such designs was Frutiger developed in 1976; at first sight similar to Helvetica, on a closer look this font reveals some "anti-geometric" features, such as uneven width of strokes (especially in bold variants), non-perpendicular cuts, and slightly bent-off tips of strokes (e.g. the bottom of the vertical stroke in "d"). All these subtleties were intended to smooth out the too harsh edges of the generic sans serif design and improve legibility of characters, and their net result is a relatively warm and friendly-looking typeface – especially when compared to Helvetica or Futura.

AaBbCcDdEeFfGgHhIiJjKkLlMmNnOoPpQqRrSsTtUuVvWwXxYyZz

AaBbCcDdEeFfGgHhIiJjKkLlMmNnOoPpQqRrSsT

AaBbCcDdEeFfGgHhIiJjKkLlMmNnOoPp

AaBbCcDdEeFfGgHhIiJjKkLlMmN

Figure 15.7 *Officina Sans is another Meta-like font designed by Spiekermann*

The trends that were hinted at in Frutiger were later fully developed in a family of fonts extremely popular both on the web and in print design. The original typeface of this family, called Meta, was developed in 1984 by German designer Erik Spiekermann. In Meta and its offsprings, strokes have slightly varying width, the creator's goal was that in small sizes, thinner strokes should not "drop out", but become undistinguishable from the thicker ones and, in compensation for the missing serifs, bent-off tips of vertical strokes in letters like "d" or "n". Both uppercase and lowercase characters are narrower than in most other sans serif fonts. Here we can see how we can have an example showing how far can we go in "humanizing" sans serifs and borrowing serif-specific features, while remaining within the sans serif paradigm.

Interestingly, the problems that the designer tried to resolve with the new typeface were purely practical – Spiekermann's goal was to create an economic font readable in a wide variety of sizes and conditions.

Typography for the Animator

The majority of design and animation projects pose difficult problems because of the variety of emphasis required. To solve this you have to find two or more different typefaces, each matching not only its corresponding text but also all other fonts in the composition. Creating solid contrast links between different fonts is a real challenge. Each font being nearly as complex as a character in an animation; it is next to impossible to find two fonts whose features can be used for the variety of different stresses in a movie. The safest option in any project is using the same font, or its different variants (e.g. bold or italic), for all of your needs. This single font solution may not be perfect, but in many cases it may be better to ensure consistency instead of taking risky aesthetic decisions. Using one font is by far preferable in small compositions such as logos, or information graphics on an interface.

But, let's say you really need two fonts for your work (for example, one for headings and the other for body text), and you're not satisfied by using variations of the same font. Which pair to choose? The basic answer is: serif fonts work fine with sans serifs, and vice versa. These two types of fonts are different enough for their contrast to be immediately obvious, resulting in a harmonious and

Figure 15.8 *Letters in detail*

well-balanced page. As serif and sans serif were not developed in parallel, we cannot base our decisions on historical acceptance; most, if not all, of today's serif faces are rooted in past ages, while the majority of sans serifs were created in the current century. More useful is matching the level of looseness vs rigidness and artificiality.

Harmony in Pairs

Garamond and Frutiger work perfectly together because once set the composition style and the fonts are left to interact only with each other, and because the contrast between them is so deep and multi-aspect. Perpetua and Gill Sans is another beautiful combination of fonts. Both fonts designed by Eric Gill for Stanley Morison of the Monotype Corporation in 1925. Gill was asked to create a new typeface "for the expression of a contemporary artist". He began work on what would become known as Perpetua, and not long after that a sans serif, to be called Gill Sans. They became an immediate success with the public. Gill Sans has become the leading British sans serif, sometimes being described as the "national typeface of England".

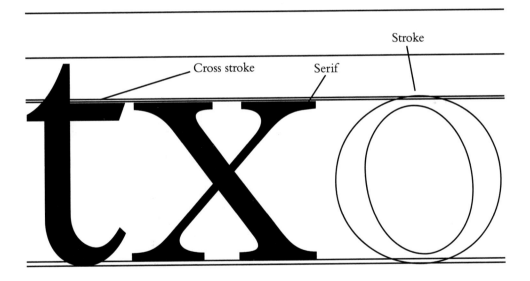

Stroke

Cross stroke Serif

It is a good idea to accompany the contrast of fonts by the contrast of other typesetting aspects, particularly font variations (bold, italic, etc.). You may have noticed that many sans serif fonts do not have italics in the proper sense, but only slanted (sometimes called oblique) variations. This is not by accident; the very nature of sans serif design doesn't allow for an easy transformation into an italic face. Most serif fonts have really small italics that, despite having very different letter shapes, are well dovetailed with the roman variety.

AaBbCcDdEeFfGgHhIiJjKkLlMmNnOoPpQqRrSsTtUuVvWwXxYyZz

AaBbCcDdEeFfGgHhIiJjKkLlMmNnOoPpQqRrSsT

AaBbCcDdEeFfGgHhIiJjKkLlMmNnOoPp

AaBbCcDdEeFfGgHhIiJjKkLlMmN

Figure 15.9 *Gill Sans*

Professional designers rarely use something besides the simple, traditional typefaces. The budding typographer should focus on a careful study of a small set of classical typefaces rather than indulge in complex designs. The better the type style the more focus is drawn to the content rather than the distraction of complex combinations.

Five Important Steps to Type Design and Layout

The modern animator designer has a very difficult role to play out in producing a movie. That role takes you through many of the traditional disciplines and yet the final quality of animation and character needs to shine through. Below I have outlined five steps to good layout:

1. Font selection:
 - Pair a serif font for body text and a sans serif font for headlines. Avoid mixing two very similar typefaces, such as two scripts or two sans serifs. This will cause a visual clash.
 - Limit the number of fonts.
 - Limit the number of different typefaces used in a single document to no more than three or four. Avoid monospaced typefaces for body copy. They draw too much attention to the individual letters distracting the reader from the message.

2. Column width:
 Avoid setting type in lines of more than sixty-five characters. Longer lines cause the reader to "double", or read the same line twice. Avoid setting type in lines of less than thirty-five characters. Shorter lines cause sentences to be broken and are hard to understand.

3. Line length:
 Apply the alphabet-and-a-half rule to your text. This would place ideal line length at 39 characters regardless of type size. Apply the points-times-two rule to your text. Take the type size and multiply it by two. The result is your ideal line length in picas. That is, 12 point type would have an ideal line length of 12 X 2 or 24 picas (approx. 4 inches).

4. Heading and uppercase:
 Keep headlines between 14 and 30 points, keeping in mind that the closer in size to the body text, the harder it is to distinguish headlines from other text. Avoid setting type in all capital letters. Capital letters slow reading speed and take 30% more space than lowercase letters. Make sure headings are close to the paragraphs they belong with. That makes it easy for readers to tell what paragraph the heading relates to.

5. Kerning:
 Kerning is the pushing together or pulling apart of individual letters. Normally, lack of kerning is noticeable in larger type sizes. Letters that often need kerning:

 > T and o
 > T and r
 > T and a
 > Y and o
 > Y and a
 > W and o
 > W and a
 > T and A
 > P and A
 > y and o
 > w and e

 Round characters can be kerned more than straight characters.

Text Animation

Text animation can be very time-consuming, since every letter in a block of text must be manually animated, add this to ActionScript for effects and you have a long process. The idea of pre-programming text effects for ease of use is just brilliant. At Sprite Interactive we use a number of tools for text animation. They are handy and inexpensive with an automated process and a series of text-animation templates. The two most popular tools are Swish 2.0 and the web site Flashtyper (on www.flashkit.com). Both pieces of software are easy to use: you simply enter your text and select an animation effect from a pull-down menu. You can then move the effect along

the timeline to co-ordinate it with any other elements or effects you need to add. Images can also be animated with Swish, and the program includes basic drawing tools so you can add custom shapes to your animation. Both include hundreds of animation effects with unlimited customisation options with which to create your own.

Animations created in Swish 2.0 or Flash Typer can be exported to Macromedia Flash's SWF format, as well as to Flash; you can use them as movie clips within a larger animations. You can use both of these tools even if you do not have a copy of Flash; however, Swish provides several features that let you create full-featured web animations.

1. Go to the Flash Typer home page at http://www.flashkit.com/textfx/start.shtmand launching Flash Typer. The first thing you need to do is input some text, so click on the Edit Text button, and a window will appear. In this window you can enter the text that you want to animate, so highlight the default text, delete it and type in your text. Once you have done this you can minimise or close the Text Editor by clicking on either icon in the top right-hand corner of the Editor.

2. The next step is to choose a text colour and a background colour for your effect. You select these using the Colour Editor and Backcolour Editor buttons. When you click on either

Figure 15.10 *The Flash Kit homepage*

of these a palette will appear where you can select the relevant colour. You can then close or minimise the window in the same way you did for the Text Editor.

3. Now you are ready to add an effect to your text. To open the FX Editor, click on the FX Editor button in the menu. The FX Editor contains a preview window, a favourites button and the list of effects. If you click on an effect name you will get a preview at the top of the window. You can add more effects by clicking the edit button, which will take you into your Flash Kit profile.

Figure 15.11 *The Flash Typer homepage*

4. One very useful feature of the Flash Typer is the Load Movie option. This option lets you easily design an effect to fit a particular project. You need to upload your swf file to the web, and then type an absolute URL to reference it, and the size of your movie. Once you have done this a preview of your movie will be placed in the background of the Flash Typer

Figure 15.12 *The Colour Editor*

and you can then position your text onto it.

5. You can edit the text attributes using the Text Options Editor. This lets you choose the font you want to use, set the size of it and set the kern and line spacing. As you select

Figure 15.13 *The Colour Editor*

Figure 15.14 *The Load Movie panel*

different settings these will happen to your text on the screen, so you can see the effects of your changes as you try them. If you select the Add More button, you can add fonts into your Flash Kit profile, which will then be listed in Flash Typer.

6. You can move the text around and resize the text box by using the tab at the bottom left. To generate the effect click on the Generate button, and a box will appear with six options:

- Make Your Effect Play Automatically After Loading:
 This makes your text effect play as soon as it loads into your movie.
- Wait for X seconds and Play:
 This option will wait for the number of seconds you indicate then play the text effect, only after the movie is fully loaded.
- Wait For Play Command From User:
 This effect stops on frame 1 and will only play when you tell it to using the Tell Target action.
- Stop For X Seconds After All Text Shown:
 This option will pause the text effect for the time in seconds you specify after all the text has been displayed.
- Don't Remove Text:
 This option will stop the text effect from fading out until you go to a different page.

Figure 15.15 *A movie loaded into the background*

- Wait For User Action

 This option will stop the text effect until it is commanded to fade out. To make the text appear and disappear use the fade in and out buttons.

7. The effect will be saved as a .zip file, and you can then load it into your movie using the loadmovie command. If you need any more help there are a number of useful tutorials on the Flash Kit site.

Case Studies

For the last fifteen years I have worked as animator through to producer on many titles. The range of products is equal to the range of members of the team involved in a project. This chapter contains eight case studies of projects I have worked on over the last fifteen years.

Jeep Wrangler

The Jeep Wrangler CD was created as a lifestyle promotional vehicle for the new range of Jeep Wranglers that were launched in 1997/8. The CD features an interactive map for the user to drive their Jeep Wrangler around, visiting various places on the way. These places contain interviews, the history of the Jeep, adverts, information on different Jeep models and information on Chrysler, the makers of the Jeep.

MTV

Throughout my final year of a Masters Degree in Computer Animation and for the following few years I worked with the team at MTV Europe to prepare for the launch of the new station.

TONI&GUY – on the Edge

The "on the Edge" CD was a promotional and educational vehicle for TONI&GUY sent out to all their salons around the world. The CD featured the new range of styles at the time, giving the viewer an interactive lesson in cutting-edge fashion styles. This, coupled with some stunning animation sequences, made this CD a very compelling piece, even to the non-hairdresser.

Aramis

This was an interactive kiosk created for Aramis to promote the sales of the Lab Series for Men range of products. The kiosk featured interactive questions to find out which kind of Aramis products the user was most suited to and then gave them an animated demonstration of those products.

Innovations – Battery Charger

A 3D character animation lasting 60 seconds created to promote a stand-alone battery recharger for Innovations.

BMG

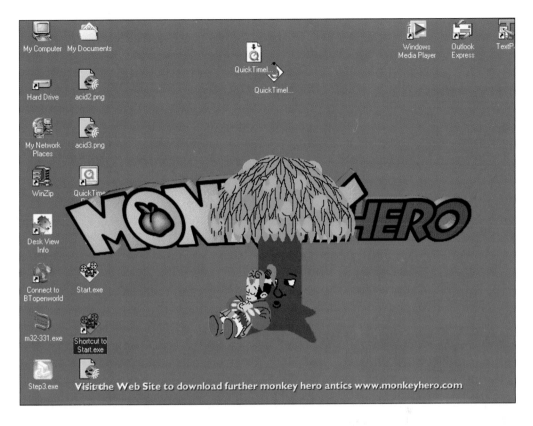

This screensaver was created for the launch of Monkey Hero, by BMG, in 1998. The final product was a dual-platform application built in Macromedia products, randomly playing one of three movies as a screensaver, on top of a screen grab of the current desktop.

Solaglas

The Solaglas SGG Design CD was created to promote the Solaglas range of products. It features a full commentary by the Sola Man, an animated character who talks the user through the products as they navigate.

Ellen and Zak

Ellen and Zak were originally characters created for a children's educational website. They and their friends have gone on to feature in a number of my projects, most recently this book. They both have special powers – Ellen flies and Zak can become invisible, except for the star on his jumper.

Showcase

Showcase

The convergence of the media world has not only affected the way we see things but also the way we have things delivered visually to our chosen device. My phone has a number of animated themes. Because of their brand association I expect these animations to be of a high quality even though I had not seen some of them. This is quite typical of the cross-pollination between platform and content. This rich and productive cross-pollination between design and animation mediums is one of the forces that keeps animation vital, and the web interesting. We will see more of these transitions from design, print to animation, since one of the great trends of the past decade is the conglomeration and merger of media companies. Comic strips can gain a second round of profits in animated form. This represents an economic windfall that will become increasingly irresistible to media moguls, cartoonists and animation studios alike.

The printed comic strip and animated cartoons have shared a long mutual history; in many cases, the former has given birth to the latter. Bill Melendez did a terrific job of bringing Charles Schultz' Peanuts strip to life, putting Charlie Brown and crew into some of the coolest cartoon specials of the 1960s and 1970s.

So... what's out there that might carry on the grand old tradition and reinvent a genre?

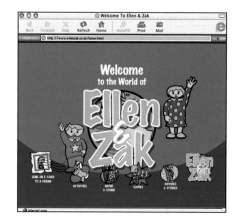

I have selected a few of the many sites that I feel are inspiring in one way or another; ultimately they have all been selected because of there animation qualities. I will start with Sprite Interactive's web site and work because that is who I work for and one way or another the existence of this book and all its examples are a credit to the team at Sprite. The Zak and Ellen characters have been taken from a 3D world to TV to mobile phone and pocket organisers, an exhausting journey of convergence.

Enjoy the trip.

357

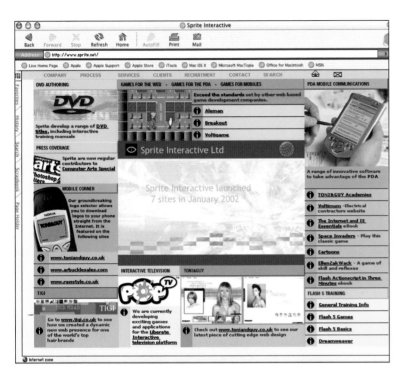

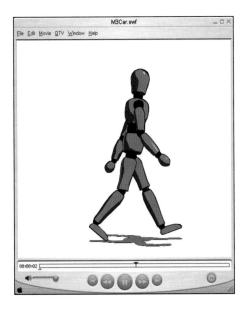

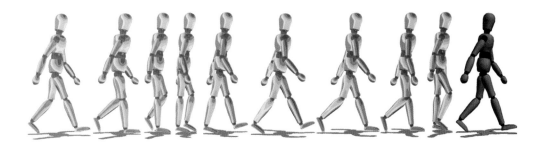

Sprite Interactive – Backstage

www.mezzetty.com

Great site, great music. Smooth graphic execution with just enough animation to complement the design. I love the single colour scheme. The interviews are interesting and the long exposure photography makes this site a fine example of the marriage of animation design with well-thought-out content.

www.identikal.com

In addition to twelve original font families this site is a visually compelling presentation and provides layers of information. It's a simple interface with a great window onto Identikal's work. A simple design, with a simple and clear navigation. Great fonts.

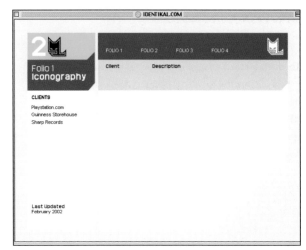

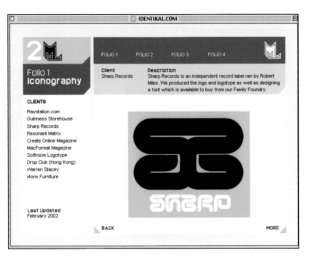

www.markclarkson.com

To quote Mark Clarkson: "I write, I draw, I animate, I play computer games ... it's sad, but at 42 I still haven't decided what I want to do when I grow up." Mark's site is fun, check out Fishin' ain't so Bad. Everybody should have their own personal site.

www.wmteam.com

Fantastically minimal. Colour and animation in a simple format with great navigation based around a few characters on a building site. The use of ActionScript in Flash is understated and the whole thing is carried through eloquent animation. This site is probably the model for all the major entertainment sites.

A **concept** to enjoy.
Design with passion.
The **technology** is always "up to date".
Cross marketing with farsightedness.

That's the material we use for
successful advertising.

[Skip]

03/2002: Logo-design for German Soccer League
03/2002: WM Team wins silver eMIL-Award
03/2002: Orange Project website relaunch

March 2002:
WM Team designed the new
logo for German Soccer League

In a two-stage competitive pitch
we triumphed over 4 renowned
agencies and secured our place
as the new lead agency of the
German Soccerl League, the "Fußball Bundesliga".

The most important component of the pitch was
the new Bundesliga logo. Currently we are working
on a style guide, which will stipulate the corporate
design of the Bundesliga in all its media

Slideshow

BUNDES LIGA

WM TEAM
NEWS
INFO
WORK
TEAM
CONTACT

DON'T PUSH!

TNT

WM TEAM
NEWS
INFO
WORK
TEAM
CONTACT

WM Team Werbeagentur
Empelder Straße 96
D-30455 Hannover, Germany

Phone: +49 (0) 511 / 270 370 -1
Fax: +49 (0) 511 / 270 370 -2
E-Mail: contact@wmteam.de

Map guide

Route planning

OFF
1
2
3

INTERNET
PRINT

HARDENBERG-
WILTHEN AG
Three strong brands
under a single heading

How does one attain a uniform presentation of three
different brands? In the case of Hardenberg grain spirit,
Wilthen brandy and the salmon liquor from Danzig, we
found that these brands have the regional aspect in
common, this being confirmed by market research.
Therefore, we are sending the user on a city tour during
which he may get to know the products. Anyone whose
appetite has been wetted simply orders through the
integrated shop.

Hardenberg-
Wilthen AG

Link: http://www.hardenberg-wilthen.de

WM TEAM
NEWS
INFO
WORK
TEAM
CONTACT

www.bionic-systems.com

This has a techy navigation system but with a minimal use of animation the site takes on a life of its own. The mutation page is a little scary in a soft cuddly kind of way. There are loads of ideas here, as well as a reminder that sci-fi is not just for the few – we can all explore this genre and develop the most provocative mini movies.

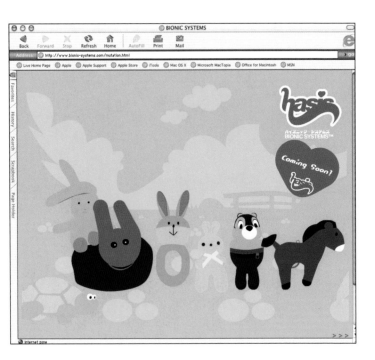

www.pmayhem.com/caseyjones

This site features the work of Casey Jones, an American illustrator who produces artwork for a number of major comics. His work is very varied, and the site also contains a sketchbook of his latest art. Although the site does not use any Flash animation, Casey's work is an inspiration to anybody drawing characters for any environment. His work exemplifies the art of character illustration.

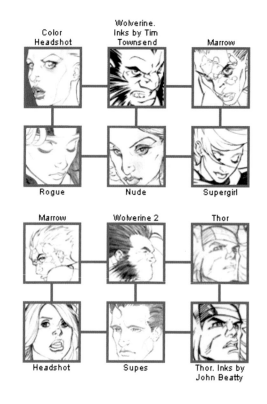

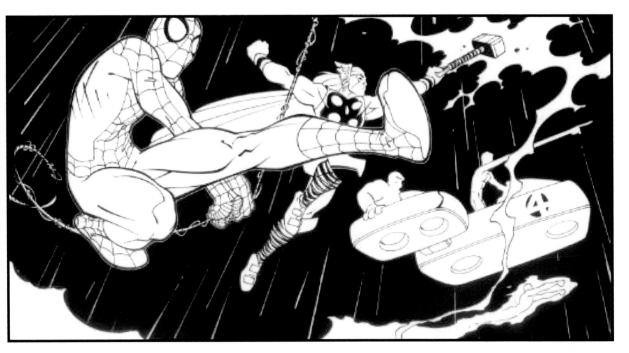

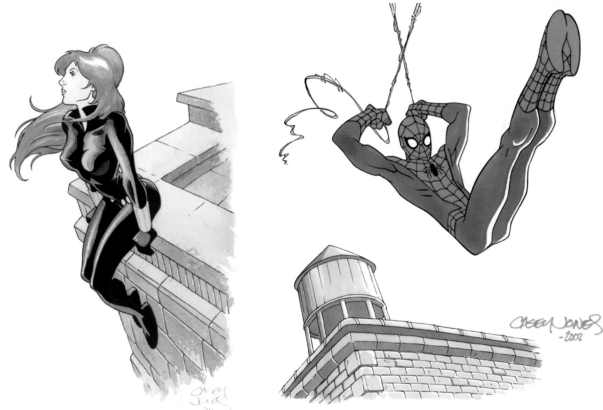

www.scottsmind.com

I love the evil clown generator on this site. When it comes down to it, I really cannot define this site other than it's probably not complete, but it's definitely worth a visit – the cartoons may one day turn into something that animates.

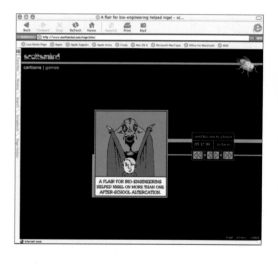

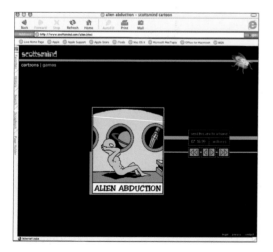

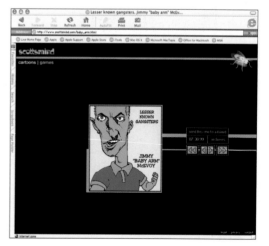

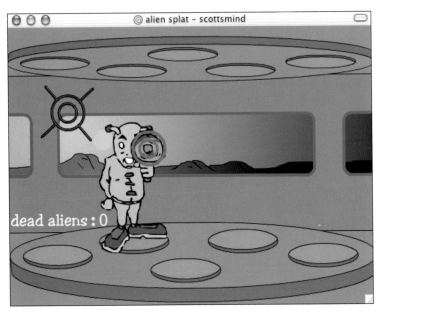

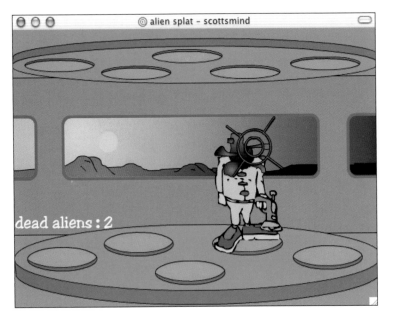

www.aardman.com

The site is pleasant, welcoming and packed with information about all their projects. In particular the GIF of Morph and friends is worth seeing. I particularly liked the film *Al Dente at the Steak Barn Meat Restaurant*. The head waiter takes an order for the "vegetarian option", which creates havoc in the kitchen.

© 2002 Aardman Animations Ltd

www.cartoons-online.com

The chat rooms bring avatars to the world of cartooning. It is a great community site, but, most of all, my favourite is the chat room built and designed in Flash, it's fun.

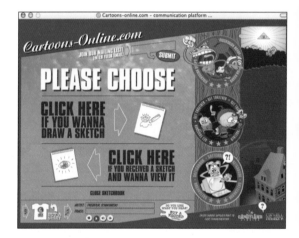

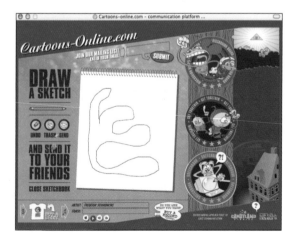

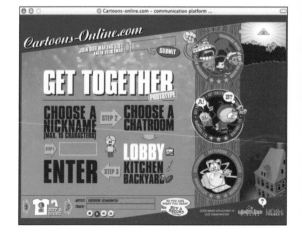

www.mongadillo.com

Mongadillo are an American animation company. They have a number of hilarious characters, including "The Bottle" a drunken superhero, and "Shawks", a group of child shark hunters, with a difference. The cartoons are very well drawn and executed, and are a great example of some of the best adult-oriented animation that the web has to offer.

www.cartoonsaloon.ie

The Cartoon Saloon is dedicated to the production of high quality animation. Their work is both innovative and highly creative. They have recently developed quite a reputation for their work internationally. The team are skilled in traditional animation and illustration. This site has great links to some very interesting content. Check out the character design and illustration sections.

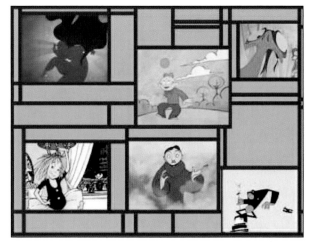

www.jibjab.com

An animation company that produces a number of high-quality adult-oriented cartoons. They mix live action with animation in a number of their cartoons to great effect, and many of their works include some kind of interactive element, such as Nasty Santa, where you can choose the way he is attacked by the police. They have a wicked sense of humour that runs through all their works, which range from political satire to plain slapstick comedy.

All images Copyright 2002 JibJab Media Inc. All rights reserved. JibJab and Nasty Santa are registered trademarks of JibJab Media Inc.

Frank Gapinsky

Frank Gapinsky is an Australian author who runs the www.flashtoonz.com web site. He produces a range of animated movies in Flash, most of which are of a comic nature. I especially liked the *Gladiator* spoof and the *Friday in Hell* movie. Frank also produces a range of animated commercials for television and advertising companies. He has won multiple awards for his work, which is featured on a number of high-profile web sites.

Appendices

Appendix A: Animators' Glossary

Alpha: A fourth colour channel in the RGB colour model that represents transparency. Alpha values can range from completely transparent to completely opaque. Not supported by all file formats.

Animatic: A storyboard that has been put onto video or film with a soundtrack to give a better idea of the finished product.

Animated GIF: Solid-colour animated graphic file format that doesn't include audio. It's best suited for small frame sizes, and ideal for low-impact animations on the web.

Animation Path: A line that objects follow during the course of an animation, also called a motion path.

Anti-Aliasing: A rendering technique to reduce the jagged lines produced by the low resolution of computer screens It determines the colour value of a pixel by averaging the colour value of the pixels around it and softening the hard lines.

Anticipation Movement: A rule of animation that dictates that an object has to have an opposite movement before it can travel in the desired direction.

Application: A software package that allows the user to perform some kind of work function. Also called a program.

Aspect Ratio: The ratio of width to height of a screen. Standard television aspect ratio is 4:3. Some motion picture sizes are 16:9.

AVI: Audio-Video Interleaved. A standard compressed video file format for Windows.

Background: Normally painted or drawn artwork that is scanned into the computer and used as a static backdrop for animations.

Back-up: A way to store files on some kind of storage device in case they are lost or destroyed.

Bézier: A way to define curved lines invented by Pierre Bézier, a French mathematician.

Bi-linear Interpolation: A texture display mode used to minimise aliasing.

Bitmap: A grid of pixels assigned a colour and X and Y locations to make up an image. Bitmap images are resolution dependent, and are also known as raster images.

Byte: A unit of computer data consisting of eight bits.

Camera: The viewpoint through which a scene is viewed.

Cel: A clear cellulose sheet used for traditional animation. Drawn with black ink on one side, and then coloured on the reverse.

Cel Animation: Traditional form of animation. Images are drawn by hand, transferred to acetate, coloured and photographed one frame at a time.

Client: A computer workstation connected to a server on a network.

CMYK: Cyan, magenta, yellow and black. A process of identifying the colours used by printers.

Collision Detection: The process whereby the boundaries of objects are detected by other objects in a scene. This prevents objects from passing through each other, used extensively in games.

Colour Depth: The number of bits per pixel used to define colour. Different monitor systems and software can display colours in 1 bit (black and white), 4 bits (16 colours), 8 bits (256 colours), 16 bits (65536 colours), 24 bits (16.4 million colours), and 32 bits (16.4 million colours with 256 levels of transparency).

Colour Index: A single value that represents a colour by name, rather than by value.

Colour Wheel: A representation of the colour spectrum in the form of a circle.

Cursor: The on-screen pointer that shows the position at which you're working. It can take a variety of forms.

Cycle: A sequence of drawings, creating a movement by repeating themselves continuously, for example a walk cycle.

DAT: Digital audio tape, a format used for string audio material or computer data.

Desktop: The main work area on a computer screen.

Disk: A magnetic storage medium for data.

DPI: Dots per inch. The display resolution of devices such as monitors or printers.

Direct3D: Microsoft's standardised 3D programming interface.

Dithering: Simulates unavailable colours using patterns that intersperse pixels from available colours. Dithered colours often look coarse and grainy.

Dope Sheet: A chart used in traditional animation that contains notes for a cameraperson to follow while they are filming the animation artwork.

Drag: To move an object around the screen by holding a mouse button and "dragging" the mouse around.

Driver: A software program that is used by the computer to give instructions to hardware devices.

Email: Electronic mail. A system of communication that allows the user to send messages to other users as long as they too have an email address.

EPS: Encapsulated PostScript file. A standard graphics format.

Exposure Sheet: A dope sheet.

FAT: File allocation table. A hard disk storage and retrieval method used by computers.

Filter: A process applied to an image to create an effect, e.g. blurring.

Follow Through: An action in animation drawings that obeys the law of motion that when an object is stopped a part of the body continues to follow the direction it was going.

Fps: frames per second. The speed at which a computer renders each frame.

Frame: A single image on a roll of film. In an NTSC video signal, one frame is 1/30 of a second. In a PAL video signal one frame equals 1/25 of a second.

Frame Rate: The rate at which a computer renders each frame of an animation.

Geometry: The 3D structure of an object.

Grab: The technique of acquiring a still graphic from the screen of a computer or a video.

Graphics Engine: Software that generates interactive 2D and 3D graphics. Examples of graphics engines are Direct3D and OpenGL.

Hardware: The components of a computer system, for example the hard disk or the motherboard.

Hold: Frames within an animation sequence where an object does not move, but maintains its position.

HSB: Hue, saturation, brightness. Based on the human perception of colour, the HSB model describes three fundamental characteristics of colour.

Icon: A small picture that represents an application, file type or other computer related item.

In-betweening: In animation, the process of adding frames between keyframes to produce smooth motion. Also known as tweening.

Interface: The display and presentation of information on the computer screen.

Interpolation: Literally: filling in the empty space between existing parts. Interpolation is used in graphics to describe the process of upscaling graphics. It's used in animation to describe the process of tweening.

JPEG: Joint Photographic Experts Group. A commonly used graphics file format that compresses graphics. It supports up to 24-bit color. Its small size makes it ideal for web graphics.

Keyframe: In animation, a frame that marks the position of an object at a point in time. A series of keyframes show the object at key positions during the course of motion. In-between frames then represent the actual movement.

Lathing: Creating a 3D surface by rotating a 2D spline around an axis.

Layout: A drawing of the background and animation characters created as a plan to visually describe the main features of a scene.

Level of Detail: A series of models representing the same object and containing increasing levels complexity and detail. The less detailed models are displayed when the viewer is far away. The more detailed models are displayed as the viewer gets closer.

Lip Sync: Synchronising a character's mouth movements to a spoken soundtrack.

Luminance: The perceived brightness of a surface.

Memory: Computer hardware that is used for short-term storage, also known as RAM.

MOV: Movie. Apple's QuickTime movie format.

Motion Capture: The process of digitising a motion and applying it to a model.

Monitor: A computer screen.

Mouse: A pointing device that has one or more buttons.

MPEG: Motion Picture Experts Group. A compressed video file format.

Network: A connected group of computers, each sharing information.

NTSC: National Television Standards Committee. Created the standards for American televisions. This acronym also refers to the standard formulated by the committee. This format has approximately 30 frames (60 fields) per second.

OpenGL: An open graphics API originally developed by SGI. It's used with many video adapters for many 3D applications, from games to high-end CAD.

Operating System: The basic software that defines how a computer operates.

PAL: phase alternate line. A video format used in Europe and England. There are approximately 25 frames (50 fields) per second in this format.

Pan: The movement of a camera across a scene.

Parenting: The process of assigning hierarchy to objects.

PCX: Commonly used by IBM PC-compatible computers. It supports RGB, indexed-colour, greyscale and bitmap colour modes. It does not support alpha channels. PCX supports the RLE compression method.

PICT: Apple graphic file format. It can include bitmapped or vector images, and can use different compression schemes. It's available only for Apple.

Pixel: picture element. The smallest element that can be independently assigned colour.

Polygon: A near-planar surface bounded by edges specified by vertices.

QuickTime: A compressed video file format developed by Apple.

RAM: Random-Access Memory.

Rasterise: The process of converting a projected point, line, polygon, or the pixels of a bitmap or image to fragments, each corresponding to a pixel in the framebuffer.

Rendering: The process of producing images or pictures. Rendering techniques such as shading, light modelling or depth cueing are sometimes used to make an image look realistic.

Resolution: For a CRT, the maximum number of displayable pixels in the horizontal and vertical directions. For a printer or plotter, the number of pixels per inch.

RGB: Red, Green, Blue. A colour model. A large percentage of the visible spectrum can be represented by mixing red, green and blue (RGB) in various proportions and intensities. Where the colours overlap, they create cyan, magenta, and yellow. RGB colours are used for lighting, video and monitors.

Rotation: A geometric transformation that causes points to be reoriented about an axis.

Saturation: The amount of colour.

Server: A computer that controls other users' access to a network.

Scaling: Changing the size of an object without changing its location or orientation.

SCSI: Small Computer Systems Interface. A standard connection that allows hardware devices to be attached to a computer.

Shading: The process of interpolating colour within the interior of a polygon or between the vertices of a line during rasterisation.

Squash and Stretch: A rule of motion applied to animated drawings. An object will stretch and then squash as soon as it stops against a surface.

Texture: A 2D bitmap image applied to 3D surfaces.

Texture Mapping: The process of applying a texture to 3D surfaces. It's used to add visual detail to 3D surfaces without increasing the geometry.

TIFF: Tagged Image File Format. An industry standard bitmap image format supported by many applications.

TGA: Targa. Graphic file format that supports any bit depth, and includes features such as alpha channels, gamma settings and built-in thumbnails.

Timeline: A scale measured in either frames or seconds.

Transformation: Translation, scaling, and rotation of a geometric object.

TWAIN: Technology without an interesting name. An industry standard for exchanging information between applications and devices.

Tweening: In animation, the process of adding frames between keyframes to produce smooth motion. It's also known as in-betweening.

VCR: Video Cassette Recorder.

Viewing Co-ordinates: A co-ordinate system that defines the positions of objects relative to the location of a viewer or camera.

VTR: Video Tape Recorder.

Window: A rectangular area in which information is presented on the screen.

Wireframe: The process of drawing a model by tracing features such as edges or contour lines without attempting to remove invisible or hidden parts, or to fill surfaces. The result is a model "frame".

Xsheet: The Xsheet is the final application where the completed scene is put together.

Zoom: The enlargement or reduction of the image created by adjusting the lens on a video camera.

Appendix B: Animation Software

2D Animation Software:

Animo
http://www.animo.com

A comprehensive toolkit to create animated productions in digital format that takes the animator through the whole process: from the scanner to outputting on film or video. Many of the digital techniques featured in the package emulate traditional methods.

Archer
http://www.yogurt-tek.com/

Archer is a modular-based software painting package designed to create high-quality 2D animation that can be configured according to different working environments and preferences. This bitmap system offers scanning, Bgmaker, Analyser, Painter, Xsheet and Composer modules.

Axa Team 2D Pro
http://www.axasoftware.com

A program designed specifically to do 2D cel animation in a Windows environment; easy to use, affordable and expandable

CelAction
http://www.celaction.com/

Professional 2D animation software for films, TV series and commercials. It is a cheap package, but very easy to use and allows animators to design 2D character models on computer as resolution-independent vector graphics or scanned bitmaps.

Crater Software
http://www.cratersoftware.com

CTP (Cartoon Television Program) is a PC compatible computer program specifically designed for broadcast quality animated series production. To run the CTP you only need a standard PC, a simple scanner and any video input/output board.

Creatoon
http://www.creatoon.com

PC software that allows the animator to create 2D animation in the cut-out style that shows your animations on screen in real time as you are creating them.

Flash
http://www.macromedia.com

A vector-based software system to allow you to create high-impact animations specifically for the Internet. Its purpose is too limited for general film and video production, however.

Linker Systems
http://www.linker.com

Animation Stand is a computer assisted 2D character animation system, available for all major platforms.

MediaPegs
http://www.mediapegs.com

A system that digitises the entire post-paper animation process from scanning to delivery; can run on Silicon Graphics stations and Windows NT machines. The package is intended for all animated media, including animated series, commercials and web content.

Retas!Pro
http://www.retas.com

A 2D digital animation production system which puts all the power and flexibility of professional creativity at your fingertips: digital drawing, pencil test, line trace, ink and paint, composting and special effects.

Softimage Toonz
http://www.softimage.com

Toonz is a complete 2D animation system used extensively in high-profile film, video, and interactive media productions. It includes a flexible automated workflow, palette management and ways to eliminate the labour intensive processes involved with animation.

Toonboom
http://www.toonboom.com

A 100% vector-based, resolution independent system for producing 2D animations from the web to film, featuring an animator-tested interface.

2D Drawing Tools:

Corel Draw
http://www3.corel.com

CorelDRAW® delivers vector illustration, layout, bitmap creation, image-editing, painting and animation software. CorelDraw supports development for both print and the web, and also now features a bundled application for creating Flash animations.

Fireworks
http://www.macromedia.com

Fireworks allows you to create, edit, and animate web graphics using a complete set of bitmap and vector tools and export them into a number of HTML editors. Links in seamlessly with Flash and Dreamweaver.

FreeHand

http://www.macromedia.com

FreeHand creates vector-based illustrations, web site storyboards, and features a unique multi-page workspace. The package can be used to generate both web- and print-based material.

Adobe Illustrator

http://www.adobe.com

Illustrator produces vector graphics alongside creative options and powerful tools for efficiently publishing artwork on the web and in print. The package features innovative slicing options, live distortion tools and dynamic data-driven graphics.

3D Packages:

3DS Max 4.2/Character Studio 3

http://www.discreet.com

Discreet 3DS Max is used by animators across the board, from videogames to TV and film animation. It is one of the best character animation packages on the market, and handles complex textures easily. Character Studio 3 is one of the most popular add-ons that anyone doing character animation in 3DS will have in their toolset.

Cinema 4D XL7

http://www.cinema4d.com

This package is notable due to the ability to create poseable figures as easily as creating crude cubes or spheres. This means the animator can easily create primitive figures to set up a scene quickly and simply. The package can be extended with add-ons, and provides a lot of tools for the character animator to play with at a good price.

Hash Animation Master

http://www.hash.com

Hash animation master is a stand-alone package with some unconventional tools. It is a low-cost, but heavyweight package that allows you to simplify and reuse animation once you have built up a library of poses; what it does it does well and with a minimum of fuss.

Lightwave 7

http://www.newtek-europe.com

This package runs on a 3D-based system, unlike the 2D systems in many other packages, allowing the animator to produce more realistic results. Lightwave 7 handles 3D well, and is a tried and tested tool for the 3D animator.

Maya 4

http://www.aw.sgi.com

Perhaps the most sought-after 3D animation tool, Maya has been used on a wide range of television programmes, video games and films, and is used for everything from cartoon animation to ultra-realistic character animation. Maya makes complex animation tasks a lot less tricky and has the power to animate down to the finest detail.

Poser/Poser Pro

http://www.curiouslabs.com

A low-cost, but effective, package for creating and animating 3D characters. Poser has a user-friendly interface and an extensive set of character animation tools, letting you animate characters through a set of poses quickly and easily. Poser sacrifices rendering quality for speed and ease of use, but this can be solved by taking your models into another 3D package.

Project Messiah:animate 3.0

http://www.projectmessiah.com

Once a Lightwave plug-in, Project Messiah has been designed for those who work on character animation full time. Featuring advanced morphing and blending to allow you create animations quickly, Project Messiah is a strong package that gives you a wide range of tools for character animation.

Softimage XSI 2.0

http://www.softimage.com

The package is one of the top players in the 3D animation world, and contains a special meta-clay feature that lets you mould organic shapes from a soft, sticky material. Strong texturing and rendering makes this a very desirable package.

Strata Pro

http://www.strata3d.com/

Strata 3D pro is a versatile application for 3D modelling, rendering and animation. The package has a range of features, including light sourcing, a wide range of modelling capabilities and a number of rendering options, including .swf Flash formatting.

Swift 3D

http://www.swift3d.com/

A low-cost, easy-to-use, vector-based animation package that is a useful choice for 3D Flash animation as it can export files in .swf and a range of other formats, and has other features such as light sourcing and a powerful rendering engine.

Lip Syncing Applications:

Face2Face
http://www.f2f-inc.com
This program lets you capture full facial movement and motion, allowing you to create facial expressions, head and lips movements and near-perfect lip sync.

Magpie Pro
http://www.thirdwishsoftware.com
Magpie Pro is a powerful lip sync and animation timing tool for the professional animator. It was created in such a way that allows the animator to approach the task in different ways according to his or her personal taste, and includes automatic speech recognition, a curve editor and multiple animatable channels.

Ventriloquist
http://www.lipsinc.com
Ventriloquist is a plug-in designed to ease and radically speed up the creation of talking characters for individual animators and production houses using 3ds max™ R3 and R4. Ventriloquist automatically generates the entire animation through a sophisticated – and hands-off – analysis of the voice file.

Appendix C: Professional Organisations for TV and iTV

Advanced Television Systems Committee (ATSC)

ATSC works to co-ordinate television standards among different communications media. Specifically in digital television, interactive systems, and broadband multimedia communications. http://www.atsc.org

Advanced Television Forum (ATV Forum)

Non-profit organisation that provides an open forum for commercial deployment of dynamic, interactive content. http://www.atvforum.com

Advanced Television Enhancement Forum (ATVEF)

A cross-industry alliance of companies representing the broadcast and cable networks, television transports. http://www.atvef.com

Association for Interactive Media (AIM)

A non-profit trade organisation devoted to helping marketers use interactive opportunities to reach their respective marketplaces. http://www.imarketing.org/

Cable and Telecommunications Association for Marketing (CTAM)

CTAM is dedicated to the development of consumer marketing standards in cable television, new media and telecommunications services. http://www.ctam.com

Corporation for Public Broadcasting (CPB)

Public broadcasting's largest single source of funds for analogue and digital programme development and production. http://www.cpb.org

Digital Video Broadcasting (DVB)

A consortium of over 300 broadcasters, manufacturers, network operators, software developers, regulatory bodies and others in over 35 countries committed to building global standards of the delivery of digital television and data services. http://www.dvb.org

National Association of Television Programme Executives (NATPE)

An organisation committed to furthering the quality and quantity of content in television. http://www.natpe.org

National Cable Telecommunications Association (NCTA)

The principal trade association of the cable television industry in the United States.

http://www.ncta.com

National Center for Accessible Media (NCAM)

A research and development facility dedicated to the issues of media and information technology for people with disabilities.

http://ncam.wgbh.org

Society of Motion Picture and Television Engineers (SMPTE)

The leading technical society for the motion imaging industry.

http://www.smpte.org

Women in Cable and Telecommunications (WICT)

The oldest and largest organisation serving women professionals in cable and telecommunications.

http://www.wict.org

World Wide Web Consortium (W3C)

Develops interoperable technologies (specifications, guidelines, software, and tools) to lead the web to its full potential as a forum for information, commerce, communication, and collective understanding.

http://www.w3.org

Appendix D: Animators' Web Links

General Interest Animation Sites:

Absolut Panushka
A history of experimental animation.
http://panushka.absolutvodka.com/panushka/map/current/index.html

Animation, Anime and Cartoons at Netscape's Open Directory
http://dmoz.org/Arts/Animation/

Animation Express
An archive of online animated shorts.
http://www.animationexpress.com

Animation Nation
A look at the animation industry from the inside.
http://www.animationnation.com

Animation Resources
Compiled by Leslie Bishko.
http://fas.sfu.ca/cs/people/GradStudents/bishko/personal/anim/

Ani-mato!
A Finnish site for animation, stop-motion and 3D-movie enthusiasts.
http://www.saunalahti.fi/~animato

An Introduction to Anime
http://www.rightstuf.com/introduction/index.html

National Film Board of Canada Archive of Animated Materials
754 animations that have been produced by the NFB.
http://www.nfb.ca/FMT/E/cate/A/Animated_Materials.html

Optical Toys
http://www.opticaltoys.com

SXA Experimental Animation Homepage
An introduction to experimental and fine art animation.
http://mypage.direct.ca/w/writer/FAA.html

The Voice Actors Ultimate Links Treasury
http://dmoz.org/Arts/Animation/Voice_Actors/

Wild Brain
A digital drive-in, showcasing animations from around the world.
http://www.wildbrain.com

Organisations and Archives:

ASIFA – The International Animated Film Society
http://asifa.net

One of many ASIFA chapters is located in Hollywood.
http://www.asifa-hollywood.org

The Bill Douglas Centre for the History of Cinema and Popular Culture
Located at the University of Exeter, this site includes photos of many optical toys.
http://www.ex.ac.uk/bill.douglas/

AWN – Animation World Network
http://www.awn.com

The California Museum of Photography
Information on animation and virtual reality, also early photographic equipment.
http://www.cmp.ucr.edu/netscape.html

CARTOON
An animation organisation representing the European Union.
http://www.cartoon-media.be/

Iota
Dedicated to preserving and promoting the art of light and movement.
http://www.iotacenter.org

Library of Congress
http://lcweb2.loc.gov/ammem/oahtml/oahome.html

SIGGRAPH
Promote the exchange of information on the theory, design, implementation, and application of computer-generated graphics and interaction.
http://www.siggraph.org

Women In Animation
http://women.in.animation.org

Online Magazines/News:

Animation Artist
http://www.animationartist.com

Animation Blast
http://www.awn.com/blast

Animation Magazine
http://www.animag.com

Anime Village
http://www.animevillage.com

Anime Web Turnpike
http://www.anime.jyu.fi/~anipike/

Cartoon Research
News and commentary by Jerry Beck.
http://www.cartoonresearch.com

Digital Animators
http://www.digitalanimators.com

Toon Zone
http://toonzone.net/

Offline News/Updates:

The Animation Flash
http://www.awn.com/flash (email–delivered)

ANiMATO!
http://www.awn.com/newsstand/newsanimato.phtml

Animatrix
http://animation.filmtv.ucla.edu/animtx.htm

Cinefex
http://cinefex.com

f.p.s. (Frames Per Second)
http://www.awn.com/fps

TOON Magazine
http://www.toonmagazine.com

Animation Art Conservation:

S/R Laboratories Animation Art Conservation Center
http://www.srlabs.com

Vintage Ink & Paint
http://www.vintageip.com

Appendix E: CD Contents

Figure E.1 *The CD navigation system*

The cover CD will work on the Mac or the PC, and will self-boot when you insert it into the CD drive on the PC. The loading files are: PC – main.exe and Mac – Projector. The navigation system allows you to browse around the content for every chapter, and also gives you a brief description of each chapter. On the PC all files need to be accessed through Windows Explorer and they are saved in the main chapter folders.

Included on the CD is a demo of Macromedia Flash MX, set to time out after 30 days. This demo allows you to take full advantage of the techniques covered in this book.

For more information and updates for the CD you can visit www.sprite.net or email alex.michael@sprite.net.

CD Structure

Also featured on the CD are the .fla and .swf files for each tutorial. Each chapter folder is split into two directories, one that contains all the files for each tutorial and another that contains any other relevant files for that chapter. The tutorials are organised into their own sub-folders, each containing all the assets necessary for that tutorial. The following screengrab shows a breakdown of the CD structure, with the chapter12 folder expanded to show you how it is organised.

Figure E.2 *The CD file structure*

Index